Nikon® D3200[™] FOR DUMMES®

Nikon® D3200[™] FOR DUMMIES®

by Julie Adair King

John Wiley & Sons, Inc.

Nikon[®] D3200[™] For Dummies[®]

Published by John Wiley & Sons, Inc. 111 River Street Hoboken, NJ 07030-5774

www.wiley.com

Copyright © 2012 by John Wiley & Sons, Inc., Hoboken, New Jersey

Published by John Wiley & Sons, Inc., Hoboken, New Jersey

Published simultaneously in Canada

No part of this publication may be reproduced, stored in a retrieval system or transmitted in any form or by any means, electronic, mechanical, photocopying, recording, scanning or otherwise, except as permitted under Sections 107 or 108 of the 1976 United States Copyright Act, without either the prior written permission of the Publisher, or authorization through payment of the appropriate per-copy fee to the Copyright Clearance Center, 222 Rosewood Drive, Danvers, MA 01923, (978) 750-8400, fax (978) 646-8600. Requests to the Publisher for permission should be addressed to the Permissions Department, John Wiley & Sons, Inc., 111 River Street, Hoboken, NJ 07030, (201) 748-6011, fax (201) 748-6008, or online at http://www.wiley.com/go/permissions.

Trademarks: Wiley, the Wiley logo, For Dummies, the Dummies Man logo, A Reference for the Rest of Us!, The Dummies Way, Dummies Daily, The Fun and Easy Way, Dummies.com, Making Everything Easier, and related trade dress are trademarks or registered trademarks of John Wiley & Sons, Inc. and/or its affiliates in the United States and other countries, and may not be used without written permission. Nikon and D3200 are trademarks of Nikon Corporation. All other trademarks are the property of their respective owners. John Wiley & Sons, Inc. is not associated with any product or vendor mentioned in this book.

LIMIT OF LIABILITY/DISCLAIMER OF WARRANTY: THE PUBLISHER AND THE AUTHOR MAKE NO REPRESENTATIONS OR WARRANTIES WITH RESPECT TO THE ACCURACY OR COMPLETENESS OF THE CONTENTS OF THIS WORK AND SPECIFICALLY DISCLAIM ALL WARRANTIES, INCLUDING WITH-OUT LIMITATION WARRANTIES OF FITNESS FOR A PARTICULAR PURPOSE. NO WARRANTY MAY BE CREATED OR EXTENDED BY SALES OR PROMOTIONAL MATERIALS. THE ADVICE AND STRATEGIES CONTAINED HEREIN MAY NOT BE SUITABLE FOR EVERY SITUATION. THIS WORK IS SOLD WITH THE UNDERSTANDING THAT THE PUBLISHER IS NOT ENGAGED IN RENDERING LEGAL, ACCOUNTING, OR OTHER PROFESSIONAL SERVICES. IF PROFESSIONAL ASSISTANCE IS REQUIRED, THE SERVICES OF A COMPETENT PROFESSIONAL PERSON SHOULD BE SOUGHT. NEITHER THE PUBLISHER NOR THE AUTHOR SHALL BE LIABLE FOR DAMAGES ARISING HEREFROM. THE FACT THAT AN ORGANIZA-TION OR WEBSITE IS REFERRED TO IN THIS WORK AS A CITATION AND/OR A POTENTIAL SOURCE OF FURTHER INFORMATION DOES NOT MEAN THAT THE AUTHOR OR THE PUBLISHER ENDORSES THE INFORMATION THE ORGANIZATION OR WEBSITE MAY PROVIDE OR RECOMMENDATIONS IT MAY MAKE. FURTHER, READERS SHOULD BE AWARE THAT INTERNET WEBSITES LISTED IN THIS WORK MAY HAVE CHANGED OR DISAPPEARED BETWEEN WHEN THIS WORK WAS WRITTEN AND WHEN IT IS READ.

For general information on our other products and services, please contact our Customer Care Department within the U.S. at 877-762-2974, outside the U.S. at 317-572-3993, or fax 317-572-4002.

For technical support, please visit www.wiley.com/techsupport.

Wiley publishes in a variety of print and electronic formats and by print-on-demand. Some material included with standard print versions of this book may not be included in e-books or in print-on-demand. If this book refers to media such as a CD or DVD that is not included in the version you purchased, you may download this material at http://booksupport.wiley.com. For more information about Wiley products, visit www.wiley.com.

Library of Congress Control Number: 2012943022

ISBN 978-1-118-44683-6 (pbk); ISBN 978-1-118-44678-2 (ebk); ISBN 978-1-118-44680-5 (ebk); ISBN 978-1-118-44682-9 (ebk)

Manufactured in the United States of America

10 9 8 7 6 5 4 3

About the Author

Julie Adair King is the author of many books about digital photography and imaging, including the best-selling *Digital Photography For Dummies*. Her most recent titles include a series of *For Dummies* guides to popular Nikon, Canon, and Olympus cameras. Other works include *Digital Photography Before & After Makeovers, Digital Photo Projects For Dummies, Julie King's Everyday Photoshop For Photographers, Julie King's Everyday Photoshop Elements, and Shoot Like a Pro!: Digital Photography at such locations as the Palm Beach Photographic Centre.*

An Ohio native and graduate of Purdue University, she now resides in West Palm Beach, Florida, and does not miss Midwestern winters even a little bit (although she very much misses friends who have not yet made the journey south).

Author's Acknowledgments

I am deeply grateful for the chance to work once again with the wonderful publishing team at John Wiley and Sons. Kim Darosett, Jennifer Webb, Steve Hayes, Barry Childs-Helton, and Sheree Montgomery are just some of the talented editors and designers who helped make this book possible. And finally, I am also indebted to technical editor Scott Proctor, without whose insights and expertise this book would not have been the same.

Publisher's Acknowledgments

We're proud of this book; please send us your comments at http://dummies.custhelp.com. For other comments, please contact our Customer Care Department within the U.S. at 877-762-2974, outside the U.S. at 317-572-3993, or fax 317-572-4002.

Some of the people who helped bring this book to market include the following:

Acquisitions and Editorial

Senior Project Editor: Kim Darosett

Executive Editor: Steven Hayes

Senior Copy Editor: Barry Childs-Helton

Technical Editor: Scott Proctor

Editorial Manager: Leah Michael

Editorial Assistant: Leslie Saxman

Sr. Editorial Assistant: Cherie Case

Cover Photo:

© iStockphoto.com / Maxim Bolotnikov

Cartoons: Rich Tennant (www.the5thwave.com)

Composition Services

Project Coordinator: Sheree Montgomery

Layout and Graphics: Carl Byers, Timothy Detrick, Joyce Haughey, Christin Swinford

Proofreaders: Lindsay Amones, Melissa Cossell, Rebecca Denoncour

Indexer: Infodex Indexing Services, Inc.

Publishing and Editorial for Technology Dummies

Richard Swadley, Vice President and Executive Group Publisher

Andy Cummings, Vice President and Publisher

Mary Bednarek, Executive Acquisitions Director

Mary C. Corder, Editorial Director

Publishing for Consumer Dummies

Kathleen Nebenhaus, Vice President and Executive Publisher

Composition Services

Debbie Stailey, Director of Composition Services

Contents at a Glance

.

0 0

Introduction 1
Part 1: Fast Track to Super Snaps
Chapter 1: Getting the Lay of the Land
Part 11: Working with Picture Files
Part III: Taking Creative Control211Chapter 7: Getting Creative with Exposure213Chapter 8: Manipulating Focus and Color259Chapter 9: Putting It All Together299
Part 1V: The Part of Tens317Chapter 10: Ten Fun and Practical Retouch Menu Features319Chapter 11: Ten Special-Purpose Features to Explore on a Rainy Day341
Index

Table of Contents

.

.

.

.

Introduction	1
A Quick Look at What's Ahead Part I: Fast Track to Super Snaps Part II: Working with Picture Files Part III: Taking Creative Control Part IV: The Part of Tens Icons and Other Stuff to Note eCheat Sheet Practice, Be Patient, and Have Fun!	1 2 2 2 2 2 3
Part 1: Fast Track to Super Snaps	
Chapter 1: Getting the Lay of the Land	7
Getting Comfortable with Your Lens	
Attaching a lens	
Removing a lens	10
Setting the focus mode (auto or manual)	
Zooming in and out	
Using a VR (Vibration Reduction) lens	
Adjusting the Viewfinder Focus	
Working with Memory Cards	
Exploring External Camera Controls	
Topside controls	
Back-of-the-body controls	
Front-left buttons	
Front-right features	
Hidden connections Ordering from Camera Menus	
Using the guided menus	
Ordering off the main menus	
Monitoring Shooting Settings	
Changing Settings Using the Information Display	
Displaying Help Screens	
Customizing Your Camera: Setup Menu Options	
Restoring Default Settings	
Chapter 2: Choosing Basic Picture Settings	47
Choosing an Exposure Mode	
Choosing the Release Mode	
Single Frame and Quiet Shutter Release modes	
Continuous (burst mode) shooting	

Nikon D3200 For Dummies _____

Self-timer shooting	54
Wireless remote-control modes	55
Adding Flash	
Enabling flash	
Setting the Flash mode	
Choosing the Right Quality Settings	61
Diagnosing quality problems	
Considering image size: How many pixels are eno	ugh?63
Understanding Image Quality options (JPEG or Ra	
My take: Choose JPEG Fine or Raw (NEF)	
Setting Image Size and Quality	73
Chapter 3: Taking Great Pictures, Automatically	
Setting Up for Automatic Success	
As Easy As It Gets: Auto and Auto Flash Off	
Taking Advantage of Scene Modes	
Getting More Creative with Guide Mode	
0	
Chapter 4: Exploring Live View Photography and Movi	
Using Your Monitor as a Viewfinder	
Live View safety tips	
Customizing the Live View display	
Focusing in Live View Mode	
Choosing the right focusing pairs	
Autofocusing in Live View and Movie mode	
Manual focusing for Live View and movie photogr	
Shooting Still Pictures in Live View Mode	
Shooting Digital Movies	
Choosing the video mode (NTSC or PAL)	
Setting video quality (frame size, frame rate, and	
Controlling audio	
Manipulating movie exposure	
Reviewing a few final recording options	
Recording a movie	
Screening Your Movies	
Trimming Movies	
Saving a Movie Frame as a Still Image	

Part 11: Working with Picture Files 135

Chapter 5: Playback Mode: Viewing, Erasing, and Protecting Photos	137
Customizing Basic Playback Options	
Adjusting playback timing Adjusting and disabling instant image review	
Enabling automatic picture rotation	

_____ Table of Contents

Viewing Images in Playback Mode	
Viewing multiple images at a time (thumbnails view)	143
Displaying photos in Calendar view	144
Choosing which images to view	146
Zooming in for a closer view	146
Viewing Picture Data	148
File Information mode	150
Highlights display mode	152
RGB Histogram mode	153
Shooting Data display mode	156
GPS Data mode	157
Overview Data mode	157
Deleting Photos and Movies	
Deleting files one at a time	
Deleting all photos and movies	
Deleting a batch of selected files	
Protecting Photos and Movies	
Creating a Digital Slide Show	164
Viewing Your Photos and Movies on a Television	168
Chapter 6: Downloading, Printing, and Sharing Your Photos	171
Choosing the Right Photo Software	
Three free photo programs	
Advanced photo programs	
Sending Pictures to the Computer	
Connecting the camera and computer for picture download	
Starting the transfer process	
Downloading using ViewNX 2	
Processing Raw (NEF) Files	
Processing Raw images in the camera Processing Raw files in ViewNX 2	
Planning for Perfect Prints	
Check the pixel count before you print	
Allow for different print proportions	
Get print and monitor colors in sync	
Preparing Pictures for E-Mail and Online Sharing	
Prepping online photos using ViewNX 2	
Resizing pictures from the Playback menu	
Resizing pictures from the rayback menu initial	
Part 111: Taking Creative Control)11
Fait III. Taking Creative Control	
Chapter 7: Getting Creative with Exposure	.213
Introducing the Exposure Trio: Shutter Speed, Aperture, and ISO	
Understanding exposure-setting side effects	
Doing the exposure balancing act	

xiii

Nikon D3200 For Dummies _____

Exploring the Advanced Exposure Modes	222
Reading the Meter	224
Setting Aperture, Shutter Speed, and ISO	227
Adjusting aperture and shutter speed	227
Controlling ISO	230
Choosing an Exposure Metering Mode	
Sorting Through Your Camera's Exposure-Correction Tools	
Applying Exposure Compensation	
Using autoexposure lock	
Expanding tonal range with Active D-Lighting	
Investigating Advanced Flash Options	244
Choosing the right Flash mode	247
Adjusting flash output	
Controlling flash output manually	
Chapter 8: Manipulating Focus and Color	
Mastering the Autofocus System	
Reviewing autofocus basics	
Understanding the AF-Area mode setting	
Changing the Focus mode setting	
Choosing the right autofocus combo	
Using autofocus lock	
Focusing Manually	
Manipulating Depth of Field	
Controlling Color	
Correcting colors with white balance	
Changing the White Balance setting	
Fine-tuning White Balance settings	
Creating white balance presets	
Choosing a Color Space: sRGB versus Adobe RGB	
Taking a Quick Look at Picture Controls	
Chapter 9: Putting It All Together	299
Recapping Basic Picture Settings	
Shooting Still Portraits	
Capturing action	
Capturing scenic vistas	
Capturing dynamic close-ups	
Part 1V: The Part of Tens	. 317
Chapter 10: Ten Fun and Practical Retouch Menu Features	
Applying the Retouch Menu Filters	
Removing Red-Eye	
Straightening Tilting Horizon Lines	

xiv

_____ Table of Contents

Inder	36	5
	50	-

xVi Nikon D3200 For Dummies

Introduction

Nikon. The name has been associated with top-flight photography equipment for generations. And the introduction of the D3200 has only enriched Nikon's well-deserved reputation, offering all the control a die-hard photography enthusiast could want while at the same time providing easy-to-use, point-and-shoot features for the beginner.

In fact, the D3200 offers so *many* features that sorting them all out can be more than a little confusing, especially if you're new to digital photography, SLR photography, or both. For starters, you may not even be sure what SLR means or how it affects your picture taking, let alone have a clue as to all the other techie terms you encounter in your camera manual — *resolution, aperture, white balance,* and so on. And if you're like many people, you may be so overwhelmed by all the controls on your camera that you haven't yet ventured beyond fully automatic picture-taking mode. Which is a shame because it's sort of like buying a Porsche and never actually taking it on the road.

Therein lies the point of *Nikon D3200 For Dummies*. Through this book, you can discover not just what each bell and whistle on your camera does, but also when, where, why, and how to put it to best use. Unlike many photography books, this one doesn't require any previous knowledge of photography or digital imaging to make sense of things, either. In classic *For Dummies* style, everything is explained in easy-to-understand language, with lots of illustrations to help clear up any confusion.

In short, what you have in your hands is the paperback version of an in-depth photography workshop tailored specifically to your Nikon picture-taking powerhouse.

A Quick Look at What's Ahead

This book is organized into four parts, each devoted to a different aspect of using your camera. Although chapters flow in a sequence that's designed to take you from absolute beginner to experienced user, I've also tried to make each chapter as self-standing as possible so that you can explore the topics that interest you in any order you please.

Here's a brief preview of what you can find in each part of the book:

Part 1: Fast Track to Super Snaps

Part I contains four chapters to help you get up and running. Chapter 1 offers a tour of the external controls on your camera, shows you how to navigate camera menus to access internal options, and walks you through initial camera setup. Chapter 2 explains basic picture-taking options, such as shutter-release

mode and Image Quality settings, and Chapter 3 shows you how to use the camera's fully automatic exposure modes. Chapter 4 explains the ins and outs of using Live View, the feature that lets you compose pictures on the monitor, and also covers movie recording.

Part 11: Working with Picture Files

This part offers two chapters, both dedicated to after-the-shot topics. Chapter 5 explains how to review your pictures on the camera monitor, delete unwanted images, and protect your favorites from accidental erasure. Chapter 6 offers a look at some photo software options — including Nikon ViewNX 2, which ships free with your camera — and then guides you through the process of downloading pictures to your computer and preparing them for printing and online sharing.

Part 111: Taking Creative Control

Chapters in this part help you unleash the full creative power of your camera by moving into the advanced shooting modes (P, S, A, and M). Chapter 7 covers the critical topic of exposure, and Chapter 8 explains how to manipulate focus and color. Chapter 9 summarizes all the techniques explained in earlier chapters, providing a quick-reference guide to the camera settings and shooting strategies that produce the best results for portraits, action shots, landscape scenes, and close-ups.

Part IV: The Part of Tens

In famous *For Dummies* tradition, the book concludes with two "top ten" lists containing additional bits of information and advice. Chapter 10 covers the most useful photo-editing tools found on the camera's Retouch menu, and Chapter 11 wraps up the book by detailing some camera features that, although not found on most "Top Ten Reasons I Bought My Nikon D3200" lists, are nonetheless interesting, useful on occasion, or a bit of both.

Icons and Other Stuff to Note

If this isn't your first *For Dummies* book, you may be familiar with the large, round icons that decorate its margins. If not, here's your very own icondecoder ring:

A Tip icon flags information that will save you time, effort, money, or some other valuable resource, including your sanity. Tips also point out techniques that help you get the best results from specific camera features.

When you see this icon, look alive. It indicates a potential danger zone that can result in much wailing and teeth-gnashing if ignored. In other words, this is stuff that you really don't want to learn the hard way.

Lots of information in this book is of a technical nature — digital photography is a technical animal, after all. But if I present a detail that is useful mainly for impressing your technology-geek friends, I mark it with this icon.

I apply this icon either to introduce information that is especially worth storing in your brain's long-term memory or to remind you of a fact that may have been displaced from that memory by some other pressing fact.

Additionally, I need to point out these additional details that will help you use this book:

- Other margin art: Replicas of some of your camera's buttons and onscreen symbols also appear in the margins of some paragraphs. I include these to provide a quick reminder of the appearance of the button or feature being discussed.
- ✓ Software menu commands: In sections that cover software, a series of words connected by an arrow indicates commands that you choose from the program menus. For example, if a step tells you to "Choose File⇔Convert Files," click the File menu to unfurl it and then click the Convert Files command on the menu.

Occasionally, I need to make updates to technology books. If this book does have technical updates, they will be posted at www.dummies.com/go/nikond3200updates.

eCheat Sheet

As a little added bonus, you can find an electronic version of the famous *For Dummies* Cheat Sheet at www.dummies.com/cheatsheet/nikond3200. The Cheat Sheet contains a quick-reference guide to all the buttons, dials, switches, and exposure modes on your D3200. Log on, print it out, and tuck it in your camera bag for times when you don't want to carry this book with you.

Practice, Be Patient, and Have Fun!

To wrap up this preamble, I want to stress that if you initially think that digital photography is too confusing or too technical for you, you're in very good company. *Everyone* finds this stuff a little mind-boggling at first. So take it slowly, experimenting with just one or two new camera settings or techniques at first. Then, each time you go on a photo outing, make it a point to add one or two more shooting skills to your repertoire.

I know that it's hard to believe when you're just starting out, but it really won't be long before everything starts to come together. With some time, patience, and practice, you'll soon wield your camera like a pro, dialing in the necessary settings to capture your creative vision almost instinctively.

So without further ado, I invite you to grab your camera, a cup of whatever it is you prefer to sip while you read, and start exploring the rest of this book. Your D3200 is the perfect partner for your photographic journey, and I thank you for allowing me, through this book, to serve as your tour guide.

Part I Fast Track to Super Snaps

In this part . . .

Aking sense of all the controls on your camera isn't something you can do in an afternoon — heck, in a week, or maybe even a month. But that doesn't mean that you can't take great pictures today. By using your camera's point-and-shoot automatic modes, you can capture terrific images with very little effort. All you do is compose the scene, and the camera takes care of almost everything else.

This part shows you how to take best advantage of your camera's automatic features and also addresses some basic setup steps, such as adjusting the viewfinder to your eyesight and getting familiar with the camera menus, buttons, and other controls. In addition, chapters in this part explain how to obtain the very best picture quality, whether you shoot in an automatic or manual mode, and how to use your camera's Live View and movie-making features.

Getting the Lay of the Land

In This Chapter

- Attaching and using an SLR lens
- Adjusting the viewfinder to your eyesight
- Working with memory cards
- Exploring the camera controls
- Selecting from menus
- Using the Information display to view and adjust settings
- Customizing basic operations
- Restoring default settings

still remember the day I bought my first single-lens reflex (SLR) film camera. I was excited to finally move up from my onebutton point-and-shoot camera, but I was a little anxious, too. My new pride and joy sported several unfamiliar buttons and dials, and the explanations in the camera manual clearly were written for someone with an engineering degree. And then there was the whole business of attaching the lens to the camera, an entirely new task for me. I saved my pennies a long time to buy that camera — what if my inexperience caused me to damage the thing before I even shot my first picture?

You may be feeling similarly insecure if your Nikon D3200 is your first SLR, although some of the buttons on the camera back may look familiar if you've previously used a digital point-and-shoot camera. If your D3200 is both your first SLR and first digital camera, you may be doubly intimidated. Trust me, though — your camera isn't nearly as complicated as its exterior makes it appear. With a little practice and the help of this chapter, which introduces you to each external control, you can become comfortable with your camera's buttons and dials in no time. This chapter also guides you through the process of mounting and using a lens, working with memory cards, navigating your camera's menus, changing picture-taking settings, and customizing basic camera operations.

One note before you start: Photos in this book show the black version of the camera instead of the red one. What can I say — I'm a traditionalist, I guess. But all the buttons, menus, and other camera features work the same, no matter what the color of your camera.

Getting Comfortable with Your Lens

One of the biggest differences between a point-and-shoot camera and an SLR camera is the lens. With an SLR, you can swap out lenses to suit different photographic needs, going from a *macro lens*, which enables you to shoot extreme close-ups, to a *telephoto lens*, which lets you photograph subjects from a distance, for example. In addition, an SLR lens has a movable focusing ring that lets you focus manually instead of relying on the camera's autofocus mechanism.

Of course, those added capabilities mean that you need a little information to take full advantage of your lens. To that end, the next several sections explain the process of attaching, removing, and using this critical part of your camera.

Attaching a lens

Your camera can autofocus only with a type of lens that carries the specification *AF-S*. (Well, technically speaking, the camera can autofocus with *AF-I* lenses also. But because those are high-end, very expensive lenses that are no longer made, this is the only mention of AF-I lenses in this book.) You can use other types of lenses, as long as they're compatible with the camera's lens mount, but you have to focus manually and you may lose access to other camera functions as well. (See your camera manual for information about which functions aren't available with different types of non-AFS lenses.)

Whatever lens you choose, follow these steps to attach it to the camera body:

1. Turn the camera off and remove the cap that covers the lens mount on the front of the camera.

- 2. Remove the cap that covers the back of the lens.
- 3. Hold the lens in front of the camera so that the little white dot on the lens aligns with the matching dot on the camera body.

Official photography lingo uses the term *mounting index* instead of *little white dot*. Either way, you can see the markings in question in Figure 1-1.

Note that the figure shows as do others in this book the D3200 with its so-called *kit lens* — the 18–55mm AF-S Vibration Reduction (VR) zoom lens that Nikon sells as a unit with the camera body. If you buy a different lens, your lens mounting index may be some other color or shape, so check the lens instruction manual.

4. Keeping the dots aligned, as shown in Figure 1-1, position the lens on the camera's lens mount.

When you do so, grip the lens by its back collar, not the movable, forward end of the lens barrel.

5. Turn the lens in a counterclockwise direction until the lens clicks into place.

Figure 1-1: When attaching the lens, align the index markers as shown here.

To put it another way, turn the lens toward the side of the camera that sports the shutter button, as indicated by the red arrow in the figure.

6. On a lens that has an aperture ring, set and lock the ring so the aperture is set at the highest f-stop number.

Check your lens manual to find out whether your lens sports an aperture ring and how to adjust it. (The D3200 kit lens doesn't.) To find out more about apertures and f-stops, see Chapter 7.

Lens-release button

Part I: Fast Track to Super Snaps

Even though the D3200 is equipped with a dust-reduction system, always attach (or switch) lenses in a clean environment to reduce the risk of getting dust, dirt, and other contaminants inside the camera or lens. Changing lenses on a beach, for example, isn't a good idea. For added safety, point the camera body slightly down when performing this maneuver; doing so helps prevent any flotsam in the air from being drawn into the camera by gravity.

Removing a lens

To detach a lens from the camera body, take these steps:

- 1. Turn off the camera and then locate the lens-release button, labeled in Figure 1-1.
- 2. Press the lens-release button while turning the lens clockwise (toward the button) until the mounting index on the lens is aligned with the index on the camera body.

The mounting indexes are the little guide dots labeled in Figure 1-1. When the dots line up, the lens detaches from the mount.

3. Place the rear protective cap onto the back of the lens.

If you aren't putting another lens on the camera, cover the lens mount with the protective cap that came with your camera, too.

Setting the focus mode (auto or manual)

Again, the option to switch between autofocusing and manual focusing depends on matching the D3200 with a fully compatible lens, as I explain in the earlier section, "Attaching a lens." With the kit lens, as well as with other AF-S lenses, you can enjoy autofocusing as well as manual focusing.

The AF stands for *autofocus*, as you may have guessed. The S stands for *silent wave*, a Nikon autofocus technology.

For times when you attach a lens that doesn't support autofocusing or the autofocus system has trouble locking on your subject, you can focus manually by twisting a focusing ring on the lens. The placement and appearance of the focusing ring depend on the lens; Figure 1-2 shows you the one on the kit lens.

To focus manually with the kit lens, take these steps:

1. Set the focus mode switch on the lens to the M (manual) position.

Figure 1-2 gives you a look at the switch.

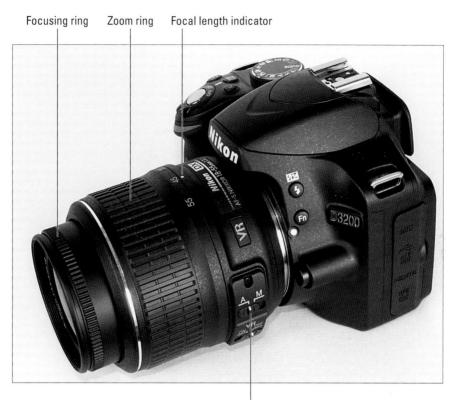

Auto/Manual focus switch

Figure 1-2: On the 18–55mm kit lens, the manual-focusing ring is set near the front of the lens, as shown here.

2. While looking through the viewfinder, twist the focusing ring to adjust focus.

If you have trouble focusing, you may be too close to your subject; every lens has a minimum focusing distance. You may also need to adjust the viewfinder to accommodate your eyesight; you can get help with the process a few paragraphs from here.

If you use a lens other than the kit lens, check the lens instruction guide for details about focusing manually; your lens may or may not have a switch similar to the one on the kit lens. Also see the Chapter 8 section related to the Focus mode option, which should be set to MF for manual focusing. (With the kit lens and some other lenses, the camera automatically chooses the MF setting for you.) You access this setting via the Information screen, a process you can read about in the section "Changing Settings Using the Information Display," later in this chapter.

Part I: Fast Track to Super Snaps

By the way, even when you focus manually, the camera provides some feedback to help you determine whether focus is set correctly. Look in the Chapter 8 section that's devoted to manual focusing for details.

Zooming in and out

If you bought a zoom lens, it has a movable zoom ring. The location of the zoom ring on the D3200 kit lens is shown in Figure 1-2. To zoom in or out, just rotate that ring.

The numbers on the zoom ring, by the way, represent *focal lengths*. I explain focal lengths in Chapter 8. In the meantime, just note that when the lens is mounted on the camera, the number that's aligned with the lens mounting index (the white dot) represents the current focal length. In Figure 1-2, for example, the focal length is 45mm.

Using a VR (Vibration Reduction) lens

Some Nikon lenses, including the 18–55mm lens sold in a kit with the D3200 camera body, offer *Vibration Reduction*. On Nikon lenses, this feature is indicated by the initials *VR* in the lens name.

Vibration Reduction attempts to compensate for small amounts of camera shake that are common when photographers handhold their cameras and use a slow shutter speed, a lens with a long focal length, or both. That camera movement during the exposure can produce blurry images. Although Vibration Reduction can't work miracles, it enables most people to capture sharper handheld shots in many situations than they otherwise could.

Here's what you need to know about taking best advantage of this feature with your D3200:

- Turn Vibration Reduction on or off by using the VR switch, labeled in Figure 1-3. On the kit lens, the switch is located directly underneath the Auto/Manual focus switch.
- ✓ Vibration Reduction is initiated when you depress the shutter button halfway (which also initiates autofocus and exposure metering). If you pay close attention, the image in the viewfinder may appear to be a little blurry immediately after you take the picture. That's a normal result of the vibration-reduction operation and doesn't indicate a problem with your camera or focus. Wait until the viewfinder image returns to normal to take your next shot.

Chapter 1: Getting the Lay of the Land

- With the kit lens, turn Vibration Reduction off when you mount the camera on a tripod. When you use a tripod, Vibration Reduction can have detrimental effects because the system may try to adjust for movement that isn't actually occurring. This recommendation assumes that the tripod is "locked down" so that the camera is immovable.
- ✓ For other lenses, check the lens manual to find out whether your lens offers a similar feature. On non-Nikon lenses, it may go by another name: *image stabilization*, optical stabilization, anti-shake, vibration compensation, and so on. In some cases, the manufacturers may recommend that you leave the system

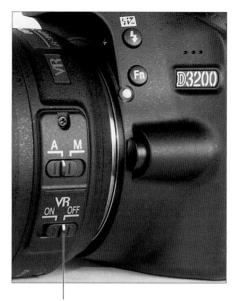

Vibration Reduction switch

Figure 1-3: Turn off Vibration Reduction when you use a tripod.

turned on or select a special setting when you use a tripod or *pan* the camera (move it horizontally or vertically as you take the picture). For the kit lens, however, you don't need to disable Vibration Reduction when panning.

Chapter 8 offers more tips on achieving blur-free photos, and it also explains focal length and its impact on your pictures. See Chapter 7 for an explanation of shutter speed.

Adjusting the Viewfinder Focus

Tucked behind the right side of the rubber eyepiece that surrounds the viewfinder is a tiny dial that enables you to adjust the focus of your viewfinder to accommodate your eyesight. Figure 1-4 shows you where to find the dial, which is officially known as the *diopter adjustment control*.

Part I: Fast Track to Super Snaps _

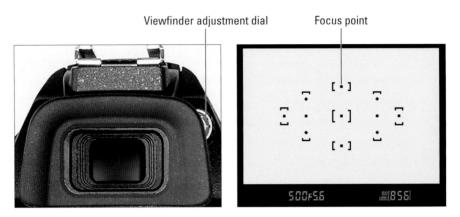

Figure 1-4: Use the diopter adjustment control to set the viewfinder focus for your eyesight.

If you don't take this step, scenes that appear out of focus through the viewfinder may actually be sharply focused through the lens, and vice versa. Here's how to make the necessary adjustment:

- 1. Turn the camera on and remove the lens cap from the front of the lens.
- 2. Look through the viewfinder and then press the shutter button halfway and release it.

You should see some shooting data appear at the bottom of the screen, as shown on the right in Figure 1-4. (The data shown may differ from what you see in the figure.) And scattered through the center of the screen are little black marks that indicate the camera's 11 autofocusing points. I labeled one of the points in Figure 1-4.

- 3. Aim the lens at a blank wall or other plain surface.
- 4. Concentrate on the viewfinder data and focusing marks and then rotate the adjustment dial until they appear sharp.

The Nikon manual warns you not to poke yourself in the eye as you perform this maneuver. This warning seems so obvious that I laugh every time I read it — which makes me feel doubly stupid the next time I poke myself in the eye as I perform this maneuver.

If your eyesight is such that you need a greater adjustment than you can achieve with the built-in diopter control, you can buy an add-on to the viewfinder eyepiece to increase the adjustment range. The official name for this accessory is Nikon DK-20C Correction Eyepiece.

Working with Memory Cards

Instead of recording images on film, digital cameras store pictures on *memory cards.* Your D3200 uses a specific type of memory card: an *SD card* (for *Secure Digital*).

Most SD cards sold today carry the designation SDHC (for *High Capacity*) or SDXC (for *eXtended Capacity*), depending on how many gigabytes (GB) of data they hold. SDHC cards hold from 4GB to 32GB of data; the SDXC moniker is assigned to cards with capacities greater than 32GB.

You also can use Eye-Fi SD cards, a special brand of card that enables you to send pictures to your computer over a wireless network. Because of space limitations, I don't cover Eye-Fi connectivity in this book; if you want more information about these cards, you can find it online at www.eye.fi. Of course, the D3200 also gives you another wireless picture-transmission option: It's compatible with the Nikon WU-1a unit, which sends pictures from your camera to certain smartphones and tablets. See Chapter 6 for more about that product.

Back to the memory cards themselves: Safeguarding your cards — and the images you store on them — requires just a few precautions:

- Inserting a card: First, be sure that the camera is turned off. Then put the card in the card slot with the label facing the back of the camera, as shown in Figure 1-5. Push the card into the slot until it clicks into place; the camera's memory card access light (labeled in Figure 1-5) blinks for a second to let you know the card is inserted properly.
- Formatting a card: The first time you use a new memory card or insert a card that's been used in other devices (such as an MP3 player), you should format it. Formatting ensures that the card is properly prepare

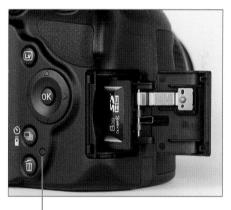

Memory Card access light

Figure 1-5: Insert the card with the label facing the camera back.

that the card is properly prepared to record your pictures.

Part I: Fast Track to Super Snaps

Formatting erases *everything* on your memory card. So before formatting, be sure that you have copied any pictures or other data to your computer.

To format a memory card, choose the Format Memory Card command from the Setup menu. The upcoming section "Ordering from Camera Menus" explains how to work with menus if you need help. When you select the command, you're informed that all images will be deleted, and you're asked to confirm your decision to format the card. Highlight Yes and press OK to go forward.

If you insert a memory card and see *For* in the viewfinder, you must format the card before you can do anything else. You also see a message requesting formatting on the camera monitor.

6

Some computer programs enable you to format cards as well, but it's not a good idea to go that route. Your camera is better equipped to optimally format cards for use in the camera.

Removing a card: After making sure that the memory card access light is off, indicating that the camera has finished recording your most recent photo, turn off the camera. Open the memory card door, as shown in Figure 1-5. Depress the memory card slightly until you hear a little click and then let go. The card pops halfway out of the slot, enabling you to grab it by the tail and remove it.

If you turn on the camera when no card is installed, the symbol [-E-] blinks in the lower-right corner of the viewfinder. If the Information screen is displayed on the monitor, that screen also nudges you to insert a memory card. If you do have a card in the camera and you get these messages, try taking it out and reinserting it.

- Handling cards: Don't touch the gold contacts on the back of the card. (See the right card in Figure 1-6.) When cards aren't in use, store them in the protective cases they came in or in a memory-card wallet. Keep cards away from extreme heat and cold as well.
- Locking cards: The tiny switch on the side of the card, labeled *lock switch* in Figure 1-6, enables you to lock your card, which prevents any data from being erased or recorded to the card. Press the switch toward the

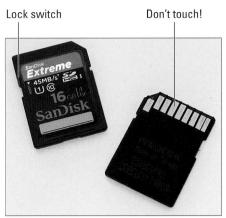

Figure 1-6: Avoid touching the gold contacts on the card.

bottom of the card to lock the card contents; press it toward the top of the card to unlock the data. (If you insert a locked card into the camera, you see a message on the monitor alerting you to the fact, and the symbol [d blinks in the viewfinder.)

You also can protect individual images on a card from accidental erasure by using the camera's Protect feature, which I cover in Chapter 5.

One side note on the issue of memory cards and file storage: Given that memory cards are getting cheaper and larger in capacity, you may be tempted to pick up a 64GB (64-gigabyte) or even larger card, thinking you can store a gazillion images on one card and not worry about running out of room. But memory cards are mechanical devices that are subject to failure, and if a large card fails, you lose *lots* of images. And putting aside the potential for card failure, it's darned easy to misplace those little guys. So I carry several 16GB SD cards in my camera bag instead of relying on one ginormous card. Although I hate to lose any images, I'd rather lose 16 GB worth of pictures than 64 GB.

Do you need high-speed memory cards?

Secure Digital (SD) memory cards are rated according to *speed classes:* Class 2, Class 4, Class 6, and Class 10, with the number indicating the minimum number of *megabytes* (units of computer data) that can be transferred per second. A Class 2 card, for example, has a minimum transfer speed of 2 megabytes, or MB, per second. In addition to these speed classes, The Powers That Be recently added a new category of speed rating, UHS, which stands for Ultra High Speed. UHS cards also carry a number designation; at present, there is only one class of UHS card, UHS 1. These cards currently offer the fastest performance. Your D3200 supports this new card speed.

Of course, with the increase in card speed comes a price increase, which leads to the question: Do you really have a need for speed? The answer is "maybe." If you shoot a lot of movies, I recommend a Class 6 card at minimum — the faster data-transfer rate helps ensure smooth movie-recording and playback performance. For still photography, users who shoot at the highest resolution or prefer the NEF (Raw) file format may also gain from high-speed cards; both options increase file size and, thus, the time needed to store the picture on the card. (See Chapter 2 for details.)

As for picture downloading, how long it takes files to shuffle from card to computer depends not just on card speed, but also on the capabilities of your computer and, if you use a memory card reader to download files, on the speed of that device. (Chapter 6 covers the file-downloading process.)

Long story short, if you want to push your camera to its performance limits, a high-speed card is worth the expense, especially for video recording. But if you're primarily interested in still photography or you already own slowerspeed cards, try using them first — you may find that they're more than adequate for most shooting scenarios.

Exploring External Camera Controls

Scattered across your camera's exterior are buttons, dials, and switches that you use to change picture-taking settings, review and edit your photos, and perform various other operations. In later chapters, I discuss all your camera's functions in detail. This section provides just a basic road map to the external controls plus a quick introduction to each.

Many of the buttons perform multiple functions and so have multiple "official" names. The AE-L/AF-L button, for example, is also known as the Protect button. In the camera manual, Nikon's instructions refer to these multi-tasking buttons by the name that's relevant for the current function. I think that's a little confusing, so I always refer to each button by the first moniker you see in the lists here. In addition, when I reference a button, its picture appears in the margin to further clarify things. (The exceptions are the Menu and OK buttons — I don't show these because they are such frequent players in the camera's operation, and so would appear way too many times on the page.)

Topside controls

Your virtual tour begins with the bird's-eye view shown in Figure 1-7. There are a number of controls of note here:

✓ On/Off switch and shutter button: Okay, I'm pretty sure you already figured out this combo button. But you may not realize that you need to use a specific technique when pressing the shutter button: Press the button halfway, pause a second to allow the exposure meter and autofocusing system to do their jobs, and then press the button the rest of the way to take the picture. See the Chapter 3 section on using the Auto exposure mode for more picture-taking basics.

✓ Exposure Compensation button: This button activates a feature that enables you to tweak exposure when working in three of your camera's autoexposure modes: programmed autoexposure, aperture-priority autoexposure, and shutter-priority autoexposure, represented by the letters P, S, and A on the Mode dial. Chapter 7 explains. In manual exposure (M) mode, you press this button while rotating the Command dial to adjust the aperture setting.

Info button: Press this button to display the Information screen on the camera monitor; press again to turn off the display. See the upcoming section "Monitoring Shooting Settings" for details on this screen.

Chapter 1: Getting the Lay of the Land

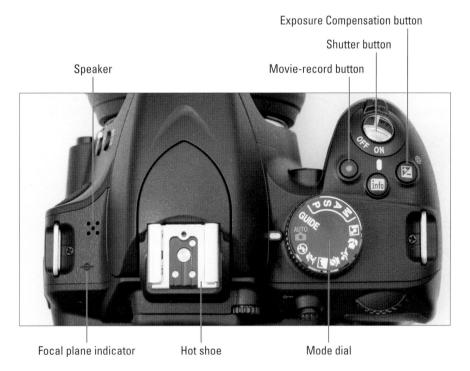

Figure 1-7: The tiny pictures on the Mode dial represent the automatic exposure modes known as Scene modes.

You also can display the screen by pressing the Information Edit button (on the back of the camera, shown in the next figure) or by pressing the shutter button halfway and releasing it. I find these methods easier, so I use the Info button only when I want to turn off the screen. Remember that if you do use the button to turn off the display, you must press it again to turn the display back on. Pressing the shutter button halfway won't do the trick. However, pressing the Info Edit button turns on the display regardless.

Movie-record button: After switching to Live View mode, press this button to start and stop recording movies. See Chapter 4 for an explanation of Live View mode and details on movie recording and playback.

Mode dial: With this dial, labeled in Figure 1-7, you set the camera to fully automatic, semi-automatic, or manual exposure mode. Choosing the Guide setting brings up the guided menu display, which helps newcomers get acquainted with the camera. The little pictographs represent Scene modes, which are automatic settings geared to specific types of photos: action shots, portraits, landscapes, and so on. Chapter 3 details the fully automatic modes; Chapter 7 explains the P, S, A, and M modes; and the section "Using the guided menus," later in this chapter, introduces you to Guide mode, which you can explore a bit more in Chapter 3.

- ✓ Flash hot shoe: A hot shoe is a connection for attaching an external flash. When you first take the camera out of the box, the contacts on the shoe are protected by a black cover; to attach a flash, slide the cover off to expose the contacts, as shown in Figure 1-7. Chapters 2 and 7 discuss flash photography.
- **Speaker:** When you play movies that contain audio, the sound comes wafting through the holes labeled *Speaker* in Figure 1-7.
- ✓ Focal plane indicator: Should you need to know the exact distance between your subject and the camera, the *focal plane indicator* is key. The mark, labeled in Figure 1-7, indicates the plane at which light coming through the lens is focused onto the negative in a film camera or the image sensor in a digital camera. Basing your measurement on this mark produces a more accurate camera-to-subject distance than using the end of the lens or some other external point on the camera body as your reference point.

Back-of-the-body controls

Traveling over the top of the camera to its back side, as shown in Figure 1-8, you encounter the following controls:

Command dial: After you activate certain camera features, you rotate this dial to select a specific setting. For example, to choose an f-stop when shooting in aperture-priority (A) mode, you rotate the Command dial. And in manual exposure (M) mode, you change the f-stop by rotating the dial while pressing the Exposure Compensation button. (Chapter 7 explains apertures and f-stops.)

AE-L/AF-L/Protect button: Pressing this button initiates autoexposure lock (AE-L) and autofocus lock (AF-L). Chapter 7 explains autoexposure lock; Chapter 8 talks about autofocus lock.

In playback mode, pressing the button activates the Protect feature, which locks the picture file — hence the little key symbol that appears to the left of the button — so that the image isn't erased if you use the picture-delete functions. See Chapter 5 for details. (The picture *is* erased if you format the memory card, however.)

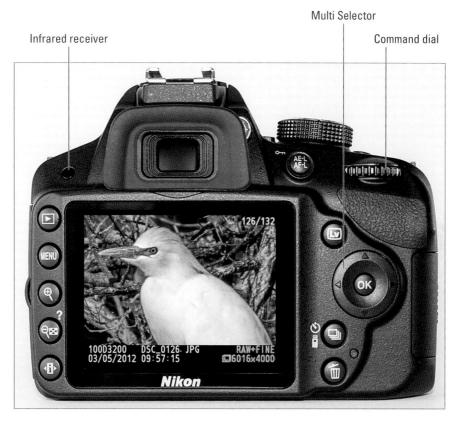

Figure 1-8: Use the Multi Selector to navigate menus and access certain other camera options.

You can adjust the performance of the button as it relates to locking focus and exposure. Instructions in this book assume that you stick with the default setting, but if you want to explore your options, see Chapter 11.

✓ Live View button: As its name implies, this switch turns the Live View feature on and off. As soon as you turn on Live View, the scene in front of the lens appears on the monitor, and you no longer can see anything through the viewfinder. You then can compose a still photo using the monitor or begin recording a movie. Turn off Live View to return to normal, through-the-viewfinder still photography. Chapter 4 details Live View photography and movie recording.

Multi Selector/OK button: This dual-natured control, labeled in Figure 1-8, plays a role in many camera functions. You press the outer edges of the Multi Selector left, right, up, or down to navigate camera menus and

access certain other options. At the center of the control is OK, which you press to finalize a menu selection or other camera adjustment.

Release mode button: This control enables you to quickly choose from six shutter-release modes: Single Frame, Continuous, Self-Timer, Quiet Shutter, and two remote-control modes. Chapter 2 discusses these options.

Delete button: Sporting a trash-can icon, the universal symbol for delete, this button enables you to erase pictures from your memory card. Chapter 5 has specifics.

- Playback button: Press this button to switch the camera into picture review mode. Chapter 5 details playback features.
- Menu button: Press this button to access menus of camera options. See the section "Ordering from Camera Menus," later in this chapter, for details on navigating menus.

- Zoom Out/Thumbnail/Help button: This button has a number of functions, but the most important ones are
 - *Display help screens:* You can press this button to display helpful information about certain menu options. See "Displaying Help Screens," later in this chapter, for details.
 - *Adjust the image display during playback:* In playback mode, pressing the button enables you to display multiple image thumbnails on the screen, reduce the magnification of the currently displayed photo, and access Calendar display, which makes it easy to see all the photos shot on a particular day. Again, see Chapter 5 for a complete rundown of playback options.

✓ Zoom In: In playback mode, pressing this button magnifies the currently displayed image and also reduces the number of thumbnails displayed at a time. Note the plus sign in the middle of the magnifying glass — plus for zoom in. Like the Zoom Out button, this one also serves a few minor roles that I explain in later chapters.

✓ Information Edit button: With this button — which I hereby designate as simply the Info Edit button to save space — you can display the Information screen. Press again, and you can then shift to what I call the Info Edit screen, which enables you to adjust the settings shown on the screen. See the upcoming sections "Monitoring Shooting Settings" and "Changing Settings Using the Information Display" for details.

✓ Infrared receiver: This little round sensor, labeled in Figure 1-8, picks up the signal from the optional ML-L3 wireless remote control. There's a second sensor on the front of the camera; see the upcoming section "Front-right features" for a look-see.

Chapter 1: Getting the Lay of the Land

Front-left buttons

On the front-left side of the camera body, featured in Figure 1-9, you find the following controls:

Flash/Flash compensa-

tion: In the advanced exposure modes (P. S. A, and M), pressing this button pops up the camera's built-in flash. (In other modes, the camera decides whether the flash is needed.) After the flash is raised, you can hold the button down and rotate the Command dial to adjust the Flash mode (normal, red-eye reduction, and so on). In advanced exposure modes, you also can adjust the flash power by pressing the button while simultaneously pressing the Exposure

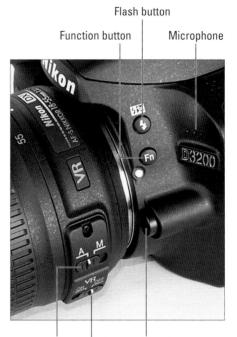

Auto/Manual focus switch

Lens-release button

Vibration Reduction switch

Figure 1-9: Press the Flash button to pop up the built-in flash.

Compensation button and rotating the Command dial. See Chapter 2 for an introduction to flash; check out Chapter 7 for the detailed story.

- ✓ Function (Fn) button: By default, this button gives you fast access to the ISO Sensitivity setting, which you can explore in Chapter 7. If you don't use that feature often, you can use the button to perform one of three other operations. Chapter 11 provides the details on changing the button's purpose. (*Note:* Instructions in this book assume that you haven't changed the button function.)
- Lens-release button: Press this button to disengage the lens from the lens mount so that you can remove the lens from your camera. See the first part of this chapter for help with mounting and removing lenses.
- Lens switches: As detailed in the first part of this chapter, use the A/M switch to set the kit lens to automatic or manual focusing. The VR switch turns the Vibration Reduction feature on and off. For other lenses, see your lens manual for help with these options.

Microphone: The three little holes just above the silver D3200 label lead to the camera's internal microphone. See Chapter 4 to find out how to disable the microphone if you want to record silent movies.

Front-right features

On the front-right side of the camera, you find a couple additional features, both labeled in Figure 1-10:

AF-assist lamp: In dim lighting, the camera may emit a beam of light from this lamp when you use autofocusing. The light helps the camera find its focusing target. If you're shooting in a setting where the light is distracting or otherwise annoving, you can disable it via the Built-in AF-assist illuminator option on the Shooting menu. On the flip side, there are some situations in which the lamp is automatically disabled: It doesn't light in Live View mode or during movie recording, for example.

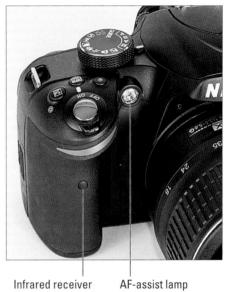

The AF-assist lamp also shoots out light when you use red-eye reduction flash and the Self-

Figure 1-10: In dim lighting, the AF-assist lamp helps illuminate the subject for better autofocusing performance.

Timer shutter-release mode, both covered in Chapter 2. You can't disable the lamp for these two functions.

Infrared receiver: Here's another infrared receiver, which, like the one on the back of the camera, picks up the wireless signal from the optional ML-L3 remote control unit.

Hidden connections

Hidden under a little cover on the left side of the camera, you find the following four connection ports, labeled in Figure 1-11:

Microphone jack: If you're not happy with the audio quality provided by the internal microphone, you can plug in the optional Nikon ME-1 microphone here.

Chapter 1: Getting the Lay of the Land

✓ USB/AV port: Through this port, you can connect your camera to your computer via a USB (Universal Serial Bus) connection for picture downloading. Nikon supplies the cable you need in the camera box; see Chapter 6 for downloading help.

A second USB cable is provided to enable you to connect the camera to a television set via standard A/V plugs (in other words, an analog connection). Chapter 5 explains the process.

Finally, if you buy the wireless mobile adapter WU-1a, you use this port to connect the device to the camera.

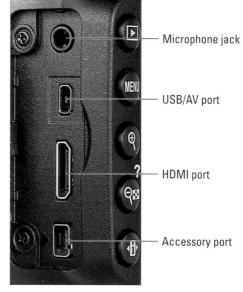

Figure 1-11: Open the cover on the side of the camera to reveal these connections.

- HDMI port: Through this port, you can connect your camera to an HD (high definition) television. However, you need to pony up the cash for the necessary cable, as Nikon doesn't supply one with the camera. Buy a Type C mini-pin HD cable.
- Accessory terminal: You can plug in the optional Nikon MC-DC2 remote shutter-release cable or the Nikon GP-1 GPS unit here. I don't cover these other accessories in this book, but the manual that comes with the devices can get you up and running.

If you turn the camera over, you find a tripod socket, which enables you to mount the camera on a tripod that uses a $\frac{1}{4}$ -inch screw, plus the battery chamber.

Ordering from Camera Menus

Pressing the Menu button on your camera gives you access to a whole slew of options in addition to those you control via the external buttons and dials. But what type of menu screens you see depends on the setting of the Mode dial:

- Guide: Pressing the Menu button brings up the first screen of the guided menus, which provide a simple, walk-me-through-it approach to using the camera.
- All other settings: Pressing the Menu button brings up the normal, text-based menus.

The next two sections provide an overview of using both types of menus. But for reasons you can discover in the following discussion, the rest of this book pretty much ignores the guided menus and relies on the regular menus to get things done — a choice that I suggest you make as well.

Using the guided menus

The guided menus work much like interactive menus you encounter in other areas of your life — on cellphones, bank machines, grocery-store self-checkout kiosks, and the like — except that instead of pressing buttons on the screen, you use the Multi Selector and OK button to make your menu selections. And thankfully, your camera also doesn't nag you to hurry up and "please place the item in the bagging area!" every three seconds.

With that rant about the modern grocery-store experience out of my system, here's how to use the guided menus:

1. Set the Mode dial to Guide, as shown on the left in Figure 1-12.

You see the initial guided menu screen, shown on the right in the figure. You're offered three options: Shoot, View/Delete, and Set Up.

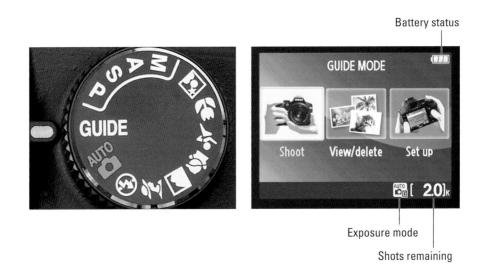

Figure 1-12: Set the Mode dial to Guide to use the guided menus.

The items labeled in the figure, which appear on all the guided menu screens, tell you the following information:

- *Battery status*: A full icon like the one in Figure 1-12 says you're good to go. If the little battery symbol appears half full or less, dig out your battery charger.
- *Exposure mode:* Even though the Guide option is on the Mode dial, it's not an exposure mode per se rather, it's a menu-based way for you to access the actual exposure modes. Through the guided menus, you can access any exposure mode except manual exposure (M). The symbol in the lower-right corner of the guided menu screen tells you which exposure mode is selected. In Figure 1-12, the symbol shows that the Auto exposure mode is selected. The letter G or the word Guide tells you that you're in Guide mode, in case you forget.
- *Shots remaining*: The other value in the lower-right corner shows you the number of shots you can fit in the remaining space on your memory card. Values larger than 999 are indicated by a tiny k, which in this case translates to thousand. For example, the value 2.0k in the figure says that 2,000 more pictures can fit on the memory card.

2. Press the Multi Selector right or left to highlight the category you want to choose.

(Remember, the Multi Selector is the big four-way rocker switch that has the OK button in the middle.) Here's a quick preview of what each category enables you to do:

- *Shoot:* Select this icon to select options that walk you through the process of choosing basic picture-taking options and shooting pictures.
- *View/Delete:* Select this category to access picture-playback functions and erase pictures from your memory card.
- *Set Up:* Choose this icon to access camera setup options things like setting the date and time, adjusting monitor brightness, and so on.

This category also contains two options that make a big impact on picture quality: Image Size and Image Quality. They really belong with the rest of the picture settings in the Shoot category, as they're organized in the regular menus. At any rate, check out Chapter 2 for help choosing the right settings. *Note:* For these two settings and some others, your settings apply only while you shoot in Guide mode.

3. Press OK.

You see a screen that lists available options in the category you chose. The left screen in Figure 1-13 shows the first screen that appears if you select Shoot in Step 2, for example.

Figure 1-13: Use the Multi Selector to highlight an option and press OK to move to the next step.

4. Highlight the option that interests you and press OK to display the next screen of information and instructions.

For example, if you highlight Easy Operation, as in Figure 1-13, and press OK, you see the second screen in the figure. There, you can use the Multi Selector to explore the available shooting options and then press OK again to move to the next screen.

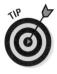

From this point on, keep highlighting options and pressing OK to move forward. For the Shoot category, you ultimately reach a screen that looks like the one on the left in Figure 1-14, telling you which exposure mode the camera is using. When you next press OK, you see a screen similar to the one on the right in the figure. If you want to explore more shooting settings, select the bottom option on the screen and press OK to explore them, as shown in Figure 1-15.

Auto (Auto 💷
The camera is now in "Auto" mode with the release mode set to single frame.	Use the viewfinder OX
the release mode set to single frame.	Use live view
	Shoot movies
	More settings
🕄 Back OBNext 🛅 [2.0]ĸ	🕀 Back 🖾 Next 🖽 [2.0

Figure 1-14: These two screens appear at the end of the Shoot section of the guided menu.

Figure 1-15: Choose More Settings to see what other picture-taking options you can access.

When you finish adjusting settings, press the Multi Selector left until you again reach the screen shown on the right in Figure 1-14.

The last step is to choose one of the three top options on that screen to tell the camera whether you want to shoot using the viewfinder, switch to Live View, or record a movie. Highlight your choice and press OK. If you select viewfinder shooting, you then see the Information screen, described later in this chapter. Otherwise, the camera initiates Live View, which enables you to frame the scene using the monitor (also the first step in shooting a movie). Chapter 4 details Live View still photography as well as movie recording.

As you explore the guided menus, you also can take advantage of these menu-navigation tricks:

- Return to the previous screen. If you see a Back symbol at the bottom of the screen, press the Multi Selector left to go back one screen. Both screens in Figure 1-15 show this symbol.
- Exit a screen without making changes. Don't see a Back icon? Look instead for a little "turnaround" arrow like the one labeled Exit symbol on the screen in Figure 1-16. Highlight that symbol and press OK to exit the current screen.

Exit symbol

Figure 1-16: Highlight the U-turn symbol and press OK to exit the screen without making any changes to the current settings.

Part I: Fast Track to Super Snaps

- Display more help. If you see a little question mark in the lower left corner of the screen, press and hold the Zoom Out button to display a help screen with more information. This help system is also available when you're not using Guide mode; see the upcoming section "Displaying Help Screens" for details.
- Return to the main guided menu screen. Press the Menu button to jump from any screen to the initial guided menu screen.
- Exit the guided menus. If you're on the final shooting screen (shown on the right in Figure 1-14), choose any option except More Settings and then press OK. You also can depart from your guide at any time by pressing the shutter button halfway and releasing it.

Although I appreciate the idea of the guided menus, I opted to largely ignore them in this book and instead show you how to perform different camera operations through the regular menus, which you can investigate in the next section. Here's why:

- You can't access all your camera's features through the guided menus. For example, you can't access autofocusing adjustments, discussed in Chapter 8, through the guided menus. Instead, you have to wait until you reach the final Shoot menu screen and exit the guided menus to make adjustments.
- ✓ In many cases, using the guided menus actually makes things more difficult. For example, if you select the Easy Operation choice on the Shoot menu, you're presented with a list of possible picture types. (See Figure 1-13.) Suppose that you select No Flash. The camera then engages the Auto Flash Off exposure mode which you can do yourself simply by turning the Mode dial to the No Flash symbol. (Chapter 3 introduces you to this exposure mode.)
- ✓ Some choices Nikon made for the arrangement of the guided menus set you up for confusion down the line. Remember my tip in the preceding steps about the Image Size and Image Quality options found in the Set Up section of the guided menus? Well, in the regular menus, those options live on the Shooting menu, not on the Setup menu. So if you get used to selecting those options in one place when you use guided menus, you have to learn a whole new organization when you move on to the regular menus.

Additionally, when you adjust certain settings, including Image Size and Image Quality, your changes apply *only* in Guide mode. So when you return to another shooting mode, you have to adjust those settings again.

After you get past the initial guided menu screens, some options aren't any less confusing than when you access them through the main menus. In some cases, you can display a help screen by pressing the Zoom Out button (the one with the question-mark symbol), but you can get the same help when using regular menus, too. Don't get me wrong: If you like the guided menus, by all means, take advantage of them. But my guess is that you don't need much help from me to do so. So with the exception of Chapter 3, which provides some details about a couple cool options available when you select Advanced Operation from the Shoot menu, I limit future discussions to the regular menus so that I have more room to help you explore the camera's more advanced features.

Ordering off the main menus

To display the regular (non-guided) menus, set the Mode dial to any setting but Guide and then press the Menu button. You then see a screen similar to the one shown in Figure 1-17. The icons along the left side of the screen represent the available menus. (Table 1-1 labels the icons and includes a brief description of the goodies found on each menu.) In the menu screens, the icon that's highlighted or appears in color is the active menu; options on that menu automatically appear to the right. In the figure, the Shooting menu is active, for example.

Menu icons

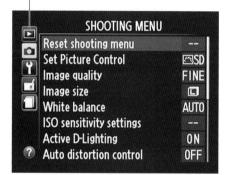

Figure 1-17: Highlight a menu in the left column to display its contents.

Table 1-1 D3200 Menus		
Symbol	Open This Menu	To Access These Functions
	Playback	Viewing, deleting, and protecting pictures
D	Shooting	Basic photography settings
Y	Setup	Additional basic camera operations
4	Retouch	Built-in photo-retouching options
1	Recent Settings	Your 20 most recently used menu options

Part I: Fast Track to Super Snaps

I explain all the important menu options elsewhere in the book; for now, just familiarize yourself with the process of navigating menus and selecting options therein. The Multi Selector (refer to Figure 1-8) is the key to the game. You press the edges of the Multi Selector to navigate up, down, left, and right through the menus.

In this book, the instruction "Press the Multi Selector left" simply means to press the left edge of the control. "Press the Multi Selector right" means to press the right edge, and so on.

Here's a bit more detail about the process of navigating menus:

- To select a different menu: Press the Multi Selector left to jump to the column containing the menu icons. Then press up or down to highlight the menu you want to display. Finally, press right to jump over to the options on the menu.
- ✓ To select and adjust a function on the current menu: Again, use the Multi Selector to scroll up or down the list of options to highlight the feature you want to adjust and then press OK. Settings available for the selected item then appear. For example, if you select the Image Quality item from the Shooting menu, as shown on the left in Figure 1-18, and press OK, the available Image Quality options appear, as shown on the right in the figure. Repeat the old up-and-down scroll routine until the choice you prefer is highlighted. Then press OK to return to the previous screen.

SHOOTING MENU		Image quality	
Reset shooting menu Set Picture Control	 ⊡SD	NEF (RAW) +	IDEG fine
Image quality	FINE	NEF (RAW)	JFEG TITLE
Image size		JPEG fine	្រា
White balance	AUTO	JPEG normal	
ISO sensitivity settings		JPEG basic	
Active D-Lighting	ON	ST LO DUSIC	
Auto distortion control	OFF	0	

Figure 1-18: Select the option you prefer and press OK again to return to the active menu.

In some cases, you see a right-pointing arrowhead instead of the OK symbol next to an option. That's your cue to press the Multi Selector right to display a submenu or other list of options. (Although, most of the time, you also can just press the OK button if you prefer.) If any menu options are dimmed in the menu, you can't access them in the current exposure mode; remember, to use all the camera's features, you must set the Mode dial to P, S, A, or M. Chapter 7 explains these advanced exposure modes.

✓ To quickly access your 20 most recent menu items: The Recent Settings menu, shown in Figure 1-19, lists the 20 menu items you ordered most recently. So if you want to adjust those settings, you don't have to wade through all the other menus looking for them — just head to this menu instead. You can remove an item from the menu by highlighting it and pressing the Delete (trash can) button twice.

RECENT SETTINGS	
Auto off timers	Ð.
Auto info display	ON
Image quality	FINE
Info display format	info
Monitor brightness	0
ISO sensitivity settings	
Playback display options	
Active D-Lighting	ON

Exit menus and return to shooting: Just give the shutter button a quick half-press and Figure 1-19: The Recent Settings menu offers quick access to the last 20 menu options you selected.

then release it. Or press the Menu button to display the Information screen, described next. (You may need to press the Menu button twice to back out of all the menu screens.)

Monitoring Shooting Settings

Your D3200 gives you the following ways to monitor the most critical picture-taking settings:

Information display: If your evesight is like mine, reading the tiny type in the viewfinder is a tad difficult. Fortunately, you also can press the Info Edit button to display the Information screen on the monitor. Shown in Figure 1-20, the Information screen displays the current shooting settings at a size that's a little easier on the eyes and also provides more detailed data than the viewfinder. If you rotate the camera to compose a *portrait* shot (the image is taller than it is wide), the Information display rotates as well.

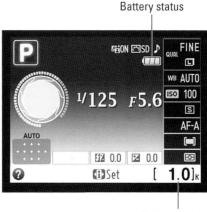

Shots remaining

Figure 1-20: Press the Info or Info Edit button to view picture-taking settings on the monitor.

Part I: Fast Track to Super Snaps

In this book, I show the screen with the black-and-white color scheme you see in Figure 1-20, instead of the default colors, which feature a mix of black and white text on a bluish-gray background and don't reproduce as well in print. To find out how to change the color scheme, see the section "Customizing Your Camera: Setup Menu Options" later in this chapter.

To display the Information screen, you also can just press the shutter button halfway and release it (my favorite tactic) or press the Info button (top of camera, near the shutter button). Press the Info button again to turn off the display. If you turn off the display via the Info button, though, you can't bring it back to life via the shutter button. You must either use the Info Edit button or the Info button.

Viewfinder: You can view some camera settings in the viewfinder as well. For example, the data in Figure 1-21 shows the current shutter speed, f-stop, ISO setting, and number of shots remaining. The exact viewfinder information that appears depends on what action you're currently undertaking.

If what you see in Figures 1-20 and 1-21 looks confusing, don't worry. Many of the settings relate to options that won't mean anything to you until you make your way through later chapters and

But do make note of the following two

500 (5 #1855)

Shots remaining

your way through later chapters and explore the advanced exposure modes. information at the bottom of the viewfinder.

key points of data that are helpful even when you shoot in the fully automatic modes:

Battery status indicator: A full-battery icon like the one in Figure 1-20 shows that the battery is fully charged; if the icon appears empty, look for your battery charger.

Your viewfinder also displays a tiny low-battery icon when things get to the dangerous point. The icon appears just to the right of center in the settings strip at the bottom of the viewfinder. If the icon blinks, the battery is totally kaput, and shutter release is disabled.

✓ Shots remaining: Labeled in Figures 1-20 and 1-21, this value indicates how many additional pictures you can store on the current memory card. As with the Guided menu display, covered earlier in this chapter, the value is presented a little differently when the number exceeds 999.

The initial *K* appears with the number, as shown in Figure 1-20, to indicate that the first value represents the picture count in thousands. For example, 1.0K means that you can store 1,000 more pictures (*K* being a universally accepted symbol indicating 1,000 units). The number is then rounded down to the nearest hundred. So if the card has room for, say, 1,230 more pictures, the value reads 1.2K.

Changing Settings Using the Information Display

After you press the Info Edit or Info button to bring up the Information display, shown on the left in Figure 1-22, you can press the Info Edit button to shift to a screen like the one shown on the right in the figure. Through this screen, you can adjust many picture-taking settings faster than you can by digging through camera menus.

If you've used earlier Nikon cameras, you may know this display as the Quick Settings screen, but Nikon did away with that nomenclature for the D3200. To make things a little clearer in this book, I refer to it as the Info Edit screen instead of the "screen that appears when you press the Info Edit button twice." My thinking is that you're going to "edit" the settings shown on the Information screen. Hope that rationale works for you; if not, please contact Nikon and ask them to give the thing an official name. When you're not busy having a life and all, I mean.

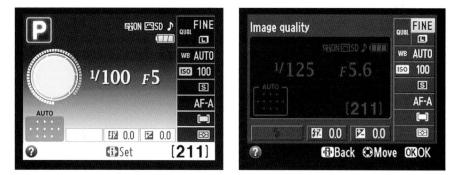

Figure 1-22: When the Information screen is displayed (left), press the Info Edit button to access and change the settings visible on the screen (right).

Note the little symbol at the center of the bottom of the Information screen (left side of Figure 1-22), by the way: The Info Edit button symbol and the word Set remind you to press the button to get to the Info Edit display. And on the Info Edit screen, the same symbol is labeled Back, meaning that you can press the button to exit to the Information screen.

After you bring up the display, follow these steps to adjust the available options:

1. Use the Multi Selector to highlight the setting you want to change.

The available settings are represented by the icons along the right side and bottom of the screen. A little label appears at the top of the screen to tell you the name of the selected setting. For example, in the right screen in Figure 1-22, the Image Quality setting is selected.

2. Press OK to jump to a screen that contains the available settings for the selected option.

For example, Figure 1-23 shows the available Image Quality options.

3. Use the Multi Selector to highlight your choice and then press OK.

You return to the Info Edit display.

To exit the display and return to the initial Information screen, press the Info Edit button again or press the shutter button halfway and release it.

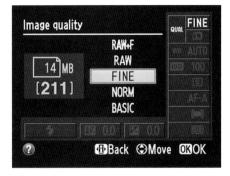

Figure 1-23: Highlight the setting you want to use and press OK to make the change official.

Displaying Help Screens

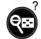

If you see a small question mark in the lower-left corner of a menu, press and hold the Zoom Out button — note the question-mark label above the button — to display information about the current shooting mode or selected menu option. For example, Figure 1-24 shows the help screen associated with the Image Quality setting. If you need to scroll the screen to view all the help text, keep the button depressed and scroll by using the Multi Selector. Release the button to close the information screen.

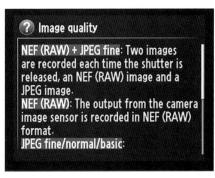

Figure 1-24: Press and hold the Zoom Out button to display onscreen help.

ALINEMBER

A blinking question mark in the viewfinder or Information screen indicates that the camera wants to alert you to a problem. Again, press the Zoom Out button to see what solution the camera suggests.

Customizing Your Camera: Setup Menu Options

Your camera offers scads of options for customizing its performance. Later chapters explain settings related to actual picture taking, such as those that affect flash behavior and autofocusing. The rest of this chapter details options found on the Setup menu, which relate to the basic camera interface and operation.

To access the Setup menu, first set the Mode dial on top of the camera to any setting except Guide. Press the Menu button to display the regular menus. The Setup menu is the one marked with the little wrench icon, which appears highlighted in Figure 1-25.

Figure 1-25 shows the first screen of menu options; the menu actually contains four screens of settings. Press the Multi Selector up and down to scroll through the menu.

Here's what you can accomplish with the first screen of options, shown in Figure 1-25:

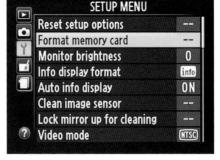

Figure 1-25: Visit the Setup menu to customize your camera's basic appearance and operation.

- Reset Setup Options: You can use this option to restore all the Setup menu options to their default settings. Before you do, though, see the last section of this chapter for some important details.
- Format Memory Card: You can use this command to format your memory card, which wipes all data off the card and ensures that it's properly set up to record pictures. See the earlier section "Working with Memory Cards" for more details about formatting.

✓ Monitor Brightness: This option enables you to make the camera monitor brighter or darker, as shown in Figure 1-26. If you take this step, keep in mind that what you see on the display may not be an accurate rendition of the actual exposure of your image. Crank up the monitor brightness, for example, and an underexposed photo may look just fine. So I recommend that you keep the brightness at the default setting (0).

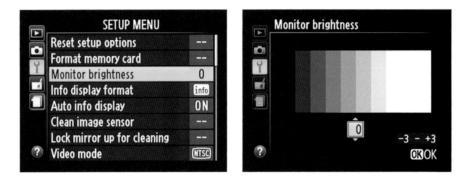

Figure 1-26: If you adjust the monitor brightness, you may not be able to accurately judge exposure during playback.

Info Display Format: Use this command to customize the appearance of the Information screen. You can choose from two styles, Classic and Graphic, and for each style, you can select from three color schemes. Figure 1-27 shows you a couple possible variations. The one on the left shows the default style, Graphic White; the one on the right illustrates the Classic Blue style.

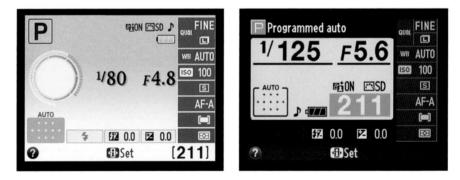

Figure 1-27: Change the appearance of the Information screen through the Info Display Format option.

Again, in this book, I use the Graphic Black color scheme because it reproduces in a way that makes the settings data a little easier to read in figures.

✓ Auto Info Display: When this option is set to On, as it is by default, the Information screen appears when you press the shutter button halfway and release it. And, if you disable Image Review (an option covered in Chapter 5), the screen also appears after you take a picture. Turn off the Auto Info Display option, and the screen appears briefly when you first turn on the camera, but after that, you must press the Info button or the Info Edit button to display it. Instructions in this book assume that you stick with the default setting (On).

Clean Image Sensor: Your D3200 is set up at the factory to perform an internal cleaning routine each time you turn the camera on or off. This cleaning system is designed to keep the image sensor — that's the part of the camera that actually captures the image — free of dust and dirt.

By choosing the Clean Image Sensor menu item, you can perform a cleaning at any time, however. Just choose the menu item, press OK, select Clean Now, and press OK again. (Nikon recommends that you set the camera on a solid surface, base down, when you perform the cleaning.) Don't try to perform the cleaning several times in a row, by the way — if you do, the camera will temporarily disable the function to protect itself.

The other option available through the Clean Image Sensor item, called Clean At Startup/Shutdown, enables you to specify whether you want the camera to change from the default setting (cleaning at startup and shutdown) to clean only at startup, only at shutdown, or never. I suggest that you stick with the default.

- Lock Mirror Up for Cleaning: This feature is necessary for cleaning the camera's image sensor. I don't recommend that you tackle this operation yourself because you can easily damage the camera if you don't know what you're doing. And if you've previously used mirror lock-up on an SLR camera to avoid camera shake when shooting long-exposure images, note that as the menu name implies, this camera's mirror lock-up is provided for cleaning purposes only. You can't take pictures on the D3200 while mirror lock-up is enabled.
- ✓ Video Mode: This option is related to viewing your images on a television, a topic I cover in Chapter 5. It also determines which movie settings are available; see Chapter 4 for details on that issue. Select NTSC if you live in North America or other countries that adhere to the NTSC video standard; select PAL for areas that follow that code of video conduct.

To get to the next group of customization options, use the Multi Selector to scroll to the second screen of the Setup menu, shown in Figure 1-28:

- HDMI: This setting relates to options involved with connecting your camera to an HDMI (highdef) device; again, check out Chapter 5 for details.
- Flicker Reduction: If you notice flickering or color banding on the monitor when Live View

SETUP MENU	
HDMI	
Flicker reduction	AUTO
Time zone and date	
🕘 Language	0
Image comment	0FF
Auto image rotation	ON
Image Dust Off ref photo	
? Auto off timers	NORM

Figure 1-28: Use the Multi Selector to scroll to this second screen of the menu.

is enabled, changing this setting may help alleviate the problem. See Chapter 4 for details.

✓ **Time Zone and Date:** When you turn on your camera for the very first time, it automatically displays this option and asks you to set the current date and time. Keeping the date and time accurate is important because that information is recorded as part of the image file. In your photo browser, you can then see when you shot an image and, equally handy, search for images by the date they were taken.

The camera's internal clock has its own battery that gets recharged whenever the main battery is in place. If you see a message that the clock is not set and you know you did set the time and date, the clock battery is out of gas. No worries: Just reset the time and date and then give the clock battery time to recharge. It takes about three days of charging to keep the clock running for a month.

- Language: You're asked to specify a language along with the date and time when you fire up your camera for the first time. Your choice determines the language of text on the camera monitor. Screens in this book display the English language, but I find it entertaining (on occasion) to hand my camera to a friend after changing the language to, say, Swedish. I'm a real yokester, yah?
- ✓ Image Comment: See Chapter 11 to find out how to use this feature, which enables you to add text comments into a picture file. You then can read that information in Nikon ViewNX 2, the software that shipped with your camera, as well as on the camera monitor during picture playback. (The text doesn't actually appear on the image itself.)
- Auto Image Rotation: When enabled, this feature records the camera orientation (horizontal or vertical) as part of the picture file information. This enables the camera to automatically rotate the picture to its proper orientation, and the auto-rotating also occurs when you browse your image thumbnails in ViewNX 2 and other photo programs that can read the orientation date. See Chapter 5 for more about this option and rotating pictures during playback.
- Image Dust Off Ref Photo: This specialty feature enables you to record an image that serves as a point of reference for the automatic dust-removal filter available in Nikon Capture NX 2. I don't cover this accessory software, which must be purchased separately, in this book.
- ✓ Auto Off Timers: To help save battery power, your camera automatically shuts off the monitor, exposure meter, and viewfinder display if you don't perform any camera operations for a period of time. Through the Auto Off Timers menu option, you can specify how long you want the camera to wait before taking that step.

After selecting the option, press OK to display the screen shown on the left in Figure 1-29. Here you can select from three prefab timing settings, Short, Normal, and Long, which produce the following shut-off intervals:

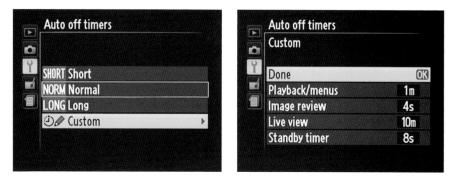

Figure 1-29: Through the Auto Off Timers option, you can adjust the timing of automatic shutdown of the monitor, viewfinder, and exposure meter.

- *Short:* For picture playback and menus, the monitor shuts off after 20 seconds; for image review, 4 seconds; and during Live View shooting, 5 minutes. The standby timer, which affects the exposure meter, viewfinder display, and Information display, is set to a 4-second delay.
- *Normal:* This setting uses a 1-minute delay for playback and menu screens; 4 seconds for image review; 10 minutes for Live View shooting; and 8 seconds for the standby timer. This option is the default.
- *Long:* Auto shutdown occurs after 1 minute for playback and menu display; image review shuts down after 20 seconds, and Live View has a 20-minute shutoff delay. The standby timer is set to a 1-minute delay.

If none of those settings works well for you, choose Custom, which displays the screen shown on the right in Figure 1-29. You then can customize the shut-off timing for playback and menu display, image review, Live View, and the standby timer independently. If you go this route, be sure to highlight Done, as shown in the figure on the right, and press OK after changing the settings. Otherwise your changes don't stick.

Scrolling to the third screen of the Setup menu, shown in Figure 1-30, brings you to the following additional setup options:

Self-Timer: This setting comes into play when you take pictures using the Self-Timer Release mode, covered in Chapter 2. Your choice determines how long the camera waits to record the picture after you press the shutter button and how many pictures are recorded with each shutter press. (You can choose from 1 to 9 shots.)

	SETUP MENU	
	Self-timer	
•	Remote on duration	8 1 m
T	Веер	∢»L
	Rangefinder	0FF
	File number sequence	ON
	Buttons	
	Slot empty release lock	LOCK
?	Print date	OFF

Figure 1-30: The first item on this screen lets you control self-timer shooting.

- Remote On Duration: This option relates to shooting with the optional wireless remote control unit. You can specify how long the camera waits for a signal from the remote before it cancels out of remote-control mode and reverts back to the previously selected shutter-release mode. See Chapter 2 for more about shutter-release modes.
- ✓ Beep: By default, your camera beeps at you after certain operations, such as after it sets focus when you shoot in autofocus mode. You can set the volume to High or Low (the default). Or, if you're doing top-secret surveillance work and need the camera to hush up, select Off. On the Information display, a little musical note icon appears near the top-right corner of the screen when the beep is enabled. Turn off the beep, and the icon appears in a circle with a slash through it.
- Rangefinder: In some exposure modes, you can choose to swap out the normal exposure meter for a *rangefinder*, which is another type of meter that can come in handy when you use manual focus. See Chapter 8 for details.
- ✓ File Number Sequence: This option controls how the camera names your picture files. When the option is set to Off, as it is by default, the camera restarts file numbering at 0001 every time you format your memory card or insert a new memory card. Numbering is also restarted if you create custom folders (an advanced option covered in Chapter 11).

Needless to say, this setup can cause problems over time, creating a scenario where you wind up with multiple images that have the same filename — not on the current memory card, but when you download images to your computer. So I strongly encourage you to set the option to On, as I did in Figure 1-30. Note that when you get to picture number 9999, file numbering is still reset to 0001, however. The camera automatically creates a new folder to hold your next 9999 images.

As for the Reset option, it enables you to assign the first file number (which ends in 0001) to the next picture you shoot. Then the camera behaves as if you selected the On setting.

If you're a really prolific shooter and snap enough pictures to reach image 9999 in folder 999, the camera will refuse to take another photo until you choose that Reset option and either format the memory card or insert a brand new one.

- ✓ Buttons: Through this Setup menu item, you can change the function of the Function (Fn) button and the AE-L/AF-L button. You can also specify whether you want a half-press of the shutter button to lock focus only, as it does by default, or lock focus and exposure together. For now, leave all three options alone so that the instructions you find in this book work the way they should. When you're ready to go further, Chapter 11 shows you how to customize the button functions.
- ✓ Slot Empty Release Lock: This cryptically named feature determines whether the camera lets you take a picture when no memory card is installed in the camera. If you set it to Enable Release, you can take a temporary picture, which appears in the monitor with the word *Demo* but isn't recorded anywhere. The feature is provided mainly for use in camera stores, enabling salespeople to demonstrate the camera without having to keep a memory card installed. I can think of no good reason why anyone else would change the setting from the default, Release Locked.
- Print Date: Through this option, you can imprint the shooting date, date and time, or the number of days between the day you took the picture and another date that you specify. This feature works only with pictures that you shoot in the JPEG file format; see Chapter 2 for details about file formats.

The default setting, which disables the imprint, is the best way to go, however; you don't need to permanently mar your photos to find out when you took them. Every picture file includes a hidden vat of text data, called *metadata*, that records the shooting date and time, as well as all the camera settings you used — f-stop, shutter speed, and lots more. You can view this data during picture playback and also in the free software provided with your camera as well as in many photo programs. Chapters 5 and 6 show you how.

If you do enable the Print Date feature, the word Date appears in the upper-left corner of the Information screen. Also remember that applying some Retouch menu options, such as the Trim function, may crop away the date imprint or leave it illegible.

Continue scrolling through the menu to uncover the final Setup menu options, shown in Figure 1-31 and presented for your consideration in the following list:

Part I: Fast Track to Super Snaps

- Storage Folder: You need to pay attention to this option only if you create custom image folders, an advanced feature you can explore in Chapter 11. If you take that step, you specify which folder you want to use for your next photos through this menu option. You also must specify which folder you want to view during playback. Chapter 5 discusses playback options.
- ✓ GPS: If you attach the optional GPS unit to the camera, you adjust settings related to that tool and view the current GPS

Figure 1-31: Check the Firmware Version item to find out whether your camera's internal software is up to date.

data through this menu option. See the GPS unit's instruction manual for details.

Eye-Fi Upload: This option (not shown in Figure 1-31) appears on the menu only if you insert an Eye-Fi memory card in your camera. Eye-Fi cards enable you to transmit your files wirelessly to other devices. That's a cool feature, but unfortunately, the cards themselves are more expensive than regular cards. If you do choose to use them and you find yourself in an area that does not allow wireless transmissions (such as hospitals and the like), you can disable the feature through this menu option. You also initiate the wireless transfer through the option.

For information about the Nikon WU-1a wireless unit, which enables you to transfer images from the camera to some smartphones and tablets, see Chapter 6.

Firmware Version: Select this option and press OK to view what version of the camera *firmware*, or internal software, your camera runs. You see two firmware items, C and L. At the time this book was written, C was version 1.00; L was 1.005.

Keeping your camera firmware up-to-date *is* important, though, so visit the Nikon website (www.nikon.com) regularly to find out whether your camera sports the latest version. You can find detailed instructions on how to download and install any firmware updates on the site.

Restoring Default Settings

You can quickly reset all the options on the Shooting menu by selecting Reset Shooting Options, as shown on the left in Figure 1-32. Likewise, the Setup menu also has a Reset Setup Options item to restore all settings on that menu, as shown on the right.

Chapter 1: Getting the Lay of the Land

SHOOTING MENU		SETUP MENU	
Reset shooting menu		Reset setup options	
Set Picture Control	₽SD	Format memory card	
Image quality	FINE	Monitor brightness	0
Image size		🖳 Info display format	info
White balance	AUTO	💷 Auto info display	OFI
ISO sensitivity settings		Clean image sensor	
Active D-Lighting	ON	Lock mirror up for cleani	ng
Auto distortion control	OFF	Video mode	INTSC

Figure 1-32: Choose the Reset option to return to the default settings for the respective menu.

A couple potential flies in the ointment:

Resetting the Shooting menu defaults wipes out any customizations you made to a Picture Control setting — for example, if you tweaked the Vivid setting to produce even more saturated colors than it does by default. Chapter 8 talks more about this feature.

Additionally, a Shooting menu reset restores the default settings of a couple options not on the menu, including the Release mode, Exposure Compensation, Flash Compensation, Flash mode, and the Focus mode. The default focus point resets to the center point (unless Auto Area is selected for the AF-Area mode setting during viewfinder shooting, in which case all focus points are active). Finally, the AE-L/AF-L button returns to its normal operation as well. Visit Chapter 7 for all issues related to flash and exposure; check out Chapter 8 for details about focusing. Chapter 11 explains how to modify the behavior of the AE-L/AF-L button.

- More worrisome is that resetting the Setup menu restores the File Number Sequence option to its default, Off, which is most definitely Not a Good Thing. So if you restore the menu defaults, be *sure* that you revisit that option and return it to the On setting. See the preceding section for details.
- Resetting the Setup menu does not affect the Video Mode, Time Zone and Date, Language, or Storage Folder options, on the other hand. So you need to adjust those settings individually if necessary.

Part I: Fast Track to Super Snaps _____

46

2

Choosing Basic Picture Settings

In This Chapter

- Spinning the Mode dial
- ▶ Changing the shutter-release mode
- Adding flash
- Choosing the right Image Size (resolution) setting
- ▶ Understanding the Image Quality (file type) setting

Every camera manufacturer strives to provide a good *out-of-box* experience — that is, to ensure that your initial encounter with the camera is a happy one. To that end, the camera's default settings are carefully selected to make it as easy as possible for you to take a good picture the first time you press the shutter button. On your camera, the default settings are designed to let you take a picture the same way you do with fully automatic, point-and-shoot cameras: Compose the shot, press the shutter button halfway to focus, and then press the button the rest of the way to record the image.

Although you can get a nice picture using the default settings in many cases, they're not designed to produce the optimal results in every shooting situation. You may be able to use the defaults to take a decent portrait, for example, but probably need to tweak a few settings to capture action. And adjusting a few options can help turn that decent portrait into a stunning one.

So that you can start fine-tuning camera settings to your subject, this chapter explains the most basic picture-taking options, such as the exposure mode, shutter-release mode, and the image file type and size. They're not the most exciting options (don't think I didn't notice you stifling a yawn), but they make a big difference in how easily you can capture the photo you have in mind. You also need to understand this core group of settings to take best advantage of the advanced controls covered in Part III of the book.

Choosing an Exposure Mode

The first picture-taking setting to consider is the *exposure mode*, which vou select via the Mode dial, as shown in Figure 2-1. Your choice determines how much control you have over two critical exposure settings - aperture and shutter speed — as well as many other options, including those related to color and flash photography. But don't worry if you don't yet know anything about aperture and shutter speed: the camera has many modes designed for people with no photography experience. (When you're ready to explore exposure controls, Chapter 7 spells out everything you need to know.)

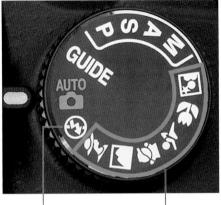

Auto Flash Off

Scene modes

Your exposure-mode choices break down as follows:

Figure 2-1: The Mode setting determines how much input you have over exposure, color, and other picture options.

- ✓ Fully automatic modes: For novices who haven't yet explored photography concepts such as aperture and shutter speed — or who just aren't interested in "going there" — your camera offers the following point-and-shoot modes:
 - *Auto:* The camera analyzes the scene in front of the lens and tries to select the most appropriate camera settings to capture the image.
 - *Auto Flash Off:* This mode, represented by the icon labeled in Figure 2-1, works just like Auto but disables the flash.
 - *Scene modes:* These modes, labeled in Figure 2-1, automatically select settings geared to capturing specific types of shots: portraits, landscapes, child photos, action shots, close-ups, and night portraits. You set the Mode dial to the icon that represents the scene type, and the camera does the rest.

Chapter 3 provides details about Auto, Auto Flash Off, and Scene modes. But one critical point to understand now is that these fully automatic modes prevent you from taking advantage of most of the camera's exposure, color, and autofocusing controls. You have access to picturetaking options discussed in this chapter, but that's about it.

- Semi-automatic modes: To take more creative control but still get some exposure assistance from the camera, choose one of these modes, all detailed in Chapter 7:
 - *P* (*programmed autoexposure*): The camera selects the aperture and shutter speed necessary to ensure a good exposure. But you can choose from different combinations of the two to vary the creative results. For example, shutter speed affects whether moving objects appear blurry or sharp. So you might use a fast shutter speed to freeze action, or you might go the other direction, choosing a shutter speed slow enough to blur the action, creating a heightened sense of motion.
 - *S* (*shutter-priority autoexposure*): You select the shutter speed, and the camera selects the proper aperture to properly expose the image. This mode is ideal for capturing sports or other moving subjects because it gives you direct control over shutter speed.
 - *A (aperture-priority autoexposure):* In this mode, you choose the aperture, and the camera automatically chooses a shutter speed to properly expose the image. Because aperture affects *depth of field,* or the distance over which objects in a scene remain in sharp focus, this setting is great for portraits because you can select an aperture that results in a soft, blurry background, putting the emphasis on your subject. For landscape shots, on the other hand, you might choose an aperture that keeps the entire scene sharply focused so that both near and distant objects have equal visual weight.

All three semi-automatic modes give you complete access to all the camera's features. So even if you're not ready to explore aperture and shutter speed yet, go ahead and set the mode dial to P if you need to access a setting that's off limits in the fully automatic modes. The camera then operates pretty much as it does in Auto mode but without limiting your ability to control picture settings if you need to do so.

- Manual: In this mode, you select both the aperture and shutter speed. But the camera still offers an assist by displaying an exposure meter to help you dial in the right settings. You have complete control over all other picture settings, too.
- Guide: Selecting this setting accesses the guided menu system, which I introduce in Chapter 1 and talk about in a bit more detail in Chapter 3. As a result of choices you make as you step through the guided menu screens, the camera ultimately selects the exposure mode for you.

One very important — and often misunderstood — aspect of the exposure modes: Although your choice determines your access to exposure controls (as well as to some other camera features), it has no bearing on whether you can use autofocusing or manual focusing (assuming that your lens offers autofocusing). Just set the lens switch to the focus option you prefer. However, you can't access all the available autofocusing settings until you shift to P, S, A, or M exposure modes. Chapter 4 talks about how those autofocus settings work when you use Live View mode or shoot movies; Chapter 8 discusses autofocusing options for viewfinder shooting.

Choosing the Release Mode

By default, the camera captures a single image each time you press the shutter button. But by changing the Release Mode setting, you can vary this behavior. For example, you can set the camera to Self-Timer mode so that you can press the shutter button and then run in front of the camera and be part of the picture. Or you can switch to Continuous mode, which records a burst of images as long as you hold down the shutter button — a great feature for photographing a fast-moving subject.

Why *Release Mode?* Well, it's short for *shutter-release mode*. Pressing the shutter button tells the camera to release the *shutter* — an internal light-control mechanism — so that light can strike the image sensor and expose the image. Your choice of Release Mode determines when and how that action occurs. (See Chapter 7 for more about the shutter and its role in exposure.)

You can view and change the setting as follows:

✓ View the current setting:

Display the Information screen by pressing the shutter button halfway and releasing it or by pressing the Info Edit button, shown in the margin here. You also can turn the screen on and off by using the Info button on top of the camera. Whatever route you take, a symbol representing the current mode appears in the area labeled in Figure 2-2. The S symbol in the figure represents the default mode, Single Frame.

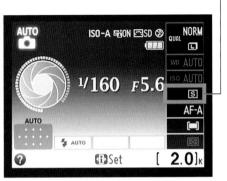

Figure 2-2: This symbol represents the selected Release mode.

Release Mode setting

- Change the Release mode: You have two options:
 - *Press the Release Mode button:* Pressing the button takes you to the screen shown in Figure 2-3, and you can then use the Multi Selector to scroll through the available settings. Press OK to finalize your decision and return to the Information display.
 - After displaying the Information screen, press the Info Edit button. Doing so activates the Info Edit screen, which gives you access to the available set-

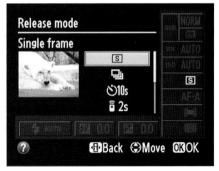

Figure 2-3: Pressing the Release Mode button takes you directly to the screen where you can adjust the setting.

tings on the Information display. Use the Multi Selector to highlight the Release Mode icon (see Figure 2-2) and press OK. You then see the screen shown in Figure 2-3. Select the setting you want to use and then press OK.

As you scroll through the options, the name of the setting appears in the upper-left corner of the screen, along with an example photograph that represents the type of shot that lends itself to that setting. To the right, you see the symbol that represents each setting on the Information display.

Now that you understand the nuts and bolts of accessing the Release Mode setting, the next several sections explain how each option works.

Hey, my shutter button isn't working!

You press the shutter button ... and press it, and press it — and nothing happens. Don't panic: This error is most likely related to autofocusing. You see, when you use certain autofocus modes, including the default ones, the camera insists on achieving focus before it releases the shutter to take a picture. You can press the shutter button all day, and the camera just ignores you if it can't set focus.

Try backing away from your subject a little — the focusing issue may be occurring because

you've exceeded the minimum focusing distance of the lens. If that doesn't work, the subject just may not be conducive to autofocusing. Highly reflective objects, scenes with very little contrast, and subjects behind fences are some of the troublemakers. The easiest solution? Switch the camera to manual focusing and set focus yourself.

Chapter 8 has more information on focusing.

Single Frame and Quiet Shutter Release modes

At the default Release Mode setting, Single Frame, you get one picture each time you press the shutter button. In other words, this is normal-photography mode. The only other thing you need to know is that you must press the shutter button in two stages for autoexposure and autofocusing to work correctly: Press the button halfway; pause to let the camera set focus and exposure, and then press the rest of the way to take the picture.

Q

Quiet Shutter Release mode works just like Single Frame mode but makes less noise as it goes about its business. Designed for situations when you want the camera to be as silent as possible, this mode automatically disables the beep that the autofocus system normally sounds when it achieves focus. (If you prefer, you can disable the beep for other Release Mode settings through the Beep option on the Setup menu.)

Additionally, Quiet Shutter Release mode affects the operation of the internal mirror that causes the scene coming through the lens to be visible in the viewfinder. Normally, the mirror flips up when you press the shutter button and then flips back down after the shutter opens and closes. This mirror movement makes some noise — some photographers refer to it as *mirror slap*. In Quiet Shutter Release mode, you can prevent the mirror from flipping back down by keeping the shutter button fully pressed after the shot. This feature enables you to delay the final mirror movement — and its accompanying clicking sound — to a moment when the noise won't be objectionable.

Continuous (burst mode) shooting

Sometimes known as *burst mode*, this mode records a continuous series of images as long as you hold down the shutter button, making it easier to capture action. On the D3200, you can capture up to four frames per second.

A few critical details:

Enabling flash disables continuous shooting. Flash isn't compatible with burst mode photography because the time that the flash needs to recycle between shots slows down the capture rate too much. If flash is enabled, the camera operates as if you were using Single Frame mode. To avoid the conflict, set the Mode dial to the Auto Flash Off mode (refer to Figure 2-1) or use the P, S, A, or M modes, which enable you to control whether the flash fires. The Landscape and Sports Scene modes also disable flash; you can read about those modes in Chapter 3.

✓ Images are stored temporarily in the memory buffer. The camera has a little bit of internal memory — a *buffer* — where it stores picture data until it has time to record them to the memory card. The number of pictures the buffer can hold depends on certain camera settings, such as resolution and file type (JPEG or Raw). The viewfinder displays an estimate of how many pictures will fit in the buffer; see the upcoming sidebar "What does [r 24] in the viewfinder mean?" for details.

After shooting a burst of images, wait for the memory-card access light on the back of the camera to go out before turning off the camera. That's your signal that the camera has successfully moved all data from the buffer to the memory card. Turning off the camera before that happens may corrupt the image files.

✓ Your mileage may vary. The maximum number of frames per second is an approximation. The actual number of frames you can capture depends on a number of factors, including your shutter speed. At a slow shutter speed, the camera may not be able to reach the maximum frame rate. (See Chapter 7 for an explanation of shutter speed.) Additionally, although you can capture as many as 100 frames in a single burst, the frame rate can drop if the buffer gets full.

What does [r 24] in the viewfinder mean?

When you look in your viewfinder to frame a shot, the initial value shown in brackets at the right end of the viewfinder display indicates the number of additional pictures that can fit on your memory card. For example, in the left viewfinder image below, the value shows that the card can hold 856 more images.

As soon as you press the shutter button halfway, which kicks the autofocus and exposure mechanisms into action, that value changes to instead show you how many pictures can fit in the camera's *memory buffer*. In the right image here, for example, the r 24 value tells you that 24 pictures can fit in the buffer.

So what's the *buffer*? It's a temporary storage tank where the camera stores picture data until

it has time to fully record that data onto the camera memory card. This system exists so that you can take a continuous series of pictures without waiting between shots until each image is fully written to the memory card.

When the buffer is full, the camera automatically disables the shutter button until it catches up on its recording work. Chances are, though, that you'll very rarely, if ever, encounter this situation; the camera is usually more than capable of keeping up with your shooting rate.

For more information about rapid-fire photography, see the section on action photography in Chapter 9. And for help translating the other viewfinder information shown in the figures here, check out Chapter 7.

500F55	AUTO (855)	500F5.6	AND - 24	

Self-timer shooting

You're no doubt familiar with this release mode, which delays the shutter release for a few seconds after you press the shutter button, giving you time to dash into the picture. Here's how it works on your camera: After you press the shutter button, the AF-assist illuminator on the front of the camera starts to blink, and the camera emits a series of beeps (assuming that you didn't disable its voice via the Beep option on the Setup menu). A few seconds later, the blinking and beeping occur more rapidly to let you know that the camera's about to trigger the shutter release.

By default, the camera waits ten seconds after you press the shutter button and then records a single image. But you can tweak the delay time and capture as many as nine shots at a time. Set your preferences through the Self-Timer option on the Setup menu, shown in Figure 2-4. Here's what you need to know:

SETUP MENU		Self-timer	
Self-timer			
Remote on duration	â 1 m		
Beep	∢ »L	Self-timer delay	N'110.
Rangefinder	0FF	Self-timer delay	Olus P
I File number sequence	ON	Number of shots	
Buttons		Number of shots	
Slot empty release lock	LOCK		
Print date	0FF		

Figure 2-4: You can adjust the self-timer Release Mode behavior via the Setup menu.

- Self-Timer Delay: Choose a delay time of 2, 5, 10, or 20 seconds. On the Information screen, the number next to the self-timer symbol tells you the selected delay time.
- ✓ Number of Shots: Specify how many frames you want to capture with each press of the shutter button; the maximum is nine frames.

Whatever delay time or frame number you choose, remember one critical point about Self-Timer mode: It remains in effect *only* for a single press of the shutter button. After the camera records your shot (or series of shots), the Release mode reverts back to Single Frame, Continuous, or Quiet Shutter, depending on which mode you used last.

When you use Self-Timer mode or trigger the shutter release with a remote control — that is, any time you take a shot without your eye to the viewfinder — you should remove the little rubber cup that surrounds the viewfinder and then insert the viewfinder cover that shipped with your camera. (Dig around in the accessories box — the cover is a tiny black piece of plastic, about the size of the viewfinder.) Otherwise, light may seep into the camera through the viewfinder and affect exposure. You also can use the camera strap or something else to cover the viewfinder in a pinch.

Wireless remote-control modes

The final two Release mode settings relate to the optional Nikon ML-L3 wireless remote-control unit and work as follows:

Delayed Remote: The camera snaps the picture two seconds after you press the shutter-release button on the remote unit.

Remember that in order for the wireless remote control to work, you must aim it at one of the camera's two infrared receivers. One is located on the front of the camera; the other, on the back. Figure 2-5 points out both sensors.

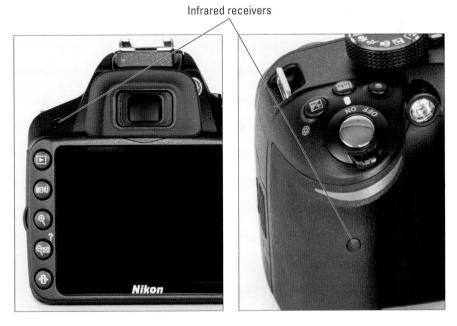

Figure 2-5: When using the optional wireless remote control, aim the unit at one of these two infrared receivers.

Normally, the camera cancels out of the remote control modes if it doesn't receive a signal from the remote after about one minute. You can adjust this timing through the Remote On Duration option on the Setup menu, shown in Figure 2-6. The maximum delay time is 15 minutes; keep in mind that a shorter delay time saves battery life. After the delay time expires, the camera resets itself to either Single Frame, Quiet Shutter, or Continuous mode, depending on which mode you last used.

SETUP MENU	
Self-timer	
Remote on duration	ā 1 m
Beep	∢ »L
Rangefinder	OFF
File number sequence	ON
Buttons	
Slot empty release lock	LOCK
Print date	OFF

Figure 2-6: This Setup menu option controls how long the camera waits for a signal from the remote before canceling out of remotecontrol mode.

Note that these release modes are not meant to be used with a remote-

control that you attach to the camera via the Accessory port (found under the cover on the side of the camera). Select one of the normal Release Mode settings and then press the shutter-release button on the remote to trigger the shutter. See your remote's operating guide for details.

Adding Flash

The built-in flash on your camera, shown in its raised position on the left in Figure 2-7, offers an easy, convenient way to add light to a scene. For even more lighting power, you can attach an external flash head to the camera via the *hot shoe*, shown on the right in the figure. (The hot shoe's contacts are covered by a little black insert when you receive the camera; leave the cover in place until you're ready to attach a flash.)

Because the features of external flash heads vary from model to model, this book concentrates on using the built-in flash. If you need help using an external flash, though, one good place to start is www.strobist.com, a website loaded with flash photography tips and techniques. (*Strobe* is another word for *flash*.) Nikon also offers many resources on the subject at its United States website, www.nikonusa.com.

The next two sections provide the fundamentals of using the built-in flash; Chapter 7 discusses more advanced aspects of flash photography with your camera.

Chapter 2: Choosing Basic Picture Settings

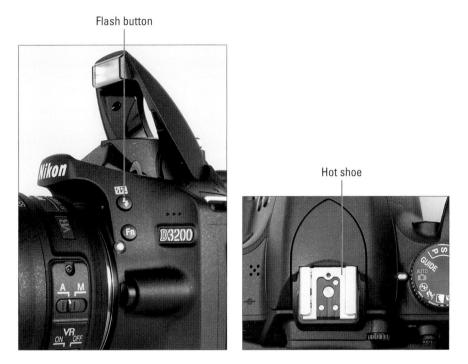

Figure 2-7: In P, S, A, and M modes, press the Flash button to raise the built-in flash (left); attach an external flash via the hot shoe (right).

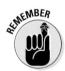

Enabling flash

Whether you have any control over the flash depends on your exposure mode, as follows:

✓ Auto, Portrait, Child, Close-Up, and Night Portrait mode: The built-in flash pops up and fires automatically if the camera thinks the existing lighting is insufficient. However, you can disable the flash by changing the Flash mode, explained in the next section. What you *can't* do is force the flash to fire if the camera thinks the ambient light is sufficient to expose the image. That limitation can be problematic for outdoor daytime portraits and close-ups, which often can benefit from a little bit of extra light, even on a sunny day. Chapter 7 has some further advice on the subject.

- ✓ Landscape, Sports, and Auto Flash Off: Flash is disabled. That setup makes sense for Auto Flash Off mode, of course. But why no flash in Sports and Landscape mode, you ask? Well, Sports mode is designed to capture moving subjects, and the flash makes that more difficult because it needs time to recycle between shots. On top of that, the maximum shutter speed possible with the built-in flash is 1/200 second, which often isn't fast enough to ensure a blur-free subject. Finally, action photos often aren't taken at a range close enough for the flash to reach the subject, which is also why flash is disabled for Landscape mode.
- ✓ Guide mode: In Guide mode, available flash controls depend on the path you take through the guided menus. For example, if you select the Easy Operations menu item and then select Close-ups as the type of photo you want to take, you can choose from three Flash modes: Auto, Auto with Red-Eye Reduction, and Off. To get to the flash options, select the More Settings menu item after you select the picture type. Chapter 3 provides additional details about Guide mode photography.

P, S, A, and M: You have complete control over the flash. To raise the flash, press the Flash button, labeled in Figure 2-7. The flash will fire on your next shot regardless of the ambient light. To disable flash, just close the flash unit by pressing it down gently.

If you use flash, check out the next section to find out how to set the Flash mode and see Chapter 7 for details on adjusting the flash power. (Look for the section related to Flash Exposure Compensation.) The latter feature works only in the P, S, A, and M exposure modes.

When you're not using flash, by the way, keep the flash unit closed. Keeping the flash recycled and ready to fire consumes power, so you can preserve battery life by doing so.

Setting the Flash mode

For exposure modes that allow flash, you can adjust the flash behavior via the *Flash mode* setting. Table 2-1 offers a quick-reference guide to the six basic modes. In addition to these basic modes, the camera also offers some combo modes, such as Auto with Red-Eye Reduction, Slow-Sync with Red-Eye Reduction, and the like.

Table 2-1		Flash Mode Quick-Reference Guide		
Symbol	Flash Mode	What It Does		
4 AUTO	Auto	Fires the flash automatically if the camera thinks the ambient light is insufficient or the subject is backlit		
4	Fill	Fires the flash regardless of the ambient light		
(4)	Off	Disables the flash		
4 ©	Red-Eye Reduction	AF-assist lamp lights briefly before the flash goes off to help reduce red-eye reflections		
\$ SLOW	Slow-Sync	Results in a longer-than-normal exposure time so that the background is illuminated by ambient lig and the foreground is lit by the flash		
4 REAR	Rear-Curtain Sync	When combined with a slow shutter speed, causes illuminated, moving objects (such as car headlights to appear as long, trailing fingers of light behind the subject		

You can check the current Flash mode in the Information display, as shown on the left in Figure 2-8. The viewfinder doesn't advise you of the specific Flash mode but instead displays the lightning-bolt icon — the universal symbol for flash — when the flash is enabled, as shown on the right in the figure.

If you disable the flash and the camera thinks you're making a mistake, the flash symbol blinks in the viewfinder. You also see a blinking question mark in both the viewfinder and Information display, indicating that you can press the Zoom Out button to display a help screen with advice on getting a better exposure.

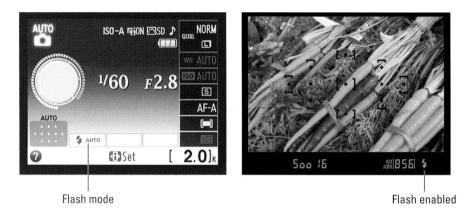

Figure 2-8: Look here to check flash status.

To change the Flash mode, use either of these two methods:

Flash button plus Command dial: Press and hold the Flash button (refer to Figure 2-7) to display the screen shown in Figure 2-9. Keep holding the button as you rotate the Command dial to cycle through the Flash modes available for your selected exposure mode.

Info Edit screen: You can also change the Flash mode by using the Info Edit screen. Press the Info Edit button twice to shift to the screen and then use the Multi Selector to highlight the Flash mode icon, as shown on the left

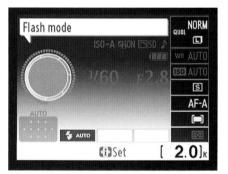

Figure 2-9: The fastest way to change the Flash mode is to hold down the Flash button while rotating the Command dial.

in Figure 2-10. Press OK to display the screen shown at right in the figure, highlight your choice, and press OK again.

Now for the bad news: When you try to change the Flash mode, you'll quickly discover that you have access to only a couple Flash modes when you shoot in the fully automatic exposure modes (Auto, Auto Flash Off, and the Scene modes). For the Auto, Portrait, Child, Close-Up, and Night Portrait modes, the flash mode reverts to the default setting if you switch to another exposure mode. Additionally, you don't have access to Flash Compensation, which enables you to diminish or strengthen the burst of light the flash produces, as well as a few other flash features your camera offers. Bummer, as the youngsters say.

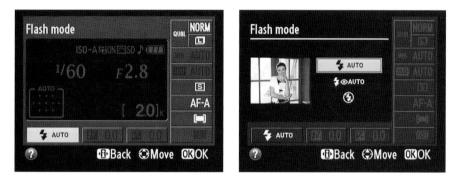

Figure 2-10: You also can change the Flash mode by using the Info Edit screen.

You can find details about which Flash modes are available in each of the fully automatic exposure modes in Chapter 3. For details about remaining flash features, see Chapter 7.

Choosing the Right Quality Settings

Almost every review of your camera contains glowing reports about the camera's top-notch picture quality. As you've no doubt discovered, those claims are true: This baby can create large, beautiful images.

What you may *not* have discovered is that Nikon's default Image Quality setting isn't the highest that your camera offers. Why, you ask, would Nikon do such a thing? Why not set up the camera to produce the best images right out of the box? The answer is that using the top setting has some downsides. Nikon's default choice represents a compromise between avoiding those disadvantages while still producing images that will please most photographers.

Whether that compromise is right for you, however, depends on your photographic needs. To help you decide, the rest of this chapter explains the Image Quality setting, along with the Image Size setting, which is also critical to the quality of images that you print. Just in case you're having quality problems related to other issues, though, the next section provides a handy quality-defect diagnosis guide.

If you already know what settings you want to use and just need some help finding out how to select the options, skip to the very last section of the chapter.

Diagnosing quality problems

When I say *picture quality*, I'm not talking about the composition, exposure, or other traditional characteristics of a photograph. Instead, I'm referring to how finely the image is rendered in the digital sense.

Figure 2-11 illustrates the concept: The first example is a high-quality image, with clear details and smooth color transitions. The other examples show five common digital-image defects.

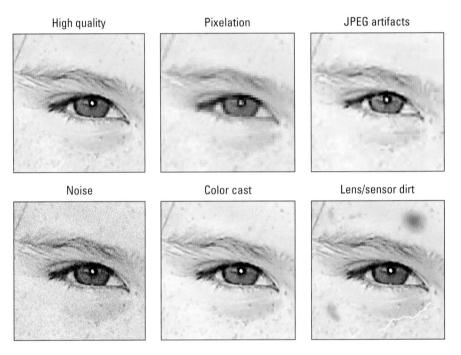

Figure 2-11: Refer to this symptom guide to determine the cause of poor image quality.

Each of these defects is related to a different issue, and only one is affected by the Image Quality setting on your camera. So if you aren't happy with your image quality, first compare your photos to those in the figure to properly diagnose the problem. Then try these remedies:

Pixelation: When an image doesn't have enough *pixels* (the colored tiles used to create digital images), details aren't clear, and curved and diagonal lines appear jagged. The fix is to increase image resolution, which you do via the Image Size control. See the next section, "Considering image size: How many pixels are enough?" for details.

- ✓ JPEG artifacts: The "parquet tile" texture and random color defects that mar the third image in Figure 2-11 can occur in photos captured in the JPEG (*jay-peg*) file format, which is why these flaws are referred to as JPEG artifacts. This is the defect related to the Image Quality setting; see "Understanding Image Quality options (JPEG or Raw)," later in this chapter, to find out more.
- ✓ Noise: This defect gives your image a speckled look, as shown in the lower-left example in Figure 2-11. Noise can occur with very long exposure times or when you choose a high ISO Sensitivity setting on your camera. You can explore both issues in Chapter 7.
- Color cast: If your colors are seriously out of whack, as shown in the lower-middle example in the figure, try adjusting the camera's White Balance setting. Chapter 8 covers this control and other color issues.
- Lens/sensor dirt: A dirty lens is the first possible cause of the kind of defects you see in the last example in the figure. If cleaning your lens doesn't solve the problem, dust or dirt may have made its way onto the camera's image sensor. See the sidebar "Maintaining a pristine view," later in this chapter, for information on safe lens and sensor cleaning.

When diagnosing image problems, you may want to open the photos in Nikon ViewNX 2 or some other photo software and zoom in for a close-up inspection. Some defects, especially pixelation and JPEG artifacts, have a similar appearance until you see them at a magnified view. (See Part II for information about using ViewNX 2.)

I should also tell you that I used a little digital enhancement to exaggerate the flaws in my example images to make the symptoms easier to see. With the exception of an unwanted color cast or a big blob of lens or sensor dirt, these defects may not even be noticeable unless you print or view your image at a very large size. And the subject matter of your image may camouflage some flaws; most people probably wouldn't detect a little JPEG artifacting in a photograph of a densely wooded forest, for example.

In other words, don't consider Figure 2-11 as an indication that your camera is suspect in the image-quality department. First, *any* digital camera can produce these defects under the right circumstances. Second, by following the guidelines in this chapter and the others mentioned in the preceding list, you can resolve any quality issues that you may encounter.

Considering image size: How many pixels are enough?

Pixels are the little square tiles from which all digital images are made. You can see some pixels close up in the right image in Figure 2-12, which shows a greatly magnified view of the eye area in the left image.

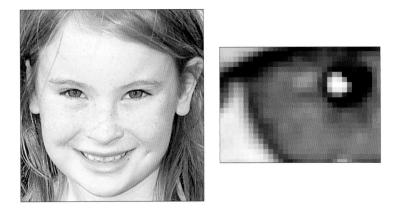

Pixel is short for *picture element*. The number of pixels in an image is referred to as *resolution*. You can define resolution either in terms of the *pixel dimensions* — the number of horizontal pixels and vertical pixels — or total resolution, which you get by multiplying those two values. This number is usually stated in *megapixels*, or MP for short, with one megapixel equal to one million pixels. For example, your camera offers a maximum resolution of 6016 x 4000 pixels, which translates to about 24.1 megapixels.

You control resolution on your camera via the Image Size setting. You can choose from three settings: Large, Medium, and Small; Table 2-2 lists the resolution values for each setting. (Megapixel values are rounded off.)

Table 2-2	Image Size (Resolution) Options
Setting	Resolution
Large	6016 × 4000 (24.1 MP)
Medium	4512 x3000 (13.5 MP)
Small	3008 × 2000 (6.0 MP)

However, if you select Raw (NEF) as your file format, all images are captured at the Large setting. You can vary the resolution only when choosing JPEG as the file format. The upcoming section "Understanding Image Quality options (JPEG or Raw)" explains file formats.

To choose the right Image Size setting, you need to understand the three ways that pixel count affects your pictures:

✓ Print size: Pixel count determines the size at which you can produce a high-quality print. If you don't have enough pixels, your prints may exhibit the defects you see in the pixelation example in Figure 2-11, or worse, you may be able to see the individual pixels, as in the right example in Figure 2-12. Depending on your photo printer, you typically need anywhere from 200 to 300 pixels per linear inch, or *ppi*, of the print. To produce an 8 x 10 print at 200 ppi, for example, you need a pixel count of 1600 x 2000, or a little more than 3 megapixels.

Even though many photo editing programs enable you to add pixels to an existing image, doing so isn't a good idea. For reasons I won't bore you with, adding pixels — known as *upsampling* — doesn't enable you to successfully enlarge your photo. In fact, upsampling typically makes matters worse. The printing discussion in Chapter 6 includes some example images that illustrate this issue.

- Screen display size: Resolution doesn't affect the quality of images viewed on a monitor, television, or other screen device the way it does for printed photos. Instead, resolution determines the *size* at which the image appears. This issue is one of the most misunderstood aspects of digital photography, so I explain it thoroughly in Chapter 6. For now, just know that you need *way* fewer pixels for onscreen photos than you do for printed photos. In fact, even the Small resolution setting on your camera creates a picture too big to be viewed in its entirety in e-mail programs that don't automatically shrink large photos that come through the intertubes.
- File size: Every additional pixel increases the amount of data required to create a digital picture file. So a higher-resolution image has a larger file size than a low-resolution image.

Large files present several problems:

- You can store fewer images on your memory card, on your computer's hard drive, and on removable storage media such as a DVD.
- The camera needs more time to process and store the image data on the memory card after you press the shutter button. This extra time can hamper fast-action shooting.
- When you share photos online, larger files take longer to upload and download.
- When you edit your photos in your photo software, your computer needs more resources and time to process large files.

As you can see, resolution is a bit of a sticky wicket. What if you aren't sure how large you want to print your images? What if you want to print your photos *and* share them online?

I take the better-safe-than-sorry route, which leads to the following recommendations about which Image Size setting to use:

Always shoot at a resolution suitable for print. You then can create a low-resolution copy of the image in your photo editor for use online. In fact, your camera offers a built-in resizing option; Chapter 6 shows you how to use it.

Again, you *can't* go in the opposite direction, adding pixels to a low-resolution original in your photo editor to create a good, large print. Even with the very best software, adding pixels doesn't improve the print quality of a low-resolution image.

✓ For everyday images, Medium is a good choice. I find the Large setting (24.1 MP) to be overkill for most casual shooting, which means that you're creating huge files for no good reason. Keep in mind that even at the Small setting, your pixel count (3008 x 2000) is enough to produce a 15 x 10-inch print at 200 ppi.

Choose Large for an image that you plan to crop, print very large, or both. The benefit of maxing out resolution is that you have the flexibility to crop your photo and still generate a decent-sized print of the remaining image. Figures 2-13 and 2-14 offer an example. When shooting this photo, I couldn't get close enough to fill the frame with the subjects that most interested me — the pair of juvenile blue herons conversing in the center of the shot. But because I had the resolution cranked up to Large, I could later crop the shot to the composition you see in Figure 2-14 and still produce a great print. In fact, I could have printed the cropped image at a much larger size than fits here.

Figure 2-13: I couldn't get close enough to fill the frame with the subject, so I captured this image at the Large resolution setting.

Figure 2-14: A high-resolution original enabled me to crop the photo tightly and still have enough pixels to produce a quality print.

Reduce resolution if shooting speed is paramount. If you're shooting action and the shot-to-shot capture time is slower than you want — that is, the camera takes too long after you take one shot before it lets you take another — dialing down the resolution may help. Also see Chapter 9 for other tips on action photography.

After you decide which resolution setting is right for your picture, visit the section "Setting Image Size and Quality," at the end of this chapter.

Understanding Image Quality options (JPEG or Raw)

If I had my druthers, the Image Quality option on your camera would instead be called File Type because that's what the setting controls.

Here's the deal: The file type, more commonly known as a file *format*, determines how your picture data is recorded and stored. Your choice does impact picture quality, but so do other factors, as outlined at the beginning of this chapter. In addition, your choice of file type has ramifications beyond picture quality.

At any rate, your camera offers the two file types common on most of today's digital cameras: JPEG and Camera Raw, or just Raw for short, which goes by the specific moniker NEF (*Nikon Electronic Format*) on Nikon cameras. The next sections explain the pros and cons of each format. If your mind is already made up, skip ahead to "Setting Image Size and Quality," near the end of this chapter, to find out how to make your selection.

Don't confuse *file format* with the Format Memory Card option on the Setup menu. That option erases all data on your memory card; see Chapter 1 for details.

JPEG: The imaging (and web) standard

Pronounced *jay-peg*, this format is the default setting on your camera, as it is for most digital cameras. JPEG is popular for two main reasons:

- Immediate usability: All web browsers and e-mail programs can display JPEG files, so you can share them online immediately after you shoot them. The same can't be said for Raw (NEF) files, which must be processed and converted to JPEG files before you can share them online. And although you can view and print your camera's Raw files in Nikon ViewNX 2 without converting them, many third-party photo programs don't enable you to do that. You can read more about the conversion process in the upcoming section "Raw (NEF): The purist's choice."
- Small files: JPEG files are smaller than Raw files. And smaller files consume less room on your camera memory card and in your computer's storage tank.

The downside — you knew there had to be one — is that JPEG creates smaller files by applying *lossy compression*. This process actually throws away some image data. Too much compression leads to the defects you see in the JPEG artifacts example in Figure 2-11.

Fortunately, your camera enables you to specify how much compression you're willing to accept. You can choose from three JPEG settings, which produce the following results:

JPEG Fine: At this setting, the compression ratio is 1:4 — that is, the file is four times smaller than it'd otherwise be. In plain English, that means that very little compression is applied, so you shouldn't see many compression artifacts, if any.

- ✓ JPEG Normal: Switch to Normal, and the compression ratio rises to 1:8. The chance of seeing some artifacting increases as well.
- JPEG Basic: Shift to this setting, and the compression ratio jumps to 1:16. That's a substantial amount of compression and brings with it a lot more risk of artifacting.

Note, though, that even the JPEG Basic setting on your camera doesn't result in anywhere near the level of artifacting that you see in my example in Figure 2-11. Again, that example is exaggerated to help you be able to recognize artifacting defects and understand how they differ from other image quality issues. In fact, if you keep your image print or display size small, you aren't likely to notice a great deal of quality difference between the Fine, Normal, and Basic compression levels, although details in the Fine and Normal versions may appear slightly crisper than the Basic one. It's only when you greatly enlarge a photo that the differences become apparent.

Given that the differences between the compression settings aren't that easy to spot until you enlarge the photo, is it okay to stick with the default setting — Normal — or even drop down to Basic to capture smaller files? Well, only you can decide what level of quality your pictures demand. For me, the added file sizes produced by the Fine setting aren't a huge concern, given that the prices of memory cards fall all the time. Long-term storage is more of an issue; the larger your files, the faster you fill your computer's hard drive and the more DVDs or CDs you need for archiving purposes. But in the end, I prefer to take the storage hit in exchange for the lower compression level of the Fine setting. You never know when a casual snapshot is going to be so great that you want to print or display it large enough that even minor quality loss becomes a concern. And of all the defects that you can correct in a photo editor, artifacting is one of the hardest to remove.

To make the best decision, do your own test shots, carefully inspect the results in your photo editor, and make your own judgment about what level of artifacting you can accept. Artifacting is often much easier to spot when you view images onscreen. It's difficult to reproduce artifacting here in print because the printing press obscures some of the tiny defects caused by compression. Your inkjet prints are more likely to reveal these defects.

If you don't want *any* risk of artifacting, bypass JPEG altogether and change the file type to Raw (NEF). Or consider your other option, which is to record two versions of each file, one Raw and one JPEG. The next section offers details.

SHARNING!

Preserving the quality of edited photos

If you retouch pictures in your photo software, don't save the altered images in the JPEG format. As explained in the section "JPEG: The imaging (and web) standard," elsewhere in this chapter, JPEG creates smaller files by eliminating some image data, a process called *lossy compression.*

Every time you alter and save an image in the JPEG format, you apply another round of lossy compression. And with enough editing, saving, and compressing, you can eventually get to the level of image degradation shown in the JPEG example in Figure 2-11. (Simply opening and closing the file does no harm.)

Instead, always save your edited photos in a nondestructive format. TIFF, pronounced *tiff*, is a good choice and is a file-saving option available in most photo-editing programs. Should you want to share the edited image online, create a JPEG copy of the TIFF file when you finish making all your changes. That way, you always retain one copy of the photo at the original quality captured by the camera. Chapter 6 explains how to create a JPEG copy of a photo for online sharing.

Raw (NEF): The purist's choice

The other picture file type you can create on your camera is *Camera Raw*, or just *Raw* (as in uncooked) for short.

Each manufacturer has its own flavor of Raw. Nikon's is NEF, for *Nikon Electronic Format,* so you see the three-letter extension NEF at the end of Raw filenames.

Raw is popular with advanced, very demanding photographers, for the following reasons:

✓ Greater creative control: With JPEG, internal camera software tweaks your images, adjusting color, exposure, and sharpness as needed to produce the results that Nikon believes its customers prefer. With Raw, the camera simply records the original, unprocessed image data. The photographer then copies the image file to the computer and uses special software — a *Raw converter* — to produce the actual image, making decisions about color, exposure, and so on at that point. The upshot is that "shooting Raw" enables you, not the camera, to have the final say on the visual characteristics of your image.

✓ Higher bit depth: Bit depth is a measure of how many distinct color values an image file can contain. JPEG files restrict you to 8 bits each for the red, blue, and green color components, or *channels*, that make up a digital image, for a total of 24 bits. That translates to roughly 16.7 million possible colors. On your camera, a Raw file delivers a higher bit count, collecting 12 bits per channel. (Chapter 8 provides more information about the red-green-blue makeup of digital images.)

Although jumping from 8 to 12 bits sounds like a huge difference, you may not really ever notice any difference in your photos — that 8-bit palette of 16.7 million values is more than enough for superb images. Where having the extra bits can come in handy is if you really need to adjust exposure, contrast, or color after the shot in your photo-editing program. In cases where you apply extreme adjustments, having the extra original bits sometimes helps avoid a problem known as *banding* or *posterization*, which creates abrupt color breaks where you should see smooth, seamless transitions. (A higher bit depth doesn't always prevent the problem, however, so don't expect miracles.)

Best picture quality: Because Raw doesn't apply the destructive compression associated with JPEG, you don't run the risk of the artifacting that can occur with JPEG.

But of course, as with most things in life, Raw isn't without its disadvantages. To wit:

- ✓ You can't do much with your pictures until you process them in a Raw converter. You can't share them online, for example, or put them into a text document or multimedia presentation. You can view and print them immediately if you use the free Nikon ViewNX 2 software, but most other photo programs require you to convert the Raw files to a standard format first. Ditto for retail photo printing. So when you shoot Raw, you add to the time you must spend in front of the computer instead of behind the camera lens. Chapter 6 shows you how to process your Raw files using Nikon ViewNX 2 as well as the converter built into the camera.
- Raw files are larger than JPEGs. Unlike JPEG, Raw doesn't apply lossy compression to shrink files. In addition, Raw files are always captured at the maximum resolution available on your camera, even if you don't really need all those pixels. For both reasons, Raw files are significantly larger than JPEGs, so they take up more room on your memory card and on your computer's hard drive or other picture-storage device.

🛛 🛩 To get the full benefit of Raw, you need software other than Nikon

ViewNX 2. The ViewNX 2 software that ships free with your camera does have a command that enables you to convert Raw files to JPEG or to TIFF, a popular file format for print images. Chapter 6 shows you how to use this tool. However, this free converter gives you only limited control over how your original data is translated in terms of color, exposure, and other characteristics — which defeats one of the primary purposes of shooting Raw. The same is true for the Raw converter built into the camera.

Nikon Capture NX 2 offers a sophisticated Raw converter, but it costs about \$180. (Sadly, if you already own Capture NX, you need to upgrade to version 2 to open the Raw files from your camera.) Chapter 6 talks more about this software and other programs that provide good Raw conversion tools.

Whether the upside of Raw outweighs the down is a decision that you need to ponder based on your photographic needs, your schedule, and your computer-comfort level. If you decide to try Raw shooting, you can select from the following two Image Quality options:

- ✓ RAW: This setting produces a single Raw file at the maximum resolution (24.1 megapixels).
- RAW+JPEG Fine: This setting produces two files: the standard Raw file plus a JPEG Fine version. Both files are captured at the maximum resolution, so remember that creating two files for every image eats up substantially more memory card space than sticking with a single file.

I often choose the Raw+JPEG Fine option when I shoot pictures I want to share right away with people who don't have software for viewing Raw files. I upload the JPEGs to a photo-sharing site where everyone can view them and then I process the Raw versions of my favorite images for my own use when I have time. Having the JPEG version also enables you to display your photos on a DVD player or TV that has a slot for an SD memory card — most can't display Raw files but can handle JPEGs. Ditto for portable media players and digital photo frames.

My take: Choose JPEG Fine or Raw (NEF)

At this point, you may be finding all this technical goop a bit much — I recognize that panicked look in your eyes — so allow me to simplify things for you. Until you have time or energy to completely digest all the ramifications of JPEG versus Raw, here's a quick summary of my thoughts on the matter:

If you require the absolute best image quality and have the time and interest to do the Raw conversion, shoot Raw. See Chapter 6 for more information on the conversion process.

- If great photo quality is good enough for you, you don't have wads of spare time, or you aren't that comfortable with the computer, stick with JPEG Fine.
- If you don't mind the added file-storage space requirement and want the flexibility of both formats, choose Raw+JPEG Fine.
- If you go with JPEG only, stay away from JPEG Normal and Basic. The tradeoff for smaller files isn't, in my opinion, worth the risk of compression artifacts. As with my recommendations on image size, this fits the "better safe than sorry" formula: You never know when you may capture a spectacular, enlargement-worthy subject, and it'd be a shame to have the photo spoiled by compression defects.

Setting Image Size and Quality

To sum up this chapter:

- The Image Size and Image Quality options both affect the quality of your pictures and also play a large role in image file size.
- Choose a high Image Quality setting Raw (NEF) or JPEG Fine and the maximum Image Size setting (Large), and you get top-quality pictures and large file sizes.
- Combining the lowest Quality setting (JPEG Basic) with the lowest Size setting (Small) greatly shrinks files, enabling you to fit lots more pictures on your memory card, but it also increases the chances that you'll be disappointed with the quality of those pictures, especially if you make large prints.

You can view the current Image Size and Image Quality settings in the Information display, in the area labeled in Figure 2-15. (Press the Info button or Info Edit button to access the screen. Or just press the shutter button halfway and release it.) To adjust the settings, you have the following choices:

Info Edit display: Press the Info Edit button twice — once to bring up the Information

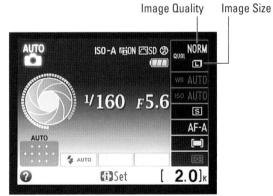

Figure 2-15: The current Image Quality and Image Size settings appear here.

display and then again to shift to the Info Edit screen. Use the Multi Selector to highlight the Image Quality option, located in the top-right corner, as shown on the left in Figure 2-16. Press OK to view the second screen in the figure, where you can select the option you want to use. Highlight your choice and then press OK.

Repeat the process to set the Image Size option, which is right below the Image Quality setting on the Info Edit and Information displays.

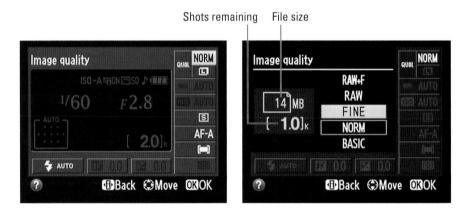

✓ Shooting menu: As an alternative, you can adjust the settings via the Shooting menu, as shown in Figure 2-17. Note: If you use the guided menus instead of the regular menus, you access the Size and Quality options through the Set Up category, not the Shoot section, and your settings apply only to pictures you take in Guide mode. See Chapter 1 for more information about the guided menus, including the reasons why I suggest you stick with the regular menus.

SHOOTING MENU			e quality	
Reset shooting menu	 SD			
Image quality	NORM	ľ.	NEF (RAW) + JPEG fin NEF (RAW)	9
Image size White balance			JPEG fine	
ISO sensitivity settings	AUTU		JPEG normal	OK
Active D-Lighting	ON		JPEG basic	
Auto distortion control	OFF			

Figure 2-17: You also can set Image Size and Image Quality via the Shooting menu.

✓ Use the Fn button with the Command dial: Through the Buttons option on the Setup menu, you can set the Fn button to access the Image Quality and Image Size options. Then you hold down the button while rotating the Command dial to cycle through the various combinations of Image Size and Image Quality. See Chapter 11 to find out more about this button customization. (Normally, the Fn button is set to provide access to the ISO Sensitivity option.)

However you adjust the Size and Quality options, remember that when you choose the Raw (NEF) or Raw+JPEG Fine format, you don't need to worry about the Image Size setting. For these formats, all pictures are automatically captured at the Large resolution, and you can't choose a lower resolution setting.

Adjusting the Image Size or Image Quality setting changes the picture file size, which changes the number of new shots you can fit on the current memory card. If you adjust the options through the Info Edit screen, the display reports the resulting file size and shots remaining values in the area highlighted on the right in Figure 2-16. And when you adjust the Image Size via the Shooting menu, as shown on the left in Figure 2-18, you can view the pixel dimensions (pixels across by pixels down) and the total megapixel count for each setting, as illustrated on the right.

		Pixel dim	ensions Tot	al megapixels
SHOOTING MENU		imag	ae size	
Reset shooting menu Set Picture Control Image quality	 Esd Norm		Large 6016x4000; 24-1	OK) M
Image size			Medium	
White balance ISO sensitivity settings	AUTO	S	4512x3000; 13.5 Small	
Active D-Lighting	ON		3008x2000; 6.0	M
Auto distortion control	OFF	?		

Figure 2-18: Setting the Image Size via the Shooting menu displays resolution info.

Keep in mind that certain other factors also affect file size, such as the level of detail and color in the subject. If you're interested, the camera manual contains a table that shows the approximate file sizes that result from each combination of the Image Size and Image Quality settings, along with information about how many pictures you can expect to fit on an 8GB memory card at those file sizes.

Maintaining a pristine view

Often lost in discussions of digital photo defects — compression artifacts, pixelation, and the like — is the impact of plain-old dust and dirt on picture quality. But no matter what camera settings you use, you aren't going to achieve great picture quality with a dirty lens. So make it a practice to clean your lens on a regular basis, using one of the specialized cloths and cleaning solutions made expressly for that purpose.

If you continue to notice random blobs or hair-like defects in your images (refer to the last example in Figure 2-11), you probably have a dirty *image sensor*. That's the part of your camera that does the actual image capture the digital equivalent of a film negative, if you will.

Your camera offers an automated, internal sensor-cleaning mechanism. By default, this automatic cleaning happens every time you turn the camera on or off. You also can request a cleaning session at any time via the Clean Image Sensor command on the Setup menu. (Chapter 1 has details on this menu option.)

But if you frequently change lenses in a dirty environment, the internal cleaning mechanism may not be adequate, in which case a manual sensor cleaning is necessary. You can do this job yourself, but... I don't recommend it. Image sensors are pretty delicate beings, and you can easily damage them or other parts of your camera if you aren't careful. Instead, find a local camera store that offers this service. In my area (southern Florida), sensor cleaning costs from \$30-\$50.

One more cleaning tip: Never — and I mean *never* — try to clean any part of your camera using a can of compressed air. Doing so can not only damage the interior of your camera, blowing dust or dirt into areas where it can't be removed, but also crack the external monitor.

Taking Great Pictures, Automatically

In This Chapter

- Shooting your first pictures
- ▶ Understanding the pros and cons of Auto mode
- ▶ Getting creative by using Scene modes
- Experimenting with the advanced Guide mode options

A re you old enough to remember the Certs television commercials from the 1960s and '70s? "It's a candy mint!" declared one actor. "It's a breath mint!" argued another. Then a narrator declared the debate a tie and spoke the famous catchphrase: "It's two, two, two mints in one!"

Well, that's sort of how I see the Nikon D3200. On one hand, it provides a full range of powerful controls, offering just about every feature a serious photographer could want. On the other, it offers automated photography modes that enable people with absolutely no experience to capture beautiful images. "It's a sophisticated photographic tool!" "It's as easy as 'point and shoot!'" "It's two, two, two cameras in one!"

Now, my guess is that you bought this book for help with your camera's advanced side, so that's what other chapters cover. This chapter, however, is devoted to your camera's easiest shooting modes, showing you how to get the best results in your camera's fully automatic modes, including Auto, Portrait mode, Sports mode, and the other Scene modes. In addition, a section at the end of the chapter helps you start taking a little more creative control with an assist from Guide mode. *Note:* Information in this chapter assumes that you're using the viewfinder to compose your pictures. Things work a little differently in Live View mode, which enables you to use the monitor instead of the viewfinder, so Chapter 4 concentrates on that shooting option.

Setting Up for Automatic Success

Your D3200 offers eight fully automatic exposure modes, which you access via the Mode dial, as shown in Figure 3-1. Your choices include Auto, which is a general purpose, point-and-shoot type of option, Auto Flash Off, which does the same thing as Auto but without flash, plus six Scene modes, which are geared to shooting specific types of pictures.

All these exposure modes are designed for people without any knowledge of photography. You just frame the shot and press the shutter button. But you still have a few ways to control the camera's behavior.

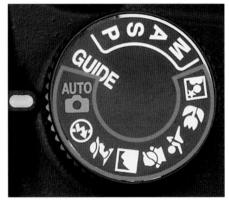

Figure 3-1: For point-and-shoot simplicity, choose from one of these exposure modes.

Figure 3-2 labels the available settings that appear on the Information screen when you shoot in the Auto and Auto Flash Off modes; in the Scene modes, you can also adjust ISO, an exposure control I cover in Chapter 7. You have access to certain options not displayed on the screen, too.

Here's a rundown of the options you can control:

✓ Focusing method: You can focus manually or enjoy autofocusing, assuming that your lens is capable of autofocusing when paired with the D3200. (You must use an AF-S or AF-I type lens; see Chapter 1 for details.) On the 18–55mm kit lens, select the focusing method via the A/M (Auto/Manual) switch, labeled in Figure 3-3.

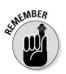

Autofocusing options: Autofocusing behavior is determined by two settings, the AF-Area mode and the Focus mode. I explain both fully in Chapter 8, but here's the condensed version:

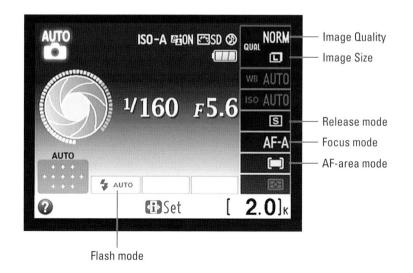

Figure 3-2: Settings that are dimmed in the Information screen are off-limits, but you can modify these basic options.

• Focus mode: For all automatic exposure modes, this option is set to AF-A, which stands for auto-servo autofocus. Here's how it works: If the subject isn't moving. focus is set when you press the shutter button halfway down, and focus remains locked as long as you keep pressing the button halfway. But if the camera detects motion in front of the lens, it may instead continually adjust focus to track your subject. setting the final focusing distance at the time you press the button fully to record the picture. If your subject is moving. be sure to reframe as needed to keep your subject within the area

Auto/Manual focus switch

Vibration Reduction switch

Figure 3-3: You can choose automatic or manual focusing in any exposure mode (if your lens supports autofocusing with the D3200).

of the viewfinder covered by the camera's 11 focus points. See Figure 3-4, in the next section, for a look at the focus points.

Although the Focus mode option is accessible, the only other setting you can use is MF, for manual focusing. With the kit lens and most others, the camera automatically selects that setting when you set the lens focus switch to M. Otherwise you can adjust the setting via the Info Edit screen. If you want access to all Focus mode settings, you must use an advanced exposure mode (P, S, A, or M). You also can access the settings in Guide mode if you follow the Advanced Operation path through the menus.

- *AF-Area mode:* This option determines which of the 11 focus points is used to establish the focusing distance. You have access to all available settings for this one you can change it via the Info Edit screen or the Shooting menu but be sure to read the explanations in Chapter 8 first so that you understand how the autofocusing system works at each of the settings. The default setting varies depending on your exposure mode; I spell out the details when discussing the various modes later in this chapter. Also be aware that the setting reverts to the default if you turn the camera off or select a different exposure mode.
- ✓ Vibration Reduction: When enabled, this feature helps produce sharper images by compensating for camera movement that can occur when you handhold the camera. On the kit lens, turn Vibration Reduction on or off via the VR switch, labeled in Figure 3-3. Select On for handheld photography; set the switch to Off when you mount the camera on a tripod. See Chapter 1 for additional details.
- Flash: In Auto exposure mode, as well as in some Scene modes, the camera automatically raises and fires the built-in flash in dim lighting. In other modes, flash is disabled.

In modes that permit flash, some Scene modes let you alter the behavior of the flash through the Flash mode setting. Chapter 2 introduces the Flash mode, and Chapter 7 provides complete details about all the possible modes. But here's a quick review:

• *Checking the current Flash mode:* A symbol representing the current Flash mode appears in the Information display. For example, in Figure 3-2, the symbol shows that the flash is set to Auto, meaning that the camera will automatically fire the flash if it thinks the ambient lighting is insufficient.

• *Changing the Flash mode:* The fastest option is to press and hold the Flash button as you rotate the Command dial. You also can change the setting via the Info Edit screen. (Chapter 1 shows you how to use this screen.)

Chapter 3: Taking Great Pictures, Automatically

• Using red-eye reduction flash: Look for the Flash mode accompanied by the little eye icon, as shown here. The word Auto also appears with the icon. In this mode, the camera still controls whether the flash fires, and if it sees the need for flash, a little lamp on the front of the camera — officially named the AF-assist illuminator (AF for autofocus) — emits a brief burst of light before the flash fires the idea being that the prelight will constrict the subject's pupils, which helps reduce the chances of red-eye. Warn your subject to wait until after the flash to stop smiling.

Note that the Night Portrait Scene mode uses a variation of redeye reduction, combining that feature with a slow shutter speed. In that case, you see the little eye icon plus the words Auto Slow. Because of the long exposure time (slow shutter speed), it's important to use a tripod and ask your subject to remain still during the exposure to avoid a blurry picture.

Release mode: This setting determines the number of images that are recorded with each press of the shutter button and the timing of each shot. Here's a quick recap of your options, detailed in Chapter 2:

- *Single Frame:* Records a single picture immediately after you depress the shutter button fully.
- *Continuous:* Records up to four frames per second for as long as you hold down the shutter button, up to 100 frames at a time. Remember that you can't use flash during continuous shooting.
- *Self-Timer*: Captures the image a few seconds after you press the shutter button. The default delay is 10 seconds, but you can change that delay via the Self Timer option on the Setup menu. Through the same menu item, you also can set the camera to record up to nine shots with each press of the shutter button. Remember that the Self-Timer setting stays in effect only for a single press of the shutter button; then the Release mode reverts to Single Frame, Quiet Shutter, or Continuous, depending on which mode you used most recently.
- *Quiet Shutter:* Works like Single Frame mode but silences the camera's normal operating sounds as much as possible.
- *Delayed and Quick-Response Remote:* These two modes relate to the Nikon wireless ML-L3 remote control. The first setting triggers the shutter release about two seconds after you press the remote's shutter button; the second option takes the picture immediately after you press the button.

10

Part I: Fast Track to Super Snaps

To access the Release mode setting, your fastest option is to press the Release Mode button on the back of the camera, which takes you directly to the Release Mode options screen. Use the Multi Selector to highlight your choice and then press OK.

- Image Quality and Image Size: By default, pictures are recorded at the Large Image Size setting, producing a 24.1-MP (megapixel) image, and the Normal Image Quality setting, which creates a JPEG picture file with a moderate amount of compression. Chapter 2 explains both options.
- ISO Sensitivity: In the Scene modes, you have access to one exposureadjustment option, ISO Sensitivity, which determines how much light is needed to properly expose the image. At the default setting, Auto, the camera adjusts the ISO Sensitivity as needed. This option is a little complex, so I save it for Chapter 7; stick with Auto for now. You can view the current setting in the Information screen. It's located directly above the Release mode setting (refer to Figure 3-2). Guide mode also provides access to the setting if you follow the Advanced Operation path through the menus. See the end of this chapter for help with Guide mode.
- Advanced Shooting menu options: You also can control the following more advanced Shooting menu options:
 - Auto Distortion Control: This feature attempts to correct for the slight distortion that can occur when you shoot with wide-angle or extreme telephoto lenses. Leave this one set to its default, Off, until you explore the details in Chapter 8.
 - Color Space: Again, stick with the default setting, sRGB, until you delve into the advanced color issues covered in Chapter 8.
 - Noise Reduction: This feature tries to compensate for image defects that can occur when you use a high ISO setting or a long exposure time. Chapter 7 explains the pros and cons of enabling the feature. Leave the setting at its default, On, for now.

In fact, if you're not up to sorting through any of the options in the preceding list, just leave them all at their default settings and skip to the next section to get step-by-step help with taking your first pictures. After all, the defaults are chosen because they're the best solutions for most shooting scenarios. (See the end of Chapter 1 to find out how to restore the default settings if you changed them already.)

As Easy As It Gets: Auto and Auto Flash Off

In Auto mode, the camera analyzes the scene in front of the lens and selects the picture-taking options that it thinks will best capture the image. All you need to do is compose the scene and press the shutter button.

Auto Flash Off mode does the exact same thing, except flash is disabled. This mode provides an easy way to ensure that you don't break the rules when shooting in locations that don't permit flash: museums, churches, and so on.

The following steps walk you through the process of taking a picture in both modes. Remember that these steps assume that you're using the viewfinder, which is the best option in most cases. Chapter 4 explains why and shows you how to take pictures in Live View mode.

Before you work through the steps, adjust the viewfinder to your eyesight so that you get an accurate idea of whether the scene is in focus. (Chapter 1 shows you how.) Also select your focusing method, Release mode, Vibration Reduction setting, and other options that I cover in the preceding section.

1. Set the Mode dial to Auto or Auto Flash Off.

2. Looking through the viewfinder, frame the image so that your subject appears under one of the 11 focus points, as shown in Figure 3-4.

The *focus points* are those tiny rectangles surrounded by brackets to make them a little easier to see. I labeled one of the little guys in the figure.

3. If focusing manually, twist the focusing ring on the lens until the scene appears in focus.

On the kit lens, set the lens switch to M before turning the focusing ring to avoid damaging

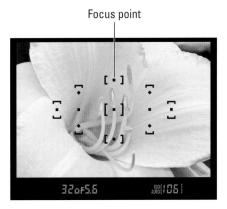

Figure 3-4: The markings in the viewfinder indicate autofocus points.

signing/

the lens. The camera then automatically selects the MF (manual focus) setting for the Focus mode option. If you use another lens, check the lens manual for instructions. Either way, also see Chapter 8 for additional information that may help you achieve better results when focusing manually.

4. Press and hold the shutter button halfway down.

At this point, the following occurs:

• *Exposure metering begins.* The autoexposure meter analyzes the light and selects initial aperture (f-stop) and shutter-speed settings, which are two critical exposure controls. These two settings appear in the viewfinder; in Figure 3-5, the shutter speed is 1/320 second, and the f-stop is f/13. Chapter 7 explains these two options in detail.

Part I: Fast Track to Super Snaps

- In Auto exposure mode, the built-in flash may pop up if additional light is needed.
 You can set the Flash mode to Auto (normal) or Auto Red-Eye Reduction mode.
 Or, you can disable flash by changing the Flash mode to Off; the preceding section has details.
- If autofocusing is enabled, the camera's autofocus system begins to do its thing. In dim light, the AF-assist lamp may shoot out a beam of light so that it can better establish focus.

Selected focus points

• The shots-remaining value changes to show how many shots can fit in the buffer (the camera's temporary memory). This comes into play when you use the Continuous Release mode setting. See Chapter 2 for details.

When the camera establishes focus, one or more of the focus points turns red, as shown in Figure 3-5, for a split second. The red focus points represent the areas of the frame that were used to establish the focusing distance. In the display at the bottom of the viewfinder, the green focus lamp, labeled in the figure, lights to give you further notice that focus has been achieved. Note that if your subject is moving, the light may blink on and off as the camera adjusts focus to track the subject. However, if the focus light blinks continuously, the camera can't achieve focus (and won't let you take the picture). Make sure that you're not too close to your subject; if problems persist, you may need to switch to manual focusing.

The autoexposure meter continues monitoring the light up to the time you take the picture, so the f-stop and shutter-speed values in the viewfinder may change if the lighting conditions change.

5. Press the shutter button the rest of the way down to record the image.

While the camera sends the image data to the camera memory card, the memory card access lamp on the back of the camera lights. Don't turn off the camera or remove the memory card while the lamp is lit, or you may damage both camera and card.

When the recording process is finished, the picture appears briefly on the camera monitor. If the picture doesn't appear or you want to take a longer look at the image, see Chapter 5, which covers picture playback.

Scene modes in focus (or not)

When you focus the lens, either in autofocus or manual focus mode, you determine only the point of sharpest focus. *Depth of field*, which is the distance to which the sharp-focus zone extends in front of and behind the focus point, depends in part on the *aperture setting*, or *f-stop*, which is an exposure control. Some Scene modes are designed to choose aperture settings that deliver a certain depth of field.

The Portrait, Child, Close Up, and Night Portrait Scene modes, for example, try to use a wide aperture (low f-stop number) because doing so shortens the depth of field, rendering backgrounds softly focused — an artistic choice that most people prefer for those types of shots. On the flip side, the Landscape mode tries to use a small aperture (high f-stop number), which produces a large depth of field, keeping both foreground and background objects sharp.

However, the range of apertures the camera can select varies depending on the light. In dim lighting, an open aperture is needed to properly expose the picture, and in bright light, a small aperture may be required to avoid overexposing the picture. Additionally, the range of available aperture settings varies from lens to lens, and the amount of background blurring also increases as the distance between your subject and the background grows. So how much depth of field any Scene mode produces varies from shot to shot.

Another exposure-related control, shutter speed, also plays a focus role when you photograph moving objects. Moving objects appear blurry at slow shutter speeds; at fast shutter speeds, they appear sharply focused. In Sports mode, the camera tries to select a shutter speed fast enough to freeze action, but in dim lighting, that may not be possible: The less light, the slower the shutter speed needed to expose the photo. Thus a moving subject may appear blurry even in Sports mode. Additionally, Night Portrait mode purposely chooses a slow shutter speed to cope with dark settings. For this mode, it's critical to use a tripod because any camera movement during the exposure can also blur the image.

To fully understand these issues and to control focus and depth of field to a greater extent than the Scene modes allow, visit Chapters 7 and 8.

A few important points about working in the Auto and Auto Flash Off modes:

- ✓ Exposure: If an exposure meter blinks in the viewfinder or Information display, the camera can't select settings that will properly expose the picture. See Chapter 7 for details about reading the exposure meter and coping with exposure problems. If you're shooting in the Auto Flash Off mode, however, changing to Auto and enabling flash may provide a solution.
- Autofocusing: As with all the fully automatic modes, the camera uses the AF-A Focus mode. Focus is locked as long as you hold the shutter button halfway down unless the camera senses motion and adjusts focus as needed to track your subject.

For the AF-Area mode, the Auto Area setting is selected by default. In that mode, the camera selects which autofocus points to use when establishing focus. Typically, focus is set on the closest object. Chapter 8 explains how to modify this autofocusing behavior, but if you're having trouble getting the camera to focus on your subject, the easiest solution is to switch to manual focusing.

I didn't include an example of a photo taken in Auto or Auto Flash Off mode because, frankly, the results that these settings create vary widely, depending on how well the camera detects whether you're trying to shoot a portrait, landscape, action shot, or whatever, as well as on lighting conditions. But the bottom line is that both take a one-size-fits-all approach that may or may not take best advantage of your camera's capabilities. So if you want to take great pictures (instead of merely good ones) more consistently, I encourage you to explore the exposure, focus, and color information found in Part III so that you can abandon this mode in favor of modes that put more photographic decisions in your hands. At the very least, step up to one of the Scene modes, detailed in the next section.

Taking Advantage of Scene Modes

In Auto and Auto Flash Off modes, the camera tries to figure out what type of picture you want to take by assessing what it sees through the lens. If you don't want to rely on the camera to make that judgment, your camera offers six *Scene modes,* which select settings designed to capture specific scenes in ways that are traditionally considered best from a creative standpoint. For example,

most people prefer portraits that have softly focused backgrounds. So in Portrait mode, the camera selects settings that can produce that type of background. To choose a Scene type, just rotate the Mode dial to the corresponding symbol. I labeled all the choices in Figure 3-6.

A few general tips before I get into the specifics of each Scene mode:

Autofocusing: For all the scene modes, the camera uses the AF-A Focus mode. That means that focus is locked when you press the shutter button halfway down *unless* the camera senses motion in front of the lens, in which case it adjusts focus up to the time you take the shot.

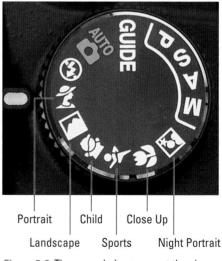

For the AF-Area mode, which is the setting that controls which focus point is used, the camera uses a different default setting depending on your Scene mode, so see the upcoming descriptions for details. You can switch out of the default mode if you want; Chapter 8 explains all the possibilities of this setting.

✓ ISO Sensitivity: This option determines how much the camera's image sensor reacts to light and, therefore, how much light you need to expose the image. Chapter 7 covers this setting fully, but until you're ready to explore that information, stick with the default setting, Auto. The camera then adjusts the ISO Sensitivity option as needed to expose the picture.

In addition, you have access to all the other options described in the earlier section "Setting Up for Automatic Success."

Now for the characteristics to expect from each of the Scene modes:

Portrait: Choose this mode to produce the classic portrait look, with the subject set against a softly focused background, as shown in Figure 3-7. Colors are adjusted to produce naturallooking skin tones. You can set the flash to Auto, Auto with Red-Eye Reduction, or Off.

> For autofocusing, the camera uses the Auto Area AF-Area mode by default, which means that it selects the focus point for you. Again, you can change this setting, but see Chapter 8 to find out how each option works before you do.

Landscape: In the time-honored tradition of landscape photography, this mode produces crisp images with vivid blues and greens to create that bold, vacation-magazine look (see Figure 3-8). The camera also tries Portrait mode

Figure 3-7: Portrait mode produces soft backgrounds to help emphasize your subject.

to select a high f-stop setting to extend depth of field, which keeps both foreground and background objects as sharp as possible. Flash is disabled. As in Portrait mode, the Auto Area AF-Area mode is selected by default.

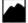

1

Part I: Fast Track to Super Snaps

Child: A variation of Portrait mode, Child mode tries to use a slightly faster shutter speed than Portrait mode. The idea is that a faster shutter speed, which freezes action, helps you get a sharp picture of children who aren't sitting perfectly still. In addition, Child mode chooses an f-stop setting that produces a slightly larger zone of sharp focus — the idea being that the child can move a little closer or farther from the camera without going out of focus.

Like Portrait mode, Child mode also aims for a blurry background and natural skin tones. Colors of clothing and other objects, however, are rendered more vividly. That's a picture characteristic I dislike: I don't want background objects or clothing to take the eye away from the face of my subject. But shoot some samples in both Portrait and Child to see

Figure 3-8: Landscape mode features bold colors and a large zone of sharp focus (depth of field).

which one you prefer. Depending on the subject's attire and the background, you may not see much difference between the two modes. You have the same flash choices as with Portrait mode (Auto, Auto with Red-Eye Reduction, and Off). If you choose autofocusing, the default AF-Area mode is Auto Area: The camera selects the focus point for you.

Sports: Select this mode to have a better chance of capturing a moving target without blur, as I did for my furkid in Figure 3-9. To accomplish this outcome, the camera selects a fast shutter speed, if possible. But remember that in dim lighting, the camera may need to use a slow shutter speed to expose the image — which typically means a shutter speed too low to freeze action. Flash is disabled.

Autofocusing in Sports mode works differently than in the aforementioned modes; the default AF-Area mode setting is Dynamic Area instead of Auto Area. In Dynamic Area mode, you start by using the Multi Selector to choose a focus point. To see which point is active, look through the view-finder and press the shutter button halfway — the active point turns red for a moment. You can then release the shutter button and press the Multi Selector up, down, left, and right to choose a different point. As you press

the Multi Selector button, the selected point flashes red.

After choosing a point, frame the picture with vour subject under that point and press the shutter button halfway. The camera sets focus on that point initially, but if your subject moves out of that point, the camera looks to the other focus point for focusing information and adjusts focus as necessary. Your responsibility is to reframe the shot as needed to keep the subject within the area covered by the 11 focus points.

Close Up: As with Portrait and Child mode, the camera selects an aperture designed to produce short depth of field, which helps keep background objects from competing for attention with your Sports mode

Figure 3-9: Try Sports mode to capture action.

main subject, as shown in Figure 3-10. You can set the Flash mode to Auto, Auto with Red-Eye Reduction, or Off.

In Close Up mode, the default AF-Area mode is Single Point mode, meaning only one point is active. The center point is selected by default, but you can use the Multi Selector to choose a different point. Again, press the shutter button halfway to light up the selected point in the viewfinder; then release the shutter button and press the Multi Selector up, down, left, or right to cycle through the points. Frame your subject so that it falls under the selected point and then press the shutter button halfway to focus.

✓ Night Portrait: This mode is designed to deliver a better-looking flash portrait at night (or in any dimly lit environment). It does so by constraining you to using Auto Slow-Sync, Auto Slow-Sync with Red-Eye Reduction, or Off Flash modes. In the first two Flash modes, the camera

•*

selects a shutter speed that results in a long exposure time. That slow shutter speed enables the camera to rely more on ambient light and less on the flash to expose the picture, which produces softer, more even lighting. If you disable flash, an even slower shutter speed is used.

I cover the issue of long exposure and slow-sync flash photography in detail in Chapter 7. For now, the critical thing to know is that the slower shutter speed means that you probably need a tripod. Your subjects also must stay perfectly still during the exposure.

For autofocusing, things work just as they do in regular Portrait mode: The camera uses

Figure 3-10: Close Up mode helps emphasize the subject by throwing the background out of focus.

the Auto Area AF-Area mode by default, which means that the camera selects the focus point for you automatically.

To see whether you approve of how your camera approaches the different scenes, take some test shots. If you aren't happy with the results, you can try adjusting the basic settings explored at the start of this chapter, in the section "Setting Up for Automatic Success." But to really take creative control, switch to one of the advanced exposure modes (P, S, A, or M) and then check out Chapters 7–9 to find out how to manipulate whatever aspect of the picture isn't to your liking.

Getting More Creative with Guide Mode

The Scene modes achieve their different effects in part by adjusting *depth of field* (the distance over which focus remains sharp) and the amount of motion blur. Shifts in depth of field are produced by changing the aperture setting (f-stop), and motion blur is controlled via shutter speed.

Part III gives you the foundation you need to really understand these aspects of your pictures. But if you aren't ready to dive into the details, the Advanced Operation option available in Guide mode makes it easy to play around with depth of field and motion blur to a greater extent than the Scene modes allow. Guide mode enables you to adjust the amount of background blurring, whereas the Scene modes set the depth of field for you. Additionally, whereas Sports mode always tries to use a fast shutter speed to freeze action, Guide mode lets you use a slow shutter speed to intentionally blur a moving object, which can create a heightened sense of motion. And a few of the advanced Guide mode settings also help you manipulate overall exposure. You can select a setting that ensures that sky colors remain vivid in sunset pictures, for example.

The following steps show you how to explore this Guide mode feature.

1. Set the Mode dial to Guide.

You see the initial Guide Mode screen on the monitor, as shown on the left in Figure 3-11.

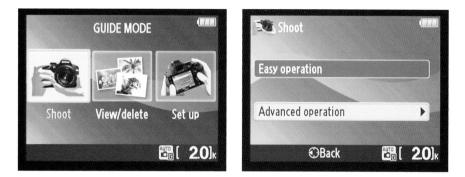

Figure 3-11: Select Advanced Operation to access settings that enable you to adjust depth of field and motion blur.

2. Highlight Shoot and press OK.

You see the screen shown on the right in Figure 3-11.

3. Highlight Advanced Operation and press OK.

The screen shown in Figure 3-12 appears. On this screen, you choose the type of photo effect you want to produce — softer background, sharper background, and so on.

4. Use the Multi Selector to scroll up and down through the list of picture options.

You have these choices:

• *Soften Backgrounds:* Select this option to create a short depth of field, meaning that your subject will be in sharp focus but objects at a distance will appear blurry. Remember that despite the name of the option, objects at a distance in *front* of the

Figure 3-12: Use the Multi Selector to scroll through the list of available picture options.

subject will also appear softly focused.

- *Bring More into Focus:* Select this option for any shot where you want a large depth of field so that both foreground and background objects appear sharp.
- *Freeze Motion (People):* Choose this setting to capture any subject human or not that's moving at a moderate pace, such as a trumpet player in a marching band or a duck swimming across a pond.
- *Freeze Motion (Vehicles):* Select this option for any fast-moving subject, whether it's a passing car, a soccer player kicking the ball across the field, or a running dog.
- *Show Water Flowing:* Choose this option to get help setting the camera to blur motion. Why Show Water Flowing as the setting name? Well, when you photograph a waterfall (or any flowing water), a slow shutter speed blurs the water enough to give it a misty, romantic look. But you can use this setting to blur any moving object, not just water. With colorful subjects, blurred motion can create a fun abstract effect. Chapter 9 has some examples of slow-shutter shots.

strening!

Using a tripod is a must when you use a slow shutter speed. Otherwise, camera shake can blur the whole picture, not just the moving objects. Remember to turn off Vibration Reduction when you use a tripod (and no, enabling that feature won't be enough to ensure a shake-free shot at shutter speeds slow enough to blur water). For most people, shutter speeds slower than 1/60 second create problems, but it varies depending on your lens and physical limitations. See Chapter 7 for more information.

• *Capture reds in sunsets:* This setting chooses a White Balance setting that helps ensure that the red hues of a sunset are emphasized in the shot. You can explore the White Balance setting further in Chapter 8.

Chapter 3: Taking Great Pictures, Automatically

• *Take bright photos:* The camera screen suggests that you use this setting to photograph food or small objects — I'm not exactly sure why. When you select this setting, it bumps up exposure to produce a photo that's brighter than normal. I guess if you want your food or other small objects to fit that description, then this setting makes sense. Otherwise, just ignore the screen suggestion and use this setting any time you want your next picture to be brighter than your last shot. (The camera creates the exposure change through Exposure Compensation, a feature you can explore in Chapter 7.)

This setting is also helpful when you're shooting a scene dominated by white objects, such as a white plate on a white tablecloth — a type of picture known in photography circles as a *high key* image, meaning that the key objects are toward the high side of the brightness spectrum. At a normal exposure, the camera may tend to underexpose the image because of all the bright objects, resulting in things that should be white looking a little gray.

• *Take dark (low key) photos:* This one is the opposite of Take Bright Photos; the camera purposely underexposes the image to create a darker picture. Again, the feature used to produce the exposure change is Exposure Compensation.

The *low key* in the setting name refers to the fact that the key objects in the image are toward the dark end of the brightness spectrum. Try this setting when shooting dark subjects, such as a black cat on a gray rug. (And don't ask me why the Take Bright Photos setting doesn't have *high key* in its name.)

• *Reduce blur:* This mode is designed for times shooting in dim lighting or when you use a long (and possibly heavy) telephoto lens and you don't have a tripod handy. It sets the ISO Sensitivity option to Auto, which means that the camera increases the light-sensitivity of the image sensor automatically to allow a faster shutter speed. That faster shutter speed can help eliminate the blur that can occur due to camera shake when you handhold the camera and use a slow shutter speed. See the first part of Chapter 7 for the scoop on shutter speed and ISO Sensitivity.

5. Highlight your choice and press OK.

A screen with some basic information appears. For example, if you select Soften Backgrounds, you see the screen shown on the left in Figure 3-13.

6. After reading the information screen, press OK.

You see a second screen that offers an adjustment related to the scene option you selected in Step 5. For the Soften Backgrounds option, you can adjust the f-stop, for example, as shown on the right in Figure 3-13.

Part I: Fast Track to Super Snaps

Figure 3-13: These screens explain more about the option you selected (left) and guide you through the process of adjusting the setting related to that option (right).

7. Use the Multi Selector to adjust the picture setting as instructed by the message on the screen.

As you do, the little picture preview updates to illustrate how your picture will be affected. (The change to the preview can be pretty subtle, so don't drive yourself crazy if you can't see much difference when you change the setting.)

For scenes that use aperture-priority autoexposure mode, which asks you to select the f-stop, the preview screen also shows you the shutter speed the camera has selected to go with your f-stop setting, as shown on the right in Figure 3-13. (Look in the lower-right corner; the shutter speed in the figure is 1/60 second.) Or, if you're using one of the freeze/ blur motion options, the screen displays the f-stop the camera needs to use to expose the picture at the shutter speed you select. Either way, keep an eye on that shutter speed and remember to use a tripod for slow speeds. And if the f-stop or shutter speed value blinks, the camera can't select settings that will properly expose the image.

In some cases, a little question mark blinks in the lower-left corner of the screen; that's your cue to press the Zoom Out button to display a help screen with information on how to solve the problem.

8. Press OK.

The screen shown in Figure 3-14 appears.

If you're ready to take the picture, choose Use the Viewfinder, as shown on the right in the figure, and press OK to exit the guided menus and take the picture. Or, to play with additional options, select More Settings, press OK, and follow the onscreen prompts until you eventually

Chapter 3: Taking Great Pictures, Automatically

get back to the screen shown in Figure 3-14 and *then* choose Use the Viewfinder and press OK.

You also can use Guide mode to shoot using the Live View preview or to shoot movies; just select the option you want instead of Use the Viewfinder. See Chapter 4 for details about those two camera features.

As you can see from exploring these steps, my earlier statement that Guide mode "makes it easy" to adjust picture settings uses "easy" as a relative

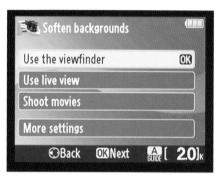

Figure 3-14: Choose one of the first two options when you're ready to actually compose and shoot a picture.

term. You have to wade through a lot of menu screens, some of which aren't completely user-friendly. For example, the screen on the left in Figure 3-13 tells you to use a lens with a focal length of at least 80mm for best results. The camera offers that recommendation because as you increase the lens focal length, you decrease depth of field, multiplying the effect you get from choosing a low f-stop setting. But if you aren't acquainted with the term *focal length*, that's not much help.

My overall take is this: You don't need to know a whole lot more than what I spelled out in these steps to use the A (aperture-priority autoexposure) or S (shutter-priority autoexposure) modes. And in those modes, you can dial in the aperture or shutter speed you want much more quickly than going the guided menu route. You also gain control over all the camera's other picture options, some of which are off limits or cumbersome to access in Guide mode. That said, any time you need a reminder of what setting you should change to produce a desired creative goal, these Guide mode screens can offer a handy assist. When you do use Guide mode, remember these final two points: First, if you turn the camera off, all Guide mode settings are restored to their defaults. Second, some settings that you establish for Guide mode, such as Image Size and Image Quality, affect Guide mode shooting only.

Part I: Fast Track to Super Snaps _____

96

Exploring Live View Photography and Movie Making

In This Chapter

- Getting acquainted with Live View mode
- Customizing the Live View display
- Exploring Live View and movie autofocusing options
- > Taking pictures in Live View mode
- >> Recording, playing, and trimming movies

ike many dSLR cameras, the D3200 offers *Live View*, a feature that enables you to use the monitor instead of the viewfinder to compose photos. Turning on Live View is also the first step in recording a movie; using the viewfinder isn't possible when you shoot movies.

In many respects, taking a picture in Live View mode is no different from regular, through-the-viewfinder photography. But a few critical steps, including focusing, work very differently when you switch on Live View. So the first part of this chapter explains everything you need to know about Live View focusing as well as other aspects of the Live View system. Following that, you can find details on taking still photos in Live View mode and shooting, viewing, and editing movies.

Using Your Monitor as a Viewfinder

The basics of taking advantage of Live View are pretty simple:

✓ Switching to Live View: Press the Live View button, labeled on the left in Figure 4-1. As soon as you take this step, you hear a clicking sound as the internal mirror that normally sends the image from the lens to the viewfinder flips up. The viewfinder goes dark, and the scene in front of the lens appears on the monitor.

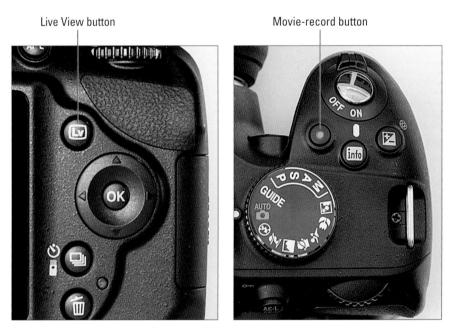

Figure 4-1: Use the LV button to toggle Live View on and off (left); press the red button to start and stop movie recording (right).

Monitoring and adjusting camera settings: During Live View, critical settings appear superimposed atop the live preview instead of on the Information screen. You can still access the Info Edit screen to adjust those settings by pressing the Info Edit button. You adjust other options via external buttons and menus as usual. Remember that which options are available depends on the exposure mode you choose (Auto, P, Guide, and so on).

Chapter 4: Exploring Live View Photography and Movie Making

Shooting photos: Things work pretty much the same as for viewfinder photography — frame, focus, and press the shutter button. The main difference relates to autofocusing; see the upcoming section "Focusing in Live View Mode" for details.

Recording movies: Press the red movie-record button, also labeled in Figure 4-1, to start and stop recording. Your focusing options are the same as for still photography in Live View mode. The section "Shooting Digital Movies," later in this chapter, explains all your movie-recording options.

Picture playback during Live View: Nothing different here, either: Just press the Playback button to shift from the Live View preview to playback mode. To return to shooting, press the button again or give the shutter button a quick half-press and release. Chapter 5 details photo playback; the section "Screening Your Movies," near the end of this chapter, explains movie-playback controls.

Exiting Live View mode: Press the Live View button to dump out of Live View mode and switch back to viewfinder shooting.

As you may have guessed from the fact that I devote a whole chapter to Live View, these points comprise just the start of the story. The next two sections provide some additional general information that applies to both still photography and movie recording; later sections get into the nitty-gritty of taking pictures in Live View mode and using the movie functions.

Live View safety tips

Whether your goal is a still image or a movie, be aware of the following tips and warnings any time you enable Live View:

✓ Cover the viewfinder to prevent light from seeping into the camera and affecting exposure. The camera ships with a little cover designed just for this purpose. To install the cover, first remove the little rubber eyecup that surrounds the viewfinder; just slide the eyecup up and out of the little groove that holds it in place. Then slide the cover down into the groove and over the viewfinder. (Orient the cover so that the Nikon label faces the viewfinder.)

✓ By default, the monitor turns off after ten minutes of inactivity. When the camera is 30 seconds away from turning off the monitor, a little countdown timer appears in the upper-left corner of the screen, as shown in Figure 4-2.

When you're composing still life images or other shots that require a bit of arranging, the ten-minute window sometimes can be too short. Fortunately, you can adjust the automatic shutdown timing if needed. Head for the Setup menu, select the

Countdown timer

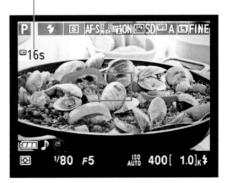

Figure 4-2: The timer tells you how many seconds until auto shutoff.

Auto Off Timers option, as shown on the left in Figure 4-3, and press OK to display the screen shown on the right in the figure.

Figure 4-3: Select this menu option to access settings that adjust the timing of the automatic monitor shutdown.

Choose Long to increase the delay time to 20 minutes; select Short to reduce the delay to 5 minutes (a good option if you want to save battery power). Normal results in the default 10-minute delay.

Keep in mind that these three options also set the automatic shutoff delay for menu and playback display, the image-review period, and the standby timer. To set the Live View option separately and to access a few additional Live View delay settings, choose Custom, as shown on the left in Figure 4-4, and press OK to access the screen shown on the right. Select Live View and press OK to access the Live View shutoff options: 5, 10, 15, 20, or 30 minutes. After making your choice, press OK to return to the right screen in Figure 4-4. Highlight Done (at the top of the screen) and press OK once more.

Figure 4-4: Choose Custom to modify the auto-shutdown timing for Live View only.

For complete information about the Auto Off Timers option, check out Chapter 1.

Any time a screen has a Done option, it's critical to highlight it and press OK. Otherwise, whatever menu change you made doesn't take effect. I hate having to take this step because I forget it all the time, but that's life. The point is, if you change a menu setting and the camera doesn't seem to respond, there's probably a stupid little Done option waiting to be selected. (Yes, I said it: Stupid!)

✓ Using Live View for an extended period can harm your pictures and the camera. When you work in Live View mode, the camera's innards heat up more than usual, and that extra heat can create the right electronic conditions for *noise*, a defect that gives your pictures a speckled look. Chapter 7 contains an illustration of this defect, which also is caused by long exposure times and high ISO Sensitivity settings.

Perhaps more importantly, the increased temperatures can damage the camera itself. For that reason, Live View is automatically disabled if the camera detects a critical heat level. In extremely warm environments, you may not be able to use Live View mode for very long before the system shuts down.

When the camera is 30 seconds or less from shutting down your Live View session to avoid overheating, the countdown timer shown in Figure 4-2 appears to let you know how many seconds you have left before the camera turns itself off. The warning doesn't appear during picture playback or when menus are active, however.

Aiming the lens at the sun or other bright lights also can damage the camera. Of course, you can cause problems doing this even during view-finder shooting, but the possibilities increase when you use Live View. You not only can harm the camera's internal components but also the monitor, not to mention your eyes.

✓ Some lights may interfere with the Live View display. The operating frequency of some types of lights, including fluorescent and mercury-vapor lamps, can create electronic interference that causes the monitor display to flicker or exhibit odd color banding. Changing the Flicker Reduction option on the Setup menu may resolve this issue. At the default setting, Auto, the camera gauges the light and chooses the right flicker reduction setting for you. But you also can choose from two specific frequencies: 50 Hz and 60 Hz, as shown in Figure 4-5. (In the U.S. and Canada, the standard frequency is 60 Hz, and in Europe, it's 50 Hz.)

This option isn't available, however, if you enable the Manual Movie Settings option and set the exposure mode to M. In this situation, try choosing a smaller aperture (higher f-stop number) before enabling Live View. The same tip applies if you shoot in the A mode and none of the Flicker Reduction settings eliminates the problem.

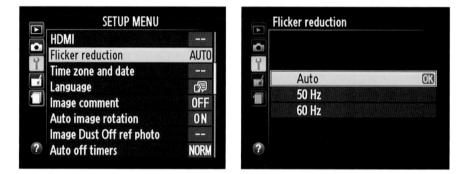

Figure 4-5: If you notice flickering on the monitor, try changing the Flicker Reduction setting.

- ✓ Live View puts additional strain on the camera battery. The monitor is a big consumer of battery juice, so keep an eye on the battery level icon. It appears in the lower left corner of the display when you use the default display mode, Show Photo Indicators. Check out the next section for a look at Live View display modes.
- ✓ The risk of camera shake during handheld shots is increased. When you use the viewfinder, you can help steady the camera by bracing it against your face. But with Live View, you have to hold the camera away from your body to view the monitor, making it harder to keep the camera absolutely still. Any camera movement during the exposure can blur the shot, so using a tripod is the best course of action. If you do handhold the camera, enabling Vibration Reduction can help compensate for a bit of camera shake; Chapter 1 discusses this feature.

Because of these complications, I don't use Live View for still photography very often. Rather, I think of it as a special-purpose tool geared to situations where framing with the viewfinder is cumbersome. I find Live View most helpful for still-life, tabletop photography, especially in cases that require a lot of careful arrangement of the scene.

For example, I have a shooting table that's about waist high. Normally, I put my camera on a tripod, come up with an initial layout of the objects I want to photograph, set up my lights, and then check the scene through the viewfinder. Then there's a period of refining the object placement, the lighting, and so on. If I'm shooting from a high angle, requiring the camera to be positioned above the table and pointing downward, I have to stand on my tiptoes or get a stepladder to check things through the viewfinder between each compositional or lighting change. At lower angles, where the camera is tabletop height or below, I have to either bend over or kneel to look through the viewfinder, causing no end of later aches and pains to the back and knees. With Live View, I can alleviate much of that bothersome routine (and pain) because I usually can see the monitor no matter what the camera position.

Customizing the Live View display

Whether you're shooting movies or still photos, you can choose from the following display styles in Live View mode. Press the Info button to cycle through the different styles.

✓ Show Photo Indicators: By default, the display uses this mode, which reveals shooting data for still photography, as shown on the left in Figure 4-6. Later sections of this chapter detail what each of the little symbols represents. Some symbols, such as those representing flash settings, appear only when you have the feature enabled.

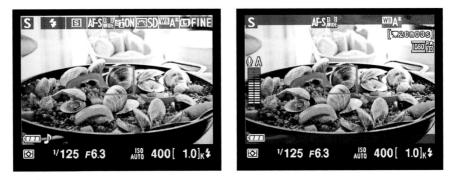

Figure 4-6: In the default Live View mode, you see still-photo shooting data (left); press Info to reveal movie-recording data (right)

✓ Show Movie Indicators: Your second press of the Info button takes you to the display mode shown on the right in Figure 4-6. Here, you see settings related to movie recording, including frame size, rate, and audio options.

Notice the transparent gray bar that appears along the top and bottom of the image area? They appear to show you how much of the vertical image area won't be included in the frame if you set the movie resolution, or frame size, to a setting that produces a 16:9 frame aspect ratio. (The only setting that doesn't produce this ratio is 640 x 424, which captures the same aspect ratio as a still photo, 3:2.)

Hide Indicators: To unclutter the screen, press the Info button a third time to cycle to this mode, which presents only the information shown on the left in Figure 4-7.

Movie frame height markers

Figure 4-7: Keep pressing the Info button to change to one of these other two display modes.

- In this display mode, as well as in the one described next, you may see four tiny horizontal markers near the corners of the image display area. They take the place of the shaded bars that indicate the movie frame area in Show Movie Indicators mode. I labeled two of the markers in Figure 4-7.
- Framing Grid: Press Info one more time to display a grid over the image, as shown on the right in Figure 4-7. The grid is helpful when you need to precisely align objects in your photo. To return to the default display Show Photo Indicators give the Info button one more push.

If you connect your camera to an HDMI (High-Definition Multimedia Interface) device, you no longer see the live scene on your camera monitor. Instead, the view appears on your video display. In that scenario, the arrangement of the shooting information on the screen may appear slightly different than in the examples in this chapter. Also note that if you connect the camera to an HDMI-CEC device, you may need to adjust an option on the Setup menu. Select HDMI, press OK, and turn off the Device Control option. Otherwise you can't record a movie or take a picture in Live View mode. See the Chapter 5 section related to connecting the camera to a television for more HD details.

Focusing in Live View Mode

As with viewfinder photography, you can opt for autofocusing or manual focusing during Live View shooting, assuming that your lens supports both. If you use the kit lens, set the lens switch to A for autofocusing and to M position to focus manually. (With other lenses, check the lens's instruction manual for help.)

It's important to understand that the camera typically takes longer to autofocus in Live View mode than it does during viewfinder photography. (The difference is because of the type of autofocusing the camera must use when in Live View.) So for the fastest autofocusing response, take the camera out of Live View mode.

For times when you opt for Live View, you can tweak the camera's focusing performance through two settings: Focus mode and AF-Area mode. You

can view the current settings at the top of the screen when you use the default display mode, Show Photo Information, as shown in Figure 4-8, or Show Movie Information (refer to the right image in Figure 4-6). Just press the Info button to change the display mode.

Back to the two focusing options: They affect focusing as follows:

Focus mode: If you use autofocusing, this option determines whether the camera locks focus when you press the shutter button halfway, or continually adjusts focus up to the moment you take the shot or throughout

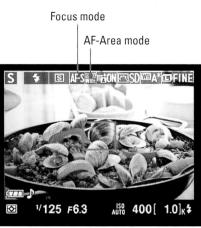

Figure 4-8: The current Focus mode and AF-Area mode settings appear here.

your entire movie recording. A third Focus mode option is provided for times when you want to focus manually.

AF-Area mode: With this option, available when you use any exposure mode except Auto or Auto Flash Off, you specify what part of the frame the autofocus system should consider when establishing focus.

You get these same focusing options for viewfinder photography, but the settings available for Live View are different from those provided for viewfinder photography. See the next two sections to explore the Live View offerings; visit Chapter 8 for information about the Focus mode and AF-Area mode settings for viewfinder photography.

Choosing a Focus mode: Auto, continuous auto, or manual?

Through the Focus mode setting, you can specify whether you want the autofocus system to lock focus at the time you press the shutter button halfway or continue to adjust focus until you take the picture or stop recording your movie. Or you can tell the camera that you prefer to focus manually.

Here's how things work at each of the Focus mode settings:

- ✓ AF-S (single-servo autofocus): The camera locks focus when you depress the shutter button halfway. This focus setting is one of the few that works the same during Live View shooting as it does during viewfinder photography. Generally speaking, AF-S works best for focusing on still subjects.
- ✓ AF-F (full-time servo AF): The main purpose of AF-F is to enable continuous focus adjustment throughout a movie recording. To use this option, keep your finger off the shutter button. Just switch the camera to the AF-F mode, wait for it to find its focus point, and then press the movie-record button to start recording. Focus is adjusted as needed if your subject moves through the frame or you pan the camera. If you decide to lock focus, you can depress the shutter button halfway. As soon as you release the button, continuous autofocusing begins again.

Unfortunately, there's a downside that makes AF-F less than ideal. If you shoot a movie with sound recording enabled and use the internal microphone, the microphone picks up the sound of the autofocus motor as it adjusts focus. So if pristine audio is your goal, use AF-S mode and lock focus before you begin recording, or abandon autofocus altogether and focus manually. As another option, you can attach an external microphone to the camera and place it far enough away that it doesn't pick up the camera sounds. See the section "Controlling audio," later in this chapter, for details about sound recording.

For still photography, focus is locked at the point you press the shutter button halfway, just as with AF-S mode. The only difference between the two modes is that AF-F mode finds a focusing target and keeps adjusting it until you press the shutter button halfway. You might find this option helpful when you're not sure where a moving subject will be when you want to snap the picture: As your subject moves or you pan the camera to keep the subject in the frame, autofocus is adjusted so that when the moment comes to take the shot, you just press halfway, pause, and take the picture. That said, I prefer the continuous autofocusing options available for viewfinder photography for this kind of shot — I find them easier and more reliable than the Live View AF-F option.

MF (manual focus): Select this option to focus manually, by twisting the focusing ring on the lens.

With the kit lens and some other lenses, simply moving the switch on the lens from the A (autofocus) to M (manual focus) position automatically selects the MF Focus mode setting. If you're not using the kit lens, check your lens instruction manual for information about whether you need to set the Focus mode to MF to focus manually.

To adjust the Focus mode setting, follow these steps:

- 1. Press the Info Edit button to bring up the Info Edit display.
- 2. Highlight the Focus mode option, as shown on the left in Figure 4-9.

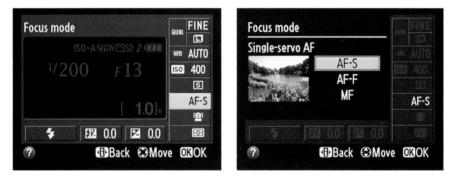

Figure 4-9: Change the Focus mode via the Quick Settings screen.

- **3.** Press OK to display the second screen in the figure, and then highlight the setting you want to use.
- 4. Press OK to jump back one screen.
- **5.** Press the shutter button halfway and release it to return to the Live View display.

Or press the Info Edit button a second time, if you prefer.

Selecting a focusing target (AF-Area mode)

Through the AF-Area mode, you give the camera's autofocusing system instructions on what part of the frame contains your subject so that it can set the focusing distance correctly.

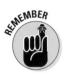

As with the Focus mode, the Live View AF-Area mode options are different than the ones available for viewfinder photography, which I detail in Chapter 8. For Live View photography and movie recording, you can choose from the following settings:

Wide Area: In this mode, you use the Multi Selector to move a little rectangular focusing frame around the screen to specify your desired focusing spot. The red rectangle you see in Figure 4-8 is the Wide Area focusing frame.

✓ Normal Area: This mode works the same way as Wide Area autofocusing but uses a smaller focusing frame. The idea is to enable you to base focus on a very specific area. With such a small focusing frame, however, you can easily miss your focus target when handholding the camera. If you move the camera slightly as you're setting focus and the focusing frame shifts off your subject as a result, focus will be incorrect. So for best results, use a tripod in this mode.

Face Priority: Designed for portrait shooting, this mode attempts to hunt down and focus on faces. Face Detection typically works only when your subjects are facing the camera, however. If the camera can't detect a face, you see a plain red focus frame, and things work as they do in Wide Area mode. In a group shot, the camera typically focuses on the closest face.

✓ Subject Tracking: This mode tracks a subject as it moves through the frame and is designed for focusing on a moving subject. But subject tracking isn't always as successful as you might hope. For a subject that occupies only a small part of the frame — say, a butterfly flitting through a garden — autofocus may lose its way. Ditto for subjects moving at a fast pace, subjects getting larger or smaller in the frame (when moving toward you and then away from you, for example), or scenes in which not much contrast exists between the subject and the background. Oh, and scenes in which there's a great deal of contrast can create problems, too. My take on this feature is that when the conditions are right, it works well, but otherwise the Wide Area setting gives you a better chance of keeping a moving subject in focus.

You can see which mode is selected in the Information display, in the area labeled in Figure 4-8. In the Auto and Auto Flash Off exposure modes, you have no control over this setting; the camera uses the Face Priority setting for Auto and Auto Flash Off. In other exposure modes, adjust the setting by using either of these options:

Use the Info Edit display. After pressing the Info Edit button to shift to the display, highlight the AF-Area mode icon, as shown on the left in Figure 4-10. The icon represents the currently selected setting; for example, in the figure, the Face Priority mode is active. Press OK to display the second screen in the figure, where you see the four focusing options. Use the Multi Selector to highlight your choice, press OK, and then press the Info Edit button or give the shutter button a quick half-press and release to return to the Live View display.

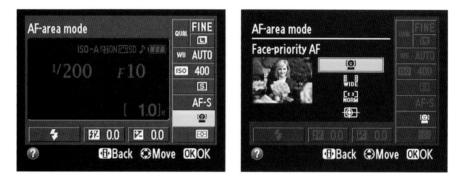

Figure 4-10: Adjust the AF-Area mode through the Quick Settings screen.

✓ Shooting menu: You also can change the setting via the Shooting menu, as illustrated in Figure 4-11. Select AF-Area Mode, as shown on the left, and press OK to display the second screen in the figure. Highlight Live View/Movie and press OK to reach the screen containing the four AF-Area mode options. Make your choice and press OK once more to finalize things. Press Menu or press the shutter button halfway and release it to return to the Live View display.

SHOOTING MENU		AF-area mode	
Color space Noise reduction	SRGB ON		
AF-area mode Built-in AF-assist illuminator		T ✔ Viewfinder	
Metering Movie settings	<u> </u>	Live view/movie	[@] →
Flash cntrl for built-in flash	TTL\$	0	

Figure 4-11: Or select the setting via the Shooting menu.

Choosing the right focusing pairs

To recap, the way the camera sets focus during Live View and movie shooting depends on your Focus mode and AF-Area mode settings. If you use the kit lens (or a similar lens), you also need to set the switch on the lens barrel to either A for autofocusing or M for manual focusing. For other lenses, check the lens's instruction manual for information about this step.

Until you get fully acquainted with all the various combinations of Focus mode and AF-Area mode and can make your own decisions about which pairings you like best, I recommend the following settings:

✓ For moving subjects: Set the Focus mode to AF-F and the AF-Area mode to Wide Area. You also can try the Subject Tracking AF-Area mode, but see my comments in the preceding section regarding which subjects may not be well suited to that mode. Either way, remember that in AF-F mode, you don't press the shutter button halfway until you're ready to lock focus and take the picture — focusing begins immediately after you switch the Autofocus mode to AF-F and continues *until* you press the shutter button halfway.

For movie recording, keep your finger off the shutter button if you want the camera to continuously adjust focus during the recording. Just remember that if you use the camera's internal microphone, the sound of the autofocus motor may be audible in the movie. Attach an external microphone or record audio using a separate device to avoid this problem.

For stationary subjects: Set the Focus mode to AF-S and the AF-Area mode to Wide Area. Or, if you're shooting a portrait, give the Face Priority AF-Area option a try.

Press the shutter button halfway to initiate focusing; after the camera finds the focusing point, focus is locked. For movie recording, you can then release the shutter button. For still photography, keep your finger on the button — otherwise, focus will be reset when you press the button to take the picture.

✓ For difficult-to-focus subjects: If the camera has trouble finding the right focusing point when you use autofocus, don't spend too much time fiddling with the different autofocus settings. Just set the camera to manual focusing and twist the focusing ring to set focus yourself. Remember that every lens has a minimum focusing distance, so if you can't focus automatically *or* manually, you may simply be too close to your subject.

Autofocusing in Live View and Movie mode

Having laid out all the whys and wherefores of the Live View autofocusing options, I offer the following summary of the steps involved in choosing the autofocus settings and then actually setting focus:

1. Choose the Focus mode (AF-S or AF-F) and AF-Area mode.

If you set the Focus mode to AF-F, the autofocus system perks up and starts hunting for a focus point immediately.

2. Locate the focus frame in the Live View display.

The appearance of the frame depends on the AF-Area mode, as follows:

- *Wide Area and Normal Area:* You see a red rectangular frame, as shown in Figure 4-12. (The figure shows the frame at the size it appears in Wide Area mode; it's smaller in Normal Area mode.)
- Face Priority: If the camera locates faces, you see a yellow focus frame around each one, as shown on the left in Figure 4-13. One frame sports corner brackets inside the frame — in the figure, it's the frame on the right. The brackets indicate the face that the camera will use to set focusing distance — typically, the closest person.

If you don't see any yellow boxes but instead see a plain red frame, the camera can't detect a face and will S ★ S AFS, # HONE SD BATE FINE V125 F6.3 AS 400 [1.0]_K‡

Focusing frame

Figure 4-12: The red box represents the focusing frame in Wide Area and Normal Area AF-Area mode.

set focus as it would if you were using Wide Area mode.

• *Subject Tracking:* A focusing frame like the one shown on the right in Figure 4-13 appears.

In AF-F mode, the frame turns green when the object under the frame is in focus. The frame blinks any time focus is being reset.

111

112 Part I: Fast Track to Super Snaps ____

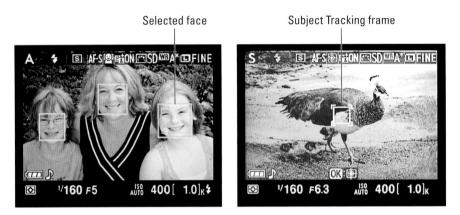

Figure 4-13: The focusing frame appears differently in Face Priority mode (left) and Subject Tracking mode (right).

3. Press the Multi Selector up, down, right, or left to position the focusing frame over your subject.

A couple tips for positioning the frame:

- *In Face Priority mode,* use the Multi Selector to move the box with the double-yellow border which indicates the final focusing point from face to face in a group portrait.
- *In Wide Area and Normal Area modes*, press OK to quickly move the focus point to the center of the frame.
- 4. In Subject Tracking AF-Area mode, press OK to initiate focus tracking.

If your subject moves, the focus frame moves with it. To stop tracking, press OK again. (You may need to take this step if your subject leaves the frame — press OK to stop tracking, reframe, and then press OK to start tracking again.)

- 5. In AF-S Focus mode, press the shutter button halfway down to start autofocusing.
- 6. Wait for the focus frame to turn green, as shown in Figure 4-14.

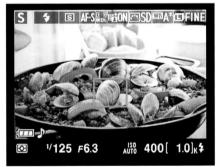

Figure 4-14: The focus frame turns green if the autofocus system was successful.

(The exact appearance of the

frame depends on your AF-Area mode; the figure shows it as it looks in Wide Area mode.)

Chapter 4: Exploring Live View Photography and Movie Making

What happens next depends on your Focus mode:

- *AF-S:* You also hear a little beep (assuming you didn't disable the beep, which you can do via the Beep option, found on the Setup menu). Focus is locked as long as you keep the shutter button pressed halfway.
- *AF-F:* Focus is adjusted if the subject moves. The focus frame turns back to red (or yellow or white) if focus is lost; when the frame turns green and stops blinking, focus has been achieved again. You can lock focus by pressing the shutter button halfway. In most cases, the camera will reset focus on your subject when you press the button, even if the focus frame is already green.

7. (Optional) Press the Zoom In button to magnify the display to doublecheck focus.

Each press gives you a closer look at the subject.

As when you magnify an image when you're viewing photos in playback mode, a small thumbnail appears in the corner of the screen, with the yellow highlight box indicating the area that's currently being magnified, as shown in Figure 4-15. Press the Multi Selector to scroll the display if needed.

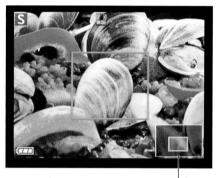

Magnified frame area

To reduce the magnification level, press the Zoom Out button. If you're not using Subject Tracking mode, you

Figure 4-15: Press the Zoom In button to magnify the display and double-check focus.

can also press OK to quickly return to normal magnification.

Manual focusing for Live View and movie photography

For manual focusing with the kit lens or a similarly featured lens, just set the A/M switch to M. The camera automatically changes the Focus mode setting to MF (manual focus). For other lenses, refer to the lens instruction manual to find out how to set the lens to manual focusing. Then twist the lens focusing ring to bring the scene into focus. But note a few quirks:

- ✓ Even with manual focusing, you still see the focusing frame; its appearance depends on the current AF-Area mode setting. In Face Priority mode, the frame automatically jumps into place over a face if it detects one. And if you press OK when Subject Tracking mode is enabled, the camera tries to track the subject under the frame until you press OK again. I find these two behaviors irritating, so I always set the AF-Area mode to Wide Area or Normal Area for manual focusing.
- The focusing frame doesn't turn green to indicate successful focusing as it does with autofocusing.

You can press the Zoom In button to check focus in manual mode just as you can during autofocusing. See Step 7 in the preceding section for details. Press the Zoom Out button to reduce the magnification level.

Shooting Still Pictures in Live View Mode

After sorting out the focusing options, the rest of the steps involved in taking a picture in Live View mode are essentially the same as for viewfinder photography. Here's the drill to follow for all exposure modes except Guide; if you want to use that mode, see Chapter 1 to find out how to walk your way through the Guided menus to reach the screen that lets you select Live View shooting. From there, continue from Step 3.

1. Turn the Mode dial (on top of the camera) to select an exposure mode.

Chapter 3 explains the fully automatic modes; Chapter 7 provides help with the advanced modes (P, S, A, and M).

In Auto and Auto Flash Off modes, the camera may shift to the Portrait, Night Portrait, Landscape, or Close Up Scene mode if it thinks one of those modes will do a better job of capturing your subject. The Exposure mode icon in the top-left corner of the display indicates which mode the camera selected for you. This feature is called Scene Auto Selector in Nikon lingo.

2. Enable Live View by pressing the Live View button.

3. Review and adjust picture settings.

In Live View mode, picture settings appear over the live preview rather than on the Information screen. Which settings you can access depends on your exposure mode; Figure 4-16 shows the options available in the advanced modes (P, S, A, and M).

If you don't see the same type of data on your monitor, press the Info button to cycle through the possible Live View display modes. The one shown in Figure 4-16 is the default (Photo Information mode).

Chapter 4: Exploring Live View Photography and Movie Making

Some settings, such as Exposure Compensation and Flash Compensation, appear only when those features are enabled. When AE Lock (autoexposure lock) is engaged, an AE-L symbol appears to the right of the Metering mode symbol. See Chapter 7 for details about all these features.

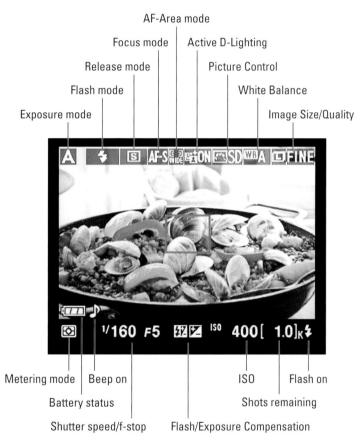

Figure 4-16: You can view these picture settings in the default Live View display mode.

For some settings, the impact of your selected option is visible in the monitor. Change the White Balance setting, for example, and you can see colors shift in the live preview. But Exposure Compensation adjustments aren't always reflected by the monitor brightness. When you increase or decrease exposure using this feature, the image on the monitor becomes brighter or darker only up to shifts of EV +/-3.0, even though you can select values as high as +5.0 and as low as -5.0. See Chapter 7 to get a primer on Exposure Compensation.

- 4. If focusing manually, twist the focusing ring to set focus.
- 5. If using autofocusing, position the focus frame over the subject.

And if you're using Subject Tracking autofocus, press OK to initiate tracking. See the previous section for details.

6. In AF-S mode, press the shutter button halfway to initiate autofocusing.

Focus is achieved when the focus frame turns green.

Regardless of the Focus mode, exposure metering begins when you press the shutter button halfway and is adjusted until you take the picture.

7. Press the shutter button the rest of the way to take the picture.

Shooting Digital Movies

Your D3200 offers the capability to record HD (high-definition) movies up to 20 minutes in length, with or without sound.

Movies are created in the MOV format, which means you can play them on your computer using most movie-playback programs. You also can view movies in Nikon ViewNX 2, the free software provided with your camera. If you want to view your movies on a TV, you can connect the camera to the TV, as I explain in Chapter 5. Or if you have the necessary computer software, you can convert the MOV file to a format that a standard DVD player can recognize and then burn the converted file to a DVD disc. You also can edit your movie in a program that can work with MOV files.

The next several sections explain how to choose recording options; following that, you can find step-by-step instructions for recording, playing, and editing a movie.

Choosing the video mode (NTSC or PAL)

The first recording option to consider is the Video Mode option. Found on the Setup menu and shown in Figure 4-17, this setting tells the camera whether you want your movies to adhere to the NTSC or PAL video standard. NTSC is used in North America; PAL is used in Europe and certain other countries. Your camera should already be set to match the country in which it was purchased, but it never hurts to check, especially because your decision affects what movie frame rate settings are available to you. (Don't worry about what NTSC and PAL mean — they're just acronyms for the technical names of the standards.)

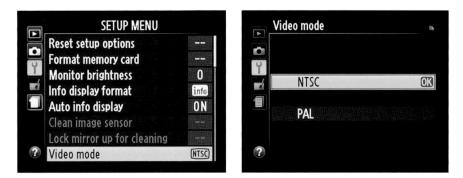

Figure 4-17: The Video Mode option should be set to the video standard — NTSC or PAL — that's used in your country.

Setting video quality (frame size, frame rate, and bit rate)

Two camera settings affect the quality of your video: Frame Size/Frame Rate and Movie Quality. You access both through the Shooting menu; look for the Movie Settings option, shown on the left in Figure 4-18, and press OK to display the options shown on the right. The next sections explain the video-quality options; following that, I explain the Microphone and Manual Movie Settings options. (See "Controlling audio" and "Manipulating movie exposure," respectively, for details about those two settings.)

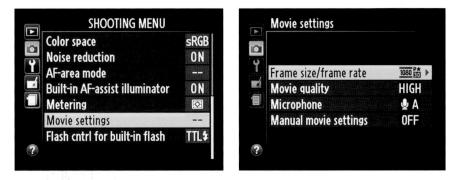

Figure 4-18: You access all movie-recording options except Video Mode through the Movie Settings option on the Shooting menu.

Understanding the Frame Size/Frame Rate options

The first option on the Movie Settings menu list is Frame Size/Frame Rate, as shown in Figure 4-19. Through this setting, you select the resolution, or frame size, of your movie, as well as the number of frames per second, both of which affect video quality. Select the option and press OK to display the second screen in the figure.

Movie settings		Movie settings Frame size/frame rate			
Mov Mic	ne size/frame rate vie quality rophone nual movie settings	iœetă ► HIGH ⊉15 ON	Y I	1000 no 1920x1080; 30p 1000 no 1920x1080; 30p 720 no 1280x 720; 60p 422 no 640x 424; 30p	03
0					

Figure 4-19: This option is one of two that affect movie quality.

The available options depend on whether you choose NTSC or PAL as the Video Mode setting. For NTSC, you see the options shown on the right in Figure 4-19. (More about how it varies when PAL is selected in a moment.) Your choices break down as follows:

- Frame size (resolution): You can choose from three frame sizes, measured in pixels:
 - *1920 x 1080:* Produces a so-called Full HD (High-Definition) movie that has a 16:9 aspect ratio.
 - 1280 x 720: Standard HD, also 16:9.
 - *640 x 424:* This setting gives you a regular definition (that is, not high-def) movie. Frames are much smaller and have an approximate aspect ratio of 3:2. (This smaller resolution can be useful for online videos.)
- ✓ Frame rate (fps): The *frame rate*, measured in *frames per second (fps)*, determines the smoothness of the playback. Assuming NTSC as the video standard, the following frame rate choices are available for the three frame sizes as follows:

- *1920 x 1080:* 30 or 24 fps
- 1280 x 720: 60 fps
- 640 x 424: 30 fps

Notice that frame rate settings are listed as 30p, 24p, and 60p on the camera screens. The *p* stands for *progressive*, which is related to how the video frames are recorded. With progressive video, frames are created by scanning one line of pixels at a time, from the top to the bottom of the frame. An older recording technology, *interlaced video*, scans and records the even and odd lines of video separately and then combines them to create a full frame. Progressive is the newer (and, theoretically, higher-quality) option. However, some folks prefer interlaced video for certain types of recordings (and some older video-editing programs support only interlaced video). I leave that whole debate up to the video wonks in the crowd, but on the D3200, it's a moot point anyway — your only choice is progressive.

For the non-wonk, here are a few pointers to help you choose which frame rate is best:

- 24 fps is the standard for motion pictures, giving your videos a softer, more movie-like look.
- *30 fps is the standard for most network broadcast TV* and produces a crisper picture.
- *60 fps is often used for creating slow-motion footage.* With more frames per second, the video is smoother when you slow down the movie playback. Just note that you give up resolution flexibility if you opt for this setting because it's available only at the 1280 x 720 frame size.

Now for the promised discussion of the options for PAL video: The only difference is with the frame rate: For PAL, you can choose from 24p, 25p, and 50p instead of 24p, 30p, and 60p.

Selecting the Movie Quality option (bit rate)

For each combination of frame rate and size, you also can choose a High or Normal setting via the Movie Quality option, as shown in Figure 4-20. Your choice determines how much compression is applied to the video file, which in turn affects the *bit rate*, or how much data is used to represent one second of video, measured in Mbps (megabytes per second). The High setting results in a higher bit rate, which means better quality and larger files. Choose Normal for a lower bit rate and smaller files. See the sidebar "Video settings summary" to find out what bit rate you get at each setting.

Part I: Fast Track to Super Snaps _

Video settings summary

Here's a recap of the movie frame size, frames per second, and bit rate options available on your D3200. You establish these settings via the Frame Size/Frame Rate and Movie Quality options, both accessed via the Movie Settings option on the Shooting menu. The table assumes NTSC as the Video Mode.

Frame Size	FPS	Quality	Bit Rate	
1920 x 1080	30 or 24	High Normal	24 Mbps 12 Mbps	
1280 x 720	60	High Normal	24 Mbps 12 Mbps	
640 x 424	30	High Normal	5 Mbps 3 Mbps	

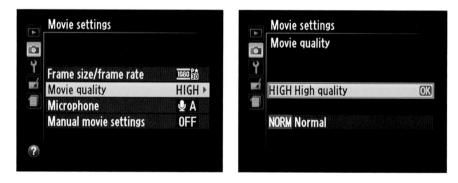

Figure 4-20: This setting determines the maximum bit rate (Mbps).

Controlling audio

You can record monaural sound using the camera's built-in microphone, labeled on the left in Figure 4-21. (Don't confuse those three little holes with the ones that lead to the camera's speaker, also labeled in the figure.) For stereo sound, you can attach the optional Nikon ME-1 stereo microphone to the jack labeled on the right in the figure.

120

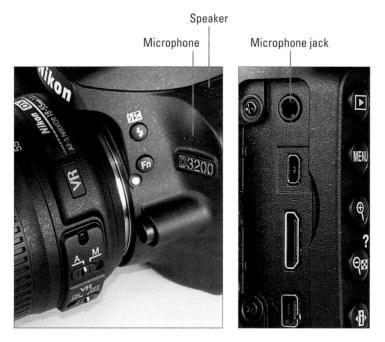

Figure 4-21: You can capture audio using the internal microphone (left) or plug an external microphone into the microphone jack (right).

Either way, to enable sound recording and access audio settings, select Movie Settings on the Shooting menu, press OK, and then select Microphone, as shown on the left in Figure 4-22. Press OK to display the settings shown on the right in the figure.

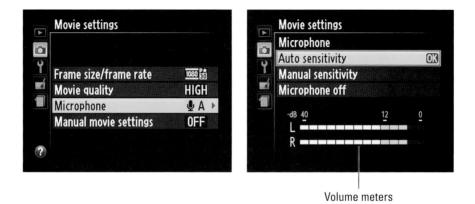

Figure 4-22: All audio recording settings are controlled through the Microphone menu option.

Compared to the mind-numbing intricacies of the video specifications outlined in the preceding section, options related to sound recording are fairly straightforward, but some of the audio menu screens can be a little intimidating until you know what's what:

✓ Volume meters: First off, the two little bars at the bottom of the screen, labeled volume meters in Figure 4-22, indicate the sound levels being picked up by the microphone. For stereo sound, the top bar represents the left audio channel; the bottom bar, the right channel. For monaural sound, both bars reflect the same data.

Audio levels are measured in decibels (dB), and levels on the volume meter range from -40 (very, very soft) to 0 (as loud as can be measured digitally). Ideally, sound should peak consistently in the -12 range, as shown in Figure 4-22. The indicators on the meter turn yellow in this range. If the sound level is too high, the volume meters will peak at 0 and appear red — a warning that audio may be distorted.

Microphone settings: You can choose from three microphone options:

- *Auto Sensitivity:* The camera automatically adjusts the volume according to the level of the ambient noise. This setting is the default.
- *Manual Sensitivity:* Choose this option and press OK to display the manual sound level control, as shown in Figure 4-23. Press the Multi Selector up and down to adjust the microphone volume; settings range from 1 to 20. Again, the volume meters serve as your guide to the correct microphone sensitivity.
- *Microphone Off:* Choose this setting to record a movie with no sound or when you're using an off-camera microphone and don't want the camera itself to record any audio.

Figure 4-23: To control the microphone sensitivity yourself, choose the Manual option (left); press the Multi Selector up or down to adjust the setting (right).

When using the built-in microphone, make sure that you don't inadvertently cover it with your finger. And keep in mind that anything *you* say will be picked up by the mic along with any other audio present in the scene. When an external microphone is attached, the internal microphone goes to sleep.

Manipulating movie exposure

Normally, the camera automatically adjusts exposure for you during movie recording. Exposure is calculated using Matrix (whole frame) metering, regardless of which Metering mode setting is selected. But if you set the camera's mode dial to M, S, A, or P — the advanced modes covered in Part III of this book — you have some control over exposure. Here's a look at your options:

Shutter speed and ISO: If you enable the Manual Movie Settings option on the Movie Settings menu, as shown in Figure 4-24, you can control shutter speed and ISO. This path is one for experienced videographers, however. If you fit that category, here are a few things you need to know:

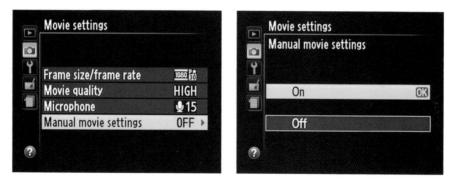

Figure 4-24: Enable this option to take control over movie exposure.

- *Exposure mode:* You must set the Mode dial to the M (manual exposure) setting, and you must set the aperture (f-stop) as well as the shutter speed and ISO to dial in the correct exposure. To set f-stop on M mode, press the Exposure Compensation button while rotating the Command dial.
- *Shutter speed:* You can select shutter speeds as high as 1/4000 second. The slowest shutter speed depends on your chosen frame rate. For 24p, 25p, and 30p, you can drop as low as 1/30 second; for 50p, 1/50 second; and for 60p, 1/60 second. To set the shutter speed in M mode, rotate the Command dial. (Again, which frame rates are available depends on whether the Video Mode option on the Setup menu is set to NTSC or PAL.)

- *ISO*: You can set the ISO value as low as 200 or as high as Hi 1. Note that Auto ISO Sensitivity control doesn't work in movie mode; the camera sticks with your selected setting regardless of the available light. You can adjust ISO via the Shooting menu or Info Edit screen. (Chapter 7 has details.)
- *Camera override:* Choose a shutter speed or ISO setting outside the stated ranges, and the camera will slap your hand and choose the closest in-range setting automatically.
- Aperture (f-stop): You can adjust f-stop before recording if you set the Mode dial to A (aperture-priority autoexposure) or M (manual exposure). This option enables you to control depth of field in your movies; Chapter 7 explains the aperture setting's role in depth of field. In A mode, rotate the Command dial to change the f-stop; again, in M mode, press and hold the Exposure Compensation button while rotating the dial. (See the next point for more about Exposure Compensation.)

✓ Exposure Compensation: Exposure Compensation enables you to override the camera's autoexposure decisions, asking for a brighter or darker picture. You can apply this adjustment for movies when the Mode dial is set to P, S, A, or M. However, you're limited to an adjustment range of EV +3.0 to −3.0 rather than the usual five steps that are possible during normal photography. See Chapter 7 to find out more about this feature. To adjust the setting, press and hold the Exposure Compensation button while rotating the Command dial *unless* you're using Manual (M) exposure mode. In that mode, you must use the Info Edit screen to apply Exposure Compensation; pressing the button while rotating the Command dial changes the f-stop in M exposure mode.

Just to head off any possible confusion: For viewfinder photography, Exposure Compensation isn't needed in M exposure mode; if you want a brighter or darker exposure, you just change your aperture, shutter speed, or ISO Sensitivity settings. But because the camera doesn't give you control over shutter speed or ISO during movie recording *unless you enable Manual Movie Settings* — you need some way to tell the camera that you want a brighter or darker picture, and Exposure Compensation is it.

Autoexposure lock: In any exposure mode except Auto or Auto Flash Off, you can lock exposure at the current settings by pressing and holding the AE-L/AF-L button. Chapter 7 also tells you more about autoexposure lock.

Reviewing a few final recording options

In addition to those settings reviewed in the preceding sections, you can control a few other aspects of your cinematic effort:

Focusing: You can choose auto or manual focusing and control autofocusing behavior via the Focus mode and AF-Area mode settings. Earlier parts of this chapter provide a primer in focusing.

124

Chapter 4: Exploring Live View Photography and Movie Making

✓ White Balance and Picture Control: The colors in your movie are rendered according to the current White Balance and Picture Control settings. Chapter 8 explains how to adjust these settings, but you have control over the options only when the Mode dial is set to P, S, A, or M or you follow the Advanced Operation path in Guide mode.

Want to record a black-and-white movie? Open the Shooting menu, choose Set Picture Control, and select Monochrome. Instant *film noir*.

Recording a movie

After you establish all the options explained in the preceding section, there's not much left to do to shoot a movie:

1. Press the Live View button to switch to Live View mode.

The viewfinder goes dark, and the scene in front of the lens appears on the monitor.

info

2. Press the Info button as needed to switch to the Show Movie Information display mode.

In this mode, you see the shooting information shown in Figure 4-25. A couple of pointers about this display:

- *Frame rate/size/quality:* This combination symbol shows the settings of the Frame Size/Frame Rate and Movie Quality options, both accessed via the Movie Settings item on the Shooting menu. In the figure, the symbols show that I selected the 1920 x 1080 frame size at a 30p frame rate. The little star indicates that I set the Movie Quality option to High. No star means that the Movie Quality option is set to Normal.
- *Recording time available:* The length of the movie you can record depends on your frame rate, size, and quality settings and the amount of free space on your memory card. The maximum movie length is 20 minutes.
- *Microphone setting/volume meter:* The little microphone symbol indicates the option you selected for the Microphone option, again accessed from the Movie Settings item on the Shooting menu. If you select Auto Sensitivity, you see an A with the tiny mic, as in the figure. If you choose Manual Sensitivity, the volume setting you selected appears instead (1 through 15). The little meter reflects the current volume levels, as explained in the earlier section "Controlling audio." Watch for the bars near the top of the meter to turn yellow they indicate that volume is in the –12 decibel range, which is optimal. If the top bar consistently turns red, the volume is too high.

After you start recording, the volume meter disappears, (as does most other onscreen information), so get the sound settings right before you press the record button.

126 Part I: Fast Track to Super Snaps

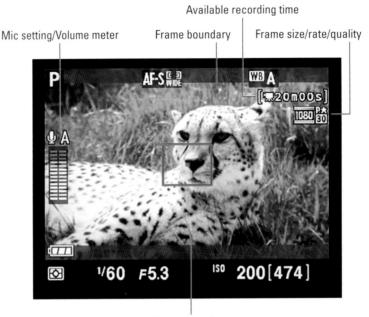

Frame boundary

Figure 4-25: These settings relate to options available for movie recording.

3. Set focus as outlined earlier in this chapter, in the section "Focusing in Live View Mode."

4. To begin recording, press the red movie-record button (just behind the shutter button, on top of the camera).

Most of the shooting data disappears from the screen, and a red Rec symbol flashes in the top-left corner. As recording progresses, the time remaining value shows you how many more seconds of video you can record. Also note the number found within the brackets in the lower-right corner of the screen — 474, in Figure 4-25. That number indicates how many still photos you can fit in the empty card space if you stop recording, and as each second of recording ticks by and card space is depleted, the value that indicates the number of still shots remaining drops.

5. To stop recording, press the movie-record button again.

Your movie is recorded to the memory card in the MOV file format, a popular digital video format.

You can stop your recording and capture a still image in one fell swoop: Just press and hold the shutter button down until you hear the shutter release.

Screening Your Movies

To play your movie, take these steps:

1. Set the camera to playback mode by pressing the Playback button.

2. Use the Multi Selector to scroll to the movie file.

You can spot a movie file in a couple ways:

• *Single-image playback mode:* Look for the little movie-camera icon in the top-left corner of the screen, as shown in Figure 4-26. This icon appears in any playback display mode (File Information, Overview, Shooting Data, and so on) except None (no information) mode. In that mode, the words OK Play at the bottom of the screen clue you into the fact that you're looking at a movie file. See Chapter 5 to find out how to enable additional playback display modes and how to interpret the onscreen data in each one. (If you already enabled other modes, press the Multi Selector up and down to change the mode.)

In File Information mode — the only one enabled by default — you see the movie data labeled in the figure. Note the star labeled Movie Quality: This star indicates that you used the High Movie Quality setting. For the Normal setting, the star doesn't appear.

• *Thumbnail and Calendar playback modes:* You see little dots along the edges of movie files, a design that's supposed to replicate the sprocket holes in a reel of movie film.

Chapter 5 details these playback modes; you cycle through them by using the Zoom In and Zoom Out buttons.

- 3. In single-image playback mode, press OK to start playback.
- 4. In Thumbnail or Calendar view, press OK twice.

The first OK takes you to single-image view; the second starts playback.

128 Part I: Fast Track to Super Snaps

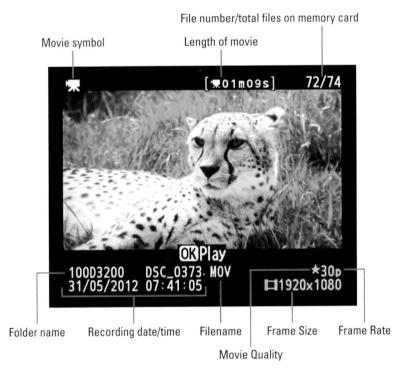

Figure 4-26: The little movie-camera symbol tells you you're looking at a movie file.

After playback begins, the display changes to show you a screen similar to what appears in Figure 4-27. The numbers in the top-right corner show you how many seconds of the movie have played so far, along with the total length of the movie. In addition, little playback control icons appear at the bottom of the screen to remind you that you can use the Multi Selector, Command dial, and Zoom In and Zoom Out buttons to control playback, as follows:

- **Stop playback:** Press the Multi Selector up.
- Pause/resume playback: Press down to pause playback; press OK to resume playback.
- ✓ Fast forward/rewind: Press the Multi Selector right or left to fastforward or rewind the movie. Press again to double the fast-forward or rewind speed; keep pressing to increase the speed. Hold the button down to fast-forward or rewind all the way to the end or beginning of the movie.
- Forward/rewind 10 seconds: Rotate the Command dial to the right to jump 10 seconds through the movie; rotate to the left jump back 10 seconds.

Advance frame by frame: First, press the Multi Selector down to pause playback. Then press the Multi Selector right to advance one frame; press left to go back one frame.

Adjust playback volume: See the little markings labeled volume control symbols in Figure 4-27? They remind you that you can press the Zoom In button to increase playback volume. For a quieter playback, press the Zoom Out button.

Chapter 5 explains how to connect your camera to a television so you can play your movies "on the big screen."

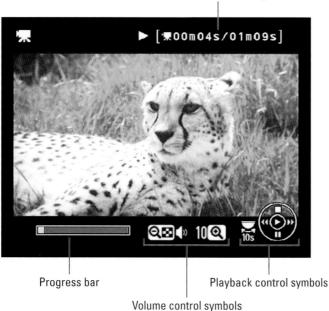

Elapsed time/total length

Figure 4-27: These little symbols remind you how to control playback.

Trimming Movies

You can do some limited movie editing in camera. I emphasize: *limited* editing. You can trim frames from the start of a movie and clip off frames from the end, and that's it.

Take these steps to trim frames from both ends of your movie, leaving just the juicy center. (More later on how to eliminate just the beginning or ending frames.)

- 1. Display your movie in full-frame view.
- 2. Press OK to begin playback.
- 3. When you reach the first frame you want to keep, press the Multi Selector down to pause the movie.

The playback screen looks similar to the one on the left in Figure 4-28. Notice the AE-L/AF-L symbol paired with the scissors symbol at the bottom of the screen? That's your clue that this button plays a major role in movie editing.

4. Press the AE-L/AF-L button.

You see the Edit Movie screen, as shown on the right in Figure 4-28.

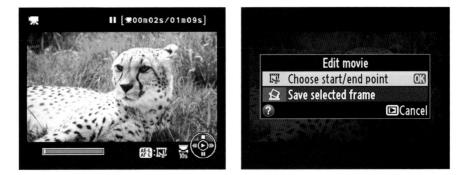

Figure 4-28: Press the Multi Selector down to pause playback on the frame that you want to use as the start of your movie (left); then press the AE-L/AF-L button to access the Edit Movie screen (right).

5. Highlight Choose Start Point/ End Point and press OK.

The screen shown in Figure 4-29 appears, asking you whether you want to use the current frame as the first or last frame of the movie.

6. Highlight Start Point and press OK.

You return to the movie frame, and the progress bar shows little markers to indicate the start and end point of the movie that you will create if you go ahead with the edit. I labeled the markers in

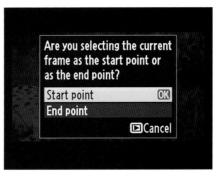

Figure 4-29: Specify whether the current frame is to be the first or last frame of your edited movie.

Figure 4-30. Notice that one is yellow, indicating the currently active marker the start point marker, in the figure.

- 7. To set the end point, press the AE-L/AF-L button to highlight the End Point progress bar marker.
- 8. Use the Multi Selector to rewind the movie from the current end point to the last frame you want to keep in the movie.

Start frame marker End frame marker

Figure 4-30: The progress bar markers indicate the start and end frames.

SENTEMBER

You can jump backward 10 seconds by rotating the Command dial to the left. If you go too far, just press OK to begin playback and then press the Multi Selector down to pause playback on the end frame you want to use.

You can toggle between the Start Point and End Point progress bar markers by pressing the AE-L/AF-L button. Whatever playback function you use (forward, rewind, and so on) then moves the selected marker along the bar. In this way, you can tweak your selection of beginning and ending frame.

9. After you set the beginning and ending frame, press the Multi Selector up to trim the movie.

Notice the little scissors icon on the control symbol in the bottomright corner of the screen — you clue that pressing the Multi Selector up invokes the trim function.

Next you see the screen shown in Figure 4-31.

10. Preview the movie (optional).

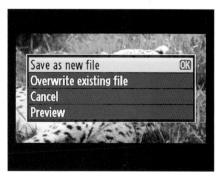

Figure 4-31: To avoid overwriting your original file, choose Save as New File.

To take a look at how the

trimmed movie will appear, highlight Preview and press OK. When the movie finishes playing, you return to the screen shown in Figure 4-31. If you're not happy with what you saw, highlight Cancel and press OK, which returns you to the screen shown in Figure 4-30, where you can adjust which frames appear in your movie.

11. To preserve your original movie and save the trimmed one as a new file, choose Save As New File and press OK.

Alternatively, you can opt to overwrite the existing file, but you can't get the original file back if you do.

A message appears telling you that the trimmed movie is being saved. During playback, edited files are indicated by a little scissors icon that appears in the area noted in Figure 4-32. Trimmed movie symbol

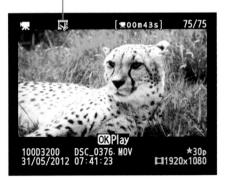

Figure 4-32: The scissors tell you that you're looking at an edited movie file.

Now for the promised hint on how to trim just the beginning or ending of the movie:

- To trim frames just from the end: In Step 3, pause the movie on the last frame you want to keep. Then in Step 6, choose Select Choose End Point and press OK. Then press the Multi Selector up to trim the movie and skip to Step 10.
- ✓ To trim frames just from the beginning: Just skip Steps 7 and 8.

Saving a Movie Frame as a Still Image

In addition to trimming frames from the beginning and end of a movie, you can do a *screen grab* — that is, save a single frame of the movie as a regular image file. Here's how:

- 1. Begin playing your movie.
- 2. When you reach the frame you want to capture, press the Multi Selector down to pause playback.

- 3. Press the AE-L/AF-L button to bring up the Edit Movie screen.
- 4. Choose Save Selected Frame, as shown in Figure 4-33, and press OK.

The selected frame appears on the screen.

Figure 4-33: Through this option, you can save a single movie frame as a still photo.

- 5. Press the Multi Selector up to initiate the screen grab.
- 6. On the confirmation screen that appears, select Yes and press OK.

Your frame is saved as a JPEG photo.

Remember a few things about pictures you create this way:

- ✓ When you view the image, it's marked with a little movie-snip icon in the upper-left corner, as shown in Figure 4-34.
- ✓ The resolution of the picture depends on the resolution of the movie. For example, if the movie resolution is 1920 x 1080, the picture has that same number of pixels. The resolution appears in blue, in the lower-right corner of the playback screen, as shown in Figure 4-34. In addition, your photo has an aspect ratio of 16:9 unless you choose the 640 x 424 frame size for your movie, which yields a 3:2 still photo.

Movie snip symbol

Figure 4-34: This icon marks pictures snipped from a movie.

You can't apply editing features from the Retouch menu to the file, and you also can't view all the shooting data that's normally associated with a JPEG picture.

For more about JPEG and picture resolution, visit Chapter 2.

134 Part I: Fast Track to Super Snaps

In this part ou have a memory card full of pictures. Now what? Now you turn to the first chapter in this part, Chapter 5, which explains all your camera's picture-playback features, including options that help you evaluate exposure and zoom the display so that you can check small details. The same chapter shows you how to delete lousy pictures and protect great ones from accidental erasure.

When you're ready to move pictures from the camera to your computer, Chapter 6 shows you the best ways to get the job done. In addition, Chapter 6 offers step-by-step guidance on printing your pictures and preparing them for online sharing.

5

Playback Mode: Viewing, Erasing, and Protecting Photos

In This Chapter

- Exploring picture playback functions
- Deciphering the picture information displays
- Understanding histograms
- Deleting bad pictures and protecting great ones
- Creating an in-camera slide show
- Viewing pictures (and movies) on a television

ithout question, my favorite thing about digital photography is being able to view my pictures on the monitor the instant after I shoot them. No more guessing whether I captured the image I wanted or I need to try again; no more wasting money on developing and printing pictures that stink. In fact, this feature alone was reason enough for me to turn my back forever on my closetful of film-photography hardware and all the unexposed film remaining from my predigital days.

But seeing your pictures is just the start of the things you can do when you switch your D3200 to playback mode. You also can review camera settings you used to take the picture, display graphics that alert you to exposure problems, and add file markers that protect the picture from accidental erasure.

This chapter tells you how to use all these playback features and also explains how to connect your camera to a television so that you can view your photos and movies on a bigger screen. (Note that much of the on-camera playback information in this chapter deals with still pictures, however; see Chapter 4 for help with the basics of movie playback.)

Customizing Basic Playback Options

You can control many aspects of picture playback on the D3200. Later sections show you how to choose what type of data appears with your pictures, how to display multiple images at a time, and how to magnify an image for a close-up look. But first, the next few sections explain options that affect overall playback performance, including how long your pictures appear onscreen and how they're oriented on the monitor.

Adjusting playback timing

By default, the camera monitor turns off after one minute of inactivity during picture playback to save battery power. If you want a longer or shorter interval before the playback cutoff, you can adjust the timing through the Auto Off Timers option, found on the Setup menu. Choose that option and press OK to display the screen shown on the left in Figure 5-1. Then choose Custom, press OK, and then select Playback/Menus to access the shutdown options, which range from eight seconds to ten minutes. Press OK, highlight Done, and press OK again to wrap up.

Figure 5-1: Choose Custom to adjust the monitor shutdown time for playback and menu display only.

The Short, Normal, and Long options (see the left screen in Figure 5-1) set the shutdown timing for playback and menu display too, but those options also affect how long the camera displays a picture immediately after you capture the image — known as the *image-review period* — as well as the standby timer and Live View display. I prefer to set these timing options separately via the Custom option, but in case you're interested, Chapter 1 spells out the various shutdown intervals produced by the Short, Normal, and Long settings.

Chapter 5: Playback Mode: Viewing, Erasing, and Protecting Photos

Adjusting and disabling instant image review

After you take a picture, it automatically appears briefly on the camera monitor. By default, this review period lasts four seconds. But you can customize this behavior in two ways:

- Adjust the length of the instantreview period. Take the same steps as outlined in the preceding section, but choose Image Review, as shown in Figure 5-2, instead of Playback/Menus. Press OK to display the timing intervals; you can choose settings ranging from four seconds to ten minutes.
- Disable instant review. Because any monitor use is a strain on battery power, consider turning off instant review altogether if your battery is running low. Just call up the Playback menu and set the Image Review option to Off, as shown in Figure 5-3. You can still view your pictures by pressing the Playback button at any time.

Enabling automatic picture rotation

When you take a picture, the camera can record the image *orientation* whether you held the camera normally, creating a horizontally oriented image, or turned the camera on its side to shoot a vertically oriented photo. During playback, the camera can then read the orientation data and

Figure 5-2: You also can adjust the length of the instant-review period through the Auto Off Timers option.

Delete	ú
Playback folder	D3200
Playback display options	
Image review	0FF
Rotate tall	ON
Slide show	
DPOF print order	A

Figure 5-3: To disable instant image review altogether, set this Playback menu option to Off.

automatically rotate the image so that it appears in the upright position, as shown on the left in Figure 5-4. The image is also automatically rotated when you view it in Nikon ViewNX 2, Capture NX 2, and other photo programs that can interpret the data. If you disable rotation, vertically oriented pictures appear sideways, as shown on the right in Figure 5-4.

139

Figure 5-4: You can display vertically oriented pictures in their upright position (left) or sideways (right).

140

Official photo lingo uses the term *portrait orientation* to refer to vertically oriented pictures and *landscape orientation* to refer to horizontally oriented pictures. The terms stem from the traditional way that people and places are captured in paintings and photographs — portraits, vertically; landscapes, horizontally.

On the D3200, set up your rotation wishes through the following two menu options, both shown in Figure 5-5:

Auto Image Rotation: This option, on the Setup menu, determines whether the orientation data is included in the picture file. The default setting is On; select Off to leave out the data.

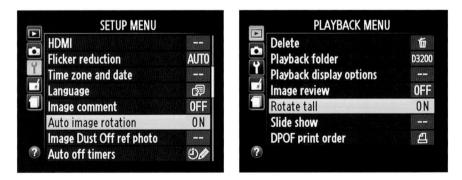

Figure 5-5: Visit the Setup and Playback menus to enable or disable image rotation.

Rotate Tall: Found on the Playback menu, this option controls whether the camera pays attention to the orientation data. The default setting is On. Select Off if you don't want the camera to rotate the image during playback.

Regardless of these settings, your pictures aren't rotated during the instant-review period.

Viewing Images in Playback Mode

To review your photos, take these steps:

1. Press the Playback button, labeled in Figure 5-6.

By default, the camera displays the last picture you took, along with some picture data, such as the filename of the photo and the date it was taken, as shown in Figure 5-6. To find out how to interpret the picture information and specify what data you want to see, see the upcoming section "Viewing Picture Data."

If your last photographic effort was to record a movie, you see the letters OK near the bottom of the picture, reminding you to press OK to begin movie playback. Again, see Chapter 4 for details on playing movies.

2. To scroll through your image files, press the Multi Selector right or left or rotate the Command dial.

Just as a reminder: The Multi Selector is the four-way rocker pad that surrounds the OK button. I labeled it in Figure 5-6.

If some files appear to be missing, the problem could be that your memory card contains multiple image folders and the camera isn't set to display all folders. For help sorting out this issue, see the section "Choosing which images to view" later in this chapter.

3. To return to picture-taking mode, press the Playback button again or press the shutter button halfway and then release it.

By default, one picture appears to shove the other off the screen as you scroll through your pictures. If you don't like this transition effect, which is named Slide In, you can disable it. Or, for fancier playback, you can opt for the Zoom/Fade transition effect, which works just the way its name implies — one frame fades into the next with a zoom effect. To adjust the setting, open the Playback menu and select Playback Display Options, as shown on the left in Figure 5-7. Press OK to bring up the screen shown on the right in the figure. Choose Transition Effects and press right to bring up a screen offering the three transition settings. Make your selection and press OK.

142

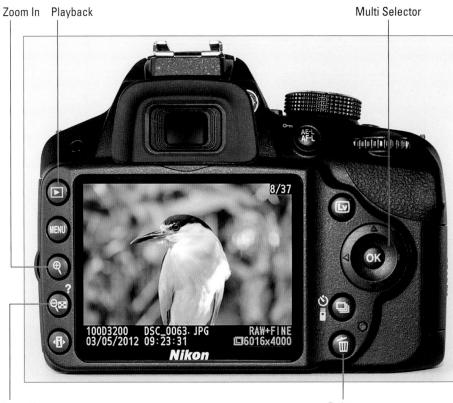

Zoom Out

Delete

Figure 5-6: These buttons play the largest roles in picture playback.

Figure 5-7: You can choose how pictures transition from one to another during playback.

All this info assumes that the camera is currently set to display a single photo at a time, as shown in Figure 5-6. You can also display multiple images at a time, as explained next.

Viewing multiple images at a time (thumbnails view)

Along with viewing images one at a time, you can display 4 or 9 thumbnails, as shown in Figure 5-8, or even a whopping 72 thumbnails. Use these techniques to change to thumbnails view and navigate your photos:

Display thumbnails. Press the Zoom Out button, labeled in Figure 5-6, to cycle from single-picture view to 4-thumbnail view; press again to shift to 9-picture view; and press once more to bring up 72 itty-bitty thumbnails. One more press takes you to Calendar view, a nifty feature explained in the next section.

✓ Display fewer thumbnails. Pressing the Zoom In button, also labeled in Figure 5-6, takes you from Calendar view back to the standard thumbnails display or, if you're already in that display, reduces the number of thumbnails so you can see each one at a larger size. Again, your first press takes you from 72 thumbnails to 9, your second press to 4 thumbnails, and your third press returns you to single-image view.

Notice the icons on these two buttons: The Zoom Out button sports a magnifying glass with a minus sign, the universal symbol for zoom out, plus a little grid that resembles a screen full of thumbnails. (The question mark to the side reminds you of the button's function of displaying Help screens, a topic covered in Chapter 1.) The Zoom In button's magnifying glass has a plus sign, reminding you that you use this button to increase the image size.

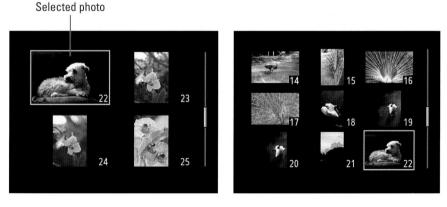

Figure 5-8: You can view multiple image thumbnails at a time.

- Scroll the display. Press the Multi Selector up and down or rotate the Command dial to scroll through your pictures.
- Select an image. To perform certain playback functions, such as deleting a photo or protecting it, first you need to select an image. A yellow box surrounds the currently selected image, as shown in Figure 5-8. To select a different image, use the Multi Selector to move the highlight box over the image.

- Jump from any thumbnail display to full-frame view. Instead of pressing the Zoom Out button multiple times, you can just press OK.
- Spot a movie file. Movie thumbnails are bordered by strips of white dots. Again, I refer you to Chapter 4 for movie playback details.

Displaying photos in Calendar view

In Calendar display mode, you see a little calendar on the screen, as shown on the left in Figure 5-9. By selecting a date on the calendar, you can quickly navigate to all pictures or movies you shot on that day. A thumbnail-free date indicates that your memory card doesn't contain any files from that day.

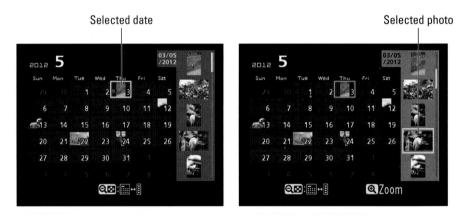

Figure 5-9: Calendar view makes it easy to view all photos shot on a particular day.

The key to navigating Calendar view is the Zoom Out button:

1. Press the Zoom Out button as needed to cycle through the Thumbnail display modes until you reach Calendar view.

If you're currently viewing images in full-frame view, for example, you need to press the button four times to get to Calendar view.

2. Using the Multi Selector or Command dial, move the yellow highlight box over a date that contains an image.

In the left example in Figure 5-9, the 3rd day of May is selected. (The number of the month appears in the top-left corner of the screen.) After you select a date, the right side of the monitor displays a vertical strip of thumbnails of pictures taken on that date.

3. To view all thumbnails from the selected date, press the Zoom Out button again.

As a reminder of what button to press, the little icon underneath the calendar displays the symbols that appear on the Zoom Out button.

After you press the button, the vertical thumbnail strip becomes active, as shown on the right in Figure 5-9, and you can scroll through the thumbnails by pressing the Multi Selector up and down. A second highlight box appears in the thumbnail strip to indicate the currently selected image.

4. To temporarily display a larger view of the selected thumbnail, hold down the Zoom In button.

Again, note the reminder icon in the bottom-right corner of the screen; it shows the plus-sign magnifying glass that appears on the face of the Zoom In button.

In the zoomed view, the image filename appears under the larger preview, as shown in Figure 5-10. When you release the Zoom In button, the large preview disappears, and the calendar comes back into view.

5. To jump from the thumbnail

Zoom Out button again.

strip back to the calendar and

select a different date, press the

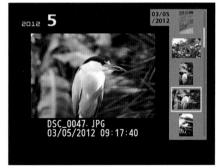

Figure 5-10: Highlight a photo in the thumbnail strip and press the Zoom In button to temporarily display it at a larger size.

6. To exit Calendar view and return to single-image view, press OK.

Choosing which images to view

Your D3200 organizes pictures and movies automatically into folders that are assigned generic names: 100D3200, 101D3200, and so on. You can see the name of the current folder by looking at the Storage Folder option found on the last screen of the Setup menu. (The default folder name appears as just D3200 on the menu.) You also can create custom-named folders through a process outlined in Chapter 11. During playback, which folder's photos appear depend on the Playback Folder option on the Playback menu, shown in Figure 5-11.

Because a folder can contain up to 9999 images, you probably don't need to worry about this setting — all your files likely are contained in one folder on your memory card, and the camera selects that folder by default. But if you use a gargantuan memory card that contains zillions of images (and therefore may contain multiple folders), or you created custom folders, or your card contains pictures taken on another camera, tell the camera which folder you want to view by highlight-

ing the Playback Folder option, press-

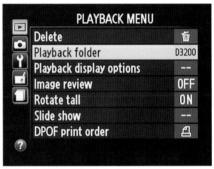

Figure 5-11: Specify which folder you want to view through this option.

ing OK, and then choosing one of the following options:

- Current: Displays images contained in the folder selected as the Storage Folder option on the Setup menu. This setting is the default. Again, unless your card contains multiple folders, all your pictures will be contained in that folder.
- All: Displays all pictures in all folders, even those taken with other cameras (as long as they're in a format the camera can display JPEG or NEF the Nikon version of the Raw image format).

Zooming in for a closer view

After displaying a photo in single-frame view, as shown on the left in Figure 5-12, you can magnify it to get a close-up look at picture details, as shown on the right. This playback trick, however, works only for still photos; you can't zoom a movie during playback.

To zoom in and out on your photos, use these techniques:

Zoom in. Press the Zoom In button. You can magnify the image to a maximum of 19 to 38 times its original display size, depending on the

146

Chapter 5: Playback Mode: Viewing, Erasing, and Protecting Photos

resolution (Image Size) of the photo. Just keep pressing the button until you reach the magnification you want.

Zoom out. To zoom out to a reduced magnification, press the Zoom Out button — the one that sports the minus-sign magnifying glass.

Magnified area

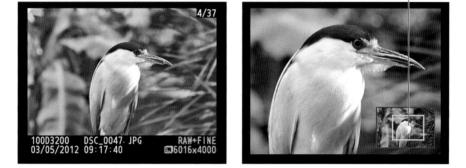

Figure 5-12: When viewing images in single-frame view (left), press the Zoom In button to magnify the picture (right).

✓ View another part of the magnified picture. When an image is magnified, a little navigation thumbnail showing the entire image appears briefly in the lower-right corner of the monitor, as shown on the right in Figure 5-12. The yellow outline in this picture-in-picture image indicates the area that's currently consuming the rest of the monitor space. Use the Multi Selector to scroll the yellow box and display a different portion of the image.

After a few seconds, the navigation thumbnail disappears; just press the Multi Selector in any direction to redisplay it.

Inspect faces. Try this trick to inspect each face in a group shot: Press the Zoom In button once to magnify the image slightly. The picture-inpicture thumbnail then displays a white border around each detected face, as shown on the left in Figure 5-13. (Typically, subjects must be facing the camera for faces to be detected.) Now press the Info Edit button and then press the Multi Selector right or left to jump from face to face.

If necessary, press the Zoom In button to increase the magnification of the current face so that you can check small details. To view the other face in close-up view, repeat the Info Edit button + Multi Selector trick. Press the Info Edit button again to return to the normal playback zoom behavior.

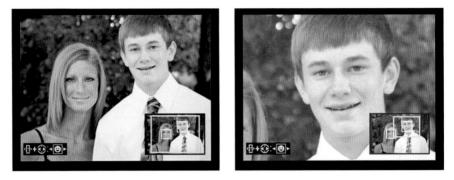

Figure 5-13: The Face Detection feature enables you to quickly inspect faces.

- ✓ View more images at the same magnification. Here's another neat trick: While the display is zoomed, you can rotate the Command dial to display the same area of the next photo at the same magnification. So if you shot the same subject several times, you can easily check how a particular detail appears in each one.
- Return to full-frame view. When you're ready to return to the normal magnification level, you don't need to keep pressing the Zoom Out button until you're all the way zoomed out. Instead, just press OK.

Viewing Picture Data

In single-picture view, you can choose from the six display modes shown in Figure 5-14. If you attach the optional GPS unit to the camera, the Shooting Data display contains an extra screen to present the GPS data.

By default, however, only the File Information display is available. To use the other display options, you must enable them from the Playback menu, as follows:

1. Open the Playback menu and highlight Playback Display Options, as shown on the left in Figure 5-15.

2. Press OK.

You see the screen shown on the right in Figure 5-15.

3. Choose Additional Photo Info and press the Multi Selector right.

A menu listing all the hidden display modes appears, as shown in Figure 5-16. A check mark in the box next to a display mode means the mode is enabled; I show them all selected in the figure, but by default, they're all turned off.

Chapter 5: Playback Mode: Viewing, Erasing, and Protecting Photos

149

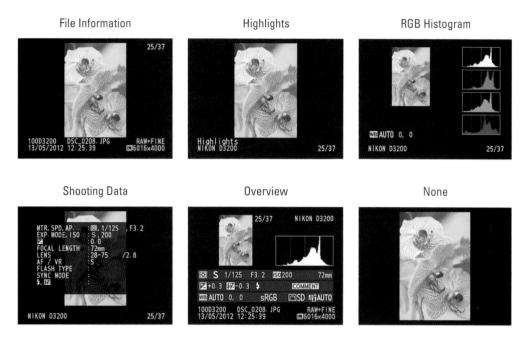

Figure 5-14: You can choose from six playback display modes.

Figure 5-15: Enable additional picture-information display modes through these menu options.

4. To toggle a display mode on, highlight it and then press the Multi Selector right.

A check mark appears in the box for that mode. To remove the check mark, press the Multi Selector right a second time.

5. After turning on the options you want to use, highlight Done, as shown in Figure 5-16, and press OK.

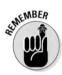

After enabling additional display modes, press the Multi Selector up or down to cycle from one to the next.

The next sections explain what details you can glean from each display mode, save for None. I present them here in the order they appear if you cycle through the modes by pressing the Multi Selector down. You can spin through the modes in the other direction by pressing up. Note that these modes also apply to movie files, but the data presented is related to movie settings instead of the picture data I describe in this chapter. Also, after

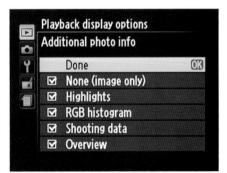

Figure 5-16: Press the Multi Selector right to toggle the boxes on and off; highlight Done and press OK to finalize your changes.

you press OK to start playback, the standard playback screen appears. See Chapter 4 for details on movies.

File Information mode

In the File Information display mode, the monitor displays the data shown in Figure 5-17. Here's the key to what information appears:

Frame Number/Total Pictures: The first value indicates the frame

number; the second tells you the number of pictures in the folder. In Figure 5-17, for example, the image is number 25 out of 37.

✓ Folder name: Folders are named by the camera unless you create custom folders, a trick you can explore in Chapter 11. The first folder is 100D3200. Each folder can contain up to 9999 images; when you exceed that limit, the camera creates a new folder and assigns the next folder number: 101D3200, 102D3200, and so on.

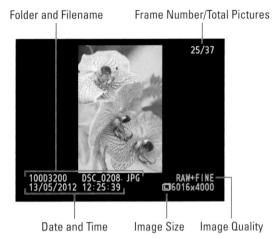

Figure 5-17: In File Information mode, you can view these bits of data.

✓ Filename: The camera also automatically names your files. Every filename ends with a three-letter code that represents the file format, which

150

Chapter 5: Playback Mode: Viewing, Erasing, and Protecting Photos

is either JPG (for JPEG) or NEF (for Raw) for still photos. If you use the Raw+JPEG Fine setting, the JPEG filename appears. Chapter 2 discusses these formats. If you record a movie, the file extension is MOV, which represents a digital-movie file format. If you create a dust-off reference image file, an advanced feature designed for use with Nikon Capture NX 2, the camera instead uses the extension NDF. (Because this software must be purchased separately, I don't cover it or the dust-off function in this book.)

The first four characters of filenames also vary. Here's what the possible codes indicate:

- *DSC_:* This code means you captured the photo at the default Color Space setting, sRGB. You can investigate this option in Chapter 8.
- _*DSC*: If you change the Color Space setting to Adobe RGB, the underscore character comes first.
- *CSC_:* When you create an edited copy of a photo by using one of the Retouch menu features, the copy's filename begins with these characters. If the underscore precedes the letters, you captured the original in the Adobe RGB color space.
- *SSC_*: These letters indicate a lower-resolution copy of a photo that you created by using the Resize option on the Retouch menu; Chapter 6 details that option. If the Color Space was set to Adobe RGB at the time you created the copy, the filename begins with _SSC instead.

Each image is also assigned a four-digit file number, starting with 0001. When you reach image 9999, the file numbering restarts at 0001, and the new images go into a new folder to prevent any possibility of overwriting the existing image files. For more information about file numbering, see the Chapter 1 section that discusses the File Number Sequence option, found on the Setup menu.

- ✓ Date and Time: Just below the folder and filename info, you see the date and time that you took the picture. Of course, the accuracy of this data depends on whether you set the camera's date and time values correctly, which you do via the Setup menu. Chapter 1 has details.
- ✓ Image Quality: Here you can see which Image Quality setting you used when taking the picture. Again, Chapter 2 has details, but the short story is this: Fine, Normal, and Basic are the three JPEG recording options, with Fine representing the highest JPEG quality. Raw refers to the Nikon Raw format, NEF (for Nikon Electronic Format). Raw+Fine indicates that you captured the picture in both formats.
- Image Size: This value tells you the image resolution, or pixel count. See Chapter 2 to find out about resolution.

In the top-left corner of the screen, you may see the following two symbols, labeled in Figure 5-18:

Protected symbol: A little key icon indicates that you used the file-protection feature to prevent the image from being erased when you use the camera's Delete function. See the "Protecting Photos" section, later in this chapter, to find out more. (*Note:* Formatting your memory card, a topic discussed in Chapter 1, *does* erase even protected pictures.) This area appears empty if you didn't apply protection.

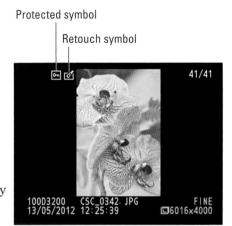

Retouch symbol: This icon appears on images that you created by applying one of the Retouch menu features to a

Figure 5-18: These symbols indicate a protected photo and a retouched photo.

photo. (The camera preserves the original and applies your alterations to a copy of the image.) Chapter 10 explains the Retouch menu.

Highlights display mode

One of the most difficult photo problems to correct in a photo-editing program is known as *blown highlights* in some circles and *clipped highlights* in others. In plain English, both terms mean that *highlights* — the brightest areas of the image — are so overexposed that areas that should include a variety of light shades are instead totally white. For example, in a cloud image, pixels that should be light to very light gray become white due to overexposure, resulting in a loss of detail in those clouds.

Highlights display mode alerts you to clipped highlights by blinking the affected pixels on and off. For example, Figure 5-19 shows you an image that contains some blown highlights. I captured the screen at the moment the highlight blinkies blinked "off" — the black areas in the figure indicate the blown highlights. (I labeled a few of them in the figure.) But as this image proves, just because you see the flashing alerts doesn't mean that you should adjust exposure — the decision depends on where the alerts occur and how the rest of the image is exposed. In my candle photo, for example, it's true that there are small white areas in the flames and the glass vase. Yet exposure in the majority of the photo is fine. If I reduced exposure to darken those spots, some areas of the reddish flower petals floating in the glass would be underexposed. In other words, sometimes you simply can't avoid a few clipped highlights when the scene includes a broad range of brightness values.

Chapter 5: Playback Mode: Viewing, Erasing, and Protecting Photos

Along with the blinking highlight warning, Highlights display mode presents the Protect and Retouch symbols, if you used those features. In the lower-right corner, you see the frame number and total number of images — 3 and 64, in Figure 5-19. The label *Highlights* also appears to let you know the current display mode.

Like all other playback display modes except File Information, the Highlights mode is disabled by default. Follow the instructions in the "Viewing Picture Data" section, earlier in this chapter, to enable it.

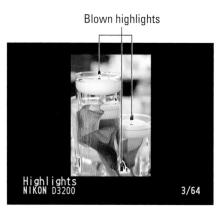

Figure 5-19: In Highlights mode, blinking areas indicate blown highlights.

RGB Histogram mode

Press the Multi Selector down to shift from Highlights mode to this mode, which displays your image in the manner shown in Figure 5-20. Again, you can view your picture in this mode only if you enable it via the Playback Display Options item on the Playback menu. (See "Viewing Picture Data," earlier in this chapter, for help.)

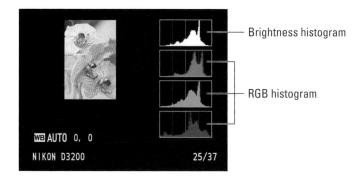

Figure 5-20: RGB Histogram mode presents exposure and color information in chart-like fashion.

Underneath the image thumbnail, you see just a few pieces of data. As with File Information mode, you see the Protect Status and Retouch Indicator icons if you used those features. Beneath that, you see the White Balance settings used for the shot. In the figure, the data shows that the picture was

captured using the Auto White Balance with zero adjustment along the blueto-amber axis and zero adjustment along the green-to-magenta axis. (Chapter 8 details White Balance options.) Along the bottom row of the display, you see the camera name along with the Frame Number/Total Pictures data, also part of the standard File Information display data.

The core of this display mode, though, are those chart-like thingies called *histograms*. You get two types of histograms: The top one is a Brightness histogram; the three others are collectively an RGB (red, green, blue) histogram.

The next two sections explain what you can discern from the histograms. But first, here's a cool trick to remember: If you press the Zoom In button while in this display mode, you can zoom the thumbnail to a magnified view. The histograms then update to reflect only the magnified area of the photo. Use the Multi Selector to scroll the display to see other areas of the picture. To return to the regular view and once again see the whole-image histogram, press OK.

Reading a Brightness histogram

You can get an idea of image exposure by viewing your photo on the camera monitor and by looking at the blinkies in Highlight mode. But the Brightness histogram provides a way to gauge exposure that's a little more detailed.

A Brightness histogram indicates the distribution of shadows, highlights, and *midtones* (areas of medium brightness) in your image. Figure 5-21 shows you the histogram for the orchid image featured in Figure 5-20, for example.

The horizontal axis of the histogram represents the possible picture brightness values — the maximum *tonal range*, in photography-speak — from the darkest shadows on the left to the brightest highlights on the right. And the vertical axis shows you how many pixels fall at a particular brightness value. A spike indicates a heavy concentration of pixels at that brightness value.

Highlights

Shadows

Figure 5-21: The Brightness histogram indicates tonal range, from shadows on the left to highlights on the right.

Keep in mind that there is no one "perfect" histogram that you should try to achieve. Instead, interpret the histogram with respect to the distribution of shadows, highlights, and midtones that comprise

your subject. You wouldn't expect to see lots of shadows, for example, in a photo of a polar bear walking on a snowy landscape. Pay attention, however, if you see a very high concentration of pixels at the far right or left end of the histogram, which can indicate a seriously overexposed or underexposed image, respectively. To find out how to resolve exposure problems, visit Chapter 7.

Chapter 5: Playback Mode: Viewing, Erasing, and Protecting Photos

Understanding RGB histograms

When you view your images in RGB Histogram display mode, you see two histograms: the Brightness histogram, covered in the preceding section, and an RGB histogram. Figure 5-22 shows you the RGB histogram for the orchid image, shown in Figure 5-20.

Less

saturated

To make sense of an RGB histogram, you first need to know that digital images are known as *RGB images* because they're created from three primary colors of light: red, green, and blue. Whereas the Brightness histogram reflects the brightness of all three color channels rolled into one, RGB histograms let you view the values for each channel.

When you look at the brightness data for a single channel, though, you glean information about color saturation rather than image brightness. (Saturation refers to the purity of a color: a fully saturated color contains no black or white.) I don't have space in this book to provide a full lesson in RGB color theory, but the short story is that when you mix red, green, and blue light, and each component is at maximum brightness, you create white. Zero brightness in all three channels creates black. If you have maximum red and no blue or green, though, you have fully saturated red. If you mix two channels at maximum brightness, vou also create full saturation. For example, maximum red and blue produce fully satu-

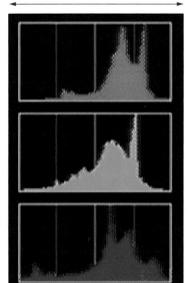

Figure 5-22: The RGB histogram can indicate problems with color saturation.

rated magenta. And, wherever colors are fully saturated, you can lose picture detail. For example, a rose petal that should have a range of tones from medium to dark red may instead be a flat blob of pure red.

The upshot is that if all the pixels for one or two channels are slammed to the right end of the histogram, you may be losing picture detail because of overly saturated colors. If all three channels show a heavy pixel population at the right end of the histogram, you may have blown highlights — again, because the maximum levels of red, green, and blue create white. Either way, you may want to adjust the exposure settings and try again.

More

saturated

A savvy RGB histogram reader can also spot color balance issues by looking at the pixel values. But frankly, color balance problems are fairly easy to notice just by looking at the image on the camera monitor. See Chapter 8 to find out how to correct any color problems that you spot during picture playback.

Shooting Data display mode

Before you can access this mode, you must enable it via the Playback Display Options setting on the Playback menu. See the earlier section "Viewing Picture Data" for details. After turning on the option, press the Multi Selector down to shift from RGB Histogram mode to Shooting Data mode.

In this mode, you can view three screens of information, which you toggle among by pressing the Multi Selector up and down. Figure 5-23 shows you the first two screens.

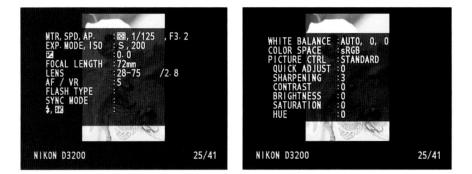

Figure 5-23: You can view the camera settings used to capture the image in Shooting Data display mode.

Most of the data here won't make any sense to you until you explore Chapters 7 and 8, which explain the exposure, color, and other advanced settings available on your camera. But I want to call your attention to a couple of factoids now:

- The top-left corner of the monitor shows the Protect and Retouch icons, if you used these features. Otherwise, the area is empty. (See the earlier section "File Information mode" for details about these particular features.)
- The current folder and frame number appear in the lower-right corner of the display.

156

- The Comment item, which is the final item on the third screen, contains a value if you use the Image Comment feature on the Setup menu. I cover this option in Chapter 11.
- If the ISO value on Shooting Data Page 1 (the first screen in Figure 5-21) appears in red, the camera overrode the ISO Sensitivity setting that you selected in order to produce a good exposure. This shift occurs only if you enable automatic ISO adjustment in the P, S, A, and M exposure modes; see Chapter 7 for details.
- If Auto appears for the Active D-Lighting item (third Shooting Data screen), the feature was enabled for the picture. If the feature was disabled, nothing is displayed next to the Active D-Lighting item.

GPS Data mode

This display mode is available only if the image you're viewing was shot with the optional Nikon GPS (Global Positioning System) unit attached. And technically, GPS Data display mode isn't really its own, independent mode, although the camera manual describes it as such. Instead, if you took a picture with the GPS unit enabled, you see a fourth screen of data when you set the display mode to Shooting Data (detailed in the preceding section.)

The data screen shows you the latitude, longitude, and other GPS information recorded with the image file.

Overview Data mode

In this mode, the playback screen contains a small image thumbnail along with scads of shooting data — although not quite as much as Shooting Data mode — plus a Brightness histogram. Figure 5-24 offers a look.

The earlier section "Reading a Brightness histogram" tells you what to make of that part of the screen. Just above the histogram, you see the Protect and Retouch symbols, if you used those features (not shown in the figure here), while the Frame Number/Total Pictures data appears at the upper-right corner of the image thumbnail. For details on that data, see the earlier section "File Information mode."

To sort out the maze of other information, the following list breaks

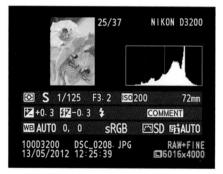

Figure 5-24: In Overview Data mode, you can view your picture along with the major camera settings you used to take the picture. down things into the five rows that appear under the image thumbnail and histogram. In the accompanying figures as well as in Figure 5-24, I include all possible data simply for the purpose of illustration; if any of the items don't appear on your screen, it simply means that the relevant feature wasn't enabled when you captured the shot.

✓ Row 1: This row shows the exposure-related settings labeled in Figure 5-25, along with the lens focal length used to take the shot. As in Shooting Data mode, the ISO value appears red if you had auto ISO override enabled in the P, S, A, or M exposure modes and the camera adjusted the ISO for you. Chapter 7 details the exposure settings; Chapter 8 introduces you to focal length.

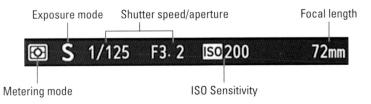

Figure 5-25: Here you can inspect major exposure settings along with the lens focal length.

✓ Row 2: This row contains a few additional exposure settings, labeled in Figure 5-26. On the right end of the row, the Comment and GPS labels appear if you took advantage of those options when recording the shot. (You must switch to the Shooting Data mode to view the actual comment and GPS data.)

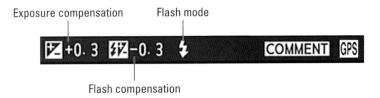

Row 3: The first three items on this row, labeled in Figure 5-27, relate to color options explored in Chapter 8. Again, the second White Balance value shows the amount of blue-to-amber fine-tuning adjustment; and the third, the amount of green-to-magenta adjustment (both values

are 0 in the figure). The last item indicates the Active D-Lighting setting, another exposure option discussed in Chapter 7. If the word Auto appears, the feature was enabled. Otherwise, this part of the data bar is empty.

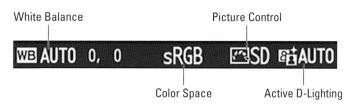

Figure 5-27: Look at this row for details about advanced color settings.

Rows 4 and 5: The final two rows of data (refer to Figure 5-24) show the same information you get in File Information mode, explained earlier in this chapter.

Deleting Photos and Movies

You have three options for erasing pictures and movies from a memory card when it's in your camera. The next sections give you the lowdown.

Whichever option you use, keep in mind that if you shot the picture using the Raw+JPEG Image Quality setting, you see the JPEG version on the monitor. But deleting that version also deletes its Raw companion.

Deleting files one at a time

Í

The Delete button is key to erasing single picture or movie files. But the process varies a little depending on which playback display mode you use, as follows:

- ✓ In single-image view, you can erase the current image by pressing the Delete button.
- In Thumbnail view (displaying 4, 9, or 72 thumbnails), use the Multi Selector to highlight the file you want to erase and then press the Delete button.

In Calendar view, first highlight the date that contains the image or movie. Then press the Zoom Out button to jump to the scrolling list of thumbnails, highlight a specific file, and press the Delete button.

After you press Delete, you see a message asking whether you really want to erase the file. If you do, press the Delete button again. Or, to cancel out of the process, press the Playback button.

See the earlier section, "Viewing Images in Playback Mode," for more details about displaying thumbnails and Calendar view.

You can also press the Delete button during the instant image-review period if you know right away that the picture's a bust. But you have to be quick or the camera returns to shooting mode.

Deleting all photos and movies

To erase all pictures and movie files, take these steps:

1. Display the Playback menu and highlight Delete, as shown on the left in Figure 5-28.

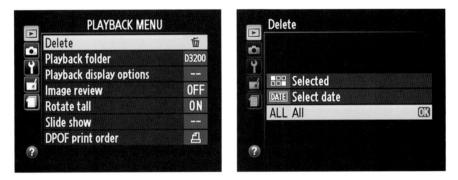

Figure 5-28: To delete all photos, use the Delete option on the Playback menu.

2. Press OK to display the second screen in the figure.

3. Highlight All and press OK.

You then see a screen that asks you to verify that you want to delete all your files.

4. Select Yes and press OK.

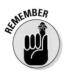

If your memory card contains multiple image folders, these steps delete only files in the folder that is currently selected via the Playback Folder option on the Playback menu. See the section "Choosing which images to view," earlier in this chapter, for information. Remember, too, that files that you tag with the Protect feature, explained later in this chapter, aren't erased by the Delete function.

160

Deleting a batch of selected files

When you want to get rid of more than a few photos or movies but not all that are on the card, don't waste time erasing each file, one by one. Instead, you can tag multiple files for deletion and then take them all out to the trash at one time.

To start, display the Playback menu and highlight Delete, as shown on the left in Figure 5-29. Press OK to display the second screen in the figure.

PLAYBACK MENU		Delete	
Delete Playback folder Playback display options	面 D3200 	► • • • • • • • • • • • • •	
I Image review Rotate tall Slide show	OFF ON 	DATE Select date	
DPOF print order	2	?	

Figure 5-29: The Delete menu option also provides two ways to quickly delete selected pictures.

You then have two options for specifying which files to erase:

Select individual files. Use this option if the files you want to delete weren't all taken on the same day. Highlight Selected, as shown on the right in Figure 5-29, and press the Multi Selector right to display a screen of thumbnails, as shown in Figure 5-30. Use the Multi Selector to place the yellow highlight box over the

first file you want to delete and then press the Zoom Out button, shown in the margin here. A little trash can icon, the universal symbol for delete, appears in the upper-right corner of the thumbnail, as shown in the figure. The file is then tagged as no longer worthy of taking up space on your memory card.

If you change your mind, press the Zoom Out button again to remove the Delete tag from the file. To undo deletion for all selected files, press the Playback button.

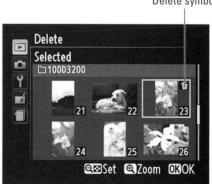

Figure 5-30: Use the Zoom Out button to tag pictures you want to delete.

Delete symbol

For a closer look at the selected image (or first frame of a movie), press and hold the Zoom In button. When you release the button, the display returns to normal thumbnails view.

Erase all files taken on a specific date. This time, choose Select Date from the main Delete screen, as shown on the left in Figure 5-31. Press the Multi Selector right to display a list of dates on which you took the files on the memory card, as shown on the right in the figure.

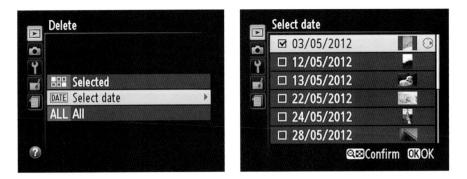

Figure 5-31: With the Select Date option, you can quickly erase all photos and movies taken on a specific date.

Next, highlight a date and press the Multi Selector right. A little check mark appears in the box next to the date, as shown on the right in Figure 5-29, tagging all images or movies shot on that day for deletion. To remove the check mark and save the files from the digital dumpster, press the Multi Selector right again.

Can't remember what files are associated with the selected date? Try this:

- To display thumbnails of all images or movies taken on the selected date, as shown on the left in Figure 5-32, press the Zoom Out button.
- To view the selected thumbnail at a temporarily magnified view, as shown on the right in the figure, press and hold the Zoom In button. Release the button to go back to thumbnails view.
- To return from thumbnails view to the date list, press the Zoom Out button again.

After tagging individual files for deletion or specifying a shooting date to delete, press OK to start deleting. You see a confirmation screen asking permission to destroy the files; select Yes and press OK. The camera trashes the files and returns you to the Playback menu.

162

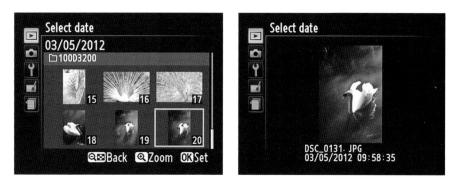

Figure 5-32: Press Zoom Out to see photos and movies shot on the selected date (left); press Zoom In to magnify the selected thumbnail (right).

You have one alternative way to quickly erase all files from a specific date: In the Calendar display mode, you can highlight the date in question and then press the Delete button instead of going through the Playback menu. You get the standard confirmation screen asking you whether you want to go forward. Press the Delete button again to dump the files. Visit the section "Displaying photos in Calendar view," earlier in this chapter, for the scoop on that display option.

Protecting Photos and Movies

You can protect pictures and movies from accidental erasure by giving them *protected* status. After you take this step, the camera doesn't allow you to delete the file from your memory card, whether you press the Delete button or use the Delete option on the Playback menu.

I also use the Protect feature when I want to keep a handful of files on the card but delete the rest. Instead of using the options described in the preceding section to select all the files I want to trash, I protect the handful I want to preserve. Then I set the Delete menu option to All and dump the rest. The protected files are left intact.

Formatting your memory card, however, *does* erase even protected files. In addition, when you protect a file, it shows up as a read-only file when you transfer it to your computer. Files that have that read-only status can't be altered until you unlock them in your photo software. In Nikon ViewNX 2, you can do this by clicking the image thumbnail and then choosing File\$Protect Files\$Unprotect.

Protecting a picture or movie is easy:

1. Display or select the file you want to protect.

- In single-image view, just display the file.
- *In 4/9/72 Thumbnail mode,* use the Multi Selector as needed to place the yellow highlight box over the file.
- *In Calendar view*, highlight the file in the strip of thumbnails that appears on the right side of the screen. (Press the Zoom Out button to jump between the calendar dates and the thumbnails.)

2. Press the AE-L/AF-L button.

See the key symbol above the button? That's your reminder that you use the button to lock a file. The same symbol appears on protected files during playback, as shown in Figure 5-33.

To remove protection, use either of these techniques:

Remove protection from the displayed or selected file: Just press the AE-L/AF-L button again.

Protected symbol

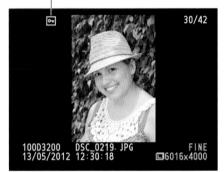

Figure 5-33: Press the AE-L/AF-L button to give an image protected status.

Remove protection from all files: Press the AE-L/AF-L and Delete

buttons together for about two seconds. Note that this action affects the folder or folders currently selected via the Playback Folder menu item on the Playback menu. (See "Choosing which images to view," earlier in this chapter, for details on that playback setting.)

Creating a Digital Slide Show

Many photo-editing and cataloging programs offer a tool for creating digital slide shows that can be viewed on a computer or, if copied to a DVD, on a DVD player. You can even add music, captions, graphics, special effects, and the like to jazz up your presentations.

But if you want to create a basic slide show — that is, one that simply displays all photos, movies, or both automatically — you don't need a computer or any photo software. You can create and run the show right on your camera. And by connecting your camera to a television, as outlined in the next section, you can present your show to a whole roomful of people.

164

Chapter 5: Playback Mode: Viewing, Erasing, and Protecting Photos

One important note before I walk you through the steps of running a slide show: Which files are available for the show depends on the setting of the Playback Folder option on the Playback menu. Read more about this setting in the earlier section "Choosing which images to view."

Follow these steps to create a slide show:

1. Display the Playback menu and highlight Slide Show, as shown on the left in Figure 5-34.

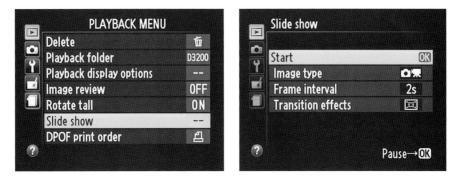

Figure 5-34: Choose Slide Show (left) and press OK to access Slide Show options (right).

2. Press OK to display the screen shown on the right in Figure 5-34.

This screen is where you set the playback options for your show.

3. Highlight Image Type, as shown on the left in Figure 5-25, and press the Multi Selector right.

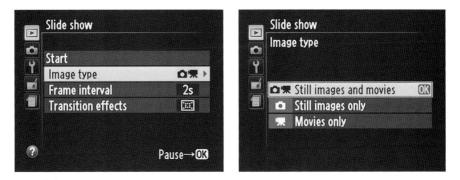

Figure 5-35: Choose this option to specify whether you want to include pictures, movies, or both in the show.

You see the screen shown on the right in the figure. Here, you can choose to include both movies and still photos, just movies, or just photos in the show.

4. Select the image types you want to include and press OK.

You return to the main slide show setup screen.

5. If you chose Movies Only in Step 4, skip to Step 10; otherwise, keep stepping.

The Frame Interval and Transition Effects described in the upcoming steps don't apply when you include only movies in your show.

6. Highlight Frame Interval, as shown in Figure 5-36, and press the Multi Selector right.

You see the list of possible frame intervals — from 2 to 10 seconds — which determine how long each photo appears on the screen. (Movies always play in their entirety.)

7. Highlight the frame interval you want to use and press OK.

You return to the Slide Show setup screen.

8. Select Transition Effects, as shown on the left in Figure 5-37, and press OK.

Figure 5-36: Through this option, you set the display time for each still photo.

Figure 5-37: Choose the transition effect for your show by using this option.

166

You see the second screen in the figure. These options control the effect the camera uses when moving from one photo to the next. With Zoom/ Fade, one image fades into the next with a zoom effect, just as it does when you choose this option for regular, in-camera playback. With the Cube option, pictures rotate into view as if you're spinning a cube that has a different photo on each side. None keeps things plain and simple: The first picture disappears completely before the next one comes into view.

9. Select a transition option and press OK.

You go back to the Slide Show setup screen (left screen in Figure 5-37).

10. Highlight Start and press OK.

Your slide show starts playing on the camera monitor.

When the show ends, you see a screen offering four options: You can choose to restart the show, adjust the frame interval, change the transition effect, or exit to the Playback menu. Highlight your choice and press OK.

During the show, you can control playback as follows:

- Pause the show. Press OK. Select Restart and press OK to restart the show. When you pause the slide show, you also can change the interval — a handy option if the pace is too quick or slow — adjust the transition effect, or exit the show. Just highlight your choice and press OK. If you adjust the timing or transition, resume playback by choosing Restart and pressing OK.
- Adjust movie volume: If your slide show contains movies with soundtracks, you can use the Zoom In and Zoom Out buttons to adjust the volume:
 - Increase volume: Press the Zoom In button.
 - Decrease volume: Press the Zoom Out button.
- Exit the show. You have these options in addition to pausing the show and choosing Exit:
 - To return to full-frame, regular playback, press the Playback button.
 - To return to the Playback menu, press the Menu button.
 - *To return to picture-taking mode,* press the shutter button halfway.
- Skip to the next/previous image manually. Press the Multi Selector right or left or rotate the Command dial.
- Change the information displayed with the image. Press the Multi Selector up or down to cycle through the info-display modes. (See the earlier section "Viewing Picture Data" for details on what information is provided in each mode.) This trick works only for still photos; movies are always played without any on-screen data.

168

Viewing Your Photos and Movies on a Television

Your camera is equipped with a feature that allows you to play your pictures and movies on a television screen. In fact, you have three playback options:

Regular (standard definition) video playback: Haven't made the leap yet to HDTV? No worries: You can set the camera to send a regular standard-definition audio and video signal to the TV. The cable you need is even provided in the D3200 camera box. (Look for the cable that has a yellow plug and a white plug at one end.)

One hang-up to note about this option: For movies, the audio playback is monaural, even if you record sound using an external stereo microphone.

HDMI playback: If you have a high-definition television, you need to purchase an HDMI cable to connect the camera and television. You need a Type C mini-pin HD cable; prices start at about \$20. Nikon doesn't make its own cable, so just look for a quality third-party version.

By default, the camera decides the proper video resolution to send to the TV after you connect the two devices. But you have the option of setting a specific resolution as well. To do so, select HDMI from the Setup menu, press OK, and then choose Output Resolution, as shown in Figure 5-38. Press the Multi Selector right to access the available settings.

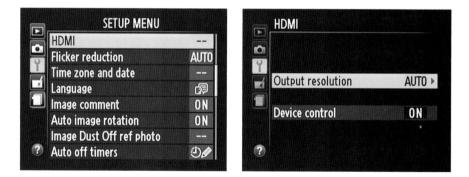

Figure 5-38: Select options for HD playback here.

✓ For HDMI CEC TV sets: If your television is compatible with HDMI CEC, your D3200 enables you to use the buttons on the TV's remote control to perform the functions of the OK button and Multi Selector during

full-frame picture playback and slide shows. To make this feature work, you must enable it via the Setup menu. Again, start with the HDMI option, but this time, select Device Control and set the option to On.

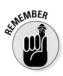

You need to make one final preflight check before connecting the camera and television: Verify the status of the Video Mode setting, also found on the Setup menu. You have just two options: NTSC and PAL. Select the video mode used by your part of the world. (In the United States, Canada, and Mexico, NTSC is the standard.) The mode should've been set at the factory to the right option for the country in which you bought your camera, but it never hurts to check.

After you select the necessary Setup menu options, grab your video cable, turn off the camera, and open the little rubber door on the left side of the camera. There you find two *ports* (connection slots): one for a standard audio/video (A/V) cable and one for the HDMI cable. Figure 5-39 labels the two ports.

The smaller plug on the A/V cable attaches to the camera. The yellow plug goes into your TV's video jack, and the white one goes into your TV's audio jack. For HDMI playback, a single plug goes to the TV.

At this point, I need to point you to your specific TV manual to find out exactly which jacks to use to connect your camera. You also need to consult your manual to find out which channel to select for playback of signals from auxiliary input devices. Then just turn on your camera to send the signal to the TV set. If you don't have the latest and greatest HDMI CEC capability (or you've lost your remote), control playback by using the same techniques as you normally do to view pictures on your camera monitor.

Figure 5-39: The video-out ports are under the little rubber door on the side of the camera.

You can also run a slide show by following the steps outlined in the preceding section.

Part II: Working with Picture Files ____

Deleting versus formatting: What's the diff?

Chapter 1 introduces the Format Memory Card command, which lives on the Setup menu and erases everything on your memory card. What's the difference between erasing photos by formatting and by choosing Delete from the Playback menu and then selecting the All option?

Well, if you happen to have stored other data on the card, such as, say, a music file or a picture taken on another type of camera, you need to format the card to erase those files. You can't use Delete to get rid of them. Also keep in mind that the Delete function affects only the currently selected folder of camera images. The section "Choosing which images to view," earlier in this chapter, talks more about this issue; Chapter 11 explains how to create custom folders.

One final — and important — note: Although using the Protect feature (explained elsewhere in this chapter) prevents the Delete function from erasing a picture, formatting erases all pictures, protected or not.

170

Downloading, Printing, and Sharing Your Photos

In This Chapter

- Choosing photo software
- Transferring pictures to your computer using Nikon ViewNX 2
- ▶ Processing Raw (NEF) files
- > Taking steps to ensure great print quality
- Preparing your photos for online sharing

For many novice digital photographers, the task of moving pictures to the computer is one of the more confusing aspects of the art form. Unfortunately, providing you with detailed downloading instructions is impossible because the steps vary widely depending on which computer software you use to do the job.

To give you as much help as I can, however, this chapter starts with a quick review of photo software, in case you aren't happy with your current solution. Following that, you can find information about downloading images, converting pictures that you shoot in the Raw format to a standard format, and preparing your pictures for print and online sharing.

Choosing the Right Photo Software

Programs for downloading, archiving, and editing digital photos abound, ranging from entry-level software designed for beginners to high-end options geared to professionals. The good news is that if you don't need serious photo-editing capabilities, you may find a free program that serves your needs — in fact, your camera ships with one free program, Nikon ViewNX 2.

The next section offers a look at Nikon ViewNX 2 along with two other freebies; following that, I offer some advice on a few popular programs to consider when the free options don't meet your needs.

Three free photo programs

If you don't need to do much retouching or other manipulation of your photos but simply want a tool for downloading and organizing pictures, one of the following free programs may be a good solution:

✓ Nikon ViewNX 2: This program is on the CD that shipped in your camera box. (You also can download the program from the support section of the Nikon web site.) As the name implies, the program provides a simple photo organizer and viewer, plus a few basic photo-editing features, including red-eye removal and exposure and color adjustment filters. You also can use the program to download pictures and to convert Raw files to a standard format. (See Chapter 2 for a primer on file formats.) I show you how to accomplish both tasks later in this chapter.

Figure 6-1 offers a look at the ViewNX 2 window as it appears when you use the Thumbnail Grid view mode, one of three display options available from the View menu.

After you download your photos, you can view camera *metadata* — the data that records the camera settings you used to take the picture — in ViewNX 2. Just display the Metadata panel, located on the right side of the program window, as shown in Figure 6-1. (If the panel is hidden, click the little triangle on the far right side of the window and then click the triangle at the top of the panel. I labeled both controls in the figure.) Many other photo programs also display metadata, but sometimes can't reveal data that's very camera specific, such as the Picture Control setting. Every camera manufacturer records metadata differently, and the Raw data structure may vary even among cameras from the same manufacturer, so it's a little difficult for software companies to keep up with each new model.

ViewNX 2 offers another cool feature that most other browsers don't: By clicking the Focus Point button, labeled in Figure 6-1, you can display a little red rectangle that indicates which focus point the camera used to establish focus for the shot, which can be helpful when you're trying to troubleshoot focus problems. You don't see the point if you used manual focusing when taking the shot, however, or if you used continuous autofocusing.

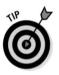

- Apple iPhoto: Most Mac users are very familiar with this photo browser, built into the Mac operating system. Along with downloading and organizing tools, the current version of iPhoto offers a collection of basic photo editing tools. Apple provides some great tutorials on using iPhoto at its website (www.apple.com) to help you get started.
- Windows Live Photo Gallery: Some versions of Microsoft Windows also offer a free photo downloader and browser, Windows Live Photo Gallery (the name varies depending on your version of Windows). Like the other two free programs, the current version of this program also offers some simple photo-editing tools.

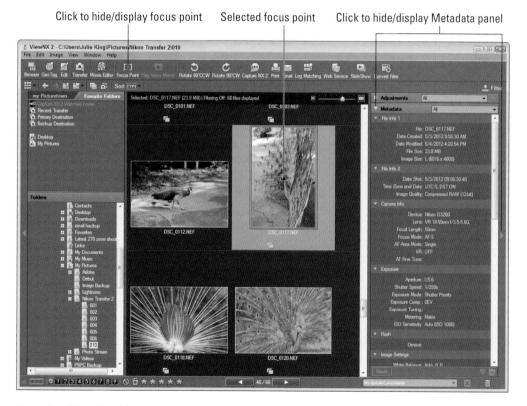

Figure 6-1: Nikon ViewNX 2 offers a basic photo viewer and some limited editing functions.

Part II: Working with Picture Files

Installing Nikon ViewNX 2

If you want to use the free Nikon software, Nikon ViewNX 2, to download, view, and organize your photos, first check your computer system specifications. In order to run the program successfully, Nikon suggests that you use one of the following computer operating systems:

- Windows 7 with Service Pack 1, Vista with Service Pack 2, or XP with Service Pack 3 (Home or Professional edition). The program may run as a 32-bit application in 64-bit installations of Windows 7 and Windows Vista. It's not compatible with the 64-bit version of Windows XP.
- Mac OS X 10.5.8, 10.6.7, or 10.7.2

If you use another OS (operating system, for the nongeeks in the crowd), check the support

pages on the Nikon website (www.nikon. com) for the latest news about any updates to system compatibility.

Also note that this book features Nikon ViewNX 2 version 2.3.2. If you own an earlier version of the program, visit the Nikon website to install the updates. (To find out what version you have installed, open the program. Then, in Windows, choose Helpt About. On a Mac, choose the About command from the ViewNX 2 menu.) You also may be able to use the built-in software updater, depending on the age of your software. Open the program and choose Helpt Check for Updates to give it a go. The updater offers a link to the software download page if it finds a more current version of the program.

Advanced photo programs

Programs mentioned in the preceding section can handle simple photo downloading and organizing tasks as well as basic photo retouching — cropping, fixing red eye, and the like. But if you're interested in serious photo retouching or digital-imaging artistry, you need to step up to a full-fledged photoediting program.

As with software in the free category, you have many choices; the following list describes just the most widely known programs.

Adobe Photoshop Elements: Elements has been the best-selling consumer-level photo-editing program for some time, and for good reason. With a full complement of retouching tools, onscreen guidance for beginners, and an assortment of templates for creating photo projects like scrapbooks, Elements offers all the features that most consumers need. Figure 6-2 shows the Elements editing window with some of the photo-creativity tools displayed to the right of the photo. The program includes a photo organizer as well, along with built-in tools to help you print your photos and upload them to photo-sharing sites. (www.adobe.com, about \$100)

174

Chapter 6: Downloading, Printing, and Sharing Your Photos

Figure 6-2: Adobe Photoshop Elements offers good retouching tools plus templates for creating scrapbooks, greeting cards, and other photo gifts.

- ✓ Nikon Capture NX 2: Shown in Figure 6-3, this Nikon program offers an image browser/organizer plus a wealth of photo-editing tools, including a sophisticated tool for processing Raw images. But as you can see from the figure, it's not exactly geared to casual photographers or novice photo editors, so expect a bit of a learning curve. Nor does this program offer the sort of photo-creativity tools you find in a program like Photoshop Elements (the same is true for the other advanced tools described in this list). (www.nikon.com, about \$180)
- Apple Aperture: Aperture is geared more to shooters who need to organize and process lots of images but typically do only light retouching work wedding photographers and school-portrait photographers, for example. (www.apple.com, about \$80 when purchased through the Mac App store.)
- Adobe Photoshop Lightroom: Lightroom is the Adobe counterpart to Aperture, although in its latest version, it offers some fairly powerful retouching tools as well. Many pro photographers rely on this program for all their work, in fact. (www.adobe.com, about \$300)

176 Part II: Working with Picture Files _____

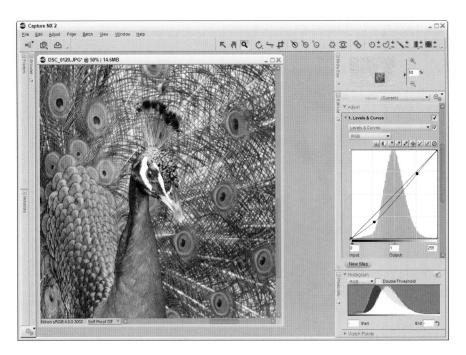

Figure 6-3: Nikon Capture NX 2 may appeal to photographers who need more robust imageediting tools than are found in ViewNX 2.

Adobe Photoshop: The granddaddy of photo editors, Photoshop offers the industry's most powerful, sophisticated retouching tools, including tools for producing HDR (high dynamic range) and 3D images. In fact, you probably won't use even a quarter of the tools in the Photoshop shed unless you're a digital imaging professional who uses the program on a daily basis — even then, some tools may never see the light of day. (www.adobe.com, about \$700)

Not sure which tool you need, if any? Good news: You can download free trials of all these programs from the manufacturers' websites.

Sending Pictures to the Computer

Whatever photo software you choose, you can take the following approaches to downloading images to your computer:

Connect the camera to the computer via a USB cable. The USB cable you need is supplied in the camera box. Use a memory card reader. With a card reader, you simply pop the memory card out of your camera and into the card reader instead of hooking the camera to the computer. Many computers and printers now have card readers, and you also can buy standalone readers for less than \$30. *Note:* If you use the new SDHC (Secure Digital High Capacity) or SDXC (Secure Digital eXtended Capacity) cards, the reader must specifically support that type.

For most people, I recommend a card reader. Sending pictures directly from the camera requires that the camera be turned on during the entire download process, wasting battery power. That said, I include information about cable transfer in the next section in case you don't have a card reader. To use a card reader, skip ahead to "Starting the transfer process," in this chapter.

You do also have the option of shooting with Eye-Fi memory cards, which enable wireless transfer to a computer. I don't cover this product, but you can read more about it at www.eye.fi.

Connecting the camera and computer for picture download

With the USB cable that shipped with your camera, you can connect the camera to your computer and then transfer images directly to the computer's hard drive. (Be sure to use the right cable: It's the one *without* the yellow and white plugs at the end. That one is for connecting your camera to a television, as explained at the end of Chapter 5.)

The next section explains the actual transfer process; the steps here just walk you through the process of connecting the two devices. You need to follow a specific set of steps when connecting the camera to your computer. Otherwise you can damage the camera or the memory card.

Here are the steps to link your computer and camera:

1. Check the level of the camera battery.

If the battery is low, charge it before continuing. Running out of battery power during the transfer process can cause problems, including lost picture data. Alternatively, if you purchased the optional AC adapter, use that to power the camera during picture transfers.

- 2. Turn on the computer and give it time to finish its startup routine.
- 3. Turn off the camera.
- 4. Insert the smaller of the two plugs on the USB cable into the USB port on the side of the camera.

Look under the rubber door on the side of the camera for this port. Figure 6-4 identifies the USB port.

5. Plug the other end of the cable into the computer's USB port.

If possible, plug the cable into a port that's built in to the computer, as opposed to one that's on your keyboard or part of an external USB hub. Those accessory-type connections can sometimes foul up the transfer process.

6. Turn on the camera.

What happens now depends on your computer operating system and what photo software you have installed on that system. The next section explains the possibilities and how to proceed with the image transfer process.

7. When the download is complete, turn off the camera and then disconnect it from the computer.

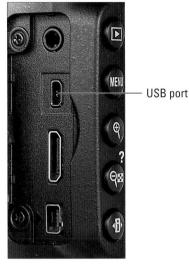

Figure 6-4: The USB port is hidden under the rubber door on the side of the camera.

I repeat: Turn off the camera before

severing its ties with the computer. Otherwise you can damage the camera.

Starting the transfer process

After you connect the camera to the computer or insert a memory card into your card reader, your next step depends, again, on the software installed on your computer and the computer operating system.

Here are the most common possibilities and how to move forward:

✓ On a computer running Windows 7, a Windows message box similar to the one in Figure 6-5 appears. The figure shows the dialog box as it appears on a computer running Windows 7. By default, clicking the Import Pictures and Videos icon starts image transfer using Windows picture-transfer utility, but you can click the Change program link to choose Nikon ViewNX 2 or some other program as your preferred transfer tool.

In older versions of Windows, typically you see a dialog box listing all the installed programs that can handle the transfer; click the one you want to use.

Chapter 6: Downloading, Printing, and Sharing Your Photos

Figure 6-5: Windows 7 may display this initial boxful of transfer options.

An installed photo program automatically displays a photo-download wizard. For example, the Nikon Transfer 2 downloader or a downloader associated with Adobe Photoshop Elements, iPhoto, or some other photo software may leap to the forefront. Usually, the downloader that appears is associated with the software that you most recently installed. Each new program that you add to your system tries to wrestle control over your image downloads away from the previous program.

If you don't want a program's auto downloader to launch whenever you insert a memory card or connect your camera (or other device that holds photos, such as an Apple iPod Touch), you can turn off that feature. Check the software manual to find out how to disable the auto launch.

Special note to Mac users: For Nikon Transfer 2, you call off the auto downloader via iPhoto, *not* through Nikon Transfer 2 preferences. Look for the setting named Connecting Camera Opens, found on the General panel of the iPhoto Preferences dialog.

✓ Nothing happens. Don't panic; assuming that your card reader or camera is properly connected, all is probably well. Someone simply may have disabled all the automatic downloaders on your system. Just launch your photo software and then transfer your pictures using whatever command starts that process.

As another option, you can use Windows Explorer or the Mac Finder to drag and drop files from your memory card to your computer's hard drive. You connect the card through a card reader, the computer sees the card as just another drive on the system. Windows Explorer also shows the camera as a storage device when you cable the camera directly to the computer. So the process of transferring files is exactly the same as when you move any other file from a CD, DVD, or other storage device onto your hard drive. (With some versions of the Mac OS, including the most recent ones, the Finder doesn't recognize cameras in this way.)

In the next section, I provide details on using Nikon ViewNX 2 to download your files. If you use some other software, the concepts are the same, but check your program manual to get the small details. In most programs, you also can find lots of information by simply clicking open the Help menu.

Downloading using ViewNX 2

Built into ViewNX 2 is a handy image-downloading tool called Nikon Transfer 2. A couple tips about using this software:

- ✓ ViewNX 2 is the best option for camera-to-computer transfers on a Mac. The Mac operating system doesn't recognize the camera when you attach the two devices via USB cable, but if you install ViewNX 2, the transfer utility does detect the camera. In fact, you can select an option when installing ViewNX 2 that forces Nikon Transfer 2 to spring to life as soon as you connect and power up the camera. (Again, turn off that feature via iPhoto if you later decide you don't like it.)
- ✓ You can use Nikon ViewNX 2 to download your photos and still use any photo-editing or image-management software you prefer. And to do your editing, you don't need to download photos a second time after you transfer photos to your computer, you can access them from any program, just as you can any file that you put on your system. With some programs, however, you must first take the step of *importing* or *cataloging* the photo files, which enables the program to build thumbnails and, in some cases, working copies of your pictures.

With that preamble out of the way, the following steps walk you through the process of downloading via Nikon ViewNX 2:

1. Attach your camera to the computer or insert a memory card into your card reader, as outlined in the first part of this chapter.

Depending on what software you have installed on your system, you may see a dialog box asking you how to download your photos. If the window that appears is the Nikon Transfer 2 window, shown in Figure 6-6, skip to Step 3.

Similarly, if you see a Windows dialog box that contains the Nikon Transfer 2 option, click that option and skip to Step 3.

If nothing happens, don't worry — just travel to Step 2, which shows you how to launch the Nikon Transfer 2 software if it didn't appear automatically.

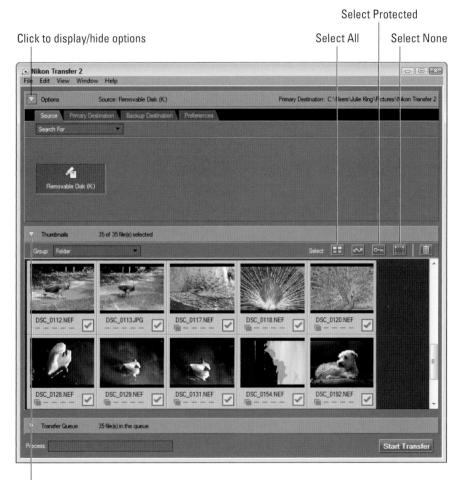

Click to display/hide thumbnails

Figure 6-6: Select the check boxes of the images that you want to download.

2. Launch Nikon Transfer 2, if it isn't already open.

To access the transfer tool, open Nikon ViewNX 2 and then choose File Launch Transfer or click the Transfer button at the top of the window. The window shown in Figure 6-6 appears. (If you use a Mac, the window decor is slightly different, but the main controls and features are the same.)

3. Display the Source tab to view thumbnails of your pictures, as shown in the figure.

Don't see any tabs? Click the little Options triangle, located near the top-left corner of the window and labeled in Figure 6-6, to display them. Then click the Source tab. The icon representing your camera or memory card should be selected, as shown in the figure. If not, click the icon.

Thumbnails of your images appear in the bottom half of the dialog box. If you don't see the thumbnails, click the arrow labeled in Figure 6-6 to open the thumbnails area.

4. Select the images that you want to download.

A check mark in the little box under a thumbnail tells the program that you want to download the image. Click the box to toggle the check mark on and off.

Here are a few tips to speed up this part of the process:

- *Select protected images only:* If you used the in-camera function to protect pictures (see Chapter 5), you can select just those images by clicking the Select Protected icon, labeled in Figure 6-6.
- *Select all images:* Just click the Select All icon, also labeled in the figure.
- *Select no images:* Click the Select None icon. (Use this trick if you accidentally select all photos and don't want to import all of them.)
- *Select a group of images:* To select a batch of consecutive images, click the first one in the group and then hold down the Shift key as you click the last one. All the thumbnails become selected, and checking or unchecking the box under one thumbnail affects the entire group.

To select a batch of images that aren't consecutive, click the first one and then Ctrl+click (Windows) or \Re -click (Mac) the others. That is, hold down the Ctrl or \Re key as you click a thumbnail.

5. Click the Primary Destination tab at the top of the window.

When you click the tab, the top of the transfer window offers options that enable you to specify where and how you want the images to be stored on your computer. Figure 6-7 offers a look.

6. Choose the folder where you want to store the images from the Primary Destination Folder drop-down list.

Chapter 6: Downloading, Printing, and Sharing Your Photos

Choose a st	orage folder	
Nikon Transfer 2 File Edit View Window Help		- 0 ×
✓ Options Source:	Removable Disk (K:)	Primary Destination: C:\Users\Julie King\Pictures\Nikon Transfer 2
Source Primary Destination	Backup Destination Preferen	ices
Primary destination folder:	O Create subfolder f	for each transfer
C:\\Pictures\Nikon Transfer 2	010 Use subfolder v	with same name if it exists
	Choose subfolder Destination folder	
	Don't use subfold	ler
	Copy folder names	s from camera

Figure 6-7: Specify the folder where you want to put the downloaded images.

The list is labeled in Figure 6-7. If the folder you want to use isn't in the list, open the drop-down list, choose Browse from the bottom of the list, and then track down the folder and select it.

By default, the program puts images in a Nikon Transfer folder, which is housed inside the My Pictures folder in Windows XP and Pictures in Windows 7, Windows Vista, and on a Mac. That My Pictures or Pictures folder is housed inside a folder that your system creates automatically for each registered user of the computer.

You don't have to stick with this default location — you can put your pictures anywhere you please. But because most photo programs automatically look for pictures in these standard folders, putting your pictures there simplifies things a little down the road. You can always move your pictures into other folders after you download them if needed, too.

7. Specify whether you want the pictures to be placed inside a new subfolder.

In the center portion of the dialog box, you get these secondary storagefolder options:

• *Create Subfolder for Each Transfer*. The program creates a new folder inside the storage folder you selected in Step 6. Then it puts all the pictures from the current download session into that new subfolder. You can either use the numerical subfolder name

the program suggests or click the Edit button to set up your own naming system. You might find it helpful to go with a folder name that includes the date that the batch of photos was taken, for example. You can reorganize your pictures into this type of setup after download, however.

- Use Subfolder with Same Name if it Exists: If the folder shown in the Create Subfolder box already exists, select this box to avoid overwriting existing photo files. The program automatically assigns new filenames to the downloaded photos if the folder contains images that have the same filenames as the downloading ones.
- *Choose Subfolder Under Primary Destination Folder*. If you don't want to create a new folder but put images into the existing subfolder under the primary folder, select this option. For example, if the primary folder is Pictures and the secondary folder is Nikon Transfer 2, as shown in Figure 6-7, your photos go into that Nikon Transfer 2 folder.
- *Don't Use Subfolder:* Pictures go into the primary folder (Pictures, in the example shown in Figure 6-7).
- *Copy Folder Names from Camera:* As one final alternative, select the Copy Folder Names from Camera box if you want the program to retain the folder structure of the camera memory card. For example, if you stick with the default camera folder structure, your pictures appear in a folder named 100D3200. That folder is placed inside whatever folder or subfolder you select via the other options.

Yowsa. Don't ever say the program developers didn't want you to have plenty of storage-folder flexibility.

8. Tell the program whether you want to rename the picture files during the download process.

If you do, select the Rename Files during Transfer check box. Then click the Edit button to display a dialog box where you can set up your new filenaming scheme. Click OK after you do so to close the dialog box.

9. Set a backup destination (optional).

This option is great for users who back up photos to a secondary hard drive. You can download your photos to your primary image-storage drive and to the backup at the same time. To take advantage of this feature, click the Backup Destination tab, select the Backup Files box, and then use the other panel options to specify where you want the files to go.

10. Click the Preferences tab to set the rest of the transfer options.

The tab shown in Figure 6-8 takes over the top of the program window. Here you find a number of options that enable you to control how the program operates, as follows:

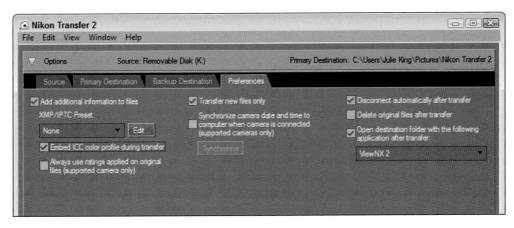

Figure 6-8: Control other aspects of the program's behavior via the Preferences tab.

• *Add Additional Information to Files:* Through this option, you can embed XMP/IPTC data in the file. *IPTC* refers to text data that press photographers are often required to tag onto their picture files, such as captions and copyright information. *XMP* refers to a data format developed by Adobe to enable that kind of data to be added to the file. IPTC stands for International Press Telecommunications Council; XMP stands for Extensible Metadata Platform.

Click the Edit button beneath the option to create and store a preset that contains the data you want to add. On your next visit to the dialog box, you can choose the preset from the drop-down list above the Edit button.

You also can tag a file with text comments in the camera, using the Image Comment feature that I cover in Chapter 11.

- *Embed ICC Color Profile during Transfer*: This option relates to the Color Space option on the Shooting menu. Nikon recommends that you enable this option if you capture images using the Adobe RGB color space instead of the default, sRGB space. Otherwise some photo programs may simply assume that the files are in the sRGB space. Chapter 8 explains the Color Space setting.
- Always use ratings applied on original files: This option doesn't apply to the D3200; it's there for users of cameras that offer a photo-rating feature.
- *Transfer New Files Only:* This option, when selected, ensures that you don't waste time downloading images that you've already transferred but are still on the memory card.
- *Synchronize Camera Date and Time* . . . : If you connect your camera to the computer via USB cable, selecting this option tells the camera to reset its internal clock to match the date and time of the computer.

Part II: Working with Picture Files

- *Disconnect Automatically after Transfer:* Choose this option to tell the transfer tool to sever the connection between the computer and the camera or memory card reader automatically when the download is complete.
- *Delete Original Files after Transfer:* Turn off this option, as shown in Figure 6-8. Otherwise your pictures are automatically erased from your memory card when the transfer is complete. Always make sure the pictures really made it to the computer before you delete them from your memory card. (See Chapter 5 to find out how to use the Delete function on your camera.)
- Open Destination Folder with the Following Application after Transfer: You can tell the program to immediately open your photo program after the transfer is complete. Choose ViewNX 2, as shown in the figure, to view, organize, and edit your photos using that program. To choose another program, open the drop-down list, choose Browse, and select the program from the dialog box that appears. Click OK after doing so.

Your choices remain in force for any subsequent download sessions, so you don't have to revisit this tab unless you want the program to behave differently.

11. When you're ready to start the download, click the Start Transfer button.

It's located in the lower-right corner of the program window. (Refer to Figure 6-6.) After you click the button, the Process bar in the lower-left corner indicates how the transfer is progressing. Again, what happens when the transfer completes depends on the choices you made in Step 10; if you selected Nikon ViewNX 2 as the photo program, it opens and displays the folder that contains your just-downloaded images.

Wireless transfer with the WU-1a

With the optional Nikon WU-1a wireless mobile adapter, you can transfer photos over a Wi-Fi connection from your camera to some smart phones and tablets. The idea is to make it easy for you to e-mail photos or upload them to Facebook and other social-networking sites without having to bother with downloading the images to your computer first. You also can use the smart phone or device to control some camera functions. The unit itself plugs into the camera's USB port, which lives under the little rubber cover on the side of the camera.

At present, this option works only with specific devices; you can get details at the Nikon website (www.nikonusa.com). The cost for the unit as I write this is about \$60.

Processing Raw (NEF) Files

Chapter 2 introduces you to the Raw file format. The advantage of capturing Raw files, or NEF files on Nikon cameras, is that you make the decisions about how to translate the original picture data into an actual photograph. You can specify attributes such as color intensity, image sharpening, contrast, and so on — which are all handled automatically by the camera if you use its other file format, JPEG. You take these steps by using a software tool known as a *Raw converter*.

The bad news: Until you convert your NEF files into a standard file format, you can't share them online or print them from most programs other than Nikon ViewNX 2. You also can't get prints from most retail outlets or open them in many photo-editing programs.

To process your NEF files, you have the following options:

- ✓ Use the in-camera processing feature. Through the Retouch menu, you can process your Raw images right in the camera. You can specify only limited image attributes, and you can save the processed files only in the JPEG format, but still, having this option is a nice feature.
- Process and convert in ViewNX 2. ViewNX 2 also offers a Raw processing feature. Again, the controls for setting picture characteristics are a little limited, but you can save the adjusted files in either the JPEG or TIFF format. See the next section for an explanation of TIFF.
- ✓ Use Nikon Capture NX 2 or a third-party Raw conversion tool. For the most control over your Raw images, you need to open your wallet and invest in a program that offers a truly capable converter. See the first part of this chapter for a review of Capture NX 2 as well as some other programs with good Raw converters.

The next two sections show you how to convert Raw files using your camera and ViewNX 2. If you opt for a third-party conversion tool, check the program's Help system for details on how to use the various controls, which vary from program to program.

Processing Raw images in the camera

Through the NEF (RAW) Processing option on the Retouch menu, you can convert Raw files right in the camera — no computer or other software required. I want to share two reservations about this option, however:

✓ You can save your processed files only in the JPEG format. As discussed in Chapter 2, that format results in some quality loss because of the file compression that JPEG applies. You can choose the level of JPEG compression you want to apply during Raw processing; you can create a JPEG Fine, Normal, or Basic file. Each of those settings produces the same quality that you get when you shoot new photos in the JPEG format and select Fine, Normal, or Basic from the Image Quality menu.

Chapter 2 details the JPEG options, but, long story short, choose Fine for the best JPEG quality. And if you want to produce the absolute best quality from your Raw images, use a software solution and save your processed file in the TIFF format instead. *TIFF* is a *lossless* format, which means that all original image quality is retained. TIFF is the publishing industry's standard format, so almost every photo program can open TIFF files.

✓ You can make adjustments to exposure, color, and a few other options as part of the in-camera Raw conversion process. Evaluating the effects of your adjustments on the camera monitor can be difficult because of the size of the display compared to your computer monitor. So for really tricky images, you may want to forgo in-camera conversion and do the job on your computer, where you can get a better — and bigger — view of things. If you do go the in-camera route, make sure that the monitor brightness is set to its default position so that you aren't misled by the display. (The Monitor Brightness adjustment option is found on the Setup menu.)

That said, in-camera Raw processing offers a quick and convenient solution when you need JPEG copies of your Raw images for immediate online sharing — JPEG is the standard format for online use — or to share with someone who doesn't have photo software that can handle Raw images. And you can always process the image once on the camera and then create a second version after downloading files to your computer — the original NEF image is always maintained, so you can create as many processed variations as you like.

Follow these steps to get the job done:

- 1. Press the Playback button to switch to playback mode.
- 2. Display the picture you want to process in the single-image (full-frame) view.

If necessary, you can shift from thumbnails view to single-image view by just pressing OK. Chapter 5 has more playback details.

3. Press OK.

The Retouch menu then appears atop your photo, as shown in Figure 6-9.

- 4. Use the Multi Selector to scroll to the NEF (RAW) Processing option, as shown in Figure 6-9.
- 5. Press OK to display your processing options, as shown in Figure 6-10.

This screen is "command central" for specifying what settings you want the camera to use when creating the JPEG version of your Raw image.

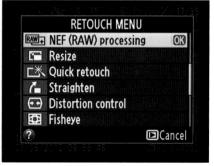

6. Set the conversion options.

Along the right side of the screen, your photo. you see a vertical column offering

Figure 6-9: In single-image playback mode, press OK to display the Retouch menu over your photo.

the conversion options labeled in Figure 6-10. To establish the setting for an option, highlight it and then press the Multi Selector right. You then see the available settings for the option. For example, if you choose the Exposure Compensation option, you see the screen shown in Figure 6-11. Use the Multi Selector to adjust or highlight the setting you want to use and press OK to return to the main Raw conversion screen. Or, if a triangle appears to the right of an option name, you can press the Multi Selector right to uncover additional options. For example, pressing the Multi Selector right after choosing one of the White Balance settings takes you to a screen where you can fine-tune the setting, just as you can when adjusting White Balance during shooting. (Chapter 8 explains that feature.)

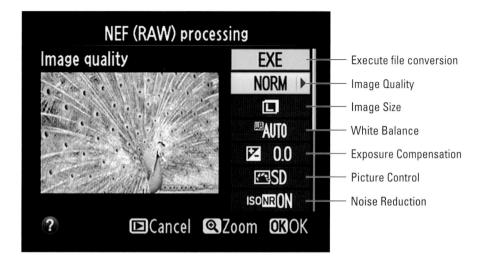

Figure 6-10: Specify Raw conversion settings here.

Rather than detailing all the options here, the following list points you to the chapter where you can explore the settings available for each:

- *Image Quality:* See the Chapter 2 section related to the JPEG quality settings for details on this option. Choose Fine to retain maximum picture quality.
- *Image Size:* Chapter 2 explains this one, too. Choose Large to retain all the original image pixels.

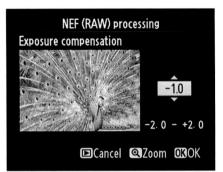

Figure 6-11: After selecting the Exposure Compensation option on the main NEF processing screen, press OK to access the available settings.

- *White Balance:* Check out Chapter 8 for details about White Balance options, which affect picture colors. Unless colors look off, stick with Auto.
- *Exposure Compensation:* With this option, you can adjust image brightness by applying Exposure Compensation, a feature that I cover in Chapter 7. For my peacock photo, I darkened the image by using an Exposure Compensation of EV –1.0, for example. When using this feature, you're limited to a range of –2.0 and +2.0; when shooting, you can choose from settings ranging from –5.0 to +5.0.
- *Picture Control:* This option enables you to adjust color, contrast, and image sharpness. For a review of the available settings, see the last part of Chapter 8.
- *ISO Noise Reduction:* See Chapter 7 for an explanation of this feature, which is designed to reduce the amount of noise in pictures shot using a high ISO Sensitivity setting.

7. When you finish setting all the conversion options, highlight EXE on the main conversion screen (refer to Figure 6-10) and then press OK.

The camera records a JPEG copy of your Raw file and displays the copy in the monitor. To remind you that the image was created with the help of the Retouch menu, the top-left corner of the display sports the little Retouch icon, as shown in Figure 6-12. In addition, filenames of pictures created with the Retouch menu begin with the three-letter prefix CSC instead of the usual DSC (or _CSC, if you captured the original

in the Adobe RGB color space, as explained in Chapter 8). The camera assigns the next available file number to the image, so the number of the original and the number of the processed JPEG don't match.

Processing Raw files in ViewNX 2

In Nikon ViewNX 2, you can convert your Raw files to the JPEG format or, for top picture quality, to the TIFF format. Although the ViewNX 2 converter isn't as full-featured as the ones in Nikon Capture NX 2 and some other Retouch symbol

Figure 6-12: The Retouch symbol indicates that you created the picture file by using an option on the Retouch menu.

photo-editing programs, it does enable you to make some adjustments to your Raw images. Follow these steps to try it out.

1. Open ViewNX 2 and click the thumbnail of the image that you want to process.

You may want to set the program to Image Viewer mode, as shown in Figure 6-13, so that you can see a larger preview of your image. Just choose View Image Viewer to switch to this display mode. To give the photo even more room, also hide the Browser panel, which normally occupies the left third of the window, and the Filmstrip panel that usually runs across the bottom of the window. Choose Window Browser and Window Filmstrip to toggle those window elements on and off.

2. Display the Adjustments panel on the right side of the program window.

You can see the panel in Figure 6-13. Show and hide this panel and the Metadata panel by choosing Window Edit or by clicking the triangle on the far-right side of the window. You can then display and collapse the individual panels by clicking the triangles to the left of their names. (I labeled the triangles in the figure.) To allow the maximum space for the Raw conversion adjustments, collapse the Metadata panel, as shown in the figure. If necessary, drag the vertical bar between the image window and the Adjustments panel to adjust the width of the panel.

192 Part II: Working with Picture Files

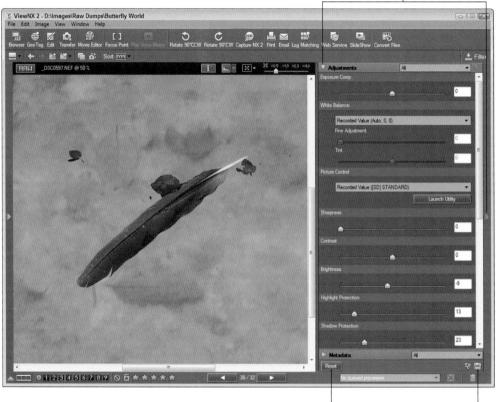

Click to hide/display Adjustments panel

Reset button Save button

Figure 6-13: Display the Adjustments panel to tweak Raw images before conversion.

3. To display all available image settings, choose All from the Adjustments drop-down list at the top of the panel, as shown in the figure.

Unless you use a large monitor, you may need to use the scroll bar on the right side of the panel to scroll the display to see all the options.

4. Use the panel controls to adjust your image.

The preview you see in the image window reflects the default conversion settings chosen by Nikon. But you can play with any of the settings as you see fit. If you need help understanding any of the options, open the built-in help system (via the Help menu), where you can find descriptions of how each adjustment affects your image.

To return to the original image settings, click the Reset button at the bottom of the panel, labeled in Figure 6-13.

5. Click the Save button at the bottom of the panel (refer to Figure 6-13).

This step stores your conversion settings as part of the image file but doesn't actually create your processed image file. Don't worry — your original Raw data remains intact; all that's saved with the file is a "recipe" for processing the image, which you can change at any time.

6. To save the processed file, choose File Convert Files.

Or just click the Convert Files button on the toolbar at the top of the program window. Either way, you see the Convert Files dialog box, shown in Figure 6-14.

Convert Files				X	
File Format: TIFF(8 Bit) -					
Original Image Size: 4288 x 2848 pixels					
Use LZW Compression					
Change the image size					
Long Edge:	4288	pixels -			
Short Edge:	2848	pixels _			
Remove camera setting information					
Remove XMP/IPTC information					
Remove ICC color profile					
Save in:					
\bigcirc The same folder as the original file					
Specified Folder					
C:\Users\Julie King\Pictures				Browse	
Create a new subfolder for each file conversion				Naming Options	
Change file names				Naming Options	
Total Number of Files: 1 Convert				4	

Figure 6-14: To retain the best image quality, save processed Raw files in the TIFF format.

7. Choose TIFF(8 Bit) from the File Format drop-down list.

TIFF (*tagged image file format*) is the best format because it retains your processed file at the highest image quality. (This format has long been the preferred format for print publication.) Don't choose JPEG; as explained in Chapter 2, the JPEG format applies *lossy compression*, thereby sacrificing some image quality. If you need a JPEG copy of your processed Raw image for online sharing — TIFF files won't work for that use — you can easily create one from your TIFF version by following the steps laid out near the end of this chapter.

As for the *8 Bit* part of the option name: A *bit* is a unit of computer data; the more bits you have, the more colors your image can contain. Although you can create 16-bit TIFF files in the converter, many photoediting programs either can't open them or limit you to a few editing tools, so I suggest you stick with the standard, 8-bit image option. Your image will contain more than enough colors, and you'll avoid potential conflicts caused by so-called *high-bit* images.

8. Deselect the Use LZW Compression option, as shown in the figure.

Although LZW compression reduces the file size somewhat and does not cause any quality loss, some programs can't open files that were saved with this option enabled. So turn it off.

9. Deselect the Change the Image Size check box.

This step ensures that you retain all the original pixels in your image, which gives you the most flexibility in terms of generating quality prints at large sizes. For details on this issue, check out the next section.

10. Deselect each of the three Remove check boxes.

If you select the check boxes, you strip image *metadata* — the extra text data that's stored by the camera — from the file. Unless you have some specific reason to do so, clear all three check boxes so that you can continue to access the metadata when you view your processed image in programs that know how to display metadata.

The first check box relates to data that you can view on the Metadata panel in ViewNX 2; the first section of the chapter gives you the low-down. The second box refers to the XMP/IPTC data that you can embed during file transfer; see the section "Downloading photos with Nikon ViewNX 2" for a discussion of that issue. The ICC profile item refers to the image *color space*, which is either sRGB or Adobe RGB. Chapter 8 explains the difference.

11. Select a storage location for the processed TIFF file.

You do this in the Save In area of the dialog box. Select the top option to save your processed file in the same folder as the original Raw file. Or, to put the file in a different folder, click the Specified Folder button. The name of the currently selected alternative folder appears below the button, as shown in Figure 6-14. You can change the storage destination by clicking the Browse button and then selecting the drive and folder where you want to put the file.

By selecting the Create a New Subfolder for Each File Conversion check box, you can put your TIFF file into a separate folder within the destination folder. If you select the box, click the Naming Options button and then specify how you want to name the subfolder.

12. Specify whether you want to give the processed TIFF a different filename from the original Raw image.

To do so, select the Change File Names check box, click the Naming Options button, and enter the name you want to use.

If you don't change the filename, the program gives the file the same name as the original Raw file. But you don't overwrite that Raw file because you're storing the copy in a different file format (TIFF). In Windows, the filename of the processed TIFF image has the three-letter extension TIF.

13. Click the Convert button.

A window appears to show you the progress of the conversion process. When the window disappears, your TIFF image appears in the storage location you selected in Step 11.

One neat thing about working with Raw images is that you can easily create as many variations of your photo as you want. For example, you might choose one set of options when processing your Raw file the first time and then use an entirely different set to create another version of the photo. Just be sure to give each processed file a unique name so that you don't overwrite the first TIFF file you create with your second version.

Planning for Perfect Prints

Images from your Nikon D3200 can produce dynamic prints, and getting those prints made is easy and economical, thanks to an abundance of digital printing services in stores and online. For home printing, today's printers are better and less expensive than ever, too. That said, getting the best prints from your picture files requires a little bit of knowledge and prep work on your part, whether you decide to do the job yourself or use a retail lab. To that end, the next three sections offer tips to help you avoid the most common causes of printing problems.

Check the pixel count before you print

Resolution — the number of pixels in your digital image — plays a huge role in how large you can print your photos and still maintain good picture quality. You can get the complete story on resolution in Chapter 2, but here's a quick recap as it relates to printing:

Choose the right resolution before you shoot: Set resolution via the Image Size option, found on the Shooting menu.

You must select the size *before* you capture an image, which means that you need some idea of the ultimate print size before you shoot. When you do the resolution math, remember to take any cropping you plan to do into account.

✓ Aim for a minimum of 200 pixels per inch (ppi): You'll get a wide range of recommendations on this issue, even among professionals. But in general, if you aim for a resolution in the neighborhood of 200 ppi, you should be pleased with your results. If you want a 4-x-6-inch print, for example, you need at least 800 x 1200 pixels.

Depending on your printer, you may get even better results at a slightly lower resolution. On the other hand, some printers do their best work when fed 300 ppi, and a few request 360 ppi as the optimum resolution. However, using a resolution higher than that typically doesn't produce any better prints.

Unfortunately, because most printer manuals don't bother to tell you what image resolution produces the best results, finding the right pixel level is a matter of experimentation. (Don't confuse *ppi* with the manual's statements related to the printer's dpi. *Dots per inch (dpi)* refers to the number of dots of color the printer can lay down per inch; many printers use multiple dots to reproduce one image pixel.)

If you're printing photos at a retail kiosk or at an online site, the software you use to order prints should determine the resolution of your files and then suggest appropriate print sizes. If you're printing on a home printer, though, you need to be the resolution cop.

What do you do if you don't have enough pixels for the print size you have in mind? You have the following two choices, neither of which provides a good outcome:

- ✓ Keep the existing pixel count and accept lowered photo quality. In this case, the pixels simply get bigger to fill the requested print size. When pixels grow too large, they produce a defect known as *pixelation*. The picture starts to appear jagged, or stairstepped, along curved or oblique lines. Or, at worst, your eye can make out the individual pixels, and your photo begins to look more like a mosaic than, well, like a photograph.
- Add more pixels and accept lowered photo quality. In some photo programs, you can add pixels to an image (the technical term for this process is *upsampling*). Some other photo programs even upsample the photo automatically for you, depending on the print settings you choose.

Although adding pixels might sound like a good option, it actually doesn't help in the long run. You're asking the software to make up photo information out of thin air, and the resulting image usually looks worse than the original. You don't see pixelation, but details turn muddy, giving the image a blurry, poorly rendered appearance.

Just to hammer home the point and remind you again of the impact of resolution on picture quality, Figures 6-15 through 6-17 show you the same image as it appears at 300 ppi (the resolution required by the publisher of this book), at 50 ppi, and then resampled from 50 ppi to 300 ppi. As you can see, there's just no way around the rule: If you want the best-quality prints, you need the right pixel count from the get-go.

300 ppi

Figure 6-15: A high-quality print depends on a high-resolution original.

Allow for different print proportions

The D3200 produces images that have a 3:2 aspect ratio, which matches the proportions of a 4-x-6-inch print. To print your photo at other traditional sizes — 5×7 , 8×10 , and so on — you need to crop the photo to match those proportions. Alternatively, you can reduce the photo size slightly and leave an empty margin along the edges of the print as needed.

As a point of reference, both images in Figure 6-18 are original, 3:2 images. The red outlines indicate how much of the original can fit within a 5-x-7-inch frame and an 8-x-10-inch frame, respectively.

Part II: Working with Picture Files $_$

50 ppi

Figure 6-16: At 50 ppi, the image has a jagged, pixelated look.

50 ppi resampled to 300 ppi

Figure 6-17: Adding pixels in a photo editor doesn't rescue a low-resolution original.

198

Figure 6-18: Composing your shots with a little head room enables you to crop to different frame sizes.

Chapter 10 shows you how to crop your image using the Trim option on the Retouch menu. However, this in-camera tool enables you to crop to only five aspect ratios: 3:2, 4:3, 5:4, 1:1, and 16:9. For other crop proportions, use Nikon ViewNX 2 or some other photo software to do the job. (The crop tool is on the Adjustments panel of the program.)

You also can usually crop your photo using the software provided at online printing sites and at retail print kiosks. If you plan to simply drop off your memory card for printing at a lab, be sure to find out whether the printer automatically crops the image without your input. If so, use your photo software to crop the photo, save the cropped image to your memory card, and deliver that version of the file to the printer.

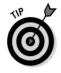

To allow yourself some printing flexibility, leave at least a little margin of background around your subject when you shoot (refer to Figure 6-18). That way, you don't clip off the edges of the subject, no matter what print size you choose. (Some people refer to this margin padding as *head room,* especially when describing portrait composition.)

Get print and monitor colors in sync

Ah, your photo colors look perfect on your computer monitor. But when you print the picture, the image is too red or too green or has another nasty color tint. This problem, which is probably the most prevalent printing issue, can occur because of any or all the following factors:

✓ Your monitor needs to be calibrated. When print colors don't match the ones you see on your monitor, the most likely culprit is the monitor, not the printer. If the monitor isn't accurately calibrated, the colors it displays aren't a true reflection of your image colors. The same caveat applies to monitor brightness: You can't accurately gauge the exposure of a photo if the brightness of the monitor is cranked way up or down. It's worth noting that many of today's new monitors are very bright, providing ideal conditions for web browsing and watching movies but not necessarily for photo editing. So you may need to turn the brightness way, way down to get to a true indication of image exposure.

To ensure that your monitor displays photos on a neutral canvas, you can start with a software-based *calibration utility*, which is just a small program that guides you through the process of adjusting your monitor. The program displays various color swatches and other graphics, and then asks you to provide feedback about the colors you see onscreen.

If you use a Mac, its operating system (OS) offers a built-in calibration utility, the Display Calibrator Assistant; Windows 7 offers a similar tool: Display Color Calibration. You also can find free calibration software for both Mac and Windows systems online; just enter the term *free monitor calibration software* into your favorite search engine.

Software-based tools, though, depend on your eyes to make decisions during the calibration process. For a more reliable calibration, you may want to invest in a hardware solution, such as the huey PRO (about \$100, www.pantone.com) or the Spyder4Express (about \$120, www. datacolor.com). These products use a device known as a *colorimeter* to accurately measure display colors.

Whichever route you take, the calibration process produces a monitor *profile*, which is simply a data file that tells your computer how to adjust the display to compensate for any monitor color casts or brightness and contrast issues. Your Windows or Mac operating system loads this file automatically when you start your computer. Your only responsibility is to perform the calibration every month or so because monitor colors drift over time.

✓ One of your printer cartridges is empty or clogged. If your prints look great one day but are way off the next, the number-one suspect is an empty ink cartridge or a clogged print nozzle or head. Check your

manual to find out how to perform the necessary maintenance to keep the nozzles or print heads in good shape.

If black-and-white prints have a color tint, a logical assumption is that your black ink cartridge is to blame, if your printer has one. But the truth is that images from a printer that doesn't use multiple black or gray cartridges typically have a slight color tint, even when all ink cartridges are fine. Why? Because to create gray, the printer instead has to mix yellow, magenta, and cyan in perfectly equal amounts, and that's a difficult feat for the typical inkjet printer to pull off. If your black-andwhite prints have a strong color tint, however, a color cartridge might be empty, and replacing it may help somewhat. Long story short: Unless your printer is marketed for producing good black-and-white prints, you'll probably save yourself some grief by simply having your blackand-whites printed at a retail lab.

When you buy replacement ink, by the way, keep in mind that thirdparty brands (though perhaps cheaper) may not deliver the same performance as cartridges from your printer manufacturer. A lot of science goes into getting ink formulas to mesh with the printer's ink-delivery system, and the printer manufacturer obviously knows most about that delivery system.

- ✓ You chose the wrong paper setting in your printer software. When you set up a print job, be sure to select the right setting from the paper type option glossy or matte, for example. This setting affects the way the printer lays down ink on the paper.
- ✓ Your photo paper is low quality. Sad but true: Cheap, store-brand photo papers usually don't render colors as well as the higher-priced, name-brand papers. For best results, try papers from your printer manufacturer; again, those papers are engineered to provide top performance with the printer's specific inks and ink-delivery system.

Some paper manufacturers, especially those that sell fine-art papers, offer downloadable *printer profiles*, which are simply little bits of software that tell your printer how to manage color for the paper. Refer to the manufacturer's website for information on how to install and use the profiles. And note that a profile mismatch can also cause incorrect colors in your prints, including the color tint in black-and-white prints alluded to earlier.

✓ Your printer and photo software fight over color management duties. Some photo programs offer *color management* tools, which enable you to control how colors are handled as an image passes from camera to monitor to printer. Most printer software also offers color management features. The problem is, if you enable the color management controls in both your photo software and printer software, you can create conflicts that lead to wacky colors. Check your photo software and printer manuals for color management options and ways to turn them on and off.

DPOF, PictBridge, and computerless printing

Your camera offers two features that enable you to print directly from the camera or a memory card, assuming that your printer offers the required options.

One of the direct-printing features is *Digital Print Order Format*, or *DPOF*. With this option, accessed via the DPOF Print Order option on the Playback menu, you select pictures from your memory card to print and then specify how many copies you want of each image. Then, if your photo printer has a Secure Digital (SD) memory card slot (or SDHC/SDXC slots, if you use these new, high-capacity cards) and supports DPOF, you just pop the memory card into that slot. The printer reads your "print order" and outputs just the requested copies of your selected images. (You use the printer's own controls to set paper size, print orientation, and other print settings.)

A second direct-printing feature, *PictBridge*, works a little differently. If you have a PictBridge-enabled photo printer, you can connect the camera to the printer by using a USB cable. (You use the same cable as for picture downloads.) A PictBridge interface appears on the camera monitor, and you use the camera controls to select the pictures you want to print. With PictBridge, you specify additional print options from the camera, such as page size and whether to print a border around the photo.

Both DPOF and PictBridge are especially useful when you need fast printing. For example, if you shoot pictures at a party and want to deliver prints to guests before they go home, DPOF and PictBridge offer quicker options than firing up your computer, downloading pictures, and so on. And, if you invest in one of the tiny portable photo printers on the market today, you can easily make prints away from your home or office. You can take both your portable printer and camera along to your regional sales meeting, for example.

If you're interested in exploring either printing feature, look for details in the electronic version of your camera manual, provided on one of the two CDs that shipped with the camera.

Even if all the aforementioned issues are resolved, however, don't expect perfect color matching between printer and monitor. Printers simply can't reproduce the entire spectrum of colors that a monitor can display. In addition, monitor colors always appear brighter because they are, after all, generated with light.

Finally, be sure to evaluate print colors and monitor colors in the same ambient light — daylight, office light, whatever — because that light source has its own influence on the colors you see. Also allow your prints to dry for 15 minutes or so before you make any final judgments.

202

Preparing Pictures for E-Mail and Online Sharing

How many times have you received an e-mail message that looks like the one in Figure 6-19? Some well-meaning friend or relative sent you a digital photo that's so large you can't view the whole thing on your monitor.

Inbox - Windows Mail File Edit View Tools Me	ssage Help		Search P
📑 Create Mail 💌 📾 Reply 🖉	noning and a second	Send/Receive - III III 🚳 -	
Local Folders Inbox (20) Outbox Sent Items	! 용 안 From 승 (S) Julie King	Subject Balloon Race	
Deleted Rems (6) Drafts Junk E-mail (13) Microsoft Communities	Had to get up at 5 a.m bu	it was worth it!	
-			U
26 message(s), 20 unread	• George Theorem		► Working Online

Figure 6-19: The attached image has too many pixels to be viewed without scrolling.

The problem is that computer monitors can display only a limited number of pixels. The exact number depends on the monitor's resolution setting and the capabilities of the computer's video card, but suffice it to say that the average photo from one of today's digital cameras has a pixel count in excess of what the monitor can handle.

Thankfully, some new e-mail programs have picture-viewing tools that can display large images at a reduced size. And some programs can even upload photos to an online storage site instead of dumping the files directly into the recipient's mailbox — the recipient can then choose to view and download the files from the online storage. But if you or the recipient use an older e-mail program, chances are that your large files come through as shown in Figure 6-19. Not only do you make it difficult for people to view your files, but you're asking them to download and store large files — remember, every pixel in the photo adds to the file size, and thus, the file download time and storage requirements.

204

In general, a good rule is to limit e-mail photos to no more than 640 pixels at its longest dimension. That ensures that people who use the older e-mail programs can view your entire picture without scrolling, as in Figure 6-20. This image measures 640 x 424 pixels.

Figure 6-20: Keep e-mail pictures to no larger than 640 pixels wide or tall.

This size recommendation means that even if you shoot at your camera's lowest Image Size setting (3008 x 2000), you wind up with more pixels than you need for onscreen viewing. Some new e-mail programs have a photo-upload feature that creates a temporary low-res version for you, but if not, creating your own copy is easy. (Details later.) If you're posting to an online photo-sharing site, you may be able to upload all your original pixels, but many sites have resolution limits.

In addition to resizing high-resolution images, check their file types; if the photos are in the Raw (NEF) or TIFF format, you need to create a JPEG copy for online use. Web browsers and e-mail programs can't display Raw or TIFF files.

You can tackle both bits of photo prep in ViewNX 2 or by using the Resize option in your camera. The next two sections explain both methods.

Chapter 6: Downloading, Printing, and Sharing Your Photos

Prepping online photos using ViewNX 2

For pictures that you already downloaded to the computer, you can create a small-sized JPEG copy for online sharing using ViewNX 2. Just click the image thumbnail and then choose the Convert Files command, found on the File menu. When the Convert Files dialog box appears, set up things as follows:

Select JPEG as the file format. Make your choice from the File Format drop-down list, as shown in Figure 6-21.

							Quality slider
Convert Fi	les		and the second	deley i con		all sea	X
File Format:	JPEG						
Original Imag	e Size: 4288	x 2848 pixels					
Quality: High	est Quality						
							ф
	L						
Change	the image si	ze					
		Long E	dge: 6	540	pixels	٦	
		Short E	dge:	425	pixels	Г	
Remove	camera seti	ting information					
Remove	XMP/IPTC in	formation					
Remove	ICC color pr	ofile					
Save in:							
The sar	ne folder as	the original file					
Specifie	ed Folder						
C:\Users	Julie King\	Pictures					Browse
Create a	new subfold	er for each file o	onversio	on			Naming Options
Change f	ile names						Naming Options
Tota	Number of	Files: 1	Con	vert]	(Cancel

Figure 6-21: In ViewNX 2, select the Convert Files option to create a JPEG version of a Raw or TIFF photo.

✓ Set the picture quality level. Use the Quality slider, labeled in the figure, to set the picture quality, which is controlled by how much JPEG compression is applied when the file is saved. For best quality, drag the slider all the way to the right, but remember the tradeoff: As you raise the quality, less compression occurs, which results in a larger file size. (See Chapter 2 for more information about JPEG compression.)

205

Set the image size (number of pixels). To resize the photo, select the Change the Image Size check box and then enter a value (in pixels) for the longest dimension of the photo. The program automatically fills in the other value.

For pictures that you want to share online, also select all three of the Remove check boxes, as shown in the figure, to eliminate adding to file sizes unnecessarily.

The rest of the options work just as they do during Raw conversion; see "Processing Raw Files," earlier in this chapter, for details. If you're resizing a JPEG original, be sure to give the small version a new name to avoid overwriting that original.

Resizing pictures from the Playback menu

The in-camera resizing tool, found on the Playback menu, works on both JPEG and Raw images. With both types of files, your resized copy is saved in the JPEG format.

To use this tool, take these steps:

- 1. Display the Playback menu.
- 2. Select the Resize option, as shown on the left in Figure 6-22, and press OK.

Figure 6-22: Use the Resize option to create a low-resolution version of a picture on your memory card.

You see the screen shown on the right in Figure 6-22.

3. Select Choose Size and press the Multi Selector right.

You see the screen shown in Figure 6-23, listing the possible image sizes, stated in megapixels. The options result in the following pixel dimensions for your small copy:

- 2.5M: 1920 x 1280 pixels
- *1.1M*: 1280 x 856 pixels
- 0.6M: 960 x 640 pixels
- 0.3M: 640 x 424 pixels
- 0.1M: 320 x 216 pixels

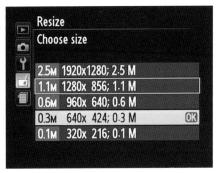

Figure 6-23: Set the size for your small copies here.

4. Highlight the size you want to use for your copy and press OK.

You're returned to the main Resize menu.

5. Choose Select Image and press the Multi Selector right to display thumbnails of your pictures, as shown in Figure 6-24.

Figure 6-24: Press the Zoom Out button to tag a picture for resizing.

208 Part II: Working with Picture Files _____

6. Move the yellow highlight box over a thumbnail and press the Zoom Out button to "tag" the photo for copying.

You see a little icon above the thumbnail, as shown in Figure 6-24. Press the button again to remove the tag if you change your mind.

A couple of notes here:

• A little yellow box with an x through it indicates that the file can't be resized. You can't resize movie files, and you can't resize a resized copy.

• You can temporarily get a magnified view of the highlighted photo by pressing the Zoom In button. When you release the button, you're returned to thumbnails view.

7. After selecting all your pictures, press OK.

A screen appears asking you for permission to make small copies of the selected photos.

8. Highlight Yes and press OK.

The camera duplicates the selected images and *downsamples* (eliminates pixels from) the copies to achieve the size you specified. The small copies are saved in the JPEG file format, using the same Image Quality setting (Fine, Normal, or Basic) as the original. Your original picture files remain untouched.

When you view small-size copies on the camera monitor, they appear with a Resize symbol next to the file size (lower right corner), as shown in Figure 6-25. The filename of the resized image begins with SSC_ (or _SSC, if the original was captured using the Adobe RGB Color Space). And if you're viewing the photo in any playback display mode except None, the Retouch icon — a little paintbrush symbol — appears at the top of the screen, as shown in the figure. (See Chapter 5 for details about playback display modes.)

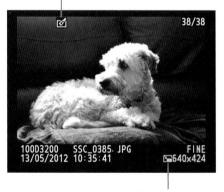

Resize symbol

Figure 6-25: The Resize icon indicates a small-size copy.

Safeguarding your digital photo files

To make sure that your digital photos enjoy a long, healthy life, follow these storage guide-lines:

- Don't rely on your computer's hard drive for long-term, archival storage. Hard drives occasionally fail, wiping out all files in the process. This warning applies to both internal and external hard drives. At the very least, having a dual-drive backup is in order — you might keep one copy of your photos on your computer's internal drive and another on an external drive. If one breaks, you still have all your goodies on the other one.
- Camera memory cards, flash memory keys, and other portable storage devices, such as one of those wallet-sized media players, are similarly risky. All are easily damaged if dropped or otherwise mishandled. And being of diminutive stature, these portable storage options also are easily lost.
- The best way to store important files is to copy them to nonrewritable DVDs. (The label should say DVD-R or DVD+R, not DVD-RW or DVD+RW.) Look for quality, brand-name DVDs that have a gold coating, which offer a higher level of security than other coatings and boast a longer life than your garden-variety DVDs.

Do be aware, though, that the DVDs you create on one computer may not be playable

on another because multiple recording formats and disc types exist: DVD minus, DVD plus, dual-layer DVD, and so on. So if you upgrade computers, be sure that your old DVDs are readable by your new DVD player; if not, make new backups using the new drive.

For a double backup, you may want to check into online storage services, such as Mozy (www.mozy.com) and IDrive (www.idrive.com). You pay a monthly subscription fee to back up your important files to the site's servers.

Note the critical phrase here: double backup. Online storage sites have a troubling history of closing down suddenly, taking all their customers' data with them. (One extremely alarming case was the closure of a photography-oriented storage site called Digital Railroad, which gave clients a mere 24-hours' notice before destroying their files.) So anything you store online should be also stored on DVD or CD and kept in your home or office. Also note that photo-sharing sites such as Shutterfly aren't designed to be long-term storage tanks for your images. Usually, you get access to only a small amount of file storage space, and the site may require you to purchase prints or other photo products periodically to maintain your account.

210 Part II: Working with Picture Files _____

In this part ...

s nice as it is to be able to set your camera to automatic mode and let the camera handle most of the photographic decisions, I encourage you to take creative control and explore the advanced exposure modes (P, S, A, and M). In these modes, you can make your own decisions about the exposure, focus, and color characteristics of your photo, which are key to capturing a compelling image as you see it in your mind's eye. And don't think that you have to be a genius or spend years to be successful — adding just a few simple techniques to your photographic repertoire can make a huge difference in the quality of the pictures you take.

The first two chapters in this part explain everything you need to know to do just that, providing both some necessary photography fundamentals as well as details about using the advanced exposure modes. Following that, Chapter 9 helps you draw together all the information presented earlier in the book, summarizing the best camera settings and other tactics to use when capturing portraits, action shots, landscapes, and close-up shots. In short, this part helps you get the most out of your camera, which results in you becoming a better photographer.

Getting Creative with Exposure

In This Chapter

- Understanding the basics of exposure
- Exploring advanced exposure modes: P, S, A, or M?
- Choosing an exposure metering mode
- > Tweaking autoexposure with Exposure Compensation
- Taking advantage of Active D-Lighting
- Using advanced flash features

And the new photographer. Discussions of the topic are loaded with technical terms — *aperture, metering, shutter speed, ISO*, and the like. Add the fact that your camera offers many exposure controls, all sporting equally foreign names, and it's no wonder that most people throw up their hands and decide that their best option is to simply stick with the Auto exposure mode and let the camera take care of all exposure decisions.

You can, of course, turn out good shots in Auto mode. And I fully relate to the exposure confusion you may be feeling — I've been there. But I can also promise that when you take things nice and slow, digesting just a piece of the exposure pie at a time, the topic is not nearly as complicated as it seems on the surface. And I guarantee that the payoff will be well worth your time and brain energy. You'll not only gain the power to resolve just about any exposure problem, but also discover ways to use exposure to put your own creative stamp on a scene.

To that end, this chapter provides everything you need to know to really exploit your camera's exposure options, from a primer in exposure science (it's not as bad as it sounds) to explanations of all the camera's exposure controls. In addition, because some controls aren't accessible in the fully automatic exposure modes, this chapter also provides more details about the four advanced modes, P, S, A, and M, first introduced in Chapter 2.

Introducing the Exposure Trio: Shutter Speed, Aperture, and ISO

Any photograph, whether taken with a film or digital camera, is created by focusing light through a lens onto a light-sensitive recording medium. In a film camera, the film negative serves as that medium; in a digital camera, it's the *image sensor*, which is an array of light-responsive computer chips.

The exposure, or brightness, of the image that results when light hits the sensor depends on three settings: *shutter speed, aperture,* and *ISO*. This three-part exposure formula works as follows:

Shutter speed (controls) duration of light): The *shutter* is a mechanical light barrier that sits between the lens and image sensor. Figure 7-1 gives you an idea of the traditional lens, shutter, and sensor placement. When you take a picture, the shutter opens to allow the light to reach the sensor and then closes to end the exposure. (The exception to this scenario is when you compose in Live View mode when you enable Live View, the shutter opens and remains open so that your image can form on the sensor and be displayed on the monitor.

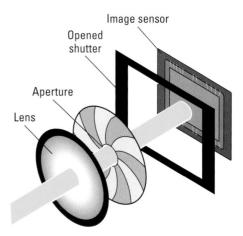

Figure 7-1: Here's a look at the traditional aperture, shutter, and image sensor setup.

When you press the shutter button, the shutter first closes and then reopens for the actual exposure.)

Either way, the length of time that the shutter is open to expose the image is called the *shutter speed* and is measured in seconds: 1/60 second, 1/250 second, 2 seconds, and so on. Shutter speeds on the D3200 range from 30 seconds to 1/4000 second when you shoot without flash. If you use flash, the range is more limited. See the sidebar "In sync: Flash timing and shutter speed," later in this chapter, for information.

Should you want a shutter speed longer than 30 seconds, Manual (M) exposure mode also provides a feature called *bulb* exposure. At this setting, the shutter stays open as long as you press the shutter button.

✓ Aperture (controls amount of light): The *aperture* is an adjustable hole in a diaphragm in the lens; Figure 7-1 gives you a rough idea of its position in the camera's light-control chain. By changing the size of the aperture, you control the size of the light beam that can enter the camera.

Chapter 7: Getting Creative with Exposure

Aperture settings are stated as *f-stop numbers*, or simply *f-stops*, and are expressed with the letter *f* followed by a number: f/2, f/5.6, f/16, and so on. The lower the f-stop number, the larger the aperture, and the more light is permitted into the camera, as illustrated by Figure 7-2.

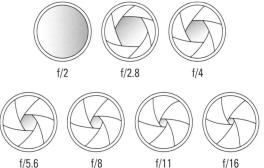

The range of possible f-stops depends on your Figure 7-2: A lower f-stop number means a larger aperture, allowing more light into the camera.

lens and, if you use a zoom lens, on the zoom position (focal length) of the lens. When you use the 18–55mm kit lens featured in this book, you can select apertures from f/3.5–f/22 when zoomed all the way out to the shortest focal length, 18mm. When you zoom in to the maximum focal length, 55mm, the aperture range is f/5.6–f/36. (See Chapter 8 for a discussion of focal lengths.)

✓ ISO (controls light sensitivity): ISO, which is a digital function rather than a mechanical structure on the camera, enables you to adjust how responsive the image sensor is to light. The term ISO is a holdover from film days, when an international standards organization rated each film stock according to light sensitivity: ISO 200, ISO 400, ISO 800, and so on.

& MEMBER

On a digital camera, the sensor itself doesn't actually get more or less sensitive when you change the ISO — rather, the light "signal" that hits the sensor is either amplified or dampened through electronics wizardry, sort of like how raising the volume on a radio boosts the audio signal. But the upshot is the same as changing to a more light-reactive film stock: A higher ISO means that less light is needed to produce the image, enabling you to use a smaller aperture, faster shutter speed, or both. (In other words, from now on, don't worry about the technicalities and just remember that ISO equals light sensitivity.)

Normal ISO settings on your camera range from ISO 100 to 6400. But if you really need to push things, you can extend that range all the way to ISO 12800. (This uber-high setting goes by the name Hi 1.) High ISO settings have a downside that you can explore in the upcoming section "ISO affects image noise."

Distilled to its essence, the image-exposure formula is just this simple:

Aperture and shutter speed together determine the quantity of light that strikes the image sensor during the exposure.

·· 215

ISO determines how much the sensor reacts to that light and, therefore, how much light you need to expose the picture.

The tricky part of the equation is that aperture, shutter speed, and ISO settings affect your pictures in ways that go *beyond* exposure. You need to be aware of these side effects, explained in the next section, to determine which combination of the three exposure settings will work best for your picture.

Understanding exposure-setting side effects

You can create the same exposure with many combinations of aperture, shutter speed, and ISO. You're limited only by the aperture range allowed by the lens and the shutter speeds and ISO range offered by the camera.

But the settings you select impact your image beyond mere exposure, as follows:

- Aperture affects *depth of field*, or the distance over which focus appears sharp.
- Shutter speed determines whether a moving subject appears blurry or sharp and whether movement of the camera during the exposure creates unwanted blur throughout the entire photo.
- ✓ ISO affects the amount of image *noise*, which is a defect that looks like tiny specks of sand.

As you can imagine, understanding how aperture, shutter speed, and ISO affect your image enables you to have much more creative control over your photographs — and, in the case of ISO, to ensure the quality of your images. (Chapter 2 discusses other factors that affect image quality.)

The next three sections explore the details of each exposure side effect.

Aperture affects depth of field

The aperture setting, or f-stop, affects *depth of field*, which is the range of sharp focus in your image. I introduce this concept in Chapter 3, but here's a quick recap: With a shallow depth of field, your subject appears more sharply focused than faraway objects; with a large depth of field, the sharp-focus zone spreads over a greater distance.

As you reduce the aperture size — or *stop down the aperture*, in photo lingo — by choosing a higher f-stop number, you increase depth of field. As an example, take a look at the two images in Figure 7-3. For both shots, I established focus on the fountain statue. Notice that the background in the first image, taken at an aperture setting of f/13, is sharper than in the right example, taken at f/5.6. Aperture is just one contributor to depth of field, however; the focal length of your lens and the distance between that lens and your subject also affect how much of the scene stays in focus. See Chapter 8

f/5.6, 1/125 second, ISO 200

for the complete story, including more examples of how changing the f-stop affects depth of field.

f/13, 1/25 second, ISO 200

Figure 7-3: Opening the aperture (by choosing a lower f-stop number) decreases depth of field, or the distance over which focus appears sharp.

One way to remember the relationship between f-stop and depth of field is to think of the *f* as standing for *focus*. A higher f-stop number produces a larger depth of field, so if you want to extend the zone of sharp focus to cover a greater distance from your subject, you set the aperture to a higher f-stop. Higher *f*-stop number, greater zone of sharp *f*ocus. (Please *don't* share this tip with photography elites, who will roll their eyes and inform you that the *f* in *f*-stop most certainly does *not* stand for focus but for the ratio between the aperture size and lens focal length — as if *that's* helpful to know if you're not an optical engineer. Again, Chapter 8 explains focal length, which *is* helpful to know.)

Shutter speed affects motion blur

At a slow shutter speed, moving objects appear blurry, whereas a fast shutter speed captures motion cleanly. This phenomenon has nothing to do with the actual focus point of the camera; rather, it's a result of the movement that's occurring — and being recorded by the camera — during the time that the shutter is open.

Compare the photos in Figure 7-3, for example. The static elements are perfectly focused in both images, although the background in the left photo appears sharper because I shot that image using a higher f-stop, increasing the zone of sharp focus. But the way the camera rendered the moving portion of the scene — the fountain water — was determined by the shutter speed. At a shutter speed of 1/25 second (left photo), the water blurs, giving it a misty look. At 1/125 second (right photo), the droplets appear more sharply focused, almost frozen in mid-air. How high a shutter speed you need to freeze action depends on the speed of your subject.

If your picture suffers from overall blur, as in Figure 7-4, the camera itself moved during the exposure, which is always a danger when you handhold the camera. The slower the shutter speed, the longer the exposure time and the longer you have to hold the camera still to avoid the blur that's caused by camera shake. Use a tripod to avoid this issue. (See the sidebar "Handholding the camera: How low can you go?" for more tips on avoiding the problem.)

Keep in mind that freezing action isn't the only way to use shutter speed to creative effect. When shooting waterfalls, for example, most photographers use a very slow shutter speed to give the water even more of a flowing, romantic look than you see in my fountain example. With colorful moving subjects, a slow shutter can produce some cool abstract effects and create a heightened sense of motion. Chapter 9 offers examples of both effects. f/29, 1/5 second, ISO 200

Figure 7-4: If both stationary and moving objects are blurry, camera shake is the usual cause.

150 affects image noise

As ISO increases, making the image sensor more reactive to light, you increase the risk of producing noise. *Noise* is a defect that looks like sprinkles of sand and is similar in appearance to film *grain*, a defect that often mars pictures taken with high ISO film. Figure 7-5 offers an example.

Ideally, then, you should always use the lowest ISO setting on your camera to ensure top image quality. But sometimes, the lighting conditions simply don't permit you to do so and still use the aperture and shutter speeds you need.

was using, to allow as much light as possible into the camera. At ISO 100, I needed a shutter speed of 1/40 second to expose the picture, and that shutter speed wasn't fast enough for a successful handheld shot. By raising the ISO to 200, I was able to use a shutter speed of 1/80 second, which enabled me to capture the flower cleanly, as shown in Figure 7-6.

Handholding the camera: How low can you go?

My students often ask how slow they can set the shutter speed and still handhold the camera instead of using a tripod. Unfortunately, there's no one-size-fits-all answer to this question.

The slow-shutter safety limit varies depending on a couple factors, including your physical capabilities and your lens — the heavier the lens, the harder it is to hold steady. For reasons that are too technical to get into, camera shake also affects your picture more when you shoot with a lens that has a long focal length. So you may be able to use a much slower shutter speed when you shoot with a lens that has a maximum focal length of 55mm, like the kit lens, than if you switch to a 200mm telephoto lens. (Chapter 8 explains focal length, if the term is new to you.)

A standard photography rule is to use the inverse of the lens focal length as the minimum handheld shutter speed. For example, with a 50mm lens, use a shutter speed no slower than 1/50 second. But that rule was developed before the advent of today's modern lenses, which tend to be significantly lighter and smaller than older lenses, as do cameras themselves. I have a very light, super-zoom lens that I can handhold at speeds as low as 1/80 second even when I zoom to focal lengths way beyond 80mm, for example.

The best idea is to do your own tests to see where your handholding limit lies. Start with a slow shutter speed — say, in the 1/40 second neighborhood, and then click off multiple shots, increasing the shutter speed for each picture. If you have a zoom lens, run the test first at the minimum focal length (widest angle) and then zoom to the maximum focal length for another series of shots. Then it's simply a matter of comparing the images in your photo-editing program. (You may not be able to accurately judge the amount of blur on the camera monitor.) See Chapter 6 to find out how to see the shutter speed you used for each picture when you view your images. That information, along with other camera settings, appears in the file metadata (data about the image), which you can display in Nikon ViewNX 2 and many other programs.

Remember, too, that if your lens offers Vibration Reduction (as does the D3200 kit lens), enabling that feature can compensate for small amounts of camera shake, enabling you to capture sharp images at slightly slower shutter speeds than normal when handholding the camera. Again, your mileage may vary, but most people can expect to go at least two or three notches down the shutter-speed ramp. See Chapter 1 for more information about this feature.

ISO 100, f/6.3, 1/40 second

Figure 7-5: Caused by a very high ISO or long exposure time, noise becomes more visible as you enlarge the image.

ISO 200, f/6.3, 1/80 second

Figure 7-6: Raising the ISO enabled me to bump up the shutter speed enough to permit a blur-free handheld shot.

Fortunately, you don't encounter serious noise on the D3200 until you really crank up the ISO. In fact, you may even be able to get away with a fairly high ISO if you keep your print or display size small. Some people probably wouldn't even notice the noise in the left image in Figure 7-5 unless they were looking for it, for example. But as with other image defects, noise becomes more apparent as you enlarge the photo, as shown on the right in that same figure. Noise is also easier to spot in shadow areas of your picture and in large areas of solid color.

How much noise is acceptable, and, therefore, how high an ISO is safe, is a personal choice. Even a little noise isn't acceptable for pictures that require the highest quality, such as images for a product catalog or a travel shot that you want to blow up to poster size.

It's also important to know that a high ISO isn't the only cause of noise: A long exposure time (slow shutter speed) can also produce the defect. So how high you can raise the ISO before the image gets ugly varies depending on shutter speed. I can pretty much guarantee, though, that your pictures will exhibit visible noise at the camera's highest ISO setting, which results in ISO 12800. In fact, that's why Nikon gave this setting its special label, Hi 1 — it's a way to let you know that you should use it only if the light is so bad that you have no other way to get the shot.

Doing the exposure balancing act

As you change any of the three exposure settings — aperture, shutter speed, and ISO — one or both of the others must also shift in order to maintain the same image brightness. Say that you're shooting a soccer game, for example, and you notice that although the overall exposure looks great, the players appear slightly blurry at your current shutter speed. If you raise the shutter speed, you have to compensate with either a larger aperture, to allow in more light during the shorter exposure, or a higher ISO setting, to make the camera more sensitive to the light — or both.

As the previous sections explain, changing these settings impacts your image in ways beyond exposure. As a quick reminder:

- ✓ Aperture affects depth of field, with a higher f-stop number keeping objects sharp over a greater distance from the lens.
- Shutter speed affects whether motion of the subject or camera results in a blurry photo. A faster shutter "freezes" action and also helps safeguard against allover blur that can result from camera shake when you're handholding the camera.
- ISO affects the camera's sensitivity to light. A higher ISO makes the camera more responsive to light but also increases the chance of image noise.

So when you boost that shutter speed to capture your soccer subjects, you have to decide whether you prefer the shorter depth of field that comes with a larger aperture or the increased risk of noise that accompanies a higher ISO.

Everyone has his or her own approach to finding the right combination of aperture, shutter speed, and ISO, and you'll no doubt develop your own system as you become more practiced at using the advanced exposure modes. In the meantime, here's how I handle things:

- ✓ I always use the lowest possible ISO setting unless the lighting conditions are so poor that I can't use the aperture and shutter speed I want without raising the ISO.
- If my subject is moving (or might move, as with a squiggly toddler or antsy pet), I give shutter speed the next highest priority in my exposure decision. I might choose a fast shutter speed to ensure a blur-free photo or, on the flip side, select a slow shutter to intentionally blur that moving object, an effect that can create a heightened sense of motion.
- ✓ For images of non-moving subjects, I make aperture a priority over shutter speed, setting the aperture according to the depth of field I have in mind. For portraits, for example, I often use the largest aperture (the lowest f-stop number, known as shooting *wide open*, in photographer speak) so that I get a short depth of field, creating a nice, soft background for my subject. For landscapes, I usually go the opposite direction, stopping down the aperture as much as possible to capture the subject at the greatest depth of field.

I know that keeping all this straight is a little overwhelming at first, but the more you work with your camera, the more the whole exposure equation will make sense to you. You can find tips for choosing exposure settings for specific types of pictures in Chapter 9; keep moving through this chapter for details on how to actually monitor and adjust aperture, shutter speed, and ISO settings on the D3200.

Exploring the Advanced Exposure Modes

In the automatic modes described in Chapter 3, you have very little control over exposure. You may be able to choose from one or two Flash modes, you can adjust ISO in the Scene modes, and you can play with depth of field and motion blur a little in Guide mode. But to gain full control over exposure, set the Mode dial to one of the advanced modes highlighted in Figure 7-7: P, S, A, or M.

The difference among the four advanced modes is the level of control over aperture and shutter speed, as follows:

222

- P (programmed autoexposure): In this mode, the camera selects both aperture and shutter speed. But you can choose from different combinations of the two for creative flexibility.
- ✓ S (shutter-priority autoexposure): In this mode, you select a shutter speed, and the camera chooses the aperture setting that produces a good exposure at your selected ISO setting.
- ✓ A (aperture-priority autoexposure): The opposite of shutterpriority autoexposure, this mode asks you to select the aperture setting. The camera then selects the appropriate shutter speed to properly expose the picture.

Advanced exposure modes

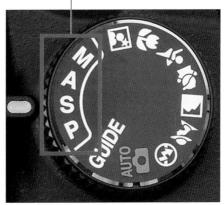

Figure 7-7: You can control exposure and certain other picture properties fully only in P, S, A, or M mode.

✓ M (manual exposure): In this mode, you specify both shutter speed and aperture.

To sum up, the first three modes are semi-automatic exposure modes that are designed to help you get a good exposure while still providing you with some photographic flexibility. You can even modify the autoexposure results by using features such as Exposure Compensation, explained later in this chapter. But it's important to note that in extreme lighting conditions, the camera may not be able to select settings that will produce a good exposure, and it doesn't stop you from taking a poorly exposed photo.

Manual mode puts all exposure control in your hands. If you're a longtime photographer who comes from the days when manual exposure was the only game in town, you may prefer to stick with this mode. If it ain't broke, don't fix it, as they say. And in some ways, manual mode is simpler than the semi-auto modes because if you're not happy with the exposure, you just change the aperture, shutter speed, or ISO setting and shoot again. You don't have to fiddle with features that enable you to modify your autoexposure results — although again, the lighting conditions determine whether a good exposure is possible at any combination of settings.

My own personal choice is to use aperture-priority autoexposure when I'm shooting still subjects and want to control depth of field — aperture is my *priority* — and to switch to shutter-priority autoexposure when I'm shooting a moving subject and so I'm most concerned with controlling shutter speed. Frankly, my brain is taxed enough by all the other issues involved in taking

pictures — what my White Balance setting is, what resolution I need, where I'm going for lunch as soon as I make this shot work — that I just appreciate having the camera do some of the exposure lifting.

However, when I know exactly what aperture and shutter speed I want to use, or I'm after an out-of-the-ordinary exposure, I use manual exposure. For example, sometimes when I'm doing a still life in my studio, I want to create a certain mood by underexposing a subject or even shooting it in silhouette. The camera is always going to fight you on that result in the P, S, and A modes because it so dearly wants to provide a good exposure. Rather than dialing in all the autoexposure tweaks that could eventually force the result I want, I simply set the mode to M, adjust the shutter speed and aperture directly, and give the autoexposure system the afternoon off.

But even in manual mode, you're never really flying without a net — the camera assists you by displaying the exposure meter, explained next.

Reading the Meter

To help you determine whether your exposure settings are on cue in M (manual) exposure mode, the camera displays an *exposure meter* in the viewfinder and Information display. The meter is the linear graphic highlighted in Figure 7-8. You can see a close-up look at how the meter looks in the viewfinder in Figure 7-9. To activate the meter in both displays, just press the shutter button halfway and then release it.

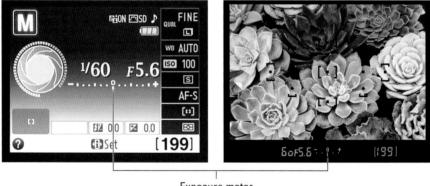

Exposure meter

Figure 7-8: In M exposure mode, the exposure meter appears in the Information display and viewfinder.

224

Chapter 7: Getting Creative with Exposure

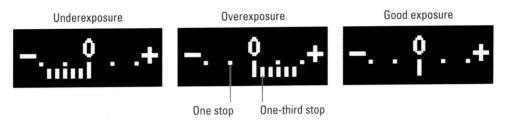

Figure 7-9: The meter indicates whether your exposure settings are on target.

Here's a short course in meter reading:

✓ Interpreting the meter: The minus-sign end of the meter represents underexposure; the plus sign, overexposure. So if the little notches on the meter fall to the left of 0, as shown in the first example in Figure 7-9, the image will be underexposed. If the indicator moves to the right of 0, as shown in the second example, the image will be overexposed. When the meter shows a balanced exposure, as in the third example in Figure 7-9, you're good to go.

A couple details to note:

• *The markings on the meter indicate exposure stops.* In photography, the term *stop* refers to an increment of exposure. To increase exposure by one stop means to adjust the aperture or shutter speed to allow twice as much light into the camera as the current settings permit. To reduce exposure a stop, you use settings that allow half as much light. Doubling or halving the ISO value also adjusts exposure by one stop.

On the D3200, the squares on either side of the 0 represent one full stop each. The small lines below, which appear only when the meter needs to indicate over- or underexposure, break each stop into thirds. So the middle readout in Figure 7-9, for example, indicates an overexposure of 1 and 2/3 stops. The left readout indicates the same amount of underexposure.

- If the meter blinks, the amount of over- or underexposure exceeds the two-stop range of the meter. In other words, you've got a serious exposure problem.
- Understanding how exposure is calculated (metering mode): The exposure information the meter reports is based on the *exposure metering mode*, which determines which part of the frame the camera considers when calculating exposure. At the default setting, exposure is based on

the entire frame, but you can select two other metering modes. See the upcoming section "Choosing an Exposure Metering Mode" for details.

- Interpreting the meter in S, A, and P modes: In these exposure modes, the meter doesn't appear unless the camera anticipates an exposure problem for example, if you're shooting in S (shutter-priority autoexposure) mode, and the camera can't select an f-stop that will properly expose your image at your chosen shutter speed and ISO. In dim lighting, you may also see a blinking flash symbol, which is a not-so-subtle suggestion to add some light to the scene. A blinking question mark tells you that you can press the Zoom Out button to display a Help screen with more information.
- Adjusting the meter shutoff timing. The viewfinder display and Information display turn on anytime you press the shutter button halfway. But then they turn off automatically, sending the meter into hiding, if you don't press the button again for a period of time — eight seconds, by default.

You can adjust this shut-off timing through the Auto Off Timers option, found on the Setup menu. After selecting the option and pressing OK, you see the screen shown on the left in Figure 7-10. Select Custom and press OK to access the options shown on the right in the figure. Then select Standby Timer and press OK to get to the meter timing options, which range from 4 seconds to 30 minutes. Remember that the metering system and viewfinder and Information displays use battery power, so keeping them active for long periods of time on a regular basis isn't a good move. After selecting your timing choice, press OK; then highlight Done and press OK once more.

Auto off timers		Auto off timers Custom	
HORT Short		Done	
ORM Normal		Playback/menus	1m
ONG Long		Image review	4s
り@ Custom	•	Live view	10m
		Standby timer	8s
		?	ner

Figure 7-10: You can adjust the automatic shutdown timing of the meter, viewfinder display, and Information screen.

As an alternative, you can control meter shutdown timing by choosing the Short, Normal, or Long option when you get to the left screen in Figure 7-10, but doing so also affects the timing of the playback/menu display, image review period, and Live View display. For the Standby Timer, Normal produces the default shutdown timing, 8 seconds; Long, 1 minute; and Short, 4 seconds. For more details on the Auto Off Timers option, check out Chapter 1.

Finally, keep in mind that the meter's suggestion on exposure may not always be the one you want to follow. For example, to shoot a backlit subject in silhouette, you *want* that subject to be underexposed. In other words, the meter is a guide, not a dictator.

Setting Aperture, Shutter Speed, and 150

The next sections detail how to view and adjust these three critical exposure settings. Remember, you can adjust ISO in any exposure mode except Auto and Auto Flash Off mode. And Guide mode, explained in Chapter 3, gives you some access to aperture and shutter speed, albeit in a bit of a roundabout way. To gain complete (and easy) access to aperture (f-stop) or shutter speed, switch to one of the four advanced exposure modes (P, S, A, or M).

Adjusting aperture and shutter speed

You can view the current aperture (f-stop) and shutter speed in the Information display and viewfinder, as shown in Figure 7-11. If you use the Graphic setting for the Info Display Format option on the Setup menu (the default setting), an aperture symbol appears just to the left of the shutter speed to remind you of the impact of changing the f-stop. As you raise the f-stop value, the yellow center of the graphic shrinks, representing the narrowing of the aperture. Note that if you change the setting of the Mode dial, the aperture graphic temporarily changes to show you the setting of that dial. (See Chapter 11 to find out how to switch to a different display format.)

In the viewfinder, shutter speeds are presented as whole numbers, even if the shutter speed is set to a fraction of a second. For example, the number 60 indicates a shutter speed of 1/60 second. When the shutter speed slows to one second or more, quote marks appear after the number — 1" indicates a shutter speed of one second, 4" means four seconds, and so on.

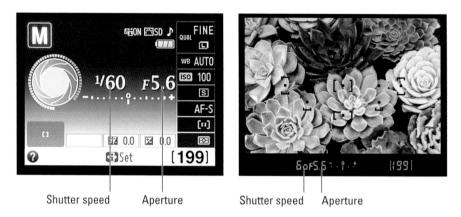

Figure 7-11: Look for the current f-stop and shutter speed here.

To select aperture and shutter speed, start by pressing the shutter button halfway to kick the exposure system into gear. You can then release the button if you want. The next step depends on the exposure mode, as follows:

✓ P (programmed autoexposure): In this mode, the camera shows you its recommended f-stop and shutter speed when you press the shutter button halfway. But you can rotate the Command dial to select a different combination of settings. The number of possible combinations depends upon the aperture settings the camera can select, which depends on your lens.

An asterisk (*) appears next to the P exposure mode symbol in the upper-left corner of the Information display if you rotate the Command dial to adjust the aperture/shutter speed settings. You see a tiny P* symbol at the left end of the viewfinder display as well. To get back to the initial combo of shutter speed and aperture, rotate the Command dial until the asterisk disappears from the Information display and the P* symbol turns off in the viewfinder.

✓ S (shutter-priority autoexposure): In this mode, you select the shutter speed. Just rotate the Command dial to get the job done. The camera automatically adjusts the aperture as needed to maintain proper exposure. Remember that as the aperture shifts, so does depth of field — so even though you're working in shutter-priority mode, keep an eye on the f-stop, too, if depth of field is important to your photo. Also note that in extreme lighting conditions, the camera may not be able to adjust the aperture enough to produce a good exposure at your current shutter speed — again, possible aperture settings depend on your lens. So you may need to compromise on shutter speed or ISO.

A (aperture-priority autoexposure): In this mode, you control aperture, and the camera adjusts shutter speed automatically. To set the aperture (f-stop), rotate the Command dial.

When you raise the f-stop value, be careful that the shutter speed doesn't drop so low that you risk camera shake if you handhold the camera. And if your scene contains moving objects, make sure that the shutter speed that the camera selects is fast enough to stop action (or slow enough to blur it, if that's your creative goal). These same warnings apply when you use P mode.

M (manual exposure): In this mode, you select both aperture and shutter speed, like so:

- *To adjust shutter speed*: Rotate the Command dial. Rotate the dial one notch past the slowest speed (30 seconds) to access the Bulb setting, which keeps the shutter open as long as the shutter button is pressed. If you attach the optional ML-L3 remote control unit, you also see a Time setting. At this setting, you press the remote's shutter button once to begin the exposure and a second time to end it; maximum exposure time is 30 minutes.
- *To adjust aperture:* Press the Exposure Compensation button while rotating the Command dial. Notice the little aperture-like symbol that lies next to the button, on the top of the camera? That's your reminder of the button's role in setting the f-stop in manual mode.

Keep in mind that when you use P, S, or A mode, the settings that the camera selects are based on what it thinks is the proper exposure. If you don't agree with the camera, you can switch to manual exposure mode and dial in the aperture and shutter speed that deliver the exposure you want, or if you want to stay in P, S, or A mode, you can tweak exposure using the features explained in the section "Sorting through Your Camera's Exposure-Correction Tools," later in this chapter.

When you view the f-stop and shutter speed in the Information display, by the way, remember that the camera continues to meter and adjust exposure up to the time you take the shot. (The exception is when you use the autoexposure lock feature, explained later in this chapter.) So if you frame the shot and then move the camera to better see the display, the exposure settings no longer reflect the ones the camera chose for your subject instead, they show the settings for whatever is now in front of the lens. And if you (like most people) hold the camera with the lens pointing down to view the monitor, the camera begins calculating the correct settings to use to photograph the ground.

Ø

The best practice is to use the monitor to select your initial shutter speed, or aperture, or both, if necessary. Then frame the shot in the viewfinder, press the shutter button halfway to meter the scene in front of the lens, and then, if the viewfinder exposure meter indicates a problem, adjust the exposure settings as necessary without taking your eye away from the viewfinder. (After you get familiar with the operation of the camera, this technique won't be as hard as it first seems, I promise.)

Controlling 150

of MEMBER

The ISO setting, introduced at the start of this chapter, adjusts the camera's sensitivity to light. At a higher ISO, you can use a faster shutter speed or a smaller aperture (higher f-stop number) because less light is needed to expose the image. But remember that a higher ISO also increases the possibility of noise, as illustrated in Figure 7-5. (Be sure to check out the upcoming sidebar "Dampening noise" for a feature that may help calm noise somewhat.)

On the D3200, you can choose ISO values ranging from 100 to 6400, plus Hi 1, which translates to ISO 12800. You also have the option of choosing Auto ISO; at this setting, the camera selects the ISO needed to expose the picture at the current shutter speed and aperture.

You can't adjust ISO in Auto and Auto Flash Off exposure modes; the camera sets the ISO automatically. In Guide mode, you access the setting via the More Settings option that appears when you choose the Advanced Operation shooting setting. (See Chapter 3 for details on Guide mode Advanced Operation).

In any other exposure mode, adjust ISO as follows:

✓ Info Edit screen: Press the Info Edit button to shift from the Information display to the Info Edit display. Highlight the ISO setting, as shown on the left in Figure 7-12 and press OK to display the options shown on the right. Choose the desired ISO setting and press OK.

✓ Shooting menu: You also can adjust the ISO Sensitivity Settings on the Shooting menu, shown in Figure 7-13. Note that the second screen in the figure shows options available in the P, S, A, and M modes; you can access only the top option in the other exposure modes. Either way, that's the option that sets a specific ISO level. More about the other options momentarily.

Fn (Function) button: By default, pressing the Fn button on the side of the camera displays the screen shown in Figure 7-14. Keep holding the button while rotating the Command dial to change the ISO setting. Chapter 11 tells you how to change the function of this button if you don't care to use it for this purpose.

230

Chapter 7: Getting Creative with Exposure

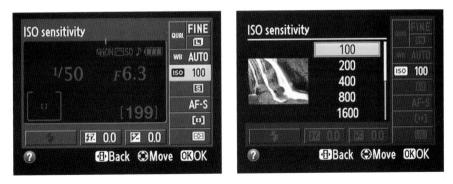

Figure 7-12: You can adjust ISO easily through the Info Edit screen.

SHOOTING MENU			ISO sensitivity settings	
Reset shooting menu			ISO sensitivity	100
Set Picture Control	₽SD			
Image quality	FINE		Auto ISO sensitivity control	ON 🕨
Image size			Maximum sensitivity	6400
White balance	AUTO	1	Minimum shutter speed	AUTO
ISO sensitivity settings				
Active D-Lighting	ON			
Auto distortion control	OFF	?		

Figure 7-13: You can access additional ISO options through the Shooting menu.

Keep these additional ISO points in mind:

Auto ISO in the fully automatic exposure modes: In Auto and Auto Flash Off modes, the camera uses the Auto ISO setting and selects the ISO setting for you. In the Scene and Guide modes, you can stick with Auto ISO (the default setting) or select a specific ISO value.

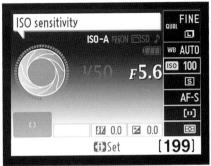

Figure 7-14: By default, pressing the Fn button while rotating the Command dial adjusts the ISO setting.

Auto ISO in P, S, A, and M modes: Auto ISO doesn't appear on the ISO settings list, but you still can enable Auto ISO as a safety net. Here's how it works: You dial in a specific ISO setting — say, ISO 100. If the camera decides that it can't properly expose the image at that ISO given your current aperture and shutter speed, it automatically adjusts ISO as necessary.

To get to this option, select ISO Sensitivity Settings on the Shooting menu, as shown on the left in Figure 7-13, and press OK. On the next screen, turn the Auto ISO Sensitivity Control option to On, as shown on the right in the figure. The camera will now override your ISO choice when it thinks a proper exposure is not possible with the settings you've specified.

Next, use the two options under the Auto ISO Sensitivity Control setting to tell the camera exactly when it should step in and offer ISO assistance:

• *Maximum Sensitivity:* This option lets you set the highest ISO value that the camera can use when it overrides your selected ISO setting — a great feature because it enables you to decide how much noise potential you're willing to accept in order to get a good exposure. For example, the value in Figure 7-13 is set to ISO 6400. So even if the picture can't be properly exposed at ISO 6400, the camera won't go any higher than that limit.

However, remember this caveat: This setting also determines the maximum ISO value that you can dial in directly. Well, technically, you can select a value higher than what you set for the Maximum Sensitivity option. But when you take the shot, the camera ignores your direct setting and instead uses the highest setting you selected for the Maximum Sensitivity value.

• *Minimum Shutter Speed:* Set the minimum shutter speed at which the ISO override engages when you use the P and A exposure modes. For example, you can specify that you want the camera to amp up ISO if needed to prevent the shutter speed from dropping below 1/30 second. If you set this option to Auto, the camera will select the minimum shutter speed setting based on the focal length of your lens, the idea being that with a longer lens, you need a faster shutter speed to avoid the blur that camera shake can cause when you handhold the camera. However, ultimately, exposure trumps camera shake issues: If the camera can't expose the picture at what it thinks is a safe shutter speed for your lens focal length, it will use a slower speed.

When the camera is about to override your ISO setting, it alerts you by blinking the ISO Auto label in the viewfinder. The message "ISO-A" blinks at the top of the Information screen as well. And in playback mode, the ISO value appears in red if you view your photos in a display mode that includes the ISO value. (Chapter 5 has details.)

233

Dampening noise

High ISO settings can result in *noise*, the digital defect that gives your pictures a speckled look. (Refer to Figure 7-5.) Long exposure times (slow shutter speeds) also create a noise potential. To help solve these problems, your camera offers the Noise Reduction filter, found on the Shooting menu.

Before you enable noise reduction, be aware that doing so has a few disadvantages. First, the filters are applied after you take the picture, as the camera processes the image data. For pictures taken at very slow shutter speed or at a very high ISO, the time needed to finish the noise removal can significantly slow down your shooting speed — in fact, it can double the time the camera needs to record the file to the memory card. While the noise-removal is in process, you see the message "Job nr" in the viewfinder, and you can't take any pictures.

Second, although long-exposure noise filters do a fairly good job, those that attack high ISO noise work primarily by applying a slight blur to the image. Don't expect this process to totally eliminate noise, and do expect some resulting image softness. You may be able to get better results by using the blur tools or noise-removal filters found in many photo editors because you can blur just the parts of the image where noise is most noticeable — usually in areas of flat color or little detail, such as skies.

To disable Auto ISO override, just reset the Auto ISO Sensitivity Control option to Off.

ISO value display: Although the Information screen always displays the current ISO setting, the viewfinder reports the ISO value only when the option is set to Auto. Otherwise the ISO area of the viewfinder is empty.

Choosing an Exposure Metering Mode

To fully interpret what your exposure meter tells you, you need to know which *metering mode* is active. The metering mode determines which part of the frame the camera analyzes to calculate the proper exposure. The metering mode affects the exposure-meter reading as well as the exposure settings that the camera chooses in the fully automatic shooting modes (Auto, Auto Flash Off, and the Scene modes) as well as in the semi-auto modes (P, S, and A).

Your camera offers three metering modes, described in the following list and represented in the Information display by the icons you see in the margins:

✓ Matrix: The camera analyzes the entire frame and then selects an exposure that's designed to produce a balanced exposure.

Your camera manual refers to this mode as 3D Color Matrix II, which is the label that Nikon created to describe the specific technology used in this mode.

- Center-weighted: The camera bases exposure on the entire frame but puts extra emphasis — or *weight* — on the center of the frame.
- ✓ Spot: In this mode, the camera bases exposure entirely on a circular area that's about 3.5mm in diameter, or about 2.5 percent of the frame. The exact location used for this pin-point metering depends on an autofocusing option called the AF-Area mode. Detailed in Chapter 8, this option determines which of the camera's focus points the autofocusing system uses to establish focus. Here's how the setting affects exposure:
 - *If you choose the Auto Area mode,* in which the camera chooses the focus point for you, exposure is based on the center focus point.
 - *If you use any of the other AF-Area modes,* which enable you to select a specific focus point, the camera bases exposure on that point.

Because of this autofocus/autoexposure relationship, it's best to switch to one of the AF-Area modes that allow focus-point selection when you want to use spot metering. In the Auto Area mode, exposure may be incorrect if you compose your shot so that the subject isn't at the center of the frame.

As an example of how metering mode affects exposure, Figure 7-15 shows the same image captured at each mode. In the matrix example, the bright background caused the camera to select an exposure that left the statue quite dark. Switching to center-weighted metering helped somewhat, but didn't quite bring the statue out of the shadows. Spot metering produced the best result as far as the statue goes, although the resulting increase in exposure left the sky a little washed out.

Matrix metering is the default setting, and you can change the metering mode only in the P, S, A, and M exposure modes. Use either of these approaches:

✓ Info Edit display: When the Information screen is displayed, press the Info Edit button to switch to the Info Edit display and then highlight the Metering mode symbol, as shown on the left in Figure 7-16. Press OK to display the list of options, as shown on the right.

Shooting menu: You also can adjust the setting via the Metering item on the Shooting menu, as shown in Figure 7-17.

Chapter 7: Getting Creative with Exposure

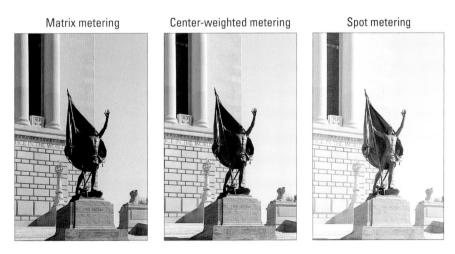

Figure 7-15: The metering mode determines which area of the frame the camera considers when calculating exposure.

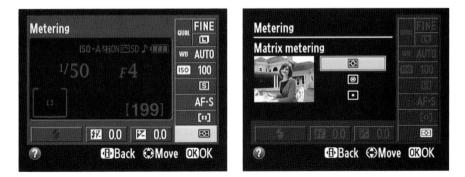

Figure 7-16: The fastest route to the metering mode is the Info Edit display.

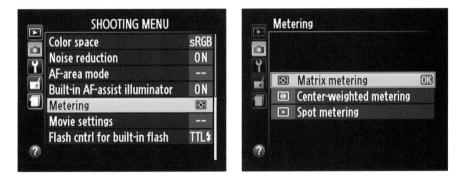

Figure 7-17: But you also can access the setting from the Shooting menu.

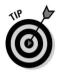

In theory, the best practice is to check the metering mode before you shoot, and choose the one that best matches your exposure goals. But in practice, that's a bit of a pain, not just in terms of having to adjust yet one more capture setting but in terms of having to *remember* to adjust one more capture setting. So here's my advice: Until you're really comfortable with all the other controls on your camera, just stick with the default setting, which is matrix metering. That mode produces good results in most situations, and after all, you can see in the monitor whether you disagree with how the camera metered or exposed the image and simply reshoot after adjusting the exposure settings to your liking. This option, in my mind, makes the whole metering mode issue a lot less critical than it is when you shoot with film.

The one exception to this advice might be when you're shooting a series of images in which a significant contrast in lighting exists between subject and background. Then, switching to center-weighted metering or spot metering may save you the time of having to adjust the exposure for each image.

Sorting Through Your Camera's Exposure-Correction Tools

In addition to the normal controls over aperture, shutter speed, and ISO, your D3200 offers a collection of tools that enable you to solve tricky exposure problems. The next several sections give you the lowdown on these features.

Applying Exposure Compensation

When you set your camera to the P, S, or A modes, you can enjoy autoexposure support but still retain some control over the final exposure. If you think that the image the camera produced is too dark or too light, you can use *Exposure Compensation*. This feature enables you to tell the camera to produce a darker or lighter exposure than what its autoexposure mechanism thinks is appropriate.

Here's what you need to know to take advantage of it:

Exposure Compensation settings are stated in terms of EV numbers, as in EV +2.0. Possible values range from EV +5.0 to EV -5.0. (EV stands for exposure value.)

Each full number on the EV scale represents an exposure shift of one *stop.* If you're new to this terminology, see the section "Reading the Meter," earlier in this chapter.

✓ A setting of EV 0.0 results in no exposure adjustment.

- ✓ For a brighter image, raise the Exposure Compensation value. The higher you go, the brighter the image becomes.
- ✓ For a darker image, lower the EV.

As an example, take a look at the first image in Figure 7-18. The initial exposure selected by the camera left the balloon a tad too dark for my taste. So I just amped the Exposure Compensation setting to EV +1.0, which produced the brighter exposure on the right.

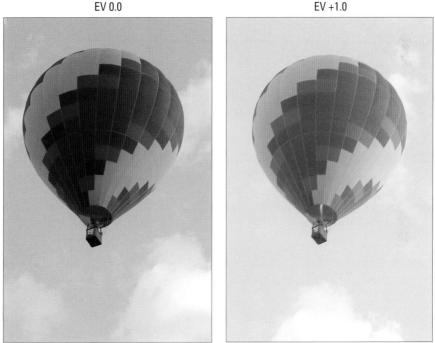

Figure 7-18: For a brighter exposure, raise the Exposure Compensation value.

To change the setting, you have two options:

Press the Exposure Compensation button while rotating the Command dial. As soon as you press the button, the Information display changes to appear as shown in Figure 7-19. If you're looking through the viewfinder, the shots remaining value is temporarily replaced by the Exposure Compensation value when you press the Exposure Compensation button.

EV +1.0

238

While holding the Exposure Compensation button, rotate the Command dial to adjust the EV. As you change the setting, the exposure meter in the viewfinder and Information display appears and updates to show you the degree of adjustment you're making. Each bar that appears under the meter equals an adjustment of 1/3 stop (EV +/-0.3).

After you release the button, the Information screen goes back to normal, and the shots remaining value returns to the viewfinder.

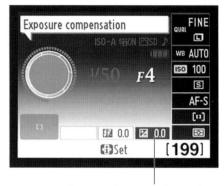

Figure 7-19: Press the Exposure Compensation button and rotate the Command dial to quickly adjust the setting.

Use the Info Edit display: You

also can adjust the Exposure Compensation setting via the Info Edit display, as shown in Figure 7-20. Remember, you can shift from the Information screen to the Info Edit display by pressing the Info Edit button.

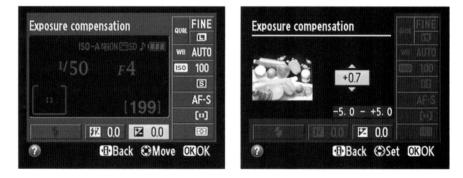

Figure 7-20: You also can raise or lower Exposure Compensation through the Info Edit screen.

In either case, the 0 on the meter in the viewfinder and Information display blinks to remind you that Exposure Compensation is active. You also see a little plus/minus symbol (the same one that decorates the Exposure Compensation button) in the viewfinder display, and the meter readout indicates the amount of compensation you applied.

In P, S, and A exposure modes, your Exposure Compensation setting remains in force until you change it, even if you power off the camera. So you may want to make a habit of checking the setting before each shoot or always setting the value back to EV 0.0 after taking the last shot for which you want to apply compensation.

Just a few other tips:

- How the camera arrives at the brighter or darker image you request through your Exposure Compensation setting depends on the exposure mode:
 - *In A (aperture-priority autoexposure) mode,* the camera adjusts the shutter speed but leaves your selected f-stop in force. Be sure to check the resulting shutter speed to make sure that it isn't so slow that camera shake or blur from moving objects is problematic.
 - *In S (shutter-priority autoexposure) mode,* the camera opens or stops down the aperture.
 - *In P (programmed autoexposure) mode,* the camera decides whether to adjust aperture, shutter speed, or both.
 - *In all three modes*, the camera may also adjust ISO if you have Auto ISO enabled.

Keep in mind that the camera can adjust f-stop only so much, according to the aperture range of your lens. And the range of shutter speeds, too, is limited by the camera itself. So if you reach the ends of those ranges, you either have to compromise on shutter speed or aperture or adjust ISO.

- ✓ When you use flash, the Exposure Compensation setting affects both background brightness and flash power. But you can further modify the flash power through a related option, Flash Compensation. You can find out more about that feature later in this chapter.
- Finally, if you don't want to fiddle with Exposure Compensation, just switch to manual exposure mode — M, on the Mode dial — and select whatever aperture and shutter speed settings produce the exposure you're after.

Although the camera doesn't change your selected exposure settings in manual mode even if Exposure Compensation is enabled, the exposure meter *is* affected by the current setting, which can lead to some confusion. The meter indicates whether your shot will be properly exposed based on the Exposure Compensation setting. So if you don't realize that Exposure Compensation is enabled, you may mistakenly adjust your exposure settings when they're actually on target for your subject. This is yet another reason why it's best to always reset the Exposure Compensation setting back to EV 0.0 after you're done using that feature.

Using autoexposure lock

To help ensure a proper exposure, your camera continually meters the light until the moment you depress the shutter button fully. In autoexposure modes, it also keeps adjusting exposure settings as needed to maintain a good exposure.

For most situations, this approach works great, resulting in the right settings for the light that's striking your subject at the moment you capture the image. But on occasion, you may want to lock in a certain combination of exposure settings. For example, perhaps you want your subject to appear at the far edge of the frame. If you were to use the normal shooting technique, you'd place the subject under a focus point, press the shutter button halfway to lock focus and set the initial exposure, and then reframe to your desired composition to take the shot. The problem is that exposure is then recalculated based on the new framing, which can leave your subject under- or overexposed.

The easiest way to lock in exposure settings is to switch to M (manual) exposure mode and use the f-stop, shutter speed, and ISO settings that work best for your subject. But if you prefer to stay with an autoexposure mode, you can press the AE-L/AF-L button to lock exposure before you reframe. This feature is known as *autoexposure lock*, or AE Lock for short.

You can take advantage of AE Lock in any autoexposure mode except Auto or Auto Flash Off. However, you get the best results using Spot metering, which you can't access in modes other than P, S, or A. So I suggest that you set your camera to one of those modes before taking these steps:

1. Set the metering mode to spot metering.

Select the option via the Info Edit screen or Shooting menu. The icon representing spot metering looks like the one shown in Figure 7-21.

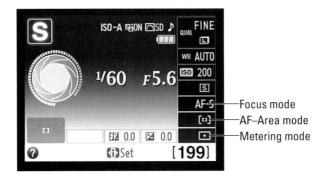

Figure 7-21: Use these metering and autofocus settings for best results when applying autoexposure lock.

2. If autofocusing, set the Focus mode to AF-S and the AF-Area mode to Single Point.

Use the Info Edit screen to select the Focus mode; use the screen or Shooting menu to adjust the AF-Area mode. Again, Figure 7-21 shows you how the icons that represent the suggested settings appear in the Information display.

3. Frame the subject so that it falls under one of the focus points, and then use the Multi Selector to select that point.

You sometimes need to press the shutter button halfway and release it to activate the exposure meters before you can do so. As you press the Multi Selector to cycle through the focus points, the currently selected point flashes red.

In spot metering mode, the focus point determines the area used to calculate exposure, so this step is critical whether you use autofocusing or manual focusing.

4. Press the shutter button halfway.

The camera sets the initial exposure settings. If you're using autofocusing, focus is also set at this point. For manual focusing, twist the focusing ring on the lens to bring the subject into focus.

5. Press and hold the AE-L/AF-L button.

This button's just to the left of the Command dial.

While the button is pressed, the letters AE-L appear at the left end of the viewfinder to remind you that exposure lock is applied.

By default, focus is locked at the same time if you're using autofocusing. You can change this behavior by customizing the AE-L/AF-L button function, as outlined in Chapter 11.

6. Reframe the shot if desired and take the photo.

Be sure to keep holding the AE-L/AF-L button until you release the shutter button! And if you want to use the same focus and exposure settings for your next shot, just keep the AE-L/AF-L button pressed.

Expanding tonal range with Active D-Lighting

A scene like the one in Figure 7-22 presents the classic photographer's challenge: Choosing exposure settings that capture the darkest parts of the subject appropriately causes the brightest areas to be overexposed. And if you instead *expose for the highlights* — that is, set the exposure settings to capture the brightest regions properly — the darker areas are underexposed.

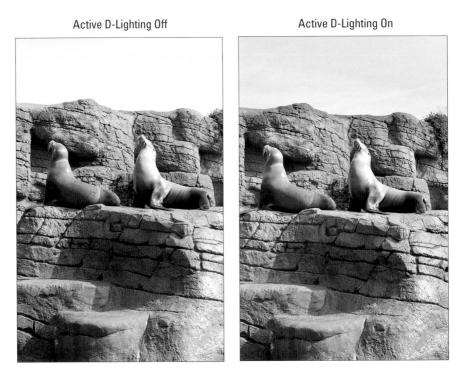

Figure 7-22: Active D-Lighting captured the shadows without blowing out the highlights.

In the past, you had to choose between favoring the highlights or the shadows. But with the D3200, you can expand the possible *tonal range* — that's photo-speak for the range of brightness values in an image — through the Active D-Lighting feature. It's designed to give you a better chance of keeping your highlights intact while better exposing the darkest areas.

The *D* in Active D-Lighting is a reference to the term *dynamic range*, which is used to describe the range of brightness values that an imaging device can capture. By turning on this feature, you enable to camera to produce an image with a slightly greater dynamic range than usual.

In my seal scene, turning on Active D-Lighting produced a brighter rendition of the darkest parts of the rocks and the seals, for example, and yet the color in the sky didn't get blown out as it did when I captured the image with Active D-Lighting turned off. The highlights in the seal and in the rocks on the lower-right corner of the image also are toned down a tad in the Active D-Lighting version. Active D-Lighting actually does its thing in two stages. First, it selects exposure settings that result in a slightly darker exposure than normal. This half of the equation guarantees that you retain details in your highlights. After you snap the photo, the camera brightens the darkest areas of the image. This adjustment rescues shadow detail.

A symbol at the top of the Information display lets you know when Active D-Lighting is enabled. Look for the symbol in the spot indicated in Figure 7-23. The option is always turned on for Auto, Auto Flash Off, Guide, and Scene modes. In the P, S, A, and M modes, you can turn Active D-Lighting on or off as follows:

- Shooting menu: The option lurks on the Shooting menu, as shown in Figure 7-24.
- ✓ Fn button plus Command dial: You also can set the Fn (Function button) to immediately call up the Active D-Lighting setting instead of performing its default role, which is to offer quick access to the ISO Sensitivity setting. Chapter 11 shows you how. If you make the change, rotate the Command dial while pressing the Fn button to toggle the Active D-Lighting setting on and off.

A few final pointers on Active D-Lighting:

You get the best results in matrix metering mode. Active D-Lighting symbol

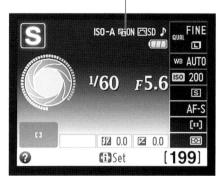

Figure 7-23: This symbol tells you whether Active D-Lighting is turned on or off.

	SHOOTING MENU	
	Reset shooting menu	
	Set Picture Control	⊡SD
Ŷ	Image quality	FINE
	lmage size	
Ľ	White balance	AUTO
	ISO sensitivity settings	
	Active D-Lighting	ON
?	Auto distortion control	0FF

Figure 7-24: In the advanced exposure modes, you can turn Active D-Lighting on or off via the Shooting menu.

- $\blacktriangleright\!\!\!/$ Active D-Lighting doesn't work when the ISO is set to Hi 1.
- In the M exposure mode, the camera doesn't change your shutter speed or f-stop to achieve the darker exposure it needs for Active D-Lighting to work; instead, the meter readout guides you to select the right settings unless you have automatic ISO override enabled. In that case, the camera may instead adjust ISO to manipulate the exposure.

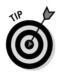

244

If you opt out of Active D-Lighting, remember that the camera's Retouch menu offers a D-Lighting filter that applies a similar adjustment to existing pictures. (See Chapter 10 for help.) Some photo-editing programs, including Nikon ViewNX 2, also have good shadow and highlight recovery filters. (In ViewNX 2, investigate the D-Lighting HS, Shadow Protection, and Highlight Protection filters; the program's Help system explains how to use them.) In any case, when you shoot with Active D-Lighting disabled, you're better off setting the initial exposure settings to record the highlights as you want them. It's very difficult to bring back lost highlight detail after the fact, but you typically can unearth at least a little bit of detail from the darkest areas of the image.

Investigating Advanced Flash Options

Sometimes no amount of fiddling with aperture, shutter speed, and ISO produces a bright-enough exposure — in which case, you simply have to add more light. The built-in flash on your D3200, shown on the left in Figure 7-25, offers the most convenient solution, but you can also attach an external flash to the camera's *hot shoe*, also labeled in the figure. When you first take the camera out of the box, the contacts on the shoe are protected by a little cover; remove the cover to reveal the contacts and attach a flash.

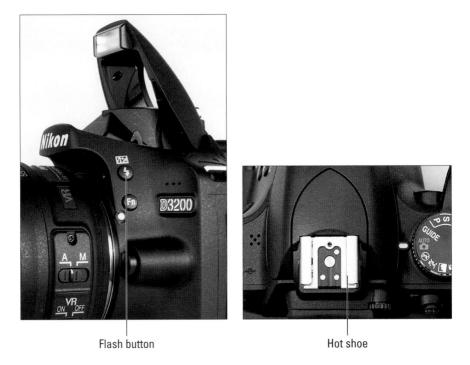

Figure 7-25: Press the Flash button to pop up the built-in flash in the P, S, A, and M exposure modes.

Chapter 2 introduces you to flash basics; here's a quick recap to save you the trouble of flipping back there:

- Enabling flash: Whether you have access to flash and how you enable it depends on your exposure mode:
 - Auto Flash Off, Landscape, and Sports: Flash is disabled and won't fire even if you beg the camera in your most endearing voice.
 - *Auto, Portrait, Night Portrait, Child, and Close-Up:* By default, the camera automatically raises and fires the built-in flash when it thinks more light is needed (assuming that an external flash isn't attached, in which case popping up the built-in flash would deliver a nasty punch in the nose). However, you can disable flash by setting the flash mode to Off, as described next.

The camera uses battery power to keep the flash recycled and ready to use. So to prolong battery life, shut the flash head when you're done with your current batch of flash shots.

Setting the Flash mode: In exposure modes that permit flash, you can access a variety of Flash modes, which determine when and how the flash fires. Upcoming sections describe each mode; first, familiarize yourself with how you adjust the setting.

A symbol representing the current Flash mode appears in the Information display, in the spot labeled on the left in Figure 7-26. You can change the mode by using either of these methods:

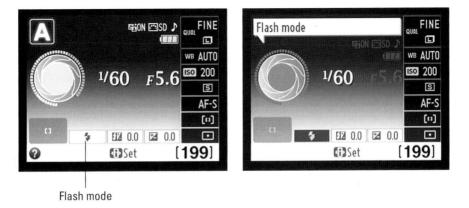

Figure 7-26: After raising the flash, press the Flash button while rotating the Command dial to change the Flash mode.

• *Flash button* + *Command dial*: After the flash is raised — remember, in P, S, A, and M modes, you have to do it yourself by pressing the Flash button — pressing the Flash button again displays the Flash mode flag on the Information screen, as shown on the right in Figure 7-26. Keep the button pressed while rotating the dial to cycle through the available Flash modes. Which modes are available depends on your exposure mode.

• *Info Edit screen:* Alternatively, you can set the Flash mode through the Info Edit screen. Press the Info Edit button to shift from the Information screen to the Info Edit screen; then highlight the Flash mode icon, as shown on the left in Figure 7-27, and press OK to display a list of mode choices, as shown on the right. Highlight your choice and press OK.

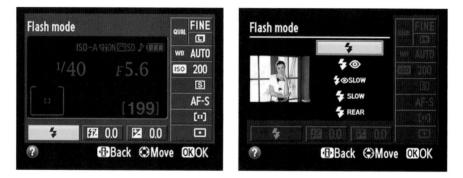

Figure 7-27: You also can adjust the Flash mode through the Info Edit screen.

With that refresher course out of the way, the rest of this chapter explains flash modes in detail and explains how you can adjust the output of the flash (an option available only in the P, S, A, and M exposure modes). Chapter 9 offers additional flash and lighting tips related to portraits and other specific types of photographs.

Before you move on, though, here's one preliminary tip: Pay careful attention to your results when you use the built-in flash with a telephoto lens that's very long. You may find that the flash casts an unwanted shadow when its light strikes the lens. For best results, try switching to an external flash head. The same warning applies to lens hoods: If you're using one, you may want to remove it for flash photography.

247

Finding more flashes of inspiration

Although this book gets you started with flash photography, there's much more to the topic than I have room to cover. So I point you toward a couple of my favorite resources for delving more deeply into the topic:

- Nikon's United States website (www. nikonusa.com) offers some great tutorials on flash photography (as well as other subjects). Start in the Learn & Explore section of the site.
- A website completely dedicated to flash photography, www.strobist.com,

enables you to learn from and share with other photographers.

✓ You can find several good books detailing the entire Nikon flash system, which it calls the *Creative Lighting System* (*CLS*, for short). This system is designed to enable you to light subjects with multiple flash heads and then control all the flashes with one main unit. Your camera doesn't have the feature which enables it to serve as a CLS controller, but you can buy an adapter that allows this function. Look for information about the SU-800 controller.

Choosing the right Flash mode

Your Flash mode choices break down into three basic categories, described in the next sections: Fill Flash; Red-Eye Reduction; and the sync modes, Slow-Sync and Rear-Sync, which are special-purpose flash options.

Note that when you shoot in the P, S, A, or M exposure modes, the list of available Flash modes doesn't include three options available in some of the fully automatic exposure modes: Auto, in which the camera makes the decisions about when to fire the flash; its companion, Auto with Red-Eye Reduction; and Off. Instead, if you don't want the flash to fire, simply keep the flash unit closed; if you do want flash, raise the flash, and it will fire when you press the shutter button.

The camera does give you a little auto-flash input though: You see a blinking question mark, flash symbol, or both in the viewfinder in the P, S, M, and A modes if the camera thinks you need flash, and the Information display also tells you that the scene is too dark. Press the Zoom Out button (the one with the question mark above it), and a message appears recommending that you use flash.

For help using flash in Auto, Guide, and Scene modes, see Chapter 3. The rest of this chapter assumes that you're working in P, S, A, or M mode.

The Fill Flash setting is represented by the plain-old lightning-bolt symbol you see in the margin here. You can think of this setting as "normal flash" — at least in the way that most think of using a flash. You may also hear this mode called *force* flash because the flash fires no matter what the available light, unlike in the Auto Flash mode provided for the fully automatic exposure modes, in which the camera decides when flash is needed. In Fill Flash mode, the flash fires even in the brightest daylight — which, by the way, is often an

Fill Flash

excellent idea.

Yep, you read me correctly: Adding a flash can really improve outdoor photos, even when the sun is at its sunniest. After all, your main light source — the sun — is overhead, so although the top of the subject may be adequately lit, the front typically needs some additional illumination. As an example, Figure 7-28 shows a floral image taken both with and without a flash. The small pop of light provided by the built-in flash is also extremely beneficial when shooting subjects that happen to be slightly shaded, such as the carousel horses featured in the "Adjusting flash output" section. For outdoor portraits, a flash is even more important; the section on shooting still portraits in Chapter 9 discusses that subject and offers a look at the difference a flash can make.

You do need to beware of a couple complications with using flash in bright light, however:

✓ Colors may need tweaking when you mix light sources. When you combine multiple light sources, such as flash with daylight, colors may appear warmer or cooler than neutral. In Figure 7-28, colors became warmer with the addition of flash. For outdoor portraits, the warming effect is usually flattering, and I usually like the result with nature shots as well. But if you prefer a neutral color rendition, see the Chapter 8 section related to the White Balance control to find out how to address this issue.

Keep an eye on shutter speed. Because of the way the camera needs to synchronize the firing of the flash with the opening of the shutter, the fastest shutter speed you can use with the built-in flash is 1/200 second. In bright sun, you may need to stop down the aperture significantly or lower ISO, if possible, to avoid overexposing the image even at 1/200 second. As another option, you can place a neutral density filter over your lens; this accessory reduces the light that comes through the lens without affecting colors. Of course, if possible, you can simply move your subject into the shade.

Chapter 7: Getting Creative with Exposure

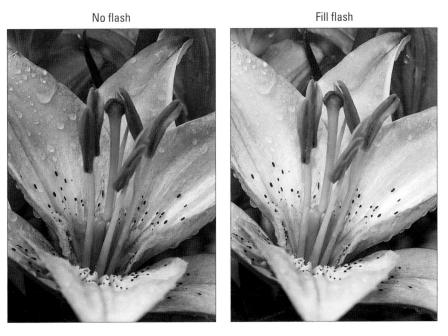

Figure 7-28: Adding flash resulted in better illumination and a slight warming effect.

- On the flip side, the camera may select a shutter speed as slow as 1/60 second in the P and A modes, depending on the lighting conditions. So if your subject is moving, it's a good idea to work in the S or M modes so that you control shutter speed.
- For close-ups, you may need to reduce flash power to avoid overexposing the subject. I find that at the default flash power, the built-in flash is almost always too strong. No worries — you can dial down the flash output, as explained later in this chapter.

Red-Eye Reduction flash

Red-eye is caused when flash light bounces off a subject's retinas and is reflected back to the camera lens. Red-eye is a human phenomenon, though; with animals, the reflected light usually glows yellow, white, or green, producing an image that looks like your pet is possessed by some demon.

Man or beast, this issue isn't nearly the problem with the type of pop-up flash found on your camera as it is on non-SLR cameras. The D3200 flash is positioned in such a way that the flash light usually doesn't hit a subject's eyes straight on, which lessens the chances of red-eye. However, red-eye may still be an

issue when you use a lens with a long focal length (a telephoto lens) or you shoot subjects from a distance. Even then, the problem usually crops up only in dark settings — in outdoor shots and other brightly lit scenes, the pupils constrict in reaction to the light, lessening the chance of red-eye. And because of the bright light, the flash power needed to expose the picture is lessened, also helping eliminate red-eye.

fy the icon shown in the margin here. In this mode, the AF-assist lamp on the front of the camera lights up briefly before the flash fires. The subject's pupils constrict in response to the light, allowing less flash light to enter the eye and cause that glowing red reflection. Be sure to warn your subjects to wait for the flash, or they may step out of the frame or stop posing after they see the light from the AF-assist lamp.

For an even better solution, try the flash-free portrait tips covered in Chapter 9. If you do a lot of portrait work that requires flash, you may also want to consider an external flash unit, which enables you to aim the flash light in ways that virtually eliminate red-eye.

If all else fails, check out Chapter 10, which shows you how to use the built-in red-eye removal tool on your camera's Retouch menu. Sadly, though, this feature removes only red-eye, not the yellow/green/white eye that you get with animal portraits.

Slow-Sync and Rear-Sync flash

In Fill Flash and Red-Eye Reduction Flash modes, the flash and shutter are synchronized so that the flash fires at the exact moment the shutter opens.

Technical types refer to this flash arrangement as *front-curtain sync*, which refers to how the flash is synchronized with the opening of the shutter. Here's the deal: Your camera uses a type of shutter that involves two curtains moving across the frame each time you press and release the shutter button. When you press the shutter button, the first curtain opens, allowing light through to the sensor. At the end of the exposure, the second curtain draws across the frame to once again shield the sensor from light. With front-curtain sync, the flash fires at the moment the front curtain opens.

Your D3200 also offers four special sync modes, which work as follows:

Slow-Sync: This mode, available only in the P and A exposure modes, also uses front-curtain sync but allows a shutter speed slower than the 1/60 second minimum that's in force when you use Fill Flash and Red-Eye Reduction flash.

The benefit of this longer exposure is that the camera has time to absorb more ambient light, which in turn has two effects: Background areas that are beyond the reach of the flash appear brighter; and less flash power is needed, resulting in softer lighting.

The downside of the slow shutter speed is, well, the slow shutter speed. As discussed earlier in this chapter, the longer the exposure time, the more you have to worry about blur caused by movement of your subject or your camera. A tripod is essential to a good outcome, as are subjects that can hold very, very still. I find that the best practical use for this mode is shooting nighttime still-life subjects like the one you see in Figure 7-29. However, if you're shooting a nighttime portrait and you have a subject that *can* maintain a motionless pose, slow-sync flash can produce softer, more flattering light. Again, the portrait section of Chapter 9 offers an example.

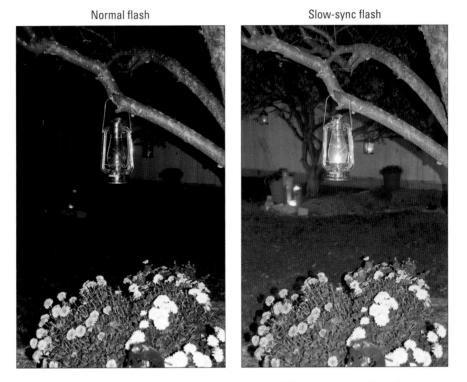

Figure 7-29: Slow-sync flash produces softer, more even lighting than normal flash in nighttime pictures.

Some photographers, on the other hand, turn the downside of slow-sync flash to an upside, using it to purposely blur their subjects. The idea is to use the blur to emphasize motion.

Note that even though the official Slow-Sync mode appears only in the P and A exposure modes, you can get the same result in the M and S modes by simply using a slow shutter speed and the normal, Fill Flash mode. You can use a shutter speed as slow as 30 seconds when using flash in those modes. In fact, I prefer those modes when I want the slow-sync look because I can directly control shutter speed. In Manual (M) mode, you can even use flash with the shutter speed set to Bulb, the setting that keeps the shutter open as long as you hold down the shutter button.

Rear-Curtain Sync: In this mode, available only in shutter-priority (S) and manual (M) exposure modes, the flash fires at the very end of the exposure, just before the shutter closes. The classic use of this mode is to combine the flash with a slow shutter speed to create trailing-light effects like the one you see in Figure 7-30. With Rear-Curtain Sync, the light trails extend behind the moving object (my hand, and the match, in this case), which makes visual sense. If instead you use slow-sync flash, the light trails appear in front of

You can set the shutter speed as low as 30 seconds and as high as 1/200 second in this Flash mode.

Figure 7-30: I used rear-curtain sync flash to create this candle-lighting image.

Rear-Curtain and Slow Sync: Hey, not confusing enough for

the moving object.

you yet? This mode enables you to produce the same motion trail effects as with Rear-Curtain Sync, but in the P and A exposure modes. The camera automatically chooses a slower shutter speed than normal after you set the f-stop, just as with regular Slow-Sync mode.

Note that as you scroll through the available Flash modes, the symbol for this mode initially shows just the flash symbol and the word Rear; after you finish selecting the setting, the label changes to Slow Rear.

REAR

✓ Slow-Sync with Red-Eye Reduction: In P and A exposure modes, you can also combine a slow-sync flash with the red-eye reduction feature. Given the potential for blur that comes with a slow shutter, plus the potential for subjects to mistake the prelight from the AF-assist lamp for the real flash and walk out of the frame before the image is actually recorded, I vote this Flash mode as the most difficult to pull off successfully.

All these modes are somewhat tricky to use successfully, however. So have fun playing around, but at the same time, don't feel too badly if you don't have time right now to master these modes plus all the other exposure options presented to you in this chapter. In the meantime, search the web for slow-sync and rear-sync image examples if you want to get a better idea of the special effects that other photographers create with these Flash modes.

Adjusting flash output

6

When you shoot with your built-in flash, the camera attempts to adjust the flash output as needed to produce a good exposure. But if you shoot in the P, S, A, or M exposure modes and you want a little more or less flash light than the camera thinks is appropriate, you can adjust the flash output by using *Flash Compensation*. (Technically, you also can access this setting in Guide mode, but if you're this far along in your photography, my guess is that you've left Guide mode behind, as it makes accessing settings such as this one more complicated. See Chapter 3 for help with Guide mode and to see if you agree with my conclusion.)

In sync: Flash timing and shutter speed

To properly expose flash pictures, the camera has to synchronize the timing of the flash output with the opening and closing of the shutter. For this reason, the range of shutter speeds available to you is more limited when you use flash than when you go flash-free.

When you use flash, the maximum shutter speed is 1/200 second. The minimum shutter speed varies depending on your exposure mode, as follows:

- Auto, Child, Close-Up: 1/60 second
- Nighttime Portrait: 1 second

- Portrait: 1/30 second
- P, A: 1/60 second (unless you use one of the Slow-Sync Flash modes, which permit a slower shutter speed)
- ▶ S: 30 seconds
- M: 30 seconds (can exceed that limit if the shutter speed is set to bulb)

These same shutter-speed requirements apply to both the built-in flash and an external flash head.

At any rate, Flash Compensation works just like Exposure Compensation, discussed earlier in the chapter, except that it enables you to override the camera's flash-power decision instead of its autoexposure decision. As with Exposure Compensation, the Flash Compensation settings are stated in terms of EV (*exposure value*) numbers. A setting of 0.0 indicates no flash adjustment; you can increase the flash power to EV +1.0 or decrease it to EV -3.0.

As an example of the benefit of this feature, look at the carousel images in Figure 7-31. The first image shows you a flash-free shot. Clearly, I needed a flash to compensate for the fact that the horses were shadowed by the roof of the carousel. But at normal flash power, as shown in the middle image, the flash was too strong, creating glare in some spots and blowing out the highlights in the white mane. By dialing the flash power down to EV -0.7, I got a softer flash that straddled the line perfectly between no flash and too much flash.

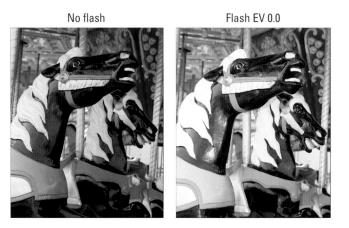

Figure 7-31: When normal flash output is too strong, dial in a lower Flash Compensation setting.

As for boosting the flash output, well, you may find it necessary on some occasions, but don't expect the built-in flash to work miracles even at a Flash Compensation of +1.0. Any built-in flash has a limited range, and you simply can't expect the flash light to reach faraway objects. In other words, don't even try taking flash pictures of a darkened recital hall from your seat in the balcony — all you'll wind up doing is annoying everyone.

The current Flash Compensation setting appears in the Shooting Info display, in the area highlighted in Figure 7-32. Don't confuse the setting with the neighboring Exposure Compensation setting, also labeled in the figure. (The flash symbol in the Flash Compensation icon is the key reminder to which setting does what.)

To adjust the amount of Flash Compensation, you have two options:

•12 **(**)

Flash button plus Exposure **Compensation button plus** Command dial: First, press the Flash button to pop up the built-in flash, if it's not already raised. Then press and hold the Flash button and the Exposure Compensation button simultaneously. When you press the buttons, you see the screen shown in Figure 7-33. In the viewfinder, the current setting takes the place of the usual shots-remaining value. While keeping both the buttons pressed, rotate the Command dial to adjust the setting. I find that any technique that involves coordinating this many fingers a little complex, but you may find it

easier than I do.

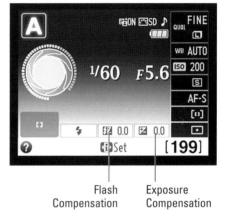

Figure 7-32: The Flash Compensation setting lives just next door to the Exposure Compensation setting.

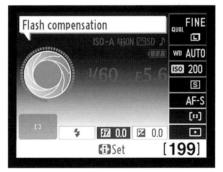

Figure 7-33: Rotate the Command dial while pressing the Flash and Exposure Compensation buttons to adjust flash power.

adjust the setting via the Info Edit display, as illustrated in Figure 7-34.

Info Edit display: You also can

As with Exposure Compensation, any flash-power adjustment you make remains in force, even if you turn off the camera, until you reset the control. So be sure to check the setting before you next use your flash.

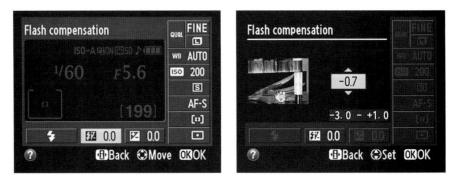

Controlling flash output manually

If you're experienced in the way of the flash, you can manually set the flash output instead of letting the camera dictate the right amount of flash light. To do so, open the Shooting menu and highlight Flash Cntrl (control) for Built-in Flash, as shown on the left in Figure 7-35. Press OK, select Manual, as shown on the right in the figure, and press OK again to display the available settings. Your options are from Full power to 1/32 power.

The TTL setting you see on the right in Figure 7-35 is the default flash setting, in which the camera sets the proper flash power for you. *TTL* stands for *through the lens*, which means that the camera meters the light that's coming through the lens to calculate flash and exposure.

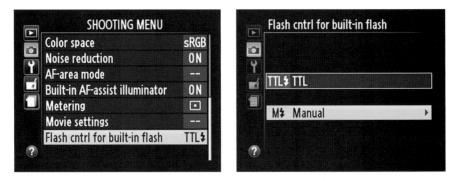

Figure 7-35: Through this option, you can control the flash output manually.

257

While manual flash control is enabled, an icon that looks like the Information display's Flash Compensation icon (a lightning bolt with a plus-minus sign) blinks in the viewfinder.

8

Manipulating Focus and Color

In This Chapter

- Adjusting the camera's autofocusing performance
- Perfecting your manual focusing technique
- Understanding focal lengths, depth of field, and other focus factors
- Exploring white balance and its effect on color
- Investigating the Color Space and Picture Control options

To many people, the word *focus* has just one interpretation when applied to a photograph: Either the subject is in focus or it's blurry. And although it's true that this characteristic of your photographs is an important one, an artful photographer knows that there's more to focus than simply getting a sharp image of a subject. You also need to consider *depth of field*, or the distance over which objects appear sharply focused.

This chapter explains all the ways to control depth of field and also explains how to use your camera's advanced focusing options. Additionally, this chapter dives into the topic of color, explaining the White Balance control, which compensates for the varying color casts created by different light sources. You also can get my take on the other advanced color options on your D3200, including the Color Space and Picture Control settings.

Note: Autofocusing features covered here relate to regular, through-the-viewfinder photography; Chapter 4 focuses (yuk yuk) on Live View and movie autofocusing, which involves a different set of features and techniques. Also, I don't address Guide mode in this chapter because the focusing and color options available to you in that mode depend on which path you take through the Guided menus, and covering all the possibilities could fill an entire second book. See Chapters 1 and 3 for help with the basics of using Guide mode, if you're interested.

Mastering the Autofocus System

Your camera offers a fast and trustworthy autofocusing system — you can rely on it for tack-sharp images 99 percent of the time, in my experience. But to get the best autofocusing performance, you need to understand which autofocus settings work best for different types of subjects. The default settings usually work fine for portraits, for example, but for sports photography, adjusting the settings typically produces more reliable results.

You have two major avenues of control over the autofocusing system:

- ✓ AF-Area mode: This setting determines which focus points the camera uses to establish focus. You can tell the camera to consider all 11 autofocus points or to base focus on a single point that you select.
- ✓ Focus mode: For autofocusing, you can set the camera to lock focus when you press the shutter button halfway or adjust focus continually up to the moment you depress the button fully to take the picture. You also have a third option, which is to disable autofocusing so that you can focus manually.

The next several sections help you master these options and other aspects of your camera's focusing system.

Reviewing autofocus basics

The Chapter 3 section on taking your first pictures in the Auto and Auto Flash Off exposure modes provides an introduction to autofocusing. But in case you haven't dug into that chapter or need a refresher, the following steps get you up to speed.

These steps apply to any exposure mode (even Guide mode, if you stick with the Easy Operation option and don't fool with any of the default settings). However, they *don't* apply to Live View photography or movie recording; again, check Chapter 4 for information on autofocusing in those modes.

1. Set the focusing switch on the lens to A (autofocus), as shown in Figure 8-1.

This instruction is specific to the kit lens sold with the D3200. Other lenses may have a different sort of switch or no switch at all, so check the lens instruction manual. And note that not all lenses provide autofocusing when paired with the D3200; the camera manual provides information on compatible lenses.

2. Frame the picture so that your subject falls under one of the 11 focus points.

The focus points are represented by the little black markings in the viewfinder.

Chapter 8: Manipulating Focus and Color

For most exposure modes, all 11 focus points are active by default, which means that the camera considers all points when deciding where to set focus. Typically, the camera picks the closest object as the focusing target. The exceptions are the Close Up and Sports modes: In these modes, focus is set on the center point by default, so be sure to frame your subject under that point.

3. Press and hold the shutter button halfway down to indicate focusing.

Depending on the lighting conditions, the AF-assist lamp on the front of the camera may emit a beam to help the autofocus system find its target. (You can disable this light through the Built-in AF-Assist Illuminator option on the Shooting menu if you're shooting in a setting where it's problematic.)

A second or two after you press the button halfway, one or more of the focus points turns red briefly, as shown in Figure 8-2, to let you know which points the camera used to establish focus. Again, in Sports and Close-Up modes, the center point is selected by default; in other modes, the camera typically selects the point(s) covering the closest object, as it did for my example image in Figure 8-2.

The camera offers these additional cues that it set focus successfully:

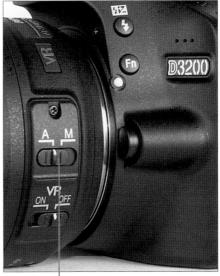

Auto/Manual focus switch

Figure 8-1: Set the lens switch to the A position to use autofocusing.

Selected focus points

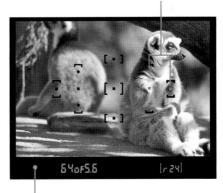

Focus indicator light

Figure 8-2: The red dots indicate selected focus points.

• *For stationary subjects:* The green focus indicator dot lights in the lower-left corner of the viewfinder, as shown in Figure 8-2, and the camera emits a beep. (Use the Beep option on the Setup menu to

adjust the beep volume or turn it off entirely.) Focus is now locked as long as you keep the shutter button depressed halfway.

• *For moving subjects:* The camera sets the initial focusing distance on your subject and then adjusts focus as needed if the subject moves toward or away from the lens. Your job now is to reframe the picture if needed to keep the subject within the area covered by the 11 focus points.

With this continuous autofocusing, the green focus indicator may flicker on and off as the camera tracks focus. But if the light blinks continuously, the camera isn't having any luck focusing on your subject. The beep may or may not sound.

Your half-press of the shutter button also kicks the exposure metering system into gear. And the shots remaining value in the viewfinder changes to show the number of frames that will currently fit in the camera's memory buffer if you shoot in the Continuous (burst) mode. In Figure 8-2, the value is r24, indicating a buffer size of 24 frames. You can explore this topic more in Chapter 2, but don't worry about it now.

4. Press the button the rest of the way to take the picture.

Now that you understand how things work at the default AF-Area mode and Focus mode settings, the next several sections explain how to modify the settings to best suit your subject.

Understanding the AF-Area mode setting

The AF-Area mode option determines which of the 11 focusing points the camera uses to establish focus. (*AF* stands for *autofocus*.) You can view the current setting in the Information display. In fact, the display contains two icons representing the setting, as shown in Figure 8-3. The one in the lower-left corner is designed to give you a bit more information than the simplified version on the right side of the screen. More about what you can glean from that detailed icon momentarily.

Shutter speed and blurry photos

A poorly focused photo isn't always related to the issues discussed in this chapter. Any movement of the camera or subject can also cause blur. Both of these problems are related to shutter speed, an exposure control that I cover in Chapter 7. Be sure to also visit Chapter 9, which provides some additional tips for capturing moving objects without blur.

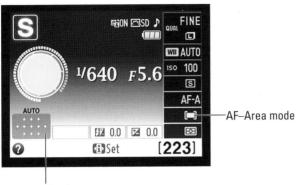

Active AF points

Figure 8-3: These symbols show the current AF-Area mode setting and which focus points are active.

You can choose from four settings, which work as described in the following list and are represented in the lower-left corner of the Information display by the margin icons shown here. (Flip ahead to Figure 8-4 to see the simplified icons that appear on the right side of the Information display.)

✓ Single Point: This mode is designed for shooting still subjects. You use the Multi Selector to choose one of the 11 focus points (details to come), and the camera sets focus on the object that falls within that point. The camera uses this mode by default when you shoot in the Close-Up Scene mode, focusing on the center point by default.

In the lower-left corner of the Information display, you see a single focus point enclosed in brackets to show you which point is selected. For example, an icon like the one you see in the margin here tells you that the center point is selected.

✓ Dynamic Area: In this mode, designed for shooting moving subjects, you select an initial focus point, just as in Single Point mode. But if the subject within that focus point moves after you press the shutter button halfway to set focus, the camera looks for focus information from the other focus points. The idea is that the subject is likely to wind up within one of the 11 focus areas. Dynamic Area is the default setting when you shoot in the Sports Scene mode.

However — and this is a biggie — for the automatic focus adjustment to occur, you also must set the Focus mode (explained in the next section) to either AF-A, the default setting, or AF-C. In fact, Dynamic Area doesn't 'even appear as an AF-Area mode option unless one of these two Focus modes is selected.

In the lower-left corner of the Information display, the icon for the Dynamic Area mode looks similar to the one in the margin here. Your selected focus point is surrounded by brackets, but you also see all the other points to indicate that they're ready to take over if your subject moves. Note that the brackets surrounding your selected focus point don't move if the camera shifts to a different point to focus, but the focus shift is happening just the same.

✓ 3D Tracking: This one is a variation of Dynamic Area autofocusing. As with the Dynamic Area mode, you have to set the Focus mode to AF-A or AF-C to access the 3D Tracking option. And as with Dynamic Area mode, you start by selecting a single focus point and then press the shutter button halfway to set focus. But the goal of this mode is to maintain focus on your subject if you recompose the shot after you press the shutter button halfway to lock focus.

The 3D Tracking icon appears in the lower-left corner of the Information display as shown in the margin here; the brackets indicate your selected focus point. As with Dynamic Area mode, the other points are visible and potentially active, too. The letters 3D above the icon distinguish it from the Dynamic Area icon.

The only problem with 3D Tracking is that the way the camera detects your subject is by analyzing the colors of the object under your selected focus point. So if not much difference exists between the subject and other objects in the frame, the camera can get fooled. And if your subject moves out of the frame, you must release the shutter button and reset focus by pressing it halfway again.

✓ Auto Area: The camera analyzes the objects under all 11 autofocus points and selects the one it deems most appropriate. This mode is the default setting for all exposure modes except Close-Up and Sports modes. In the Information display icon, you see all 11 points, as in Figure 8-3 and in the margin here. The fact that no one point is surrounded by brackets means that the camera is free to choose from any of them.

To keep my life simple, I stick with Single Point for still subjects and Dynamic Area for moving subjects. Auto Area can work well in most cases, but if it makes the wrong focus assumptions, there's no way to select a different focus point. And I prefer Dynamic Area to 3D Tracking for the reasons I just mentioned — it doesn't work for all action subjects, and by the time you figure out whether your subject is compatible with the mode, you can easily miss the shot. Still, I urge you to practice with that mode, too, in case you regularly shoot the types of subjects that it's designed to handle.

265

Whatever your conclusions on the subject, you can adjust the AF-Area mode and select a specific focus point as follows:

- **Setting the AF-Area mode:** You have two options:
 - *Info Edit display*: If the Information screen is visible, tap the Info Edit button to shift to Info Edit mode. Otherwise, press the button twice. Then highlight the AF-Area mode icon, as shown on the left in Figure 8-4, and press OK to access the second screen in the figure, where you see the simplified versions of the icons representing the different mode options.

From top to bottom, the settings are Single Point, Dynamic Area, 3D Tracking, and Auto Area. The name of the selected mode appears above the little picture to help you decode the symbols. Those pictures are supposed to remind you about the type of subject the mode is designed to handle, but I quibble with the one shown in Figure 8-4, which is clearly an action shot and so, in my opinion, a questionable candidate for the Auto Area mode. (I don't know why Nikon doesn't consult me on these things.)

• *Shooting menu:* You also can adjust the setting via the Shooting menu. Select AF-Area Mode, as illustrated on the left in Figure 8-5, and then select Viewfinder, as shown on the right. Press the Multi Selector right to access the list of the available AF-Area mode settings; select your choice and press OK. (See Chapter 4 for help with the options available for Live View and movie modes.)

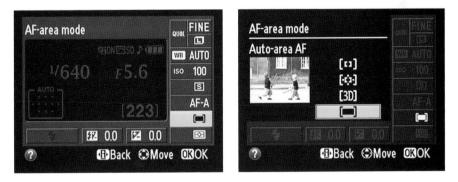

Figure 8-4: Adjust the AF-Area mode through the Info Edit screen.

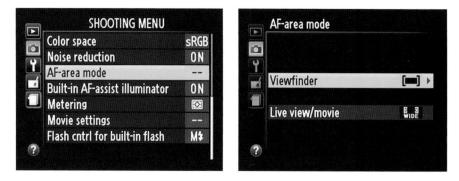

Figure 8-5: Or scroll to the second screen of the Shooting menu and select your choice there.

Don't see the 3D Tracking or Dynamic Area options in the AF-Area mode list? Again, that happens if the Focus mode is not set to either AF-A or AF-C. Refer to the next section for more information on this setting, which lives directly above the AF-Area mode setting on the Info Edit screen.

✓ Selecting a single focus point: To choose a focus point in the Single Area, Dynamic Area, or 3D Tracking modes, press the shutter button halfway and release it to engage the exposure meters, viewfinder display, and Information display. In the viewfinder, the currently selected point flashes red once when you press the shutter button halfway. For example, in the left screen in Figure 8-5, the point directly over the top of the clock tower is selected. Use the Multi Selector to cycle through all 11 points until the one you want to use flashes red.

You also can determine the active point by looking at the large icon in the lower-left corner of the Information display. The brackets indicate the selected point. Refer to the margin icons in the preceding list to see what I mean — in each case, the brackets in the icons indicate that the center point is selected. For my clock tower image, I was in Single Point mode, so the AF-Area mode symbol shows just the single selected point in brackets, as on the right in Figure 8-6. For Dynamic Area and 3D Tracking modes, you also see the other 10 focus points.

To quickly select the center focus point, press OK. No need to cycle your way through all the other focus points to get to the center.

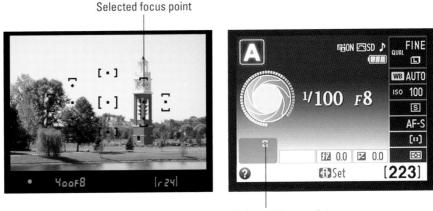

Selected focus point

Figure 8-6: Use the Multi Selector to select the focus point that's over your subject.

Changing the Focus mode setting

Throughout this book, I sometimes use the term *auto/manual focusing mode* generically to refer to the lens switch that shifts your camera from autofocusing to manual focusing — at least, on the kit lens sold with the D3200. But there is also an official Focus mode setting, which offers three settings for tweaking autofocusing behavior and one option that tells the camera that you prefer to focus manually.

The only way to select the Focus mode is via the Info Edit screen. Press the Info Edit button once to display the Information screen; press again to shift to the Info Edit screen. Then use the Multi Selector to highlight the Focus mode setting, as shown in Figure 8-7. The setting lives just upstairs from its focusing cohort, the AF-Area mode option.

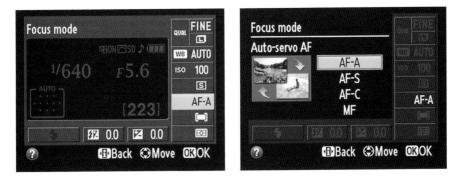

Figure 8-7: The only way to change the Focus mode is via the Info Edit screen.

When you shoot in the P, S, A, or M exposure mode, you can choose from these four options:

AF-S (single-servo autofocus): The camera locks focus when you depress the shutter button halfway. This mode is designed for shooting stationary subjects.

Try this mode if you want to frame your subject so that it doesn't fall under an autofocus point: Compose the scene initially to put the subject under a focus point, press the shutter button halfway to lock focus, and then reframe to the composition you have in mind. As long as you keep the button pressed halfway, focus remains set on your subject. Remember, though, that exposure is adjusted up to the time you take the picture. See Chapter 7 to find out how to use the AE-L/AF-L button to

ALMEMBER

One other critical point about AF-S mode: The camera won't release the shutter to take a picture in this mode until focus is achieved. If you can't get the camera to lock onto your focusing target, switching to manual focusing is the easiest solution. Also be sure that you're not too close to your subject; if you exceed the minimum focusing distance of the lens. you can't focus manually, either.

lock exposure at the same time you lock focus.

✓ AF-C (continuous-servo autofocus): In this mode, which is designed for moving subjects, the camera focuses continuously for the entire time you hold the shutter button halfway down. If the subject moves toward or away from the lens, the camera adjusts focus accordingly; if you pay attention, you may be able to hear or feel the action of the autofocus motor as it resets focus.

Should you need to lock focus at a certain distance while shooting in AF-C mode, use the technique described in the section, "Using autofocus lock," later in this chapter.

✓ AF-A (auto-servo autofocus): This mode is the default setting. The camera analyzes the scene and, if it detects motion, automatically selects continuous-servo mode (AF-C). If the camera instead believes you're shooting a stationary object, it selects single-servo mode (AF-S). Shutter release is prevented if the camera can't focus successfully.

This mode works pretty well, but it can get confused sometimes. For example, if your subject is motionless but other people are moving in the background, the camera may mistakenly switch to continuous autofocus. By the same token, if the subject is moving only slightly, the camera may not make the switch. So my best advice is to choose either AF-S or AF-C instead.

MF (manual focus): Choose this setting if you want to disable autofocusing and focus manually, by twisting the focusing ring on the lens.

On the kit lens featured in this book, simply setting the switch on the lens to M automatically sets the Focus mode to MF. However, the opposite isn't true: Choosing the MF setting for the Focus mode does not free the focusing ring so that you can set focus manually; you must set the lens switch to the M position. For other lenses, check the lens instruction manual for manual-focusing details.

In exposure modes other than P, S, A, and M, you can choose from AF-A and MF only. If you're not ready to step up to those exposure modes and you can't get the camera to autofocus on your subject in AF-A Focus mode, don't waste time trying over and over again — you're not likely to get different results. Instead, just focus manually. You can get help with that approach a few sections later in this chapter.

Choosing the right autofocus combo

You get the best autofocus results if you pair your chosen Focus mode with the most appropriate AF-Area mode because the two settings work in tandem. Here are the combinations that I suggest for the maximum autofocus control:

- ✓ For still subjects, use Single Point as the AF-Area mode and AF-S as the Focus mode. You then select a specific focus point, and the camera locks focus on that point when you press the shutter button halfway. Focus remains locked on your subject even if you reframe the shot after you press the button halfway. (It helps to remember the *s* factor: for still subjects, *S*ingle Point, and AF-S.)
- ✓ For moving subjects, set the AF-Area mode to Dynamic Area and the Focus mode to AF-C. You still begin by selecting a focus point, but if your subject moves after you press the shutter button halfway to establish focus, the camera looks to the other focus points for focusing information. (Think *motion, dynamic, continuous.*) Remember to reframe as needed to keep your subject within the boundaries of the 11 autofocus points, though.

Again, though, you get full control over the Focus mode only in the P, S, A, and M exposure modes. In the other modes, you have only two choices — either MF (manual focus) or AF-A.

Using autofocus lock

When you set your camera's Focus mode to AF-C (continuous-servo autofocus), pressing and holding the shutter button halfway initiates autofocus. But focusing is continually adjusted while you hold the shutter button halfway,

so the focusing distance may change if the subject moves out of the active autofocus point or you reframe the shot before you take the picture. The same is true if you use AF-A mode (auto-servo autofocus) and the camera senses movement in front of the lens, in which case it shifts to AF-C mode and operates as I just described. Either way, the upshot is that you can't control the exact focusing distance the camera ultimately uses.

Should you want to lock focus at a specific distance, you have a couple options:

Focus manually.

- Change the Focus mode to AF-S (single-servo autofocus). In this mode, focus is locked when you press and hold the shutter button halfway.
- Lock focus with the AE-L/AF-L button. First set focus by pressing the shutter button halfway. When the focus is established at the distance you want, press and hold the AE-L/AF-L button, located near the viewfinder. Focus remains set as long as you hold down the button, even if you release the shutter button. You see the letters AE-L in the viewfinder, and the focus indicator lamp lights.

Keep in mind, though, that by default, pressing the AE-L/AF-L button also locks in autoexposure. (Chapter 7 explains.) You can change this behavior, however, setting the button to lock just one or the other. Chapter 11 explains this option as well as a couple other ways to customize the button's function.

For my money, manual focusing is by far the easiest solution; the next section offers more advice on that topic.

Focusing Manually

Some subjects confuse even the most sophisticated autofocusing systems, causing the camera's autofocus motor to spend a long time "hunting" for its focus point. Animals behind fences, reflective objects, water, and low-contrast subjects are just some of the autofocus troublemakers. Autofocus systems also struggle in dim lighting, although that difficulty is often offset on the D3200 by the AF-assist lamp, which shoots out a beam of light to help the camera find its focusing target.

When you encounter situations that cause an autofocus hang-up, you can try adjusting the autofocus options discussed earlier in this chapter. But often, it's simply easier and faster to switch to manual focusing. For best results, follow these manual-focusing steps:

1. Adjust the viewfinder to your eyesight.

Chapter 1 shows you how to take this critical step. If you don't adjust the viewfinder, scenes that are in focus may appear blurry and vice versa.

2. Set the focus switch on the lens to M.

This step assumes that you're using a lens like the kit lens (refer to Figure 8-1).

With the kit lens, as well as some other compatible lenses, the camera automatically changes the Focus mode to MF as soon as you set the lens switch to M. For other lenses, check the lens instruction manual for details about what you need to do to focus manually.

3. Select a focus point.

Use the same technique as when selecting a point during autofocusing: Looking through the viewfinder, press the Multi Selector right, left, up, or down until the point you want to use flashes red. (You may need to first give the shutter button a quick half-press and release to wake up the viewfinder display.)

During autofocusing, the selected focus point tells the camera what part of the frame to use when establishing focus. And technically speaking, you don't *have* to choose a focus point for manual focusing the camera will set the focus according to the position that you set by turning the focusing ring. However, choosing a focus point is still a good idea, for two reasons: First, even though you're focusing manually, the camera provides some feedback to let you know if focus is correct, and that feedback is based on your selected focus point. Second, if you use spot metering, an exposure option covered in Chapter 7, exposure is based on the selected focus point.

- 4. Frame the shot so that your subject is under your selected focus point.
- 5. Press and hold the shutter button halfway to initiate exposure metering.

Chapter 7 explains how to manipulate exposure and interpret the exposure settings you see in the viewfinder and Information display.

6. Rotate the focusing ring on the lens to bring the subject into focus.

When the camera thinks focus is set on the object under your focus point, the green focus lamp in the lower-left corner of the viewfinder lights, just as it does during autofocusing.

7. Press the shutter button the rest of the way to take the shot.

I know that when you first start working with an SLR-style camera, focusing manually is intimidating. But if you practice a little, you'll find that it's really

no big deal and saves you the time and aggravation of trying to bend the autofocus system to your will when it has "issues."

In addition to the green focus lamp, the D3200 offers another manual focusing aid to help you feel more confident, too: You can swap out the viewfinder's exposure meter with a *rangefinder*, which uses a similar, meter-like display, as shown in Figure 8-8, to indicate whether focus is set on the object in the selected focus point. If bars appear to the left of the 0, as shown in the left example in Figure 8-8, focus is set in front of the subject; if the bars are to the right, as in the middle example, focus is slightly behind the subject. The more bars you see, the greater the focusing error. As you twist the focusing ring, the rangefinder updates to help you get focus on track. When you see a single bar on either side of the 0, you're good to go.

Figure 8-8: The rangefinder offers manual-focusing assistance.

Before I tell you how to activate this feature, I want to point out a couple issues:

- You can use the rangefinder in any exposure mode except M (manual exposure). In M mode, the viewfinder always displays the exposure meter.
- ✓ In the other exposure modes, you can continue to view the exposure meter in the Information display, even with the rangefinder enabled. See Chapter 7 for how to interpret the meter in exposure modes other than M. (Remember, the meter only appears in P, S, and A modes if the camera anticipates an exposure problem.)
- ✓ Your lens must offer a maximum aperture (f-stop number) of f/5.6 or lower. To understand f-stops, head to Chapter 7. The kit lens sold with the D3200 meets this qualification.
- With subjects that confuse the camera's autofocus system, the rangefinder may not work well either; it's based on the same system. If the system can't find the focusing target, you see the rangefinder display shown on the right in Figure 8-8.
- The rangefinder is automatically replaced by the normal exposure meter if you switch back to autofocusing, but reappears when you return to manual focus.

Personally, I leave the rangefinder off and just rely on the focus indicator lamp and my eyes to verify focus. I shoot in the S and A exposure modes frequently, and I find it a pain to look for the exposure meter in the Information display rather than in the viewfinder. That's not a recommendation to you either way — it's just how I prefer to work. If you want to try the rangefinder, head for Setup menu and change the Rangefinder option from Off to On, as shown in Figure 8-9.

SETUP MENU	
Self-timer	
Remote on duration	6 1m
Веер	∢ ≫ L
Rangefinder	ON
File number sequence	ON
Buttons	
Slot empty release lock	LOCK
Print date	0FF

Figure 8-9: Enable the rangefinder via the Custom Setting menu.

Correcting lens distortion

If you take a lot of pictures with wide-angle lenses, you may notice that vertical structures in the scene sometimes appear to bend outward from the center of the image. This is known as *barrel distortion*. On the flip side of the coin, shooting with a long telephoto lens sometimes causes those verticals to bow inward, which is known as *pincushion distortion*.

The Retouch menu on your camera has a postcapture Distortion Control filter you can apply to try to correct both problems. (See Chapter 10 for help.) But it also offers an Auto Distortion Control feature that attempts to correct the image as you're shooting. It only works with certain types of lenses — specifically, those that Nikon classifies as type G and D, excluding PC (perspective control), fisheye, and a few other lens types — but is worth trying if your lens is compatible. To activate the option, set the Auto Distortion Control on the Shooting Menu to On, as shown in the figure here. When you use this feature, understand that some of the area you see in your viewfinder may not be visible in the final photo because the anti-distortion manipulation requires some cropping of the scene. So after activating the feature, take some test shots and examine the pictures carefully. If you're not happy with the results, return to the menu and change the setting back to Off. Additionally, the option only relates to still photography; movie frames aren't affected.

Reset shooting menu	
Set Picture Control	⊡SD
Image quality	FINE
lmage size	
White balance	AUTO
ISO sensitivity settings	
Active D-Lighting	ON
Auto distortion control	ON

Manipulating Depth of Field

Getting familiar with the concept of *depth of field* is one of the biggest steps you can take to becoming a more artful photographer. I introduce you to depth of field in Chapters 3 and 7; here's a summary in case you missed those pages:

- *I* Depth of field refers to the distance over which objects in a photograph appear sharp.
- With a shallow, or small, depth of field, objects in front of or behind the subject appear more softly focused than the subject.
- With a large depth of field, the zone of sharp focus extends to include objects at a distance from your subject.

Which arrangement works best depends entirely on your creative vision and your subject. In portraits, for example, a classic technique is to use a shallow depth of field, as shown in the photo in Figure 8-10. This approach increases emphasis on the subject while diminishing the impact of the background. But for the photo in Figure 8-11, I wanted to emphasize that the foreground figures were in St. Peter's Square, at the Vatican, so I used a large depth of field, which kept the background buildings sharply focused and gave them equal weight in the scene.

So exactly how do you adjust depth of field? You have three points of control: aperture, focal length, and camera-to-subject distance, as follows:

Aperture setting (f-stop): The aperture is one of three main exposure settings, all explained fully in Chapter 7. Depth of field increases as you stop down

Aperture, f/5.6; Focal length, 90mm

Figure 8-10: A shallow depth of field blurs the background and draws added attention to the subject.

the aperture (by choosing a higher f-stop number). For shallow depth

Aperture, f/14: Focal length, 42mm

of field, open the aperture (by choosing a lower f-stop number). Figure 8-12 offers an example: in the f/22 version, focus is sharp all the way through the frame: in the f/13 version. focus softens as the distance from the center lure increases. I snapped both images using the same focal length and camerato-subject distance, setting focus on the red front of center lure.

Lens focal length: In lav terms. focal length determines what the lens "sees." As you increase focal length, measured in millimeters, the angle of view narrows, objects appear larger in the frame. and — the important point for this discussion depth of field decreases. Additionally, the spatial relationship of objects changes as you adjust focal length. As an example,

Figure 8-11: A large depth of field keeps both foreground and background subjects in focus.

Figure 8-13 compares the same scene shot at a focal length of 127mm and 183mm. I used the same aperture, f/5.6, for both examples.

Whether you have any focal length flexibility depends on your lens: If you have a zoom lens, you can adjust the focal length - just zoom in or out. (The D3200 kit lens, for example, offers a focal-length range of 18–55mm.) If you don't have a zoom lens, the focal length is fixed, so scratch this means of manipulating depth of field.

For more technical details about focal length and your camera, see the sidebar "Focal length and the crop factor," later in this chapter.

Camera-to-subject distance: As you move the lens closer to your subject, depth of field decreases. This assumes that you don't zoom in or out to reframe the picture, thereby changing the focal length. If you do, depth of field is affected by both the camera position and focal length.

Aperture, f/22; Focal length, 92mm

Aperture, f/13; Focal length, 92mm

Figure 8-12: A lower f-stop number (wider aperture) decreases depth of field.

Aperture, f/5.6; Focal length, 183mm

Figure 8-13: Zooming to a longer focal length also reduces depth of field.

Together, these three factors determine the maximum and minimum depth of field that you can achieve, as illustrated by my clever artwork in Figure 8-14 and summed up in the following list:

✓ To produce the shallowest depth of field: Open the aperture as wide as possible (the lowest f-stop number), zoom in to the maximum focal length of your lens, and get as close as possible to your subject.

When you use a very large aperture — f/2.0, for example — you can wind up with an extremely shallow depth of field if you also use a long focal length, are very close to your subject, or both. In fact, in a portrait in which one subject is only a foot or so in front of the other, the depth of field may not be sufficient to keep both people sharply focused. And in a floral close-up, the front petal may be sharp but the back one may appear blurred. So always shoot a test image and then use the playback zoom feature to check focus on all subjects in the frame. See Chapter 5 to find out how.

✓ To produce maximum depth of field: Stop down the aperture to the highest possible f-stop number, zoom out to the shortest focal length your lens offers, and move farther from your subject.

Greater depth of field: Select higher f-stop Decrease focal length (zoom out) Move farther from subject

Shorter depth of field: Select lower f-stop Increase focal length (zoom in) Move closer to subject

Figure 8-14: Your f-stop, focal length, and shooting distance determine depth of field.

Just to avoid a possible point of confusion that has arisen in some of the classes I teach: When I say *zoom in*, some students think that I mean to twist the zoom barrel so that it moves *in* toward the camera body. But in fact, the phrase *zoom in* means to zoom to a longer focal length, which produces the visual effect of bringing your subject closer. This requires twisting the zoom

barrel of the lens so that it extends farther *out* from the camera. And the phrase *zoom out* refers to the opposite maneuver: I'm talking about widening your view of the subject by zooming to a shorter focal length, which requires moving the lens barrel *in* toward the camera body.

Here are a few additional tips and tricks related to depth of field:

Aperture-priority autoexposure (A) mode enables you to easily control depth of field. In this mode, detailed fully in Chapter 7, you set the f-stop, and the camera selects the appropriate shutter speed to produce a good exposure. The range of aperture settings you can access depends on your lens.

Even in aperture-priority mode, keep an eye on shutter speed as well. To maintain the same exposure, shutter speed must change in tandem with aperture, and you may encounter a situation where the shutter speed is too slow to permit hand-holding of the camera. Lenses that offer optical image stabilization, or Vibration Reduction (VR lenses, in the Nikon world), enable most people to use a slower shutter speed than normal, but double-check your results just to be sure. Or use a tripod for extra security. Of course, all this assumes that you have dialed in a specific ISO Sensitivity setting; if you instead are using Auto ISO adjustment, the camera may adjust the ISO setting instead of shutter speed. (Chapter 7 explores the whole aperture/shutter speed/ISO relationship.)

- ✓ Some Scene modes are designed to produce a particular depth of field. Portrait, Child, Night Portrait, and Close Up modes are designed to produce shallow depth of field, and Landscape mode is designed for large depth of field. (Chapter 3 explains Scene modes.) You can't adjust aperture in these modes, however, so you're limited to the setting the camera chooses. In addition, the extent to which the camera can select an appropriate f-stop depends on the lighting conditions. If you're shooting in Landscape mode at dusk, for example, the camera may have to open the aperture to a wide setting to produce a good exposure.
- ✓ Guide mode gives you some control over background blurring as well. To use this feature, you must select the Advanced Operation option when you work your way through the guided menus; Chapter 3 provides the how-tos.
- ✓ For greater background blurring, move the subject farther from the background. The extent to which background focus shifts as you adjust depth of field also is affected by the distance between the subject and the background. For increased background blurring, move the subject farther in front of the background.

Focal length and the crop factor

The angle of view that a lens can capture is determined by its *focal length*, or in the case of a zoom lens, the range of focal lengths it offers. Focal length is measured in millimeters.

According to photography tradition, a focal length of 50mm is described as a "normal" lens. Most point-and-shoot cameras feature this focal length, which is a medium-range lens that works well for the type of snapshots that users of those kinds of cameras are likely to shoot.

A lens with a focal length under 35mm is characterized as a *wide-angle* lens because at that focal length, the camera has a wide angle of view, making it good for landscape photography. A short focal length also has the effect of making objects seem smaller and farther away. At the other end of the spectrum, a lens with a focal length longer than 80mm is considered a *telephoto* lens and often referred to as a *long lens*. With a long lens, angle of view narrows, and faraway subjects appear closer and larger, which is ideal for wildlife and sports photographers. Note, however, that the focal lengths stated here and elsewhere in the book are so-called *35mm equivalent* focal lengths. Here's the deal: For reasons that aren't really important, when you put a standard lens on most digital cameras, including your D3200, the available frame area is reduced, as if you took a picture on a camera that uses 35mm film negatives and then cropped it.

This so-called *crop factor* varies depending on the camera, which is why the photo industry adopted the 35mm-equivalent measuring stick as a standard. With the D3200, the crop factor is roughly 1.5. So the 18–55mm lens featured in this book, for example, captures the approximate area you would get from a 27–83mm lens on a 35mm film camera. (Multiply the crop factor by the actual focal length to get the actual angle of view.) In the figure here, the red line indicates the image area that results from the 1.5 crop factor.

When shopping for a lens, it's important to remember this crop factor to make sure that you get the focal length designed for the type of pictures you want to take.

280

Controlling Color

Compared with understanding some aspects of digital photography resolution, aperture and shutter speed, depth of field, and so on — making sense of your camera's color options is easy-breezy. First, color problems aren't all that common, and when they are, they're usually simple to fix with a quick shift of your camera's White Balance control. And getting a grip on color requires learning only a couple new terms, an unusual state of affairs for an endeavor that often seems more like high-tech science than art.

The rest of this chapter explains the aforementioned White Balance control, plus a couple menu options that enable you to fine-tune the way your camera renders colors. For information on how to use the Retouch menu's color options to alter colors of existing pictures, see Chapter 10. Chapter 11 covers the camera's color special-effects filters (Color Sketch, Color Outline, and Selective Color).

Correcting colors with white balance

Every light source emits a particular color cast. The old-fashioned fluorescent lights found in most public restrooms, for example, put out a bluish-greenish light, which is why we all look so sickly when we view our reflections in the mirrors in those restrooms. And if you think that your beloved looks especially attractive by candlelight, you aren't imagining things: Candlelight casts a warm, yellow-red glow that is flattering to the skin.

Science-y types measure the color of light, officially known as *color temperature*, on the Kelvin scale, which is named after its creator. You can see the Kelvin scale in Figure 8-15.

When photographers talk about "warm light" and "cool light," though, they aren't referring to the position on the Kelvin scale — or at least not in the way most people think of temperatures, with a higher number meaning hotter. Instead, the terms describe the visual appearance of the light. Warm light, produced by candles and incandescent lights, falls in the red-yellow spectrum you see at the bottom of the Kelvin scale in Figure 8-15; cool light, in the blue spectrum, appears in the upper part of the Kelvin scale.

At any rate, most people don't notice these fluctuating colors of light because human eyes automatically compensate for them. Except in

8000	Snow, water, shade
	Overcast skies
	Flash
5000	Bright sunshine
	Fluorescent bulbs
	Tungsten lights
3000	Incandescent bulbs
2000	Candlelight

Figure 8-15: Each light source emits a specific color.

very extreme lighting conditions, we perceive a white tablecloth as white no matter whether it's lit by candlelight, fluorescent light, or regular houselights.

Similarly, a digital camera compensates for different colors of light through white balancing. Simply put, *white balancing* neutralizes light so that whites are always white, which in turn ensures that other colors are rendered accurately. If the camera senses warm light, it shifts colors slightly to the cool side of the color spectrum; in cool light, the camera shifts colors the opposite direction.

The good news is that, as with your eyes, your camera's Auto White Balance setting tackles this process remarkably well in most situations, which means that you can usually ignore it and concentrate on other aspects of your picture. But if your scene is lit by two or more light sources that cast different colors, the white balance sensor can get confused, producing an unwanted color cast like the one you see in the left image in Figure 8-16.

Figure 8-16: Multiple light sources resulted in a yellow color cast in Auto White Balance mode (left); switching to the Incandescent setting solved the problem (right).

I shot this product image in my home studio using tungsten photo lights, which produce light with a color temperature similar to regular household incandescent bulbs. The problem is that the windows in that room also permit some pretty strong daylight to filter through. In Auto White Balance mode, the camera reacted to that daylight — which has a cool color cast — and applied too much warming, giving my original image a yellow tint. No problem: I just switched the White Balance mode from Auto to the Incandescent setting. The right image in Figure 8-16 shows the corrected colors.

There's one little problem with white balancing as it's implemented on your camera, though. You can't make this kind of manual white balance selection if you shoot in the fully automatic exposure modes. So if you spy color problems in your camera monitor, switch to P, S, A, or M exposure mode. (You can also get to the White Balance settings in Guide mode if you go through the Advanced Operation path, but it's a bit cumbersome; see Chapter 3 for details.)

Note, too, that unlike the autofocusing features discussed in the first part of this chapter, the White Balance setting is available during Live View photography as well as viewfinder photography. Your setting also affects colors in any movies you record. See Chapter 4 for complete details about Live View and movie shooting.

The next section explains precisely how to make a simple white balance correction; following that, you can explore some advanced white balance options.

Changing the White Balance setting

The current White Balance setting appears in the Information screen, as shown in Figure 8-17. Settings other than Auto are represented by the icons you see in Table 8-1. During Live View and movie shooting, an icon representing the setting appears in the top-right corner of the monitor; again, details about Live View and movie shooting await in Chapter 4.

Figure 8-17: This icon represents the current White Balance setting.

Table 8-1	Manual White Balance Settings
Symbol	Light Source
*	Incandescent
	Fluorescent
☀	Direct sunlight
4	Flash
2	Cloudy
* ///.	Shade
PRE	Preset

You can adjust the White Balance setting in a few ways:

- ✓ Info Edit screen: Remember, you can get to this screen by pressing the Info Edit button. Press once if the Information screen is already visible; otherwise, press twice. After highlighting the White Balance option, as shown on the left in Figure 8-18, press OK to display the menu shown on the right. Highlight the desired setting, and press OK.
- ✓ Shooting menu: You also can adjust the White Balance setting through the Shooting menu, as shown in Figure 8-19. Going this route gives you access to some additional White Balance settings; details momentarily.

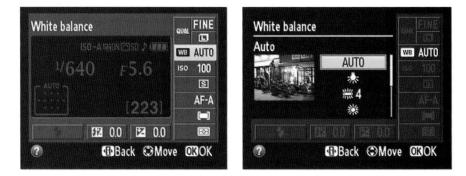

Figure 8-18: You can modify white balance through the Info Edit display.

SHOOTING MENU			Vhite balance	
Reset shooting menu		A	UTO Auto	OK
Set Picture Control	₽SD		🚸 Incandescen	t
Image quality	FINE		# 4 Fluorescent	
Image size			✤ Direct sunlig	ıht
White balance	AUTO		🗧 Flash	
ISO sensitivity settings	8		Cloudy	
Active D-Lighting	ON		👞 Shade	
Auto distortion control	ON	?		⊙Adjust

Figure 8-19: To uncover additional White Balance options, hit the Shooting menu.

Fn (Function) button plus Command dial: Through a menu option covered in Chapter 11, you can set the Fn button to bring up the White Balance setting directly. You then rotate the Command dial while pressing the button to cycle through the available White Balance settings. If you set the Fn button to this role, however, it no longer serves its default purpose, which is to access the ISO Sensitivity option.

Okay, now for the aforementioned details about using the Shooting menu to adjust the White Balance setting. Via the menus, you can accomplish the following additional white balance goals:

- ✓ Fine-tune the settings: If you choose any setting but Fluorescent, pressing the Multi Selector right takes you to a screen where you can fine-tune the setting, a process I explain in the next section. To skip the fine-tuning, just press OK after choosing your White Balance setting from the menu.
- Select a specific type of fluorescent bulb: When you choose Fluorescent from the menu, as shown on the left in Figure 8-20, pressing the Multi Selector right displays the second screen in the figure, where you can select a specific type of bulb. Select the option that most closely matches your bulbs and then press OK. Or, to go to the fine-tuning screen, press the Multi Selector right.

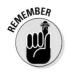

After you select a fluorescent bulb type, that option is always used when you change white balance through the Information display (as outlined previously) and choose the Fluorescent White Balance setting. Again, you can change the bulb type only through the Shooting menu.

Create a custom white balance preset: Selecting the PRE option enables you to create and store a precise, customized White Balance setting, as explained in the upcoming "Creating white balance presets" section, in this chapter. This setting is the fastest way to achieve accurate colors when your scene is lit by multiple light sources that have differing color temperatures.

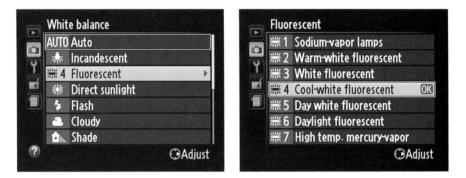

Figure 8-20: If you adjust white balance through the Shooting menu, you can select a specific type of fluorescent bulb.

286

Your selected White Balance setting remains in force for the P, S, A, and M exposure modes until you change it. So you may want to get in the habit of resetting the option to the Auto setting after you finish shooting whatever subject it was that caused you to switch to manual white balance mode.

Fine-tuning White Balance settings

You can fine-tune any White Balance setting except a custom preset that you create through the PRE option. Make the adjustment as spelled out in these steps:

- 1. Display the Shooting menu, highlight White Balance, and press OK.
- 2. Highlight the White Balance setting you want to adjust, as shown on the left in Figure 8-21, and press the Multi Selector right.

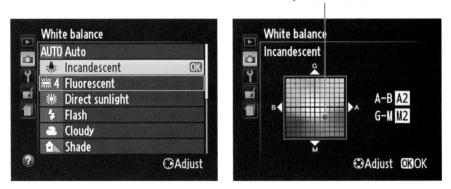

Adjustment marker

Figure 8-21: Press the Multi Selector right to get to the fine-tuning screen.

You're taken to a screen where you can do your fine-tuning, as shown on the right in Figure 8-21.

If you select Fluorescent, you first go to a screen where you select a specific type of bulb, as covered in the preceding section. After you highlight your choice, press the Multi Selector right again to get to the fine-tuning screen.

3. Fine-tune the setting by using the Multi Selector to move the white balance shift marker in the color grid.

The grid is set up around two color pairs: Green and Magenta, represented by G and M; and Blue and Amber, represented by B and A. By pressing the Multi Selector, you can move the adjustment marker — that little black box labeled in Figure 8-21 — around the grid.

As you move the marker, the A–B and G–M boxes on the right side of the screen show you the current amount of color shift. A value of 0 indicates the default amount of color compensation applied by the selected White Balance setting. In Figure 8-21, for example, I moved the

marker two levels toward amber and two levels toward magenta to specify that I wanted colors to be a tad warmer.

4. Press OK to complete the adjustment.

After you adjust a White Balance setting, an asterisk appears next to the icon representing the setting on the Shooting menu, as shown in Figure 8-22. You see an asterisk next to the White Balance setting in the Information display as well.

SHOOTING MENU	
Reset shooting menu	
Set Picture Control	⊡SD
Image quality	FINE
Image size	
White balance	* *
ISO sensitivity settings	
Active D-Lighting	ON
Auto distortion control	ON

Figure 8-22: The asterisk indicates that you applied a fine-tuning adjustment to the White Balance setting.

Creating white balance presets

If none of the standard White Balance settings do the trick and you don't want to fool with fine-tuning them, take advantage of the PRE (Preset Manual) feature. This option enables you to do two things:

- Base white balance on a direct measurement of the actual lighting conditions.
- Match white balance to an existing photo.

The next two sections provide you with the step-by-step instructions.

Setting white balance with direct measurement

To use this technique, you need a piece of card stock that's either neutral gray or absolute white — not eggshell white, sand white, or any other close-but-not-perfect white. (You can buy reference cards made just for this purpose in many camera stores for less than \$20.)

Position the reference card so that it receives the same lighting you'll use for your photo. Then take these steps:

1. Set the camera to the P, S, A, or M exposure mode.

If the exposure meter reports that your image will be under- or overexposed at the current exposure settings, make the necessary adjustments now. (Chapter 7 tells you how.) Otherwise the camera can't create your custom white balance preset.

- 2. Frame your shot so that the reference card completely fills the viewfinder.
- 3. From the Shooting menu, select White Balance, press OK, and select the PRE Preset Manual White Balance setting, as shown on the left in **Figure 8-23**.
- 4. Press the Multi Selector right, select Measure, as shown on the right in the figure, and press OK.

A warning appears, asking you whether you want to overwrite existing data.

White balance PRE Preset manual	White balance Preset manual	
	Measure	OX
	Use photo	
0		

Figure 8-23: Select these options to set white balance by measuring a white or gray card.

5. Select Yes and press OK.

You see another message, this time telling you to take your picture. You have about six seconds to do so. (The letters PRE flash in the viewfinder and Information display to let you know the camera's ready to record your white balance reference image.)

6. Take the reference shot.

If the camera is successful at recording the white balance data, the letters *Gd* flash in the viewfinder and the message "Data Acquired" appears in the Information display. If the camera couldn't set the custom white balance, you instead see the message *No Gd* in the viewfinder, and a message in the Information display urges you to try again. You need to start the process over at Step 3; try adjusting your lighting before doing so.

After you complete the process, the camera automatically sets the White Balance option to PRE so you can begin using your preset. Any time you want to select and use the preset, switch to the PRE White Balance setting, either via the Shooting menu or Info Edit screen. Your custom setting is stored in the camera until you override it with a new preset.

By the way, if you do set the Fn button to invoke the White Balance setting, a trick I explain in Chapter 11, you gain a related timesaving feature: If you press and hold the button for a few seconds while the PRE setting is in force, the camera automatically sets itself up to record a new preset reference shot. After the letters PRE start flashing in the viewfinder or Information screen, just snap your reference picture. Now that's a cool feature for photographers who regularly need to customize white balancing.

Matching white balance to an existing photo

Suppose that you're the marketing manager for a small business, and one of your jobs is to shoot portraits of the company big-wigs for the annual report. You build a small studio just for that purpose, complete with a couple photography lights and a nice, conservative beige backdrop.

Of course, the big-wigs can't all come to get their pictures taken in the same month, let alone on the same day. But you have to make sure that the colors in that beige backdrop remain consistent for each shot, no matter how much time passes between photo sessions. This scenario is one possible use for an advanced White Balance feature that enables you to base white balance on an existing photo.

Basing white balance on an existing photo works well only in strictly controlled lighting situations, where the color temperature of your lights is consistent from day to day. Otherwise the White Balance setting that produces color accuracy when you shoot Big Boss Number One may add an ugly color cast to the one you snap of Big Boss Number Two.

To give this option a try, follow these steps:

1. Copy the picture that you want to use as the reference photo to your camera memory card, if it isn't already stored there.

You can copy the picture to the card using a card reader and whatever method you usually use to transfer files from one drive to another. Assuming that you're using the default folder names, copy the file to the 100D3200 folder, inside the main DCIM folder.

2. Open the Shooting menu, highlight White Balance, and press OK.

3. Select PRE Preset Manual and press the Multi Selector right.

White balance	White balance	
Preset manual	Use photo	
Measure		
Use photo	This image	
	Select image	•

The screen shown on the left in Figure 8-24 appears.

Figure 8-24: You can create a white balance preset based on an existing photo.

4. Highlight Use Photo and press OK.

The options shown on the right in Figure 8-24 appear. If you haven't yet used the photo option to store a preset, you see an empty white box in the middle of the screen, as shown in the figure. If you previously selected a photo to use as a preset reference, the thumbnail for that image appears instead.

5. Select the photo you want to use as your reference image.

If the photo you want to use is already displayed on the screen, move on to Step 6. Otherwise, highlight Select Image and then press the Multi Selector right to access screens that let you navigate to the photo you want to use as a basis for white balance. Press OK to return to the screen shown on the right in Figure 8-24. Your selected photo appears on the screen.

6. Highlight This Image and press OK to set the preset white balance based on the selected photo.

Whenever you want to base white balance on your selected photo, just set the White Balance setting to the PRE option.

Choosing a Color Space: sRGB versus Adobe RGB

By default, your camera captures images using the *sRGB color mode*, which simply refers to an industry-standard spectrum of colors. (The *s* is for *standard*, and the *RGB* is for *red*, *green*, *blue*, which are the primary colors in the digital color world.) The sRGB color mode was created to help ensure color consistency as an image moves from camera (or scanner) to monitor and printer; the idea was to create a spectrum of colors that all these devices can reproduce.

However, the sRGB color spectrum leaves out some colors that *can* be reproduced in print and onscreen, at least by some devices. So as an alternative, your camera also enables you to shoot in the Adobe RGB color mode, which includes a larger spectrum (or *gamut*) of colors. Figure 8-25 offers an illustration of the two spectrums.

Some colors in the Adobe RGB spectrum can't be reproduced in print. (The printer just substitutes the closest printable color, if necessary.) Still, I usually shoot in Adobe RGB mode because I see no reason to limit myself to a smaller spectrum from the get-go.

However, just because I use Adobe RGB doesn't mean that it's right for you. First, if you plan to print and share your photos

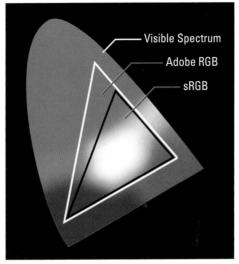

Figure 8-25: Adobe RGB includes some colors not found in the sRGB spectrum but requires some color-management savvy to use to its full advantage.

without making any adjustments in your photo editor, you're usually better off sticking with sRGB because most printers and web browsers are designed around that color space. Second, know that to retain all your original Adobe RGB colors when you work with your photos, your editing software must support that color space — not all programs do. You also must be willing to study the whole topic of digital color a little bit because you need to use some specific settings to avoid really mucking up the color works.

If you want to go with Adobe RGB instead of sRGB, visit the Shooting menu and highlight the Color Space option, as shown on the left in Figure 8-26. Press OK. Select Adobe RGB and press OK again.

You can tell whether you captured an image in the Adobe RGB format by looking at its filename: Adobe RGB images start with an underscore, as in _DSC0627.jpg. For pictures captured in the sRGB color space, the underscore appears in the middle of the filename, as in DSC_0627.jpg. See Chapter 5 for more tips on decoding picture filenames.

Taking a Quick Look at Picture Controls

Color space	sRGE
Noise reduction	ON
AF-area mode	
Built-in AF-assist illuminator	ON
Metering	$\overline{\diamond}$
Movie settings	
Flash cntrl for built-in flash	M\$

Figure 8-26: Change the Color Space setting via the Shooting menu.

A feature that Nikon calls *Picture Controls* offers one more way to tweak image sharpening, color, and contrast when you shoot in the P, S, A, and M exposure modes and choose one of the JPEG options for the Image Quality setting. (Chapter 2 explains the Image Quality setting.)

Sharpening, in case you're new to the digital meaning of the term, refers to a software process that adjusts contrast in a way that creates the illusion of slightly sharper focus. I emphasize, "slightly sharper focus." Sharpening produces a subtle *tweak*, and it's not a fix for poor focus.

When you shoot in the advanced exposure modes — P, S, A, and M you can choose from the following Picture Controls, represented in the menus and on the Information screen by the two-letter codes in parentheses. (Figure 8-27 shows you where to find the two-letter code in the Information display.) In Guide mode, you get limited access to Picture Controls if you follow the Advanced Operation path through the menus (see Chapter 3 for help). In the other exposure modes, the camera selects the Picture Control setting for you.

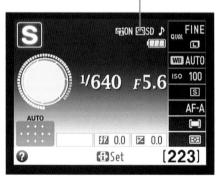

Picture Control symbol

Figure 8-27: This two-letter code represents the Picture Control setting.

Standard (SD): The default

setting, this option captures the image normally — that is, using the characteristics that Nikon offers up as suitable for the majority of subjects.

292

- ✓ Neutral (NL): At this setting, the camera doesn't enhance color, contrast, and sharpening as much as in the other modes. The setting is designed for people who want to precisely manipulate these picture characteristics in a photo editor. By not overworking colors, sharpening, and so on when producing your original file, the camera delivers an original that gives you more latitude in the digital darkroom.
- ✓ Vivid (VI): In this mode, the camera amps up color saturation, contrast, and sharpening.
- Monochrome (MC): This setting produces black-and-white photos. Only in the digital world, they're called *grayscale images* because a true blackand-white image contains only black and white, with no shades of gray.

I'm not keen on creating grayscale images this way. I prefer to shoot in full color and then do my own grayscale conversion in my photo editor. That technique just gives you more control over the look of your blackand-white photos. Assuming that you work with a decent photo editor, you can control what original tones are emphasized in your grayscale version, for example. Additionally, keep in mind that you can always convert a color image to grayscale, but you can't go the other direction. You can create a black-and-white copy of your color image right in the camera, in fact; Chapter 10 shows you how.

- Portrait (PT): This mode tweaks colors and sharpening in a way that is designed to produce nice skin texture and pleasing skin tones. (If you shoot in the Portrait or Night Portrait Scene modes, the camera selects this Picture Control for you.)
- Landscape (LS): This mode emphasizes blues and greens. As you might expect, it's the mode used by the Landscape Scene mode.

The extent to which Picture Controls affect your image depends on the subject as well as the exposure settings you choose and the lighting conditions. But Figure 8-28 gives you a general idea of what to expect. As you can see, the differences between the Picture Controls are pretty subtle, with the exception of the Monochrome setting.

Even though you can view the current Picture Control setting in the Information display, you can't adjust the setting via the Info Edit screen as you can most other settings shown on the display. Instead, set the option via the Shooting menu, as shown in Figure 8-29.

At least while you're new to the camera, I recommend that you stick with the default Picture Control setting, for two reasons. First, you have way more important camera settings to worry about — aperture, shutter speed, autofocus, and all the rest. Why add one more setting to your list, especially when the impact of changing it is minimal?

Figure 8-28: Picture Controls apply preset adjustments to color, sharpening, and other photo characteristics to images you shoot in the JPEG file format.

294

SHOOTING MENU		Set Pictur	e Control
Reset shooting menu		SD Stan	dard 🗰
et Picture Control	⊡SD	SI SNL Neut	iral
nage quality	FINE	SVI Vivio	
mage size		MC Mon	ochrome
hite balance	AUTO	💷 🖾 PT Port	rait
O sensitivity settings		🖾 LS Land	scape
ctive D-Lighting	ON		
Auto distortion control	ON	?	Grid ⊕Adjus Grid ⊕ Grid Gri

Figure 8-29: The only way to select a Picture Control setting is via the Shooting menu.

Second, if you really want to mess with the characteristics that the Picture Control options affect, you're much better off shooting in the Raw (NEF) format and then making those adjustments on a picture-by-picture basis in your Raw converter. In Nikon ViewNX 2, you can even assign any of the existing Picture Controls to your Raw files and then compare how each one affects the image. The camera does tag your Raw file with whatever Picture Control is active when you take the shot, but the image adjustments are in no way set in stone, or even in sand — you can tweak your photo at will. (The selected Picture Control does affect the JPEG preview that's used to display the Raw image thumbnails in ViewNX 2 and other browsers.)

However, in the interest of full disclosure, I should alert you to a feature that may make Picture Controls a little more useful to some people: You can modify any Picture Control to more closely render a scene the way you envision it. So, for example, if you like the bold colors of Landscape mode but don't think the effect goes far enough, you can adjust the setting to amp up colors even more.

To reserve page space in this book for functions that experience tells me will be the most useful to the most readers, I opted not to provide full details about customizing Picture Controls. But the following steps provide a quick overview of the process so that if you encounter the menu screens that contain the related options, you'll have some idea what you're seeing. So here are the basics: 1. Set the Mode dial to P, S, A, or M.

These are the only modes that let you select or modify a Picture Control.

- 2. Display the Shooting menu, choose Set Picture Control, and press OK.
- 3. Highlight the Picture Control you want to modify.

For example, I highlighted the Standard setting on the left screen in Figure 8-30.

SD Sta	ure Control		Standard	曙iON
		Ô	Quick adjust	
		Y	┌ Sharpening	A O I I I 9
Tendersteinen ander Statute			- Contrast	
The second is a second	onochrome °		- Brightness	
ESPT Po			- Saturation	
🖾 LS La	ndscape		- Hue	
?	Crid @Adjust	?	@Grid	Reset OKOK

Figure 8-30: After selecting a Picture Control, press right to display options for adjusting its effect on your pictures.

4. Press the Multi Selector right.

You see the screen shown on the right in Figure 8-31, containing sliders that you use to modify the Picture Control. Which options you can adjust depend on your selected Picture Control.

5. Highlight a picture characteristic and then press the Multi Selector right or left to adjust the setting.

A couple tips:

- Some Picture Controls offer a Quick Adjust setting, which enables you to easily increase or decrease the overall effect of the Picture Control. A positive value produces a more exaggerated effect; set the slider to 0 to return to the default setting.
- The large vertical line in the slider bar indicates the current setting for the option.
- The little line under the slider bar represents the default setting for the selected Picture Control.
- Reset all the options to their defaults by pressing the Delete button.

- **?**
- To display a grid that lets you see how your selected Picture Control compares with the others in terms of color saturation and contrast, as shown in Figure 8-31, press and hold the Zoom In button. (I vote this screen most likely to confound new camera users who stumble across it. Note that the Standard and Portrait settings are identical in terms of contrast and saturation, so the P for Portrait doesn't appear in the grid unless you selected that Picture Control initially.)

Figure 8-31: Press the Zoom In button to display a grid that ranks each Picture Style according to its level of saturation and contrast.

You can't change any settings via the grid — it's for informational purposes only. However, if you display the grid from the first Set Picture Control menu (the left screen in Figure 8-31), you can press the Multi Selector up or down to select a different Picture Control. You then can press right to access the Picture Control adjustment screen.

6. Press OK to save your changes and exit the adjustment screen.

As when you fine-tune a White Balance setting, an asterisk appears next to the edited Picture Style in the menu and Information screen to remind you that you have adjusted it.

Again, these steps are intended just as a starting point for those who are interested in playing with Picture Controls. Complete details on each of the Picture Control adjustment options are found in the electronic version of the camera manual, stored on one of the two CDs that shipped with your camera. (The other CD contains the Nikon software.) You can read the manual in Adobe Acrobat or any other program that can open PDF files. The paper manual contains only basic operating instructions, and the Picture Control editing functions didn't make the cut.

Putting It All Together

In This Chapter

- Reviewing the best all-around picture-taking settings
- > Adjusting the camera for portrait photography
- Discovering the keys to super action shots
- > Dialing in the right settings to capture landscapes and other scenic vistas
- Capturing close-up views of your subject

Garlier chapters of this book break down each and every picture-taking feature on your camera, describing in detail how the various controls affect exposure, picture quality, focus, color, and the like. This chapter pulls together all that information to help you set up your camera for specific types of photography.

Keep in mind, though, that there are no hard-and-fast rules as to the "right way" to shoot a portrait, a landscape, or whatever. So feel free to wander off on your own, tweaking this exposure setting or adjusting that focus control, to discover your own creative vision. Experimentation is part of the fun of photography, after all — and thanks to your camera monitor and the Delete button, it's an easy, completely free proposition.

Recapping Basic Picture Settings

Your subject, creative goals, and lighting conditions determine which settings you should use for some picturetaking options, such as aperture and shutter speed. I offer my take on those options throughout this chapter. But for many basic options, I recommend the same settings for almost every shooting scenario. Table 9-1 shows you those recommendations and also lists the chapter where you can find details about each setting.

300

One key point: Instructions in this chapter assume that you set the exposure mode to P, S, A, or M, as indicated in the table. These modes, detailed in Chapter 7, are the only ones that give you access to the entire cadre of D3200 features. In most cases, I recommend using S (shutter-priority autoexposure) when controlling motion blur is important, and A (aperture-priority autoexposure) when controlling depth of field is important. These two modes let you concentrate on one side of the exposure equation and let the camera handle the other. Of course, if you're comfortable making both the aperture and shutter speed decisions, you may prefer to work in M (manual) exposure mode instead. P (programmed autoexposure) is my last choice because it makes choosing a specific aperture or shutter speed more cumbersome.

I don't recommend the fully automated modes — Auto, Auto Flash Off, Scene, and Guide — because they don't permit you to access certain settings that can be critical to capturing good shots of certain subjects. For help using the automated modes, visit Chapter 3.

Finally, this chapter discusses choices for normal, through-the-viewfinder photography; Chapter 4 guides you through the options available for Live View photography and movie recording. (For Live View photography, however, most settings work the same as discussed here, with the exception of the autofocus options.)

Table 9-1 All-Purpose Picture-Taking Settings		
Option	Recommended Setting	Chapter
Exposure mode	P, S, A, or M	7
Image Quality	JPEG Fine or Raw (NEF)	2
Image Size	Large or medium	2
White Balance	Auto	8
ISO Sensitivity	100	7
Focus mode	For autofocusing: still subjects, AF-S; moving subjects, AF-C. For manual focus, MF	8
AF-Area mode	Still subjects, Single Point; moving subjects, Dynamic Area	8
Release mode	Action photos: Continuous; all others: Single Frame	2
Metering	Matrix	7
Active D-Lighting	On	7

Shooting Still Portraits

By *still portrait*, I mean that your subject isn't moving. For subjects who aren't keen on sitting still, skip to the next section and use the techniques given for action photography instead. Assuming that you do have a subject willing to pose, the classic portraiture approach is to keep the subject sharply focused while throwing the background into soft focus. This artistic choice emphasizes the subject and helps diminish the impact of any distracting background objects. The following steps show you how to achieve this look:

1. Set the Mode dial to A (aperture-priority autoexposure) and select a low f-stop value.

As Chapter 7 explains, a low f-stop setting opens the aperture, which not only allows more light to enter the camera but also shortens *depth of field*, or the distance over which focus appears sharp. So dialing in a low f-stop value is the first step in softening your portrait background. However, for a group portrait, don't go too low, or the depth of field may not be enough to keep everyone in the sharp-focus zone. Take a test shot and inspect your results at different f-stops to find the right setting.

I recommend aperture-priority mode when depth of field is a concern because you can control the f-stop while relying on the camera to select the shutter speed. Just rotate the Command dial to select your f-stop. (You need to pay attention to shutter speed as well, however, to make sure that it's not so slow that movement of the subject or camera will blur the image.)

You can monitor the current f-stop and shutter speed in the viewfinder and Information display, as shown in Figure 9-1.

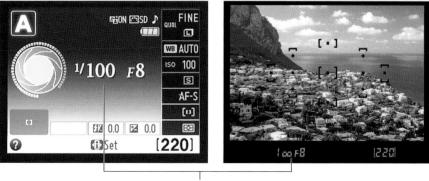

Shutter speed/aperture

2. To further soften the background, zoom in, get closer, and put more distance between the subject and background.

As covered in Chapter 8, zooming in to a longer focal length also reduces depth of field, as does moving physically closer to your subject. And the greater the distance between the subject and background, the more the background blurs. (A good rule is to place the subject at least an arm's length away from the background.) See Chapter 8 for information about calculating the effective focal lengths of lenses mounted on the D3200.

MARNING!

A lens with a focal length of 85–120mm is ideal for a classic head and shoulders portrait. You should avoid using a much shorter focal length (a wider-angle lens) for portraits. They can cause features to appear distorted — sort of like how people look when you view them through a security peephole in a door.

3. For indoor portraits, shoot flashfree if possible.

Shooting by available light rather than flash produces softer illumination and avoids the problem of red-eye. To get enough light to go flashfree, turn on room lights or, during daylight, pose your subject next to a sunny window, as I did for the image in Figure 9-2.

In the A exposure mode, simply keeping the built-in flash unit closed disables the flash. If flash is unavoidable, see my list of flash tips at the end of the steps to get better results.

4. For outdoor portraits, use a flash if possible.

Even in daylight, a flash adds a beneficial pop of light to subjects' faces, as illustrated in Figure 9-3. A flash is especially important when the background

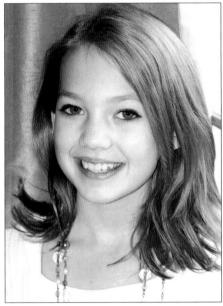

Figure 9-2: For more pleasing indoor portraits, shoot by available light instead of using flash.

is brighter than the subjects, as in this example.

In the A exposure mode, press the Flash button on the side of the camera to enable the built-in flash. For daytime portraits, use the Fill Flash setting. (That's the regular, basic Flash mode.) For nighttime images, try red-eye reduction or slow-sync flash; again, see the flash tips at the end of these steps to use either mode most effectively.

302

Chapter 9: Putting It All Together

No flash

Fill flash

Figure 9-3: To properly illuminate the face in outdoor portraits, use fill flash.

The top shutter speed for flash photography on your camera is 1/200 second, so in bright light, you may need to stop down the aperture to avoid overexposing the photo. Doing so, of course, brings the background into sharper focus. So try to move the subject into a shaded area instead.

5. Press and hold the shutter button halfway to initiate exposure metering and autofocusing.

If the camera has trouble finding the correct focusing distance, set your lens to manual focus mode and then twist the focusing ring to set focus. See Chapter 8 for help with focusing.

6. Press the shutter button the rest of the way to capture the image.

Again, these steps just give you a starting point for taking better portraits. A few other tips can also improve your people pics:

- Pay attention to the background. Scan the entire frame looking for intrusive objects that may distract the eye from the subject. If necessary, reposition the subject against a more flattering backdrop. Inside, a softly textured wall works well; outdoors, trees and shrubs can provide nice backdrops as long as they aren't so ornate or colorful that they diminish the subject (for example, a magnolia tree laden with blooms).
- Pay attention to white balance if your subject is lit by both flash and ambient light. Any time you shoot in mixed lighting, the result may be colors that are slightly warmer or cooler (bluer) than neutral. A warming effect typically looks nice in portraits, giving the skin a subtle glow. But if you aren't happy with the result, see Chapter 8 to find out how to fine-tune white balance.
- ✓ When flash is unavoidable, try these tricks to produce better results. The following techniques can help solve flash-related issues:
 - *Indoors, turn on as many room lights as possible.* With more ambient light, you reduce the flash power that's needed to expose the picture. This step also causes the pupils to constrict, further reducing the chances of red-eye. (Pay heed to my white balance warning, however.) As an added benefit, the smaller pupil allows more of the subject's iris to be visible in the portrait, so you see more eye color.
 - *Try using a Flash mode that enables red-eye reduction or slow-sync flash.* If you choose the first option, warn your subject to expect both a preliminary light from the AF-assist lamp, which constricts pupils, and the flash. And remember that slow-sync flash modes use a slower-than-normal shutter speed, which produces softer lighting and brighter backgrounds than normal flash. (Chapter 7 explains the various Flash modes.)

Take a look at Figure 9-4 for an example of how slow-sync flash can really improve an indoor portrait. When I used regular flash, the shutter speed was 1/60 second. At that speed, the camera has little time to soak up any ambient light. As a result, the scene is lit primarily by the flash. That caused two problems: The strong flash created some "hot spots" on the subject's skin, and the window frame is much more prominent because of the contrast between it and the darker bushes outside the window. Although it was daylight when I took the picture, the skies were overcast, so at 1/60 second, the exterior appears dark.

304

Chapter 9: Putting It All Together

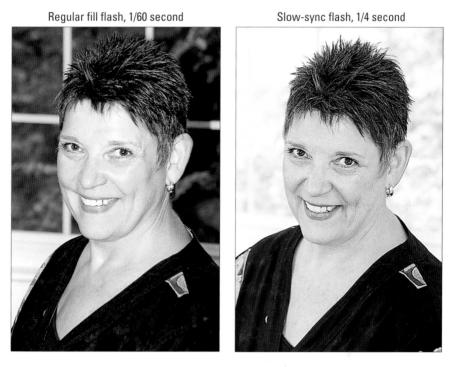

Figure 9-4: Slow-sync flash produces softer, more even lighting and brighter backgrounds.

In the slow-sync example, shot at 1/4 second, the exposure time was long enough to permit the ambient light to brighten the exteriors to the point that the window frame almost blends into the background. And because much less flash power was needed to expose the subject, the lighting is much more flattering. In this case, the bright background also helps to set the subject apart because of her dark hair and shirt. If the subject had been a pale blonde, this setup wouldn't have worked as well, of course. Again, too, note the warming effect that can occur when you use Auto White Balance and shoot in a combination of flash and daylight.

Don't forget that a slower-than-normal shutter speed means an increased risk of blur due to camera shake. So use a tripod or otherwise steady the camera. Remind your subjects to stay absolutely still, too, because they'll appear blurry if they move during the exposure. I was fortunate to have both a tripod and a cooperative subject for my examples, but I probably wouldn't try slow-sync for portraits of young children or pets.

• For professional results, use an external flash with a rotating flash head. Then aim the flash head upward so that the flash light bounces off the ceiling and falls softly down onto the subject. An external flash isn't cheap, but the results make the purchase worthwhile if you shoot lots of portraits. Compare the two portraits in Figure 9-5 for an illustration. In the first example, the built-in flash resulted in strong shadowing behind the subject and harsh, concentrated light. To produce the better result on the right, I used the Nikon Speedlight SB-600 and bounced the light off the ceiling. I also moved the subject a few feet farther in front of the background to create more background blur.

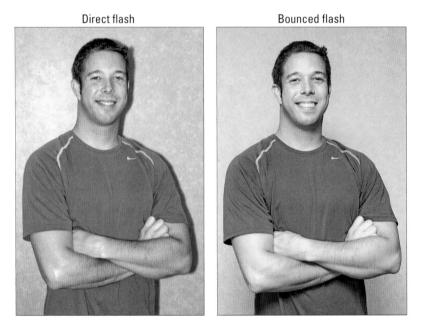

Figure 9-5: To eliminate harsh lighting and strong shadows (left), I used bounce flash and moved the subject farther from the background (right).

Make sure that the ceiling or other surface you use to bounce the light is white; otherwise the flash light will pick up the color of the surface and influence the color of your subject.

Chapter 9: Putting It All Together

- *Invest in a flash diffuser to further soften the light.* Whether you use the built-in flash or an external flash, attaching a diffuser is also a good idea. A *diffuser* is simply a piece of translucent plastic or fabric that you place over the flash to soften and spread the light much like sheer curtains diffuse window light. Diffusers come in lots of different designs, including small, fold-flat models that fit over the built-in flash.
- ✓ Frame the subject loosely to allow for later cropping to a variety of frame sizes. Your camera produces images that have an aspect ratio of 3:2. That means that your portrait perfectly fits a 4-x-6-inch print size but will require cropping to print at any other proportions, such as 5 x 7 or 8 x 10. The Chapter 6 section on printing talks more about this issue.

Capturing action

A fast shutter speed is the key to capturing a blur-free shot of any moving subject, whether it's a flower in the breeze, a spinning Ferris wheel, or, as in the case of Figure 9-6, a racing cyclist.

Along with the basic capture settings outlined in Table 9-1, try the techniques in the following steps to photograph a subject in motion:

1. Set the Mode dial to S (shutter-priority autoexposure).

In this mode, you control the shutter speed, and the camera takes care of choosing an aperture setting that will produce a good exposure.

2. Rotate the Command dial to select the shutter speed.

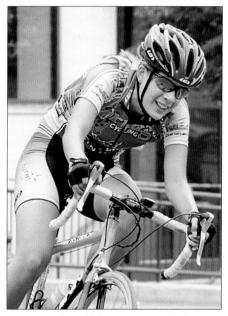

Figure 9-6: Use a high shutter speed to freeze motion.

(Refer to Figure 9-1 to locate shutter speed in the viewfinder

and Information display.) After you select the shutter speed, the camera selects an aperture (f-stop) to match.

What shutter speed should you choose? Well, it depends on the speed at which your subject is moving, so you need to experiment. But generally speaking, 1/320 second should be plenty for all but the fastest subjects (race cars, boats, and so on). For very slow subjects, you can even go as low as 1/250 or 1/125 second. My subject in Figure 9-6 was zipping along at a pretty fast pace, so I set the shutter speed to 1/500 second. Remember, though, that when you increase shutter speed, the camera opens the aperture to maintain the same exposure. At low f-stop numbers, depth of field becomes shorter, so you have to be more careful to keep your subject within the sharp-focus zone as you compose and focus the shot.

You also can take an entirely different approach to capturing action: Instead of choosing a fast shutter speed, select a speed slow enough to blur the moving objects, which can create a heightened sense of motion and, in scenes that feature very colorful subjects, cool abstract images. I took this approach when shooting the carnival ride featured in Figure 9-7, for example. For the left image, I set the shutter speed to 1/30 second; for the right version, I slowed things down to 1/5 second. In both cases, I used a tripod, but because nearly everything in the frame was moving, the entirety of both photos is blurry — the 1/5 second version is simply more blurry because of the slower shutter.

1/30 second

1/5 second

Figure 9-7: Using a shutter speed slow enough to blur moving objects can be a fun creative choice, too.

3. In dim lighting, raise the ISO setting if necessary to allow a fast shutter speed.

Unless you're shooting in bright daylight, you may not be able to use a fast shutter speed at a low ISO, even if the camera opens the aperture as far as possible. If auto ISO override is in force, ISO may go up automatically when you increase the shutter speed — Chapter 7 has details on that feature. Raising the ISO does increase the possibility of noise, but a noisy shot is better than a blurry shot.

Why not add flash to brighten the scene? Well, adding flash is tricky for action shots, unfortunately. First, the flash needs time to recycle between shots, which slows your capture rate. Second, the built-in flash has limited range — so don't waste your time if your subject isn't close by. And third, remember that the fastest shutter speed you can use with flash is 1/200 second, which may not be high enough to capture a quickly moving subject without blur.

8 1

4. For rapid-fire shooting, set the Release mode to Continuous.

In that mode, which you access via the Release Mode button, you can capture multiple images with a single press of the shutter button. As long as you hold down the button, the camera continues to record images, at a rate of up to four frames per second. Here again, though, you need to go flashfree; you can't use this Release mode with flash.

5. Select speed-oriented autofocusing options.

Try these two autofocus settings for best performance:

- Set the AF-Area mode to Dynamic Area.
- Set the Focus mode to AF-C (continuous-servo autofocus).

At these settings, the camera sets focus initially on your selected focus point but then looks to the surrounding points for focusing information if your subject moves away from the selected one. Focus is adjusted continuously until you take the shot. Chapter 8 has the details.

6. Compose the subject to allow for movement across the frame.

Frame your shot a little wider than you normally might so that you lessen the risk that your subject will move out of the frame before you record the image. You can always crop to a tighter composition later. (I used this approach for my cyclist image — the original shot includes a lot of background that I later cropped away.) It's also a good idea to leave more room in front of the subject than behind it. This makes it obvious that your subject is going somewhere.

Using these techniques should give you a better chance of capturing any fast-moving subject. But action-shooting strategies also are helpful for shooting candid portraits of kids and pets. Even if they aren't currently running, leaping, or otherwise cavorting, snapping a shot before they do move is often tough. So if an interaction catches your eye, set your camera into action mode and fire off a series of shots as fast as you can.

Capturing scenic vistas

Providing specific capture settings for landscape photography is tricky because there's no single best approach to capturing a beautiful stretch of countryside, a city skyline, or other vast subject. Take depth of field, for example: One person's idea of a super cityscape might be to keep all buildings in the scene sharply focused. But another photographer might prefer to shoot the same scene so that a foreground building is sharply focused while the others are less so, thus drawing the eye to that first building.

That said, I can offer a few tips to help you photograph a landscape the way *you* see it:

- Shoot in aperture-priority autoexposure mode (A) so that you can control depth of field. If you want extreme depth of field so that both near and distant objects are sharply focused, as in Figure 9-8, select a high f-stop value. I used an aperture of f/18 for this shot. For short depth of field, use a low value.
- ✓ If the exposure requires a slow shutter, use a tripod to avoid blurring. The downside to a high f-stop is that you need a slower shutter speed to produce a good exposure. If the shutter speed drops below what you can comfortably handhold, use a tripod to avoid picture-blurring camera shake. Remember that when you use a tripod, Nikon recommends that you turn off Vibration Reduction if you're using the kit lens. Just set the VR switch on the lens to the Off position.

No tripod handy? Look for any solid surface on which you can steady the camera. You can increase the ISO Sensitivity setting to allow a faster shutter, too, but that option brings with it the chances of increased image noise. See Chapter 7 for details.

✓ For dramatic waterfall shots, consider using a slow shutter to create that "misty" look. The slow shutter blurs the water, giving it a soft, romantic appearance, as shown in Figure 9-9. Again, use a tripod to ensure that the rest of the scene doesn't also blur due to camera shake. Shutter speed for the image in Figure 9-9 was 1/5 second.

Figure 9-8: Use a high f-stop value to keep foreground and background sharply focused.

In very bright light, you may overexpose the image at a very slow shutter, even if you stop the aperture all the way down and select the camera's lowest ISO setting. As a solution, consider investing in a *neutral density filter* for your lens. This type of filter works something like sunglasses for your camera: It simply reduces the amount of light that passes through the lens, without affecting image colors, so that you can use a slower shutter than would otherwise be possible.

At sunrise or sunset, base exposure on the sky. The foreground will be dark, but you can usually brighten it in a photo editor if needed. If you base exposure on the foreground, on the other hand, the sky will become so bright that all the color will be washed out — a

Figure 9-9: For misty waterfalls, use a slow shutter speed and a tripod.

problem you usually can't fix after the fact. You can also invest in a *grad-uated neutral-density filter*, which is a filter that's clear on one side and dark on the other. You orient the filter so that the dark half falls over the sky and the clear side over the dimly lit portion of the scene. This setup enables you to better expose the foreground without blowing out the sky colors.

Experiment with the Active D-Lighting setting as well; when enabled, it enables you to create an image that contains a greater range of brightness values than is normally possible. But take some shots with the feature turned off, too, so that you can later choose the versions you like best. Chapter 7 explains this feature, which you turn on and off via the Shooting menu.

✓ For cool nighttime city pics, experiment with slow shutter. Assuming that cars or other vehicles are moving through the scene, the result is neon trails of light like those you see in the foreground of the image in Figure 9-10. Shutter speed for this image was about ten seconds.

Instead of changing the shutter speed manually between each shot, try *bulb* mode. Available only in M (manual) exposure mode, this option records an image for as long as you hold down the shutter button. So just take a series of images, holding down the button for different

lengths of time for each shot. In bulb mode, you also can exceed the standard maximum exposure time of 30 seconds.

✓ For the best lighting, shoot during the magic hours. That's the term photographers use for early morning and late afternoon, when the light cast by the sun is soft and warm, giving everything that beautiful, gently warmed look.

Can't wait for the perfect light? Tweak your camera's White Balance setting, using the instructions laid out in Chapter 8, to simulate the color of magic-hour light.

✓ In tricky light, bracket exposures. Bracketing simply means to take the same picture at several different exposure settings to increase the odds that at least one of them will capture the scene the way you envision. Bracketing is especially a good idea in difficult lighting situations, such as sunrise and sunset. In the P, S, and A exposure modes, you can bracket shots

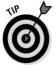

by adjusting the Exposure Compensation value between each picture. Chapter 7 explains this feature.

✓ When shooting fireworks, use manual exposure, manual focus, and a tripod. Fireworks require a long exposure, and trying to handhold your camera simply isn't going to work. If using a zoom lens, zoom out to the shortest focal length (widest angle). Switch to manual focusing and set focus at infinity (the farthest focus point possible on your lens). Set the exposure mode to manual, choose a relatively high f-stop setting — say, f/16 or so — and start at a shutter speed of one to five seconds.

From there, it's simply a matter of experimenting with different shutter speeds. Also play with the timing of the shutter release, starting some exposures at the moment the fireworks are shot up, some at the moment they burst open, and so on. For the example featured in Figure 9-11, I used a shutter speed of about five seconds and began the exposure as the rocket was going up — that's what creates the "corkscrew" of light that rises up through the frame.

Again, for an easy way to vary exposure time between shots, try using the Bulb shutter speed. This technique enables you to experiment with shutter speed more easily because you don't have to use the Command dial to adjust the setting between each shot. Remember that this option is available only in the M (manual) exposure mode; it's the setting one step below the slowest shutter speed (30 seconds).

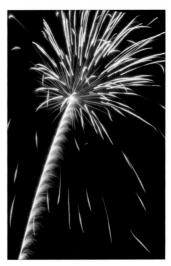

Figure 9-11: I used a shutter speed of five seconds to capture this fireworks shot.

Capturing dynamic close-ups

For great close-up shots, try these techniques:

- Check your lens manual to find out its minimum close-focusing distance. How "up close and personal" you can get to your subject depends on your lens, not the camera body.
- ✓ Take control over depth of field by setting the camera mode to A (aperture-priority autoexposure) mode. Whether you want a shallow, medium, or extreme depth of field depends on the point of your photo. In classic nature photography, for example, the artistic tradition is a very shallow depth of field, as shown in Figure 9-12, and requires an open aperture (low f-stop value). But if you want the viewer to be able to clearly see all details throughout the frame — for example, if you're

Part III: Taking Creative Control

shooting a product shot for your company's sales catalog — you need to go the other direction, stopping down the aperture as far as possible.

- Remember that zooming in and getting close to your subject both decrease depth of field. So back to that product shot: If you need depth of field beyond what you can achieve with the aperture setting, you may need to back away, zoom out, or both. (You can always crop your image to show just the parts of the subject that you want to feature.)
- When shooting flowers and other nature scenes outdoors, pay attention to shutter speed, too. Even a slight breeze may cause your subject to move, causing blurring at slow shutter speeds.
- ✓ Use flash for better outdoor lighting. Just as with portraits, a tiny bit of flash typically improves close-ups when the sun is your primary light source. Again, though, keep in mind that the maximum shutter speed possible when you use the built-in flash is 1/200 second. So in

very bright light, you may need to use a high f-stop setting to avoid overexposing the picture. You can also adjust the flash output via the Flash Compensation control. Chapter 7 offers details.

- When shooting indoors, try not to use flash as your primary light source. Because you're shooting at close range, the light from your flash may be too harsh even at a low Flash Compensation setting. If flash is inevitable, turn on as many room lights as possible to reduce the flash power that's needed — even a hardware-store shop light can do in a pinch as a lighting source. (Remember that if you have multiple light sources, though, you may need to tweak the White Balance setting.)
- To really get close to your subject, invest in a macro lens or a set of diopters. A true macro

Figure 9-12: Shallow depth of field is a classic technique for close-up floral images.

Chapter 9: Putting It All Together

lens, which enables you to get really, really close to your subjects, is an expensive proposition; expect to pay at least \$300 and much more for the top-end lenses. But if you enjoy capturing the tiny details in life, it's worth the investment.

For a less expensive way to go, you can spend about \$40 for a set of *diopters*, which are sort of like reading glasses that you screw onto your existing lens. Diopters come in several strengths -+1, +2, +4, and so on — with a higher number indicating a greater magnifying power. I took this approach to capture the extreme close-up in Figure 9-13, attaching a +2 diopter to my lens. The downfall of diopters, sadly, is that they typically produce images that are very soft around the edges, a problem that doesn't occur with a good macro lens.

Figure 9-13: To extend your lens's close-focus capability, you can add magnifying diopters.

316 Part III: Taking Creative Control

Part IV The Part of Tens

In this part ...

n time-honored *For Dummies* tradition, this part of the book contains additional tidbits of information presented in the always popular "Top Ten" list format. Chapter 10 shows you how to do some minor picture touchups, such as cropping and adjusting exposure, by using tools on your camera's Retouch menu. Following that, Chapter 11 introduces you to ten camera functions that I consider specialty tools — bonus options that, although not at the top of the list of the features I suggest you study, are nonetheless interesting to explore when you have a free moment or two.

Ten Fun and Practical Retouch Menu Features

In This Chapter

LON.

- Applying Retouch menu filters
- Removing red-eye
- > Correcting crooked horizon lines, lens distortion, and perspective
- Cropping away excess background
- Brightening shadows without blowing out highlights
- Tweaking color
- Creating monochrome images

Very photographer produces a clunker now and then. When it happens to you, don't be too quick to reach for the Delete button, because many picture problems are surprisingly easy to fix. In fact, you often can repair your photos right in the camera, thanks to tools found on the Retouch menu.

This chapter offers recipes for using the ten most useful of these repair and enhancement features. Additionally, I received special dispensation from the *For Dummies* folks to start off things with an additional section that summarizes tips that relate to all the Retouch menu options. In the words of Nigel Tufnel from the legendary rock band Spinal Tap, "This one goes to 11!"

Applying the Retouch Menu Filters

You can get to the Retouch menu features in two ways:

Display the Retouch menu, select the tool you want to use, and press OK. You're then presented with thumbnails of your photos. Use the Multi Selector to move the yellow highlight box over the photo you want to adjust and press OK. You next see options related to the selected tool.

A red X through a thumbnail means that you can't apply the selected tool to the picture. For example, after trimming a photo, you can't apply other tools to the trimmed version. (So if you want to make several changes to a photo, always use the Trim tool last.)

Switch the camera to playback mode, display your photo in singleframe view, and press OK. (Remember, you can shift from thumbnail display to single-frame view simply by pressing OK.) The Retouch menu then appears superimposed over your photo, as shown on the left in Figure 10-1.

Menu commands that are dimmed can't be applied to the picture. For example, if you took a picture without flash, the Red-eye correction filter is dimmed, as in the figure, because the camera is smart enough to know that such a picture wouldn't have any red eye.

Select the tool you want to use and press OK again to apply the tool to your picture, as shown on the right. I prefer the second method so that's how I approach things in this chapter, but it's entirely a personal choice.

However, you can't use this method for one Retouch menu option: Image Overlay, which combines two RAW (NEF) photos to create a third, blended image, requires you to use the first method of accessing the menu.

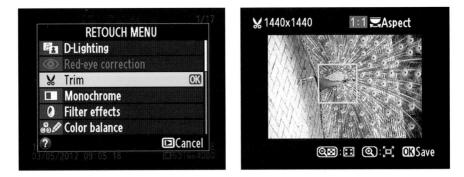

Figure 10-1: In single-frame playback view, press OK, select a retouching tool, and press OK again to apply the tool to your picture.

A few other factoids to note before you experiment with the Retouch tools:

- Your originals remain intact. When you apply a correction or enhancement from the Retouch menu, the camera creates a copy of your original photo and then makes the changes to the copy only. Your original is preserved untouched.
- All menu options work with either JPEG or Raw (NEF) originals except Image Overlay. The Image Overlay feature, which combines two pictures and is detailed in Chapter 11, works only with Raw files. See Chapter 2 for an explanation of JPEG and Raw file types.
- Retouched copies for all alterations except Image Overlay are saved in the JPEG file format. The retouched copy uses the same JPEG quality setting as the original (Fine, Normal, or Basic). For the Image Overlay option, you can store the combined photo as JPEG or Raw (or both) file.
- ✓ You can apply each correction to the same picture only once. The exception is the Image Overlay feature you can use the technique outlined in Chapter 11 to overlay more than two pictures.

- ✓ File numbers of retouched copies don't match those of the originals. Make note of the filename the retouched version is assigned so that you can easily track it down later. What numbering the camera chooses depends on the numbers of the files already on your memory card.
- Except for Image Overlay pictures, edited files are assigned a filename that begins with a special three-letter code. The codes are as follows:
 - *SSC*: Used for photos that you resize using the Resize function. Chapter 6 covers this feature, which is useful for creating lowresolution copies of your photos for e-mail sharing.
 - *CSC:* Indicates that you applied one of the other Retouch menu corrections.

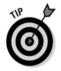

Image Overlay pictures retain the original DSC or _DSC file prefix, which can make it difficult to distinguish them from a Raw original. (DSC means that the image was captured using the sRGB color profile; _DSC indicates the Adobe RGB color profile.) The key is to look for the Retouch information during picture playback; see Chapter 5 to find out more about where to find this bit of data. Chapter 8 discusses color profiles.

✓ You can compare the original and the retouched version through the Side-by-Side Comparison menu option. To use this feature, start by displaying either the original or the retouched version in full-frame playback. Then press OK, select Side-by-Side Comparison, as shown on the left in Figure 10-2, and press OK again. Now you see the original image on one side and the retouched version on the other, as shown in the second screen in the figure. At the top of the screen, labels indicate the Retouch tool that you applied to the photo. (I applied the cropping tool, Trim, in Figure 10-2.)

Figure 10-2: Use the Side-by-Side Comparison option to see whether you prefer the retouched version of a photo to the original.

These additional tricks work in Side-by-Side display:

- *View the results of multiple changes one at a time:* If you applied more than one Retouch tool to the picture, press the Multi Selector right and left to display individual thumbnails that show how each tool affected the picture.
- *View different retouched versions:* If you create multiple retouched versions of the same original for example, if you create a monochrome version, save that, and then crop the original image and save that you use a different technique to compare all the versions. First, press the Multi Selector right or left to surround the After image with the yellow highlight box. Now press the Multi Selector up and down to scroll through all the retouched versions.
- *View the original or retouched image at full-frame size:* Use the Multi Selector to highlight its thumbnail and then press and hold the Zoom In button. Release the button to return to normal view.
- Exit Side-by-Side view: Press the Playback button.

Removing Red-Eye

From my experience, red-eye isn't a major problem with the D3200. Typically, the problem occurs only in very dark lighting, which makes sense: When little ambient light is available, the pupils of the subjects' eyes widen, creating more potential for the flash light to cause red-eye reflection.

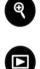

1. Display your photo in single-image view and press OK.

The Retouch menu appears over your photo. (Note that the Red-Eye Correction option appears dimmed in the menu for photos taken without flash.)

2. Highlight Red-Eye Correction, as shown on the left in Figure 10-3, and press OK.

Figure 10-3: An automated red-eye remover is built right into your camera.

If the camera detects red-eye, it applies the removal filter and displays the results in the monitor. If the camera can't find any red-eye, it displays a message telling you so.

3. Carefully inspect the repair.

Press the Zoom In button to magnify the display so that you can check the camera's work, as shown on the right in Figure 10-3. To scroll the display, press the Multi Selector up, down, right, or left. The yellow box in the tiny navigation window in the lower-right corner of the screen indicates the area of the picture that you're currently viewing.

4. If you approve of the correction, press OK twice.

The first OK returns the display to normal magnification; the second creates the retouched copy.

5. If you're not happy with the results, press OK to return to normal magnification. Then press the Playback button to cancel the repair.

Part IV: The Part of Tens

If the in-camera red-eye repair fails you, most photo-editing programs have red-eye removal tools that let you get the job done. Unfortunately, no red-eye remover works on animal eyes. Red-eye removal tools know how to detect and replace only red-eye pixels, and animal eyes typically turn yellow, white, or green in response to a flash. The easiest solution is to use the brush tool found in most photo editors to paint the proper eye colors.

Straightening Tilting Horizon Lines

I seem to have a knack for shooting with the camera slightly misaligned with respect to the horizon line, which means that photos like the one on the left in Figure 10-4 often wind up crooked — in this case, everything tilts down toward the right corner of the frame. Perhaps those who say I have a skewed view of life are right? At any rate, my inability to "shoot straight" makes me especially fond of the Straighten tool. With this filter, you can rotate tilting horizons back to the proper angle, as shown in the right image in the figure.

Figure 10-4: You can rotate crooked photos back to a level orientation with the Straighten tool.

Chapter 10: Ten Fun and Practical Retouch Menu Features

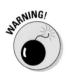

To achieve this rotation magic, the camera must crop your image and then enlarge the remaining area — that's why the after photo in Figure 10-4 contains slightly less subject matter than the original. (The same cropping occurs if you make this kind of change in a photo editor.) The camera updates the display as you rotate the photo so that you can get an idea of how much of the original scene may be lost.

Here's how to put the tool to work:

- 1. Display the photo in single-image playback mode and then press OK to get to the Retouch menu.
- 2. Highlight Straighten, as shown on the left in Figure 10-5, and press OK.

You see a screen similar to the one on the right in the figure, with a grid superimposed on your photo to serve as an alignment aid.

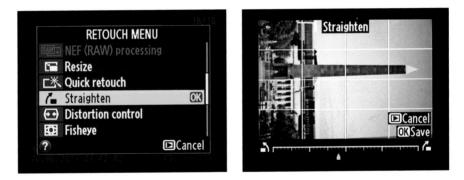

Figure 10-5: Press the Multi Selector right or left to rotate the image in increments of .25 degrees.

3. To rotate the picture clockwise, press the Multi Selector right.

Each press spins the picture by about .25 degrees. You can achieve a maximum rotation of five degrees. The yellow pointer on the little scale under the photo shows you the current amount of rotation.

- 4. To rotate in a counterclockwise direction, press the Multi Selector left.
- 5. When things are no longer off-kilter, press OK to create your retouched copy.

Part IV: The Part of Tens

Removing (Or Creating) Lens Distortion

Certain lenses can produce a type of distortion that causes straight lines to appear curved. Wide-angle lenses, for example, often create *barrel distortion*, in which objects at the center of a picture appear to be magnified and pushed forward — as if you wrapped the photo around the outside of a barrel. The effect is perhaps easiest to spot in a rectangular subject like the painting in Figure 10-6. Notice that in the original image, on the left, the edges of the painting appear to bow slightly outward. *Pincushion distortion* affects the photo in the opposite way, making center objects appear smaller and farther away.

Slight barrel distortion

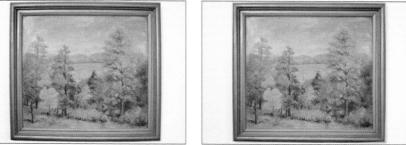

After Distortion Correction filter

Figure 10-6: Barrel distortion makes straight lines appear to bow outward.

You can minimize the chances of distortion by researching your lens purchases carefully. Photography magazines and online photography sites regularly measure and report distortion performance in their lens reviews.

If you notice a small amount of distortion, try enabling the Auto Distortion Control option on the Shooting menu. This feature attempts to correct distortion as you take the picture. (Chapter 8 has details.) Or you may prefer to wait until after reviewing your photos and then use the Distortion Control filter on the Retouch menu to try to fix things. I applied the filter to create the second version of the subject in Figure 10-6, for example. Less helpful, in my opinion, is a related filter, the Fisheye filter, that actually creates distortion in an attempt to replicate the look of a photo taken with a fisheye lens.

The extent of the in-camera adjustment you can apply is fairly minimal. Additionally, I find it a little difficult to gauge my results on the camera monitor because you can't display any sort of alignment grid over the image to help you find the right degree of correction. For those reasons, I prefer to do this kind of work in my photo editor. Wherever you make the correction, understand that you lose part of your original image area as a result of the distortion correction, just as you do when you apply the Straighten tool, covered in the preceding section. All that said, the first step in applying either the Distortion Control or Fisheye filter is to display your photo in single-image playback mode and then press OK to display the Retouch menu. From that point, the process depends on which filter you're using:

✓ Distortion Control: Select Distortion Control, as shown on the left in Figure 10-7, and then press OK to see the screen shown on the right. An Auto option is available for some lenses, as long as you didn't apply the Auto Distortion Control feature when taking the picture. As its name implies, the Auto option attempts to automatically apply the right degree of correction. If the Auto option is dimmed or you prefer to do the correction on your own, choose Manual, as shown on the right in the figure, and press OK. You then see the screen featured in Figure 10-8. The little scale under the image represents the degree and direction of shift that you're applying. Press the Multi Selector right to reduce barrel distortion (outward bowing); press left to reduce pincushioning (inward pinching). Press OK to save the corrected copy of the photo.

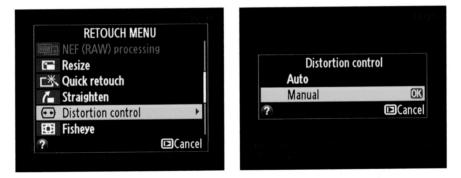

Figure 10-7: Use the Distortion Control filter to reduce barrel or pincushion distortion.

✓ Fisheye: Highlight the filter name on the Retouch menu and press OK. You see a screen similar to the one in Figure 10-8, but this time, you see the word Fisheye at the top of the screen, and the scale at the bottom of the image indicates the strength of the distortion effect. Press the Multi Selector right or left to adjust the amount and then press OK to create the fisheye copy.

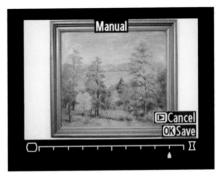

Figure 10-8: Press the Multi Selector right to reduce barrel distortion; press left to reduce pincushioning.

Correcting Perspective

When you photograph a tall building and tilt the camera up to get it all in the frame, a *convergence* or *keystoning* effect occurs. This effect causes vertical structures to appear to be leaning toward the center of the frame. Buildings sometimes even appear to be falling away from you, as shown in the left image in Figure 10-9. (If the lens is tilting down, verticals instead appear to lean outward, and the building appears to be falling toward you.) Through the Retouch menu's Perspective Control feature, you can right those leaning verticals, as shown in the after photo on the right in Figure 10-9.

Original

After perspective correction

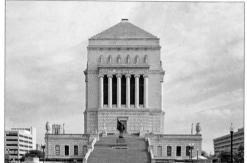

Figure 10-9: The original photo exhibited convergence (left); applying the Perspective Control filter corrected the problem (right).

Note, though, that as with the Straighten tool, you lose some area around the perimeter of your photo as part of the correction process. So when you're shooting this type of subject, frame loosely — that way, you ensure that you don't sacrifice an important part of the scene due to the correction.

To try out the Perspective filter, go the usual retouch route: Display your photo in single-image view, press OK, highlight Perspective Control, and press OK again. You then see a grid

Figure 10-10: Press the Multi Selector to adjust the correction type and amount.

and a horizontal and vertical scale, as shown in Figure 10-10.

To adjust the image, use the Multi Selector as follows:

- Rotate structures horizontally: Press the Multi Selector right and left to move the marker along the horizontal scale.
- Rotate structures toward or away from you: Press the Multi Selector up and down to move the marker on the vertical scale.

Use the guides to get the perspective as close to normal as possible and then press OK to make a copy of the original image with your changes.

Depending on the scene, you may not be able to get all structures fully corrected, so just pay attention to the most prominent ones in the scene. For severe distortion problems, you may be able to get better results in your photo editor; in some programs, you can pull and push each side of the image around independently of the others, which enables you to more freely shift perspective than is possible with the type of tool provided in the camera.

Cropping (Trimming) Your Photo

To *crop* a photo simply means to trim away some of its perimeter. Cropping away excess background can often improve an image, as illustrated by Figures 10-11 and 10-12. When shooting this scene, I couldn't get close enough to the ducks to fill the frame with them, so I simply cropped it after the fact to achieve the desired composition.

Figure 10-11: The original contains too much extraneous background.

With the Trim function on the Retouch menu, you can crop a photo right in the camera. Note a few things about this feature:

Crop aspect ratios: You can crop to five aspect ratios: 3:2, which maintains the original proportions and matches that of a 4-x-6-inch print; 4:3, the proportions of a standard computer monitor or television (that is, not a widescreen model); 5:4, which

Figure 10-12: Cropping creates a better composition and eliminates background clutter.

gives you the same proportions as an 8-x-10-inch print; 1:1, which results in a square photo; and 16:9, which is the same as a widescreen monitor or television. If your purpose for cropping is to prepare your image for a frame size that doesn't match any of these aspect ratios, crop the image in your photo software instead. (You can do the job in Nikon ViewNX 2, introduced in Chapter 6.)

- Crop sizes: For each aspect ratio, you can choose from a variety of crop sizes, which depend on the size of your original. The sizes are stated in pixel terms, such as 3600 x 2880. If you're cropping in advance of printing the image, remember to aim for at least 200 pixels per linear inch of the print. See Chapter 6 for more details about printing.
- ✓ Image Quality of trimmed picture: If you captured the original using the Raw or Raw+JPEG Image Quality setting, the cropped version is saved as a JPEG Fine image. For other JPEG images, the cropped version has the same Image Quality level as the original. (Chapter 3 explains Image Quality; for best quality, choose Fine.)

One final, critical note: After you apply the Trim function, you can't apply any other fixes from the Retouch menu. So make cropping the last of your retouching steps.

Keeping those caveats in mind, trim your image as follows:

1. Display your photo in single-image view and press OK to launch the Retouch menu.

Chapter 10: Ten Fun and Practical Retouch Menu Features

2. Select Trim and press OK.

You see the screen shown in Figure 10-13. The yellow highlight box indicates the current cropping frame. Anything outside the frame is set to be trimmed away.

3. Rotate the Command dial to change the crop aspect ratio.

The selected aspect ratio appears in the upper-right corner of the screen, as shown in Figure 10-13.

4. Adjust the cropping frame size and placement as needed.

Figure 10-13: Rotate the Command dial to change the proportions of the crop box.

The current crop size appears in the upper-left corner of the

screen. You can adjust the size and placement of the cropping frame like so:

- *Reduce the size of the cropping frame*. Press and release the Zoom Out button. Each press of the button further reduces the crop size.
- *Enlarge the cropping frame*. Press the Zoom In button to expand the crop boundary and leave more of your image intact.
- *Reposition the cropping frame*. Press the Multi Selector up, down, right, and left to shift the frame position.
- 5. Press OK to create your cropped copy.

Shadow Recovery with D-Lighting

Chapter 7 introduces you to Active D-Lighting. If you turn on this option, the camera captures the image in a way that brightens the darkest parts of the image, bringing shadow detail into the light but leaving highlight details intact. It's a great trick for dealing with high-contrast scenes or subjects that are backlit.

You also can apply a similar adjustment after you take a picture by choosing the D-Lighting option on the Retouch menu. I did just that for the photo in Figure 10-14, where strong backlighting left the balloon underexposed in the original image.

Part IV: The Part of Tens

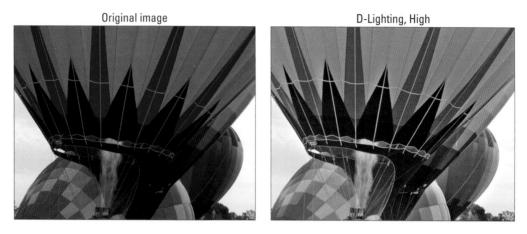

Figure 10-14: An underexposed photo (left) gets help from the D-Lighting filter (right).

To try the filter, display your photo in full-frame playback mode, press OK to display the Retouch menu, choose D-Lighting, and press OK once more. You see a screen like the one in Figure 10-15, with a thumbnail of your original image on the left and a preview of the retouched image on the right.

Here's all you need to know about the filter:

- D-Lighting
- Set the adjustment level: Press the Multi Selector up and down. You get three levels: Low,

Figure 10-15: Apply the D-Lighting filter via the Retouch menu.

Normal, and High. I used High for the repair to my balloon image.

Get a magnified view of the adjusted photo: Press and hold the Zoom In button. Release the button to return to the two-thumbnail display.

Create your retouched copy: Press OK.

You can't apply D-Lighting to a picture taken using the Monochrome Picture Control. (See Chapter 8 for details on Picture Controls.) Nor does D-Lighting work on any pictures to which you've applied the Quick Retouch filter, covered next or the Monochrome filter, detailed a little later in this chapter. Also remember that you can't apply *any* filters to cropped images you created using the Trim function, covered earlier in the chapter.

Boosting Shadows, Contrast, and Saturation Together

The Quick Retouch filter increases contrast and saturation and, if your subject is backlit, also applies a D-Lighting adjustment to restore some shadow detail that otherwise might be lost. In other words, Quick Retouch is sort of like D-Lighting on steroids.

Figure 10-16 illustrates the difference between the two filters. The first example shows my original, a closeup shot of a tree bud about to flower. I applied the D-Lighting filter to the second example, which brightened the darkest areas of the image. In the final example, I applied the Ouick Retouch filter. Again, shadows got a slight bump up the brightness scale. But the filter also increased color saturation and adjusted the overall image to expand the tonal range across the entire brightness spectrum, from very dark to very bright. In this photo, the saturation change is most noticeable in the yellows and reds of the tree bud. (The sky color may initially appear to be less saturated, but in fact, it's just a lighter hue than the original, thanks to the contrast adjustment.)

To try the filter, display your photo in single-image playback mode and press OK to bring up the Retouch menu. Highlight Quick Retouch, as shown on the left in Figure 10-17, and press OK to display the right screen in the figure. Original

D-Lighting

Quick Retouch

Figure 10-16: Quick Retouch brightens shadows and also increases saturation and contrast, producing a slightly different result than D-Lighting.

Figure 10-17: Press the Multi Selector up or down to adjust the amount of the correction.

As with the D-Lighting filter, you can set the level of adjustment to Low, Normal, or High. Just press the Multi Selector up or down to change the setting. (For my example photos, I applied both the D-Lighting and Quick Retouch filters at the Normal level.) Press OK to finalize the job and create your retouched copy.

Note that the same issues related to D-Lighting, spelled out in the preceding section, apply here as well: You can't apply the Quick Retouch filter to cropped photos, to monochrome images, or to retouched photos you created by applying the D-Lighting filter. However, you can create two retouched copies of your original image, applying D-Lighting to one and Quick Retouch to the other. You then can use the Side-by-Side Comparison feature, explained at the beginning of this chapter, to compare the retouched versions to see which one you prefer.

Two Ways to Make Subtle Color Adjustments

Chapter 8 explains how to use your camera's White Balance and Picture Control features to manipulate photo colors. But even if you play with those settings all day, you may wind up with colors that you want to tweak just a tad.

You can boost color saturation with the Quick Retouch filter, explained in the preceding section. But that tool also adjusts contrast and, depending on the photo, also applies a D-Lighting correction. With the Filter Effects and Color Balance tools, however, you can manipulate color only. The next two

Applying digital lens filters

As shown in Figure 10-18, the Filter Effects option offers five color-manipulation filters that are designed to mimic the results produced by traditional lens filters. The other two filters on the menu, Cross Screen and Soft (not visible in the figure), are special-effects filters; you can read about both in Chapter 11.

The color-shifting filters work like so:

Figure 10-18: You can choose from effects that mimic traditional lens filters.

- Skylight filter: This filter reduces the amount of blue in an image. The result is a very subtle warming effect. That is, colors take on a bit of a reddish cast.
- ✓ Warm filter: This one produces a warming effect that's just a bit stronger than the Skylight filter.
- Color intensifiers: You can boost the intensity of reds, greens, or blues individually by applying these filters.

As an example, Figure 10-19 shows you an original image and three adjusted versions. As you can see, the Skylight and Warm filters are both very subtle; in this image, the effects are most noticeable in the sky. The fourth example shows a variation created by using the Color Balance filter, explained in the next section, and shifting colors toward the cool (bluish) side of the color spectrum.

336 Part IV: The Part of Tens _____

Warm filter

Skylight filter

Color Balance filter, shifted to blue

Figure 10-19: Here you see the results of applying two Filter Effects adjustments and a Color Balance shift.

Follow these steps to apply the Filter Effects color tools:

- 1. Display your photo in single-frame playback mode and press OK to display the Retouch menu.
- 2. Highlight Filter Effects and press OK.

You see the list of available filters. (Refer to Figure 10-8.)

3. Highlight the filter you want to use and press OK.

The camera displays a preview of how your photo will look if you apply the filter.

337

4. To apply the Skylight or Warm filter, press OK.

Or press the Playback button if you want to cancel the filter application. You can't adjust the intensity of these two filters.

5. For the color-intensifier filters, press the Multi Selector up or down to specify the amount of color shift. Then press OK.

Manipulating color balance

The Color Balance tool enables you to adjust colors with more finesse than the Filter Effects options. With this filter, you can shift colors toward any part of the color spectrum. For example, shifting colors toward the cooler bluer — spectrum produced the fourth example in Figure 10-19.

Take these steps to give it a whirl:

1. Display your photo in single-image playback mode and press OK.

Up pops the Retouch menu.

2. Highlight Color Balance, as shown on the left in Figure 10-20.

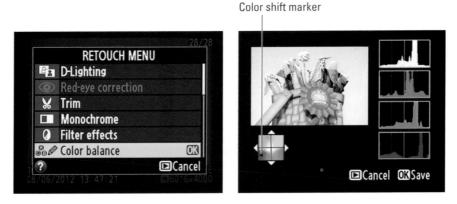

Figure 10-20: Press the Multi Selector to move the color-shift marker and adjust color balance.

3. Press OK to display the screen shown on the right in the figure.

The important control here is the color grid in the lower-left corner. Notice the tiny black square inside the grid, labeled color shift marker in the figure.

338 Part IV: The Part of Tens

4. Use the Multi Selector to move the color shift marker in the direction of the color adjustment you want to make.

Press up to make the image more green, press right to make it more red, and so on. In the figure, I positioned the marker to emphasize blue tones, for example.

The histograms on the right side of the display show you the resulting impact on overall image brightness, as well as on the individual red, green, and blue brightness values — a bit of information that's helpful if you're an experienced student in the science of reading histograms. (Chapter 5 gives you an introduction.) If not, just check the image preview to monitor your results.

5. Press OK to create the color-adjusted copy of your photo.

Creating Monochrome Photos

With the Monochrome Picture Control feature covered in Chapter 8, you can shoot black-and-white photos. Technically, the camera takes a full-color picture and then strips it of color as it's recording the image to the memory card, but the end result is the same.

As an alternative, you can create a black-and-white copy of an existing color photo by applying the Monochrome option on the Retouch menu. You can also create sepia and *cyanotype* (blue and white) images via the Monochrome option. Figure 10-21 shows you examples of all three effects.

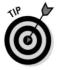

I prefer to convert my color photos to monochrome images in my photo editor; going that route simply offers more control, not to mention the fact that it's easier to preview your results on a large computer monitor than on the camera monitor. Still, I know that not everyone's as much of a photoediting geek as I am, so I present to you here the steps involved in applying the Monochrome effects to a color original in your camera:

- 1. Display your photo in single-image view and press OK to bring the Retouch menu to life, as shown on the left in Figure 10-22.
- 2. Highlight Monochrome and press OK to display the three effect options, as shown on the right in the figure.
- 3. Highlight the effect that you want to apply and press OK.

You then see a preview of the image with your selected photo filter applied.

Figure 10-21: You can create three monochrome effects through the Retouch menu.

4. To adjust the intensity of the sepia or cyanotype effect, press the Multi Selector up or down.

No adjustment is available for the black-and-white filter.

5. Press OK to create the monochrome copy.

	RETOUCH MENU	23/23			
8	D-Lighting			Monochrome	
	Red-eye correction			a superior superior and a second s	(T)
¥	Trim		avelet	Black-and-white	U.J
	Monochrome	+		Sepia	
	Filter effects			Cyanotype	
10.0100000000	Color balance		?		
?	Ē		10003		
		0601624000	08706/		

Figure 10-22: Select a filter and press OK to start the process.

E I LE

Ten Special-Purpose Features to Explore on a Rainy Day

In This Chapter

- Adding text comments to images
- Creating custom image-storage folders
- Changing the function of some controls
- Playing with a few special effects
- Combining two photos into one

Consider this chapter the literary equivalent of the end of one of those late-night infomercial offers — the part where the host exclaims, "But wait! There's more!"

The features covered in these pages fit the category of "interesting bonus." They aren't the sort of options that drive people to choose one camera over another, and they may come in handy only for certain users, on certain occasions. Still, they're included at no extra charge with your camera purchase, so check 'em out when you have a few spare moments. Who knows; you may discover that one of these bonus features is actually a hidden gem that provides just the solution you need for one of your photography problems.

Annotate Your Images

Through the Image Comment feature on the Setup menu, you can add text comments to your picture files. Suppose, for example, that you're traveling on vacation and visiting a different destination every day. You can annotate all the pictures you take on a particular outing with the name of the location or attraction. You can then view the comments in the Metadata panel

2 Part IV: The Part of Tens

of Nikon ViewNX 2, the photo software that ships free with your camera. (Chapter 6 explains how to view the Metadata panel.) Some other programs also can display the comment in their metadata panels. During picture playback, the annotation appears if you set the playback display mode to Shooting Data; see Chapter 5 for help with that option, and look for the Image Comment on the third screen of shooting data.

To add the comment to the next picture you take, follow these steps:

1. Display the Setup menu and highlight Image Comment, as shown on the left in Figure 11-1.

2. Press OK to display the right screen in the figure.

3. Highlight Input Comment and press the Multi Selector right.

Now you see a keyboard-type screen like the one shown on the left in Figure 11-2.

Figure 11-2: Highlight a letter and press OK to enter it into the comment box.

4. Use the Multi Selector to highlight the first letter of the text you want to add.

If you scroll the display down, you can access additional characters not visible on the initial screen.

- 5. Press the OK button to enter that letter into the display box at the bottom of the screen.
- 6. Keep highlighting letters and pressing the OK button to continue entering your comment.

Your comment can be up to 36 characters long.

To move the text cursor, rotate the Command dial in the direction you want to shift the cursor.

To delete a letter, move the cursor under the offending letter and then press the Delete button.

7. To save the comment, press the Zoom In button.

You're returned to the Image Comment menu.

8. Highlight Attach Comment and press the Multi Selector right to put a check mark in the box, as shown on the right in Figure 11-2.

The check mark turns on the Image Comment feature.

9. Highlight Done, as shown in Figure 11-3, and press OK.

You're returned to the Setup menu. The Image Comment menu item should now be set to On.

The camera applies your comment to all pictures you take after turning on Image Comment. To disable the feature, revisit the Image Comment menu, highlight Attach Comment, and press the Multi Selector right to toggle the check mark off. Select Done and press OK to make your decision official.

Figure 11-3: Be sure to select Done and press OK before exiting the menu.

Creating Custom Image Folders

By default, your camera initially stores all your images in one folder, which it names 100D3200. Folders have a storage limit of 999 images; when you exceed that number, the camera creates a new folder, assigning a name that indicates the folder number — 101D3200, 102D3200, and so on. You see the full name of the default folders when you view the memory card contents on

Part IV: The Part of Tens

your computer. While viewing pictures on the camera, you see only a single folder, named D3200, that holds all your pictures, even after you exceed 999 photos and the camera creates a second folder for you.

If you choose, however, you can create your own, custom-named folders. For example, perhaps you sometimes use your camera for business and sometimes for personal use. To keep your images separate, you can set up one folder named DULL and one named FUN — or perhaps something less incriminating, such as WORK and HOME.

Whatever your folder-naming idea, you create custom folders like so:

1. Display the Setup menu and highlight Storage Folder, as shown on the left in Figure 11-4.

Figure 11-4: You can create custom folders to organize your images right on the camera.

- 2. Press OK to display the screen shown on the right in Figure 11-5.
- 3. Highlight New and press the Multi Selector right.

You see a keyboard-style screen similar to the one used to create image comments, as described in the preceding section. The folder-naming version appears in Figure 11-5.

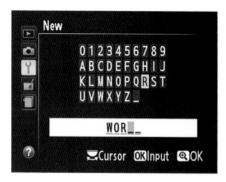

Figure 11-5: Folder names can contain up to five characters.

344

4. Enter a folder name up to five characters long.

Use these techniques:

- Enter a letter: Highlight it by using the Multi Selector. Then press OK.
- *Move the text cursor:* Rotate the Command dial in the direction you want to move the cursor.
- *Delete a letter:* Place the cursor under it and press the Delete button.

5. After creating your folder name, press the Zoom In button to complete the process and return to the Setup menu.

The folder you just created is automatically selected as the active folder.

If you take advantage of this option, remember to specify where you want your pictures stored each time you shoot: Select Storage Folder from the Setup menu and press OK to display the screen shown on the left in Figure 11-6. Highlight Select Folder and press the Multi Selector right to display a list of all your folders, as shown on the right in the figure. Highlight the folder that you want to use and press OK. Your choice also affects which images you can view in playback mode; see Chapter 6 to find out how to select the folder you want to view.

Storage folder	Select folder	
4	WORK_	OK
Select folder	D3200	
New		
Rename		
Delete		

Figure 11-6: Remember to specify where you want to store new images.

If necessary, you can rename a custom folder by using the Rename option on the Storage Folder screen. (Refer to the left screen in Figure 11-6.) The Delete option on the same screen enables you to get rid of all empty folders on the memory card.

WARNING!

Changing the Function Button's Function

Tucked away on the left-front side of the camera, just under the Flash button, the Function (Fn) button is set by default to provide quick access to the ISO Sensitivity setting. By holding down the button and rotating the Command dial, you can adjust the setting without going through the Shooting menu or Info Edit screen. But if you don't adjust the ISO setting often, you may want to assign one of three other possible functions to the button.

You establish the button's behavior via the Buttons option on the Setup menu, shown on the left in Figure 11-7. After selecting the option, press OK and choose the Assign Fn Button option, as shown on the right in the figure. You're presented with a list of possible button functions, as shown in Figure 11-8. Here's a description of the possible settings:

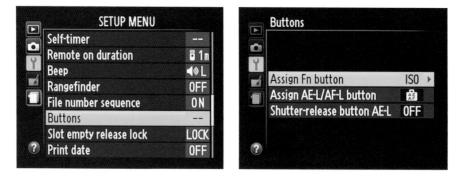

Figure 11-7: You can assign any number of jobs to the Function button.

- Image Quality/Size: If you select this option, pressing the Fn button while turning the Command dial lets you choose the desired image quality and size. As you rotate the dial, you cycle through the possible combinations of the settings, which you normally select separately, through the Image Quality and Image Size options. Chapter 2 explains these two picture settings.
- ✓ ISO Sensitivity: At this default setting, pressing the Fn button

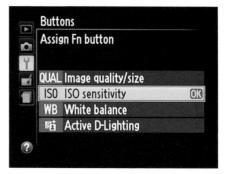

Figure 11-8: The default option enables you to use the Function button to access the ISO Sensitivity option quickly.

Chapter 11: Ten Special-Purpose Features to Explore on a Rainy Day

while turning the Command dial lets you choose the desired ISO setting. See Chapter 7 for details about the available settings.

- White Balance: If you select this option, pressing the Fn button while turning the Command dial lets you choose a white balance setting, but only in P, S, A, and M modes. Chapter 8 introduces you to the White Balance feature.
- Active-D Lighting: If you select this option, pressing the Fn button while turning the Command dial lets you turn Active D-Lighting on and off. Like the White Balance option, this one is adjustable only in the P, S, A, and M exposure modes, however. You can read about Active D-Lighting in Chapter 7.

After selecting the function you want to assign, press OK to lock in your choice.

Customizing the AE-L/AF-L Button

Set just to the right of the viewfinder, the AE-L/AF-L button enables you to lock focus and exposure settings when you shoot in autoexposure and autofocus modes, as explored in Chapters 7 and 8.

Normally, autofocus and autoexposure are locked when you press the button, and they remain locked as long as you keep your finger on the button. But you can change the button's behavior via the Buttons option on the Setup menu, shown on the left in Figure 11-9. After highlighting the Assign AE-L/AF-L option, as shown on the right, press OK to display the available settings, shown in Figure 11-10.

Figure 11-9: You can change the function of the AE-L/AF-L button through the Setup menu.

Part IV: The Part of Tens

The options produce these results:

- AE/AF Lock: This is the default setting. Focus and exposure remain locked as long as you press the button.
- AE Lock Only: Autoexposure is locked as long as you press the button; autofocus isn't affected. (You can still lock focus by pressing the shutter button halfway.)
- AF Lock Only: Focus remains locked as long as you press the button. Exposure isn't affected.

Figure 11-10: At the default setting, highlighted here, the button locks exposure and focus together.

- AE Lock (Hold): This one locks exposure only with a single press of the button. The exposure lock remains in force until you press the button again or the exposure meters turn off.
- ✓ AF-ON: Pressing the button activates the camera's autofocus mechanism. If you choose this option, you can't lock autofocus by pressing the shutter button halfway when using the viewfinder to take pictures. In Live View mode and during movie recording, you still use the shutter button to lock focus if you set the Focus mode to AF-F. Chapter 4 provides details on Live View and movie shooting.

After highlighting the option you want to use, press OK.

The information that I give in this book with regard to using autofocus and autoexposure assumes that you stick with the default setting. So if you change the button's function, remember to amend my instructions accordingly.

Using the Shutter Button to Lock Exposure and Focus

The Buttons option on the Setup menu offers a third button tweak called Shutter-release Button AE-L, as shown in Figure 11-11. This option determines whether pressing the shutter button halfway locks focus only or locks both focus and exposure. (AE-L stands for *autoexposure lock*.)

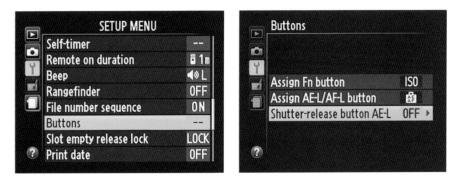

Figure 11-11: If you turn this option on, pressing the shutter button halfway locks exposure and focus.

At the default setting, Off, you lock focus only when you press the shutter button halfway. Exposure is adjusted continually up to the time you take the shot. If you change the Shutter-release Button AE-L setting to On, your halfpress of the shutter button locks both focus and exposure.

As with the AE-L/AF-L button adjustment described in the preceding section, I recommend that you leave this option set to the default while you're working with this book. Otherwise, your camera won't behave as described here (or in the camera manual, for that matter). If you encounter a situation that calls for locking exposure and focus together, you can simply use the AE-L/AF-L button as covered in Chapter 7.

Adding a Starburst Effect

Want to give your photo a little extra sparkle? Experiment with the Cross Screen filter. This filter adds a starburst-like effect to the brightest areas of your image, as illustrated in Figure 11-12.

Traditional photographers create this effect by placing a special filter over the camera lens; the filter is sometimes known as a Star filter instead of a Cross Screen filter. But you can apply a digital version of the filter via the Retouch menu, as follows:

1. Display your photo in single-image playback mode and press OK to call up the Retouch menu.

Part IV: The Part of Tens

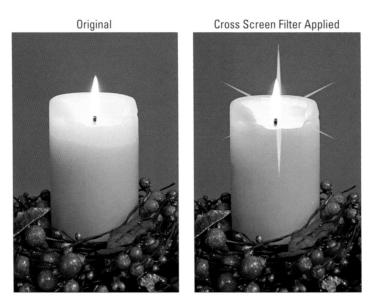

Figure 11-12: The Cross Screen filter adds a starburst effect.

2. Highlight Filter Effects, as shown on the left in Figure 11-13, and press OK.

You see the screen shown on the right in Figure 11-13.

Figure 11-13: Select the Cross Screen filter from the Filter Effects submenu.

3. Highlight Cross Screen and press OK.

Now you see a screen containing a preview that shows you the results of the Cross Screen filter at the current filter settings, as shown in Figure 11-14.

4. Adjust the filter settings as needed.

You can adjust the number of points on the star, the intensity of the effect, the length of the star's rays, and the angle of the effect. Just use the Multi Selector to highlight an option and then press the Multi Selector right to display the available settings. Highlight your choice and press OK. I labeled the four options in Figure 11-14.

5. To update the preview

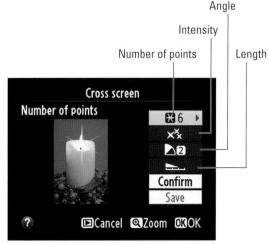

Figure 11-14: You can play with four filter settings to tweak the effect.

after changing a filter setting, highlight Confirm and press OK.

You can also press and hold the Zoom In button to temporarily view your image in full-screen view. Release the button to return to the normal preview.

6. Highlight Save and press OK to create your star-crossed image.

Keep in mind that the number of starbursts the filter applies depends on your image. You can't change that number; the camera automatically adds the twinkle effect wherever it finds very bright objects. If you want to control the exact placement of the starbursts, you may want to forgo the in-camera filter and find out whether your photo software offers a more flexible starfilter effect. (You can also create the effect manually by painting the cross strokes onto the image in your photo editor.)

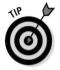

It's also important to frame your original image with a little extra "head room" around the object that will get the starburst, as I did in my examples. Otherwise there won't be room in the picture for the effect.

Creating Color Effects

Chapter 10 introduces you to some Retouch menu tools that make subtle adjustments to photo colors: the Color Balance filter and the five colorbased Filter Effects filters (Skylight, Warm, and the Red, Green, and Blue Intensifiers). But the Retouch menu also offers three filters that create special color effects: Color Outline, Color Sketch, and Selective Color. The next three sections show off these filters.

•

Part IV: The Part of Tens

Creating a color outline

As hard as I try, I cannot master the skill of drawing. In fact, most 3-year-olds can render a scene with more accuracy than I can. But thanks to the Color Outline option on the Retouch menu, I can fake a realistic drawing based on any photo, as I did in Figure 11-15. This is a fun project to do with kids, by the way — you can, in essence, create a custom coloring-book page that they can then fill in with watercolors, crayons, or markers.

Figure 11-15: You can use a photo as the basis for a color outline.

Try it out:

- 1. Display your photo in single-image playback mode and press OK to display the Retouch menu over the image.
- 2. Highlight Color Outline as shown in Figure 11-16 and press OK.

A preview of your art masterpiece appears onscreen. You can't make any adjustments to the result.

3. Press OK again.

The camera software creates a copy of your image with the effect applied.

Producing a color sketch

This Retouch menu filter also creates a sketch of your photo, but this time with a result similar to a drawing done in colored pencils. I used the filter on the architectural image shown in Figure 11-17, for example.

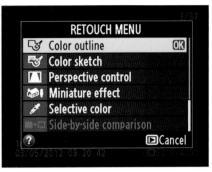

Figure 11-16: Choose Color Outline and then press OK to create the effect.

Figure 11-17: Color Sketch produces this type of effect.

The fastest way to apply the filter is to put your camera in playback mode, display the photo in full-frame view, and press OK to display the Retouch menu. Choose Color Sketch, as shown on the left in Figure 11-18, and press OK to display the second screen in the figure.

Part IV: The Part of Tens _

354

Figure 11-18: Vividness adjusts color intensity; Outlines affects the thickness of the outlines.

You can play with two options: Vividness, which affects the boldness of the colors; and Outlines, which determines the thickness of outlines. Highlight an option and press the Multi Selector right or left to adjust the setting. Press OK when you create a look you like.

Playing with the Selective Color Filter

This effect enables you to *desaturate* (remove color from) parts of a photo while leaving specific colors intact. For example, in Figure 11-19, I desaturated everything but the yellows and peaches in the rose. The result lends additional drama to your subject because the eye goes first to the areas of color, and distracting background colors are eliminated.

Figure 11-19: I used the Selective Color filter to desaturate everything but the rose petals.

Chapter 11: Ten Special-Purpose Features to Explore on a Rainy Day

To experiment with this filter, display your photo in single-image playback mode, press OK to display the Retouch menu, and then choose Selective Color and press OK. You then see a screen similar to the one on the left in Figure 11-20. Here you can select up to three colors to retain and specify how much a color can vary from the selected one and still be retained. Make your wishes known as follows:

Figure 11-20: To select a color you want to keep, move the yellow box over it and press the AE-L/AF-L button.

- °™ AEL
- Select the first color to be retained: Using the Multi Selector, move the yellow highlight box over the color. Then press the AE-L/AF-L button to tag that color, which appears in the left color swatch at the top of the screen, as shown on the right in Figure 11-20.
- ✓ Set the range of the selected color: Rotate the Command dial to display a preview of the desaturated image and highlight the number box to the right of the color swatch, as shown on the left in Figure 11-21. Then press the Multi Selector up or down to choose a value from 1 to 7. The higher the number, the more a pixel can vary in color from the selected hue and still be retained. At a low value, only pixels that are very similar to the one you selected are retained. The display updates to show you the impact of the setting; for example, lowering the value to 1 turned some of the rose petals to gray, as shown on the right in Figure 11-21.
- Choose one or two additional colors: Rotate the Command dial to highlight the second color swatch box. Then repeat the selection process: Move the yellow highlight box over the color and press the AE-L/AF-L button to select that color. Rotate the Command dial to display the preview and activate the range value box; press the Multi Selector up and down to set the range. To choose a third color, lather, rinse, and repeat.
- Fine-tune your settings: You can keep rotating the Command dial to cycle through the color swatch boxes and range values, adjusting each as necessary.

Part IV: The Part of Tens _

350

Figure 11-21: Rotate the Command dial to display a preview and activate the range value box (left); press the Multi Selector up and down to adjust the range of affected colors (right).

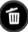

Reset a color swatch box: To empty a selected swatch box, press the Delete button. You can then move the yellow highlight box over a new color and press the AE-L/AF-L button to select it.

To reset all the swatch boxes, hold down the Delete button until you see a message asking whether you want to get rid of all selected colors. Highlight Yes and press OK.

Save a copy of the image with the effect applied: Press OK.

Softening Focus for a Dreamy Effect

Ever notice that as television and movie stars age, their portraits tend to have a slightly out-of-focus look? The soft focus effect is designed to help mask wrinkles and other signs that one is no longer a dewy-faced teen.

You actually can buy special lenses for your camera that produce this effect, but a cheaper alternative is to apply a focus-softening digital filter like the one found on the Retouch menu. You can see the results in Figure 11-22. When applied to nature subjects like the one in the figure, the filter creates a look that's similar to the watercolor-effect filter you find in many photo editing programs. Squint hard enough, and you can almost envision a Monet in the making.

Chapter 11: Ten Special-Purpose Features to Explore on a Rainy Day

Figure 11-22: I used the Soft filter at the High setting to create a blurry, painterly effect.

Apply the filter like so:

- 1. Display your photo in single-image playback mode and press OK to call up the Retouch menu.
- 2. Highlight Filter Effects, press OK, and then highlight Soft as shown in Figure 11-23.

You have to scroll to the second page of the Filter Effects screen to get to the Soft filter.

Figure 11-23: The Soft filter is found on the last page of the Filter Effects menu.

Part IV: The Part of Tens

3. Press OK.

You see thumbnails of your photo, as shown in Figure 11-24. The left thumbnail is the original; the right thumbnail offers a preview of the filter effect.

4. Press the Multi Selector up or down to determine how soft you want the image.

Your choices are Low (kinda soft), Normal (softer still), and High (pass the foggy goggles).

While you're pondering your

High ECancel QZoom OKSave

Soft

Figure 11-24: Press the Multi Selector up or down to choose the strength of the effect.

decision, you can press the Zoom In button to get a better look.

5. Press OK to apply the filter and save a copy of the retouched image.

Creating a Miniature Effect

Have you ever seen architect's small-scale models of planned developments? The ones complete with tiny trees and even people? The Miniature Effect filter on the Retouch menu attempts to create a photographic equivalent by applying a strong blur to all but one portion of a landscape, as shown in Figure 11-25. The left photo is the original; the right shows the result of applying the filter. For this example, I set the focus point on the part of the street occupied by the cars.

This effect works best if you shoot your subject from a high angle — otherwise, you don't get the miniaturization result. To try it out, take these steps:

- 1. Display your photo in full-frame playback and press OK to bring up the Retouch menu.
- 2. Highlight Miniature Effect, as shown on the left in Figure 11-26, and press OK.

You see your image in a preview similar to the one shown on the right in the figure.

3. Use the Multi Selector to position the yellow box over the area you want to keep in sharp focus.

Use these tricks to adjust the box:

- **R**
- Rotate the box 90 degrees: Press the Zoom Out button.
- *Resize the box:* Press the Multi Selector up to enlarge the box; press down to shrink it.
- Move the box: Press the Multi Selector right or left.

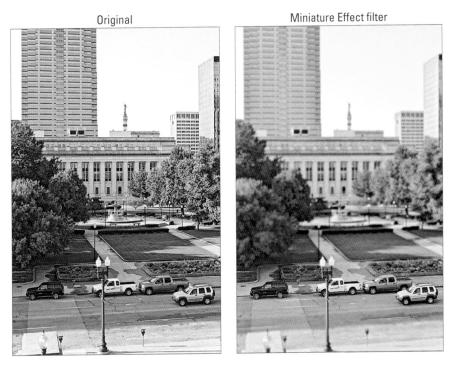

Figure 11-25: The Miniature Effect throws all but a small portion of a scene into very soft focus.

4. To preview the effect, press the Zoom In button.

When you release the button, you're returned to the screen shown on the right in Figure 11-26. Keep adjusting the placement of the box and previewing the result until you're happy.

5. To create a copy of your photo with the effect applied, press OK.

Figure 11-26: Use the Multi Selector to position the yellow rectangle over the area you want to keep in sharp focus.

Part IV: The Part of Tens

360

Combining Two Photos with Image Overlay

Are you into double exposures? Well, you can't officially do a double exposure with the D3200, but the Image Overlay feature found on the Retouch menu enables you to merge two photographs into one. I used this option to combine a photo of a werewolf friend, shown on the top left in Figure 11-27, with a nighttime garden scene, shown on the top right. The result is the ghostly image shown beneath the two originals. Oooh, scary!

Figure 11-27: Image Overlay merges two RAW (NEF) photos into one.

On the surface, this option sounds kind of cool. The problem is that you can't control the opacity or positioning of the individual images in the combined photo. For example, my overlay picture would have been more successful if I could move the werewolf to the left in the combined image so that he and the lantern aren't blended. And I'd also prefer to keep the background of the second image at full opacity in the overlay image rather than getting a 50:50 mix of that background and the one in the first image, which only creates a fuzzy-looking background in this particular example.

Chapter 11: Ten Special-Purpose Features to Explore on a Rainy Day

However, there is one effect that you can create successfully with Image Overlay: a "two views" composite like the one in Figure 11-28. But in order for this trick to work, the background in both images must be the same solid color (black seems to be best), and you must compose your photos so that the subjects don't overlap in the combined photo, as shown here. Otherwise you get the ghostly effect that you see in Figure 11-27.

Figure 11-28: If you want each subject to appear solid, use a black background and position the subjects so that they don't overlap.

Additionally, the Image Overlay feature works only with pictures that you shoot in the Camera RAW (NEF) format. For details on RAW, see Chapter 2.

To be honest, I don't use Image Overlay for the purpose of serious photo compositing. I prefer to do this kind of work in my photo editing software, where I have more control over the blend. In addition, previewing the results of the overlay settings you use is difficult, given the size of the camera monitor.

Part IV: The Part of Tens

That said, it's a fun project to try, so give it a go when you have a spare minute. Take these steps:

1. Using the Image Size and Image Quality options, set the size (pixel count) and file type (Raw, JPEG, or Raw+JPEG) for the combined image.

The camera will save the final overlay file using the settings you select. Chapter 2 explains these two settings.

2. Display the Retouch menu and highlight Image Overlay, as shown on the left in Figure 11-29.

You can't get to this option if you use the other method of applying Retouch commands — displaying your photo first and then pressing OK. You must start at the Retouch menu itself. (See Chapter 10 for help with using the Retouch menu features.)

3. Press OK.

You see the screen shown on the right in Figure 11-29, with the preview area for Image 1 highlighted. (The yellow border indicates the active preview area.)

RETOUCH MENU			Image overl	ay	
D-Lighting	82		Image 1	J	D
Red-eye correction		Y	lmage 1	Image 2	Preview
Trim	*		RAW	RAW	
Monochrome					herritrichtekstosenskeren
Filter effects	0				Overlay
Color balance	60 /		x 1. 0	x 1. 0	Save
Image overlay	E				Juve
? NEF (RAW) processing	RAWI+	?		QZoc	m OKSelec

Figure 11-29: The thumbnail marked with the yellow border represents the active image.

4. Press OK to display thumbnails of your images.

You see thumbnails only for qualified images — that is, photos taken in the Raw (or Raw+JPEG) format.

5. Select the first of the two images that you want to combine.

A yellow border surrounds the currently selected thumbnail. Press the Multi Selector right and left to scroll the display until the border appears around your chosen image. Then press OK.

Chapter 11: Ten Special-Purpose Features to Explore on a Rainy Day

The Image Overlay screen now displays your first image as Image 1, as shown on the left in Figure 11-30.

6. Press the Multi Selector right to highlight the Image 2 box. Then repeat Steps 4 and 5 to select the second image.

Now you see both images in the Image Overlay screen, with the combined result appearing in the Preview area, as shown on the right in Figure 11-30.

Figure 11-30: After selecting both photos, highlight the Preview thumbnail and press the Zoom In button to preview the results.

7. Press the Multi Selector right to move the yellow selection box over the Preview thumbnail.

8. Press the Zoom In button to get a full-frame view of the merged image.

Or highlight Overlay and press OK to see the preview.

To exit the preview press the Zoom Out button.

9. Adjust the Gain settings (optional).

If you didn't like what you saw in the preview, you can manipulate the blend of the two images by adjusting the gain setting underneath the image thumbnails. Press the Multi Selector right or left to highlight Image 1 or Image 2 and then press up or down to adjust the gain for that image. Repeat Step 8 to check your work after you make the changes. Move on to Step 10 when you're happy with the result.

10. To save the merged image, highlight Save (in the Preview thumbnail area, as shown on the right in Figure 11-30) and press OK.

364 Part IV: The Part of Tens

Index

Symbols and Numerics

? (question mark) blinking, 37, 59, 247 camera icon, 36
3D Tracking mode, 264
8-bit TIFF files, 194
16-bit TIFF files, 194

• A •

A (aperture-priority autoexposure) mode depth of field, adjusting, 279 description, 49 determining exposure, 223, 229 exposure metering, 226 Active D-Lighting, 241-244, 347 Adobe Photoshop, 174-176 Advanced Shooting options, 82 AE (autoexposure) lock, 240-241 AE-L/AF-L button, customizing, 43, 347-348 AE-L/AF-L/Protect button, 20-21 AF (autofocusing) assist lamp, 24 AF-A (auto-servo autofocus) mode, 78-80, 268 AF-Area mode, 80, 108-109, 111-113, 263-267. See also autofocus system AF-C (continuous-servo autofocus) mode, 268 AF-F mode, 111–113 AF-S lenses, 8, 10-12 AF-S mode, 111-113, 268 A/M (Auto/Manual) focus switch, 11, 23 annotations, adding to pictures, 40, 341-343 anti-shake. See Vibration Reduction Aperture (Apple), 175 aperture (f-stop). See also f-stop depth of field, 216-217 overview, 214-215

reducing, 216 setting, 222, 227-230. See also A (aperture-priority autoexposure) mode; M (manual exposure) mode; P (programmed autoexposure) mode shooting wide open, 222 stopping down, 216 aperture (f-stop), settings depth of field, adjusting, 274-275 effect on focus. 85 recording movies, 124 aperture priority. See A (aperture-priority autoexposure) mode; P (programmed autoexposure) mode aperture ring, 9 Apple Aperture, 175 Apple iPhoto, 173 artifacting, 69 aspect ratio cropping pictures, 330 printing pictures, 197-199 attaching flash, 56 lenses, 8-10 audio recording, 120-125 Auto Area mode, 264 Auto Distortion Control, 82 Auto Flash Off mode, 48, 82-86 Auto image rotation option, 40 Auto information display option, 38-39 Auto ISO Sensitivity Control, 232 Auto mode, 48, 57-58, 60, 82-86 Auto off timers option, 40-41 autoexposure in Flash mode, 60-61 locking, 20-21, 124, 348-349 recording movies, 124 autoexposure (AE) lock, 240-241 autofocus. See also Focus mode and exposure modes, 50 failure to lock on subject, 270-273 in Live View, 111-113

autofocus (continued) locking, 20-21, 105-107, 269-270 MF (manual focus), 270-273 point-and-shoot options, 78-80 rangefinder, 272 Scene modes, 86-87 shutter button interaction, 51 troubleshooting, 85-86 autofocus system. See also AF-Area mode for moving subjects, 261-262, 268, 269 overview, 260-262 for stationary subjects, 261-262, 268, 269 autofocusing (AF) assist lamp, 24 Auto/Manual (A/M) focus switch, 11, 23 automatic exposure modes. See A (aperture-priority autoexposure) mode; P (programmed autoexposure) mode; S (shutter-priority autoexposure) mode automatic picture taking. See point-andshoot automatic shutoff, 40-41, 100-101 auto-servo autofocus (AF-A) mode, 78-80, 268

• B •

backgrounds, softening, 92 backing up files. See protecting pictures barrel distortion, 273, 326-327 battery life displaying, 27, 34 flash, 58 internal clock. 40 Live View tips, 102 Beep option, 42 beeping self-timer, 54 turning on and off, 42 bit, definition, 194 bit rate, setting, 117–120 black-and-white. See monochrome blinking ? (question mark), 37, 59, 247 [-E-] (blinking viewfinder symbol), 16 exposure meter, 85, 225 "ISO-A" message, 232 blobs, 76

blown highlights, 152-153 blurring the background, 279. See also depth of field blurry photos. See also Vibration Reduction reducing blur, 93 shutter speed, 262-263 bouncing flash, 306 bright lights, safety tips, 101 brightening photographs, 93 brightness, camera monitor, 37-38 brightness, photographs. See exposure Brightness histograms, 154 bulb exposure, 214, 312, 314 buttons. See camera controls; specific buttons Buttons option, 43

• C •

calendar playback, 127 calendar view, playing pictures and movies. 144-145 camera controls. See also menus; specific controls back-of-the-body, 20-22Cheat Sheet, 3 front-left, 23-24 front-right, 24 quick reference guide, 3 topside, 18-20 camera orientation, recording, 40 camera override, recording movies, 124 Camera Raw. See Raw (NEF) file format camera settings. See settings; specific settings camera shake, 102 camera-to-subject distance, 275 Capture NX 2 (Nikon), 175 center-weighted exposure metering, 234 - 236Cheat Sheet for camera controls, 3 Child mode, 57, 88 city pictures, nighttime, 312 Clean image sensor option, 39 cleaning your camera automatic, 39, 76 with compressed air, camera damage, 76

367

dust-removal filter reference image, specifying, 40 locking up the mirror, 39 clipped highlights, 152-153 Close Up mode, 57, 60, 89 close-ups. See also macro lenses diopters, 315 macro lenses, 8 overview. 314-315 color. See also white balance adjustment filters, 333-335 desaturating, 354-356 with flash, 248 gamut, 291-292 ICC color profile, embedding in downloaded pictures, 185 outline effects, 352-353 printing pictures, 201 sketch effects, 353-354 synchronizing printer and monitor, 200 - 202temperature, 281 Color Balance filter, 335-338 color cast, 62-63 Color Outline filter, 352-353 Color Sketch filter, 353-354 color space, 291-292 Color Space settings, 82 combining photographs, 360-363 Command dial, 20-21 comments, adding to pictures, 40, 341-343 compressed air, camera damage, 76 computers, connecting camera to, 25 continuous shooting, 52, 81 continuous-servo autofocus (AF-C) mode, 268 convergence effect, 328-329 cool light, 281 correcting colors. See white balance crop factor, lenses, 280 crop sizes, 330 cropping pictures, 66, 199, 329-331. See also trimming movies Cross Screen filter, 349-351 CSC_ filenames, 151 custom folders, creating, 44, 343-345

customizing your camera. *See* settings; *specific settings* cyanotype photographs, 338–340

• /) •

darkening photographs, 93 date and time adding to pictures, 43 picture data, viewing, 151 setting, 40 synchronizing camera and computer, 185 Delayed mode, 81 Delayed Remote setting, 55-56 Delete button, 22 deleting pictures. See also protecting pictures from menus, 27 originals files after download, 186 protecting against, 20 deleting pictures, from memory cards all at once, 160 by date, 162-163 vs. formatting, 170 one at a time, 159-160 protected pictures, 163 in selected batches, 161-162 depth of field aperture settings, 216–217 exposure settings, 216-217 point-and-shoot options, 85 depth of field, adjusting aperture settings (f-stops), 274-275 blurring the background, 279 camera-to-subject distance, 275 examples, 276-277 Guide mode, 90-95, 279 lens focal length, 275 minimum/maximum, 278-279 A (aperture-priority autoexposure) mode, 279Scene modes, 279 zooming in and out, 278-279 desaturating color, 354-356 dials. See camera controls; specific dials Digital Print Order Format (DPOF), 202

Digital Railroad, 209 diopters, 315 dirt on lens or sensor, problem diagnosis. 62 - 63distance from camera to subject. See focal plane indicator Distortion Control filter, 326-327 D-Lighting filter, 331–334. See also Active **D**-Lighting double exposures, 360-363 downloading pictures to a computer. 176 - 186dpi vs. ppi, 196 DPOF (Digital Print Order Format), 202 DSC_filenames, 151 DSC filenames, 151 dust protection, 10 dust-removal filter, 40 DVDs. storage guidelines, 209 Dynamic Area mode, 263-264

• E •

[-E-] (blinking viewfinder symbol), 16 early morning photography, 313 editing movies, 129-132 8-bit TIFF files, 194 electronic interference, external lights, 102 Elements (Adobe), 174-175 e-mailing pictures, 203-208 erasing memory cards, 16 erasing pictures. See deleting pictures EV (exposure value), 236 exposure. See also brightness bracketing, 313 factors affecting, 215-216, 221-222. See also aperture; ISO; shutter speed picture data, viewing, 157-159 recording movies, 123-124 exposure compensation, 124, 190, 236-244 Exposure Compensation button, 18–19, 237 - 238exposure meter, 40-41, 85, 224-227 exposure metering mode, 225-236 exposure modes and autofocusing, 50 displaying, 27

fully automatic, 48 guided, 49 manual, 49 and manual focusing, 50 point-and-shoot options, 78–82 selecting, 48–50 semi-automatic, 49 exposure settings, side effects, 216–219, 221 exposure value (EV), 236 eXtended Capacity (SDXC) memory cards, 15 Eye-Fi SD memory cards, 15 Eve-Fi upload option, 44

• F •

Face Detection feature, 148 Face Priority, 108, 111 File Information mode, 149, 150–152 file number sequence, resetting, 45 File number sequence option, 42-43 file numbering, 151 file protection status, viewing, 152 file size factors effecting, 75 JPEG file format, 68 filenames naming conventions, 150-151 renaming converted Raw files, 195 renaming during downloading, 184 viewing, 150-151 Fill Flash, 248-249 filters (digital) color adjustment, 333-335 Color Balance, 335-338 Color Outline, 352–353 Color Sketch, 353-354 Cross Screen, 349-351 Distortion Control, 326-327 D-Lighting, 331-334 dust-removal, 40 Fisheye, 326-327 Miniature Effect, 358-359 neutral density, 312 Perspective Control, 328 Quick Retouch, 333–335

_ Index

Red-Eye Correction, 322-324 Retouch menu, 320-322 Selective Color, 354-356 Skylight, 335-337 Soften, 356-358 starburst effect, 349-351 Straighten, 324-325 Warm, 335-337 fireworks, 313 firmware versions, displaying, 44 Firmware Versions option, 44 Fisheye filter, 326-327 flash bouncing, 306 diffusing, 307 external, 56, 306 outdoor lighting, 315 still portraits, 304-307 flash, built-in. See also Night Portrait mode attaching, 56. See also Flash hot shoe automatic, 57-58 battery life, 58 books about, 247 with continuous shooting, 52 disabling, 57, 59 enabling, 57-58, 245 exposure modes, 245 forcing, 57 online resources, 247 popping up, 23, 57 shutter speed, 248-249 synching with shutter speed, 253 with telephoto lenses, 246 Flash button, 23 Flash Compensation, 253-256 Flash hot shoe, 19-20, 56-57 Flash mode with automatic exposure modes, 60-61 checking, 59 displaying, 245 Fill Flash, 248-249 front-curtain sync, 250 motion trail effects, 252 overview, 247-248 point-and-shoot options, 80-81

quick reference, 59 Rear-Curtain Sync, 252–253 Red-Eye Reduction, 249-250, 253 setting, 60-61, 245-246 slow-sync, 250-252, 253, 305 flicker reduction, 39-40, 102 Flicker reduction option, 39-40 Fn (Function) button, 23, 43, 75, 346-347 focal length, lenses, 280 focal length indicator, 11 focal plane indicator, 19-20 focus locking, 348-349 point-and-shoot options, 78, 80, 85 recording movies, 124 sharpening, 292 softening, 356-358 Focus mode, 10-12, 78-80. See also autofocus Focus mode adjustments, 107-109 Focus mode selection, 105-107, 267-270 focusing pairs, 110 focusing ring, 11 folder names, 150, 184, 345 folders custom, creating, 44, 343–345 Storage, 44 subfolders, creating, 183-184 For, viewfinder message, 16 Format memory card option, 37 formatting vs. deleting pictures, 170 memory cards, 15-16, 37 fps (frames per second), recording movies, 118 frame quality, setting for movies, 125 frame rate, setting for movies, 117-120, 125 frame size, setting for movies, 117-120, 125 framing grid, 104 freezing motion, 92, 307-310 front-curtain sync, 250 f-stop. See also aperture definition, 215 and depth of field, 217 effect on focus, 85

fully automatic exposure modes. *See* A (aperture-priority autoexposure) mode; P (programmed autoexposure) mode; S (shutter-priority autoexposure) mode Function (Fn) button. *See* Fn (Function) button

• G •

GPS attachment, 25 GPS Data mode, 157 GPS option, 44 Guide mode, 49, 58, 90–95, 279

• *H* •

hair-like defects, 76 hard drives, storage guidelines, 209 HDMI option, 39 head room, 199 help, 3, 22, 30 Help button, 22 High Capacity (SDHC) memory cards, 15 high-bit images, 194 highlights, exposing for, 241–244. *See also* Active D-Lighting Highlights mode, 149, 152–153 histograms, 154. *See also* RGB Histogram hot shoe, 19–20, 56–57

•1•

ICC color profile, embedding in downloaded pictures, 185 icons, used in this book, 2–3 IDrive, 209 Image comment option, 40 Image Dust Off ref photo option, 40 Image Overlay feature, 360–363 image quality adjusting with Fn button, 346 cropping pictures, 330 online sharing, 205

Raw conversion, 190 viewing, 151 Image Quality settings. See also quality settings changing, 73-75 displaying, 73 effects on file size, 75 file formats, 67-68. See also JPEG; Raw (NEF) file format point-and-shoot options, 82 image-review period, 138 image sensor, 214 image size e-mailing pictures, 203-204 online sharing, 206 Raw conversion, 190 resizing images, 206-208 viewing, 151 Image Size settings changing, 73-75 for cropping pictures, 66 displaying, 73 effects on file size, 75 point-and-shoot options, 82 recommendations, 66-67 resolution options, 64 image stabilization. See Vibration Reduction Info button, 19 Info display format option, 38 Info Edit button, 22 Info Edit screen changing settings, 36, 73-74 displaying, 35 exiting, 36 Focus mode adjustments, 109 settings, displaying, 33-34 Information display. See Info Edit screen Information screen, 18-19, 22, 38-39 infrared receiver, 21-22 instant image review, 139 interlaced video, 119 internal clock battery, 40 iPhoto (Apple), 173

__ Index

ISO

Auto ISO Sensitivity Control, 232 noise (visual), 216 overriding camera settings, 232 overview, 215 recommended setting, 222 settings for recording movies, 123–124 value, displaying, 233 ISO noise reduction, 190, 233 ISO Sensitivity, 23, 82, 87, 346–347 "ISO-A" blinking message, 232

•] •

"Job nr" message, 233 JPEG Basic setting, 69 JPEG file format, 62–63, 68–70, 72–73. *See also* Raw (NEF) file format JPEG Fine setting, 68, 72–73 JPEG Normal setting, 69

• K •

K (one thousand), 35 key icon (protected symbol), 152 kit lenses, 9, 13

• [•

Landscape mode, 58, 87 landscape (LS) mode, 293–294 landscape photography, 58, 87, 310–314 language, setting, 40 Language option, 40 late afternoon photography, 313 lens distortion, 273, 326–327 Lens switches, 23 lenses AF-S, 8, 10 AM (Auto/Manual) focus switch, 11 aperture ring, 9 attaching, 8–10 crop factor, 280

dust protection, 10 for extreme close-ups, 8 focal length, 275, 280 focal length indicator, 11 focus mode, setting, 10-12 focusing ring, 11 kit. 9 for long distances, 8 macro. 8 mounting index, 9 normal length, 280 removing, 10 SLR vs. point-and-shoot, 8 telephoto, 8, 280 VR (Vibration Reduction), 12-13 white dot, 9 wide-angle, 280 zoom ring, 11-12 zooming in and out, 11-12 Lens-release button, 23 light. See also aperture; ISO; shutter speed seepage, Live View safety tips, 99 sources, adjusting for, 281-283 Lightroom (Adobe), 175-176 Live Photo Gallery (Windows), 173 Live View adjusting camera settings, 98 autofocusing, 111-113 automatic shutoff, 40-41, 100-101 avoiding bright lights, 101 battery life, 102 brightness, 37-38 customizing, 103-104 exiting, 99 extended use precautions, 101 external electronic interference, 102 flicker reduction, 102 Focus mode adjustments, 107–109 Focus mode selection, 105–107 focusing, overview, 105 focusing pairs, 110 light seepage, 99 manual focusing, 113-114

Live View (continued) monitoring camera settings, 98 picture settings, displaying, 115 playing pictures and movies, 99 recording movies, 99 reducing camera shake, 102 safety tips, 99-102 settings, displaying, 33–34 shooting photographs, 99 shooting still pictures, 114-116 switching to, 98 turning on and off, 21 Live View button, 21 Lock mirror up for cleaning option, 39 lock switch, memory cards, 16-17 locking. See also protecting autoexposure, 20-21, 348-349 autofocus, 20-21 focus, 105-107, 269-270, 348-349 memory cards, 16-17 the mirror, 39 lossy compression, 68, 70 LS (landscape) mode, 293-294

• M •

M (manual exposure) mode, 49, 58, 229, 239macro lenses, 8, 315. See also close-ups; diopters magic hours, 313 magnifying. See zooming manual focus autofocus, 270-273 exposure modes, 50 Focus mode, 268-269 Live View, 113-114 margin padding, 199 matrix exposure metering, 233–236 MC (monochrome) mode, 293–294 megapixels (MP), 64 memory cards capacity, 15 cost/speed tradeoff, 17 downloading pictures to a computer, 177 erasing completely, 16

Eye-Fi SD, 15 formatting, 15-16, 37 handling, 16 inserting, 15 lock switch, 16-17 locking, 16-17 removing, 16 SD (secure digital), 15 SDHC (High Capacity), 15 SDXC (eXtended Capacity), 15 speed classes, 17 storage guidelines, 209 taking pictures without, 43 wireless. 15 Menu button, 25–26 menus, 26–27, 29–33. See also specific menus metadata. See also picture data adding information to downloaded files, 185 stripping from Raw files, 194 viewing, 172 metering exposure. See exposure metering microphone, 23-24 microphone, audio recording, 120-123, 125 microphone jack, 24-25 microphone settings, recording movies, 122 - 123midtones, 154 Miniature Effect filter, 358-359 mirror slap, 52 ML-L3 wireless remote control, 21–22, 24, 42.55-56 Mode dial, 19–20, 48–50. See also specific modes monitor (camera). See Live View monitor (computer) calibration, 200 flicker reduction, 39-40 profile, 200 Monitor brightness option, 37-38 monochrome (MC) mode, 293-294 Monochrome Picture Control feature, 338 - 340monochrome prints, 201, 338-340 motion blur, 217-218

373

motion trail effects, 252 mounting index, 9 mounting lenses. See attaching, lenses movie indicators, displaying, 104 Movie-record button, 19 movies. See also recording movies editing, 129-132 playing, 127-129 saving frames as still images, 132-133 screen grabs, 132-133 trimming, 129-132 moving subjects flowing water, 92 focusing pairs, 110 stopping action, 307-310 tracking, 108 Mozy, 209 MP (megapixels), 64 Multi Selector button, 21-22, 32

• N •

NEF (Nikon Electronic Format), 68. See also Raw (NEF) file format neutral density filters, 312 Night Portrait mode, 57, 60, 89-90. See also Portrait mode night scenes, 89-90 nighttime city pictures, 312 Nikon Capture NX 2, 175 Nikon ViewNX 2 diagnosing problems, 63 downloading pictures to a computer, 180 - 186installing, 174 operating systems supporting, 174 overview, 172-174 prepping online pictures, 205-206 Raw conversion, 191–195 viewing metadata, 172 NL (neutral) mode, 293-294 No Flash mode, 58 noise (visual), 62-63, 216, 218-219, 221 Noise Reduction, 82

None mode, 149 Normal Area, 108, 111–112 NTSC video standard, 116–117

• () •

OK button, 21–22 online storage, guidelines, 209 On/Off switch, 18–19 optical stabilization. *See* Vibration Reduction orientation of camera, recording, 40 outdoor flash lighting, 315 outline effects, 352–353 overlaying photographs, 360–363 Overview mode, 149

• p •

p (progressive) frame rates, 119 P (programmed autoexposure) mode description, 49 determining exposure, 228 exposure metering, 226 flash, 58 PAL video standard, 116–117 paper quality, 201 paper settings, 201 pausing slide shows, 167 Perspective Control filter, 328 photo indicators, displaying, 103 photo software, choosing, 172-176 Photoshop (Adobe), 176 Photoshop Elements (Adobe), 174-175 Photoshop Lightroom (Adobe), 175-176 PictBridge, 202 picture control Raw conversion, 190 recording movies, 125 Picture Controls, 292-297 picture data, viewing, 148-159. See also metadata picture elements. See pixels picture files, naming, 42-43

374

picture playback. See playback pincushion distortion, 273, 326-327 pixel dimensions, 64 pixelation, 62-63 pixels, 63-67, 195-198. See also upsampling pixels per inch (ppi), 65 playback. See also slide shows duration, setting, 138 magnifying, 22 settings, 27 thumbnail display, 22 Playback button, 22 playback options automatic picture rotation, 139-141 image-review period, 138 instant image review, 139 main menus, 31 playback duration, 138 reviewing pictures, 141-147 television, 168-169 viewing picture data, 148-159 playing movies, 99, 127-129. See also recording movies point-and-shoot options, 78-86 point-and-shoot vs. SLR, 8 Portrait (PT) mode, 57, 60, 87, 293-294. See also Night Portrait mode portraits, 87, 108 ppi (pixels per inch), 65 ppi vs. dpi, 196 presets, white balance, 287-290 previewing pictures. See playback print cartridges, inspecting, 200-201 Print date option, 43 print size, pixels, 65 printing pictures aspect ratios, 197-199 black-and-white prints have color tint, 201 color management, 201 without a computer, 202 cropping, 199 DPOF (Digital Print Order Format), 202 head room, 199 inspecting print cartridges, 200-201 margin padding, 199 monitor calibration, 200

monitor profile, 200 paper quality, 201 paper settings, 201 PictBridge, 202 pixels, 195-198 ppi vs. dpi, 196 resolution, 195-198 synchronizing printer and monitor colors, 200-202 upsampling, 196 problem diagnosis. See also specific problems blobs, 76 color cast, 62-63 hair-like defects, 76 JPEG artifacts, 62-63 lens/sensor dirt, 62-63 with Nikon ViewNX 2, 63 noise, 62-63 pixelation, 62-63 random defects, 76 programs for managing pictures. See photo software protected symbol (key icon), 152 protecting pictures. See also deleting pictures; locking basic procedure, 163 deleting protected pictures, 163 double backup, 209 storage guidelines, 209 transferring protected pictures to a computer, 163 PT (Portrait) mode, 57, 60, 87, 293-294. See also Night Portrait mode

• (2) •

quality settings. *See also* image quality color cast, 62–63 JPEG artifacts, 62–63 lens/sensor dirt, 62–63 noise, 62–63 overview, 61 pixelation, 62–63 problem diagnosis, 62–63 tradeoffs, 61

Index

375

question mark (?)
blinking, 37, 59, 247
camera icon, 36
Quick Response mode, 81
Quick Response Remote setting, 55–56
Quick Retouch filter, 333–335
Quick Settings screen. *See* Info Edit screen
Quick-Response Remote mode, 81
Quiet Shutter Release mode, 81

• *R* •

[r24] message, 53 rangefinder, 42, 272 Rangefinder option, 42 rapid-fire photography. See continuous shooting Raw conversion in the camera, 187-191 conversion process, 187-191 exposure compensation, 190 image quality, 190 image size, 190 ISO noise reduction, 190 **JPEG**, 72 in Nikon ViewNX 2, 191-195 overview, 187 picture control, 190 renaming converted files, 195 stripping metadata, 194 TIFF, 72, 193-195 white balance, 190 Raw converter, 72 Raw (NEF) file format. See also JPEG file format additional software required, 72 advantages of, 70-71 banding, 71 bit depth, 71 channels, 71 disadvantages, 71-72 file size, 71 Image Quality options, 72 image size, 64

vs. JPEG, 72-73 posterization, 71 RAW +JPEG option, 72 RAW option, 72 Rear-Curtain Sync, 252-253 recording movies. See also playing movies aperture (f-stop) settings, 124 audio, 120-123. See also microphone, audio recording autoexposure lock, 124 available recording time, 125 bit rate, setting, 117-120 camera override, 124 exposure compensation, 124 exposure settings, 123-124 focusing, 124 fps (frames per second), 118 frame quality, setting, 125 frame rate, setting, 117-120, 125 frame size, setting, 117–120, 125 interlaced video, 119 ISO settings, 123-124 in Live View, 99 making the recording, 125-127 microphone settings, 122–123 overview, 116 p (progressive) frame rates, 119 picture control, 125 resolution, 118 settings, summary table, 120 shutter speed, 123-124 sound recording, 120–123 video mode, choosing, 116-117 video quality, setting, 117-120 volume meters, 122 white balance, 125 recording sound. See audio recording Red-Eye Correction filter, 322–324 red-eve reduction, 81, 249–250, 253, 322 - 324reds in sunsets, 92 Release Mode. See shutter Release Mode Release mode button, 22 Remember icon, 3

remote control, 81. See also ML-L3 wireless remote control Remote On Duration option, 42, 56 remote shutter release, 25 removing lenses, 10 memory cards, 16 Reset setup options option, 37 resetting to defaults, 37, 44-45 resolution definition, 64 Image Size options, 64 pixels, 64, 66-67 printing pictures, 195–198 recording movies, 118 restoring default settings, 37, 44-45 Retouch menu, 320-322. See also specific retouching retouch status, 152 retouching options, 31 reviewing pictures. See also playback; slide shows in all folders, 146 basic procedure, 141 calendar view, 144-145 in the current folder, 146 scrolling the display, 144 selecting pictures, 144, 146 thumbnail views, 143-145 transition effects, 141-142 zooming in and out, 146–147 RGB color space, 291–292 RGB Histogram mode, 149, 153–156 RGB images, 155 rotating pictures, 40, 139-141, 324-325

• 5 •

S (shutter-priority autoexposure) mode description, 49 determining exposure, 228 exposure metering, 226 flash, 58 safeguarding. See locking: protecting safety tips automatic shutoff, 100-101 avoiding bright lights, 101 battery life, 102 extended use precautions, 101 external electronic interference, 102 flicker reduction, 102 light seepage, 99 reducing camera shake, 102 saturation, 155 Scene modes autofocus, 86-87 Child mode, 88 Close Up mode, 89 depth of field, adjusting, 279 description, 48 ISO Sensitivity, 87 Landscape mode, 87 Night Portrait mode, 89-90 overview, 86 Portrait mode, 87, 89-90 Sports mode, 88-89 screen display size, pixels, 65 screen grabs, 132–133 screening movies. See playing movies SD (secure digital) memory cards, 15 SD (standard) mode, 292, 294 SDHC (High Capacity) memory cards, 15 SDXC (eXtended Capacity) memory cards, 15 Selective Color filter, 354-356 self-timer changing, 42 delay time, 54-55 number of shots. 54-55 shutter release, 81 semi-automatic exposure modes, 49 sending pictures to a computer. See downloading pictures to a computer sepia photographs, 338-340 Set Up option, 27

Index

settings. See also Setup menu; specific settings AE-L/AF-L button, customizing, 43 automatic shutoff timer, 40-41 beeping, turning on and off, 42 camera orientation, recording, 40 cleaning, 39 comments, adding to pictures, 40 custom folders, specifying, 44 dates, adding to pictures, 43 dates, setting, 40 dust-removal filter reference image, specifying, 40 exposure meter, automatic shutoff, 40-41 Eye-Fi upload, 44 firmware versions, displaying, 44 Fn (Function) button, customizing, 43 GPS, adjusting, 44 HDMI options, setting, 39 Information screen appearance, 38-39 language, setting, 40 locking up the mirror, 39 memory cards, formatting, 37 memory cards, taking pictures without. 43 monitor (camera), automatic shutoff, 40 - 41monitor (camera), brightness, 37–38 monitor (computer), flicker reduction, 39 - 40picture data, viewing, 156-159 picture files, defaults for naming, 42-43 rangefinder, enabling, 42 recent, displaying, 31, 33 recommended, summary of, 300 resetting to defaults, 37, 44-45 rotating images automatically, 40 shutter self-timer, 42 television video mode, setting, 39 time zone, setting, 40 timers, setting, 40-42 viewfinder display, automatic shutoff, 40 - 41wireless remote control on-duration, setting, 42

settings, displaying battery status, 34 Info Edit screen, 33–34 shots remaining, 34 viewfinder, 33-34 Setup menu, displaying, 37 Setup menu, options Auto image rotation, 40 Auto information display, 38–39 Auto off timers, 40-41 Beep, 42 Buttons, 43 Clean image sensor, 39 Eye-Fi upload, 44 File number sequence, 42–43 Firmware versions, 44 Flicker reduction, 39-40 Format memory card, 37 GPS, 44 **HDMI**, 39 Image comment, 40 Image Dust Off ref photo, 40 Info display format, 38 Language, 40 Lock mirror up for cleaning, 39 Monitor brightness, 37-38 Print date, 43 Rangefinder, 42 Remote on duration, 42 Reset setup options, 37 Self-timer, 42 Slot empty release lock, 43 Storage folder, 44 Time zone and date, 40 Video mode, 39 shadows boosting, 333-334 brightness histogram, 154 exposure, 331-332. See also Active **D**-lighting sharing pictures online, 203–208 sharpening focus, 292 Shoot option, 27 Shooting Data mode, 149, 156–157

Shooting menu Focus mode adjustments, 109 image quality adjustments, 74 image size adjustments, 74 resetting, 45 shooting wide open, 222 shots remaining, displaying, 27, 34 shutoff timer, 40-41 shutter button autofocus interaction, 51 description, 18 doesn't work, 51 illustration, 19 release mode, setting, 22 remote release, 25 self-timer, 42 techniques for pressing, 18 shutter priority. See P (programmed autoexposure) mode; S (shutterpriority autoexposure) mode shutter Release mode burst mode, 52-53 changing, 51 continuous shooting, 52-53, 81 Delayed mode, 81 maximum frames per second, 53 options, 81-82 overview, 50 Quick Response mode, 81 Quiet Shutter Release mode, 52, 81 self-timer, 81 Single Frame mode, 52, 81-82 viewing current settings, 50 shutter speed blurry photos, 262-263 bulb exposure, 214 extra slow, 214 for flash, 248-249 and focus, 85 freezing motion, 307-310 motion blur, 217–218 noise (visual), 221 overview, 214 recording movies, 123-124 self-timer, 42

setting, 222. See also M (manual exposure) mode; P (programmed autoexposure) mode: S (shutterpriority autoexposure) mode syncing with flash, 253 Single Frame mode, 81-82 single frame shooting, 81 Single Point mode, 263 16-bit TIFF files, 194 size. See file size; image size sketch effects, 353-354 Skylight filter, 335-337 slide shows. See also playback creating, 164-167 exiting, 167 pausing, 167 skipping slides, 167 viewing picture data, 167 volume control. 167 Slot empty release lock option, 43 slow-svnc, 250-252, 253 SLR vs. point-and-shoot, 8 Soften filter, 356-358 softening backgrounds, 92 software for managing pictures. See photo software sound recording. See audio recording speaker, 19-20 spectrum of colors, 291-292 sports action, 88-89 Sports mode, 58, 88-89 spot exposure metering, 234-236 sRGB color space, 291-292 SSC_ filenames, 151 standard (SD) mode, 292, 294 starburst effect filter, 349-351 stationary subjects, 110, 301-307 still portraits, 301-307 stopping down, 216 stopping motion. See freezing motion Storage folder option, 44 storing pictures, internal memory buffer, 53. See also folders; memory cards; picture files Straighten filter, 324-325 straightening tilted pictures, 324-325

subfolders, creating, 183–184 Subject Tracking, 108, 111 sunrise/sunset, exposing for, 312 switches. *See* camera controls; *specific switches*

• 7 •

Technical stuff icon, 3 telephoto lenses crop factor, 280 definition, 8 distortion control, 82 with flash, 246 television, connecting camera to HDMI port, 25 USB/AV port, 25 video mode, setting, 39 television playback camera ports, 169 HDMI, 168 HDMI CEC, 168-169 NTSC video mode, 169 PAL video mode, 169 playing pictures and movies, 168–169 standard or HDTV, 168 3D Tracking mode, 264 through the lens (TTL), 25 Thumbnail button, 22 thumbnail playback, 22, 127, 143-145 thumbnails, viewing downloads as, 182 TIFF file format, converting from Raw, 72, 193 - 195tilted pictures, straightening, 324–325 time. See date and time time zone, setting, 40 Time zone and date option, 40 time-out duration, wireless remote setting, 56 timers, setting, 40-42 Tip icon, 3 tonal range, 154, 241-244 transition effects, playing pictures and movies, 141-142 trash-can icon, 22

trimming movies, 129–132. *See also* cropping pictures tripod socket, 25 tripods, 13, 92 TTL (through the lens), 25

• 11 •

upsampling, 65, 196

• 1/ •

VI (vivid) mode, 293-294 vibration compensation. See Vibration Reduction Vibration Reduction, 12-13, 80 video mode, 116-117 Video mode option, 39 video quality, recording movies, 117–120 View/Delete option, 27 viewfinder (eyepiece) cover for, 55 focus, 13-14 light seepage, 55 viewfinder (monitor). See Live View viewing pictures. See playback; reviewing pictures; slide shows ViewNX 2 (Nikon) diagnosing problems, 63 downloading pictures to a computer, 180 - 186installing, 174 operating systems supporting, 174 overview, 172-174 prepping online pictures, 205-206 Raw conversion, 191–195 viewing metadata, 172 volume control, 129, 167 volume meters, 122-123, 125

• 11 •

Warm filter, 335–337 warm light, 281 Warning icon, 3

380

water flowing, 92, 310-311 white balance adjusting, 283-287 color temperature, 281 correcting colors, 281-283 Fn (Function) button, 347 light sources, 281-283 matching an existing photo, 289-290 presets, 287-290 Raw conversion, 190 recording movies, 125 setting with direct measurement, 288-289 warm light, 281 white balancing, 282 white dot on lenses, 9 Wide Area, 108, 111-112 wide-angle lenses, 82, 280 Windows Live Photo Gallery, 173

wireless downloading pictures to a computer, 186 memory cards, 15 mobile adapter, 25 remote control, 81. *See also* ML-L3 wireless remote control WU-1a wireless mobile adapter, 186

• Z •

Zoom Out button, 22, 36 zooming in and out depth of field, adjusting, 278–279 individual faces in group shots, 147 playing pictures and movies, 146–147 reviewing pictures, 146–148 zoom ring, 11–12 zooming to check focus, 113

Apple & Mac

iPad 2 For Dummies, 3rd Edition 978-1-118-17679-5

iPhone 4S For Dummies, 5th Edition 978-1-118-03671-6

iPod touch For Dummies, 3rd Edition 978-1-118-12960-9

Mac OS X Lion For Dummies 978-1-118-02205-4

Blogging & Social Media

CityVille For Dummies 978-1-118-08337-6

Facebook For Dummies, 4th Edition 978-1-118-09562-1

Mom Blogging For Dummies 978-1-118-03843-7

Twitter For Dummies, 2nd Edition 978-0-470-76879-2

WordPress For Dummies, 4th Edition 978-1-118-07342-1

Business

Cash Flow For Dummies 978-1-118-01850-7

Investing For Dummies, 6th Edition 978-0-470-90545-6 Job Searching with Social Media For Dummies 978-0-470-93072-4

QuickBooks 2012 For Dummies 978-1-118-09120-3

Resumes For Dummies, 6th Edition 978-0-470-87361-8

Starting an Etsy Business For Dummies 978-0-470-93067-0

Cooking & Entertaining

Cooking Basics For Dummies, 4th Edition 978-0-470-91388-8

Wine For Dummies, 4th Edition 978-0-470-04579-4

Diet & Nutrition

Kettlebells For Dummies 978-0-470-59929-7

Nutrition For Dummies, 5th Edition 978-0-470-93231-5

Restaurant Calorie Counter For Dummies, 2nd Edition 978-0-470-64405-8

Digital Photography

Digital SLR Cameras & Photography For Dummies, 4th Edition 978-1-118-14489-3 Digital SLR Settings & Shortcuts For Dummies 978-0-470-91763-3

Photoshop Elements 10 For Dummies 978-1-118-10742-3

Gardening

Gardening Basics For Dummies 978-0-470-03749-2

Vegetable Gardening For Dummies, 2nd Edition 978-0-470-49870-5

Green/Sustainable

Raising Chickens For Dummies 978-0-470-46544-8

Green Cleaning For Dummies 978-0-470-39106-8

<u>Health</u>

Diabetes For Dummies, 3rd Edition 978-0-470-27086-8

Food Allergies For Dummies 978-0-470-09584-3

Living Gluten-Free For Dummies, 2nd Edition 978-0-470-58589-4

Hobbies

Beekeeping For Dummies, 2nd Edition 978-0-470-43065-1

Chess For Dummies, 3rd Edition 978-1-118-01695-4

Drawing For Dummies, 2nd Edition 978-0-470-61842-4

eBay For Dummies, 7th Edition 978-1-118-09806-6

Knitting For Dummies, 2nd Edition 978-0-470-28747-7

<u>Language &</u> Foreign Language

English Grammar For Dummies, 2nd Edition 978-0-470-54664-2

French For Dummies, 2nd Edition 978-1-118-00464-7

German For Dummies, 2nd Edition 978-0-470-90101-4

Spanish Essentials For Dummies 978-0-470-63751-7

Spanish For Dummies, 2nd Edition 978-0-470-87855-2

Available wherever books are sold. For more information or to order direct: U.S. customers visit www.dummies.com or call 1-877-762-2974. U.K. customers visit www.wileyeurope.com or call (0) 1243 843291. Canadian customers visit www.wiley.ca or call 1-800-567-4797. Connect with us online at www.facebook.com/fordummies or @fordummies

Math & Science

Algebra I For Dummies, 2nd Edition 978-0-470-55964-2

Biology For Dummies, 2nd Edition 978-0-470-59875-7

Chemistry For Dummies, 2nd Edition 978-1-1180-0730-3

Geometry For Dummies, 2nd Edition 978-0-470-08946-0

Pre-Algebra Essentials For Dummies 978-0-470-61838-7

Microsoft Office

Excel 2010 For Dummies 978-0-470-48953-6

Office 2010 All-in-One For Dummies 978-0-470-49748-7

Office 2011 for Mac For Dummies 978-0-470-87869-9

Word 2010 For Dummies 978-0-470-48772-3

Music

Guitar For Dummies, 2nd Edition 978-0-7645-9904-0

Learn to:

Golf

DUMMIE,S

Clarinet For Dummies 978-0-470-58477-4

iPod & iTunes For Dummies, 9th Edition 978-1-118-13060-5

Pets

Cats For Dummies, 2nd Edition 978-0-7645-5275-5

Dogs All-in One For Dummies 978-0470-52978-2

Saltwater Aquariums For Dummies 978-0-470-06805-2

Religion & Inspiration

The Bible For Dummies 978-0-7645-5296-0

Catholicism For Dummies, 2nd Edition 978-1-118-07778-8

Spirituality For Dummies, 2nd Edition 978-0-470-19142-2

Self-Help & Relationships

Happiness For Dummies 978-0-470-28171-0

Overcoming Anxiety For Dummies, 2nd Edition 978-0-470-57441-6

Seniors

Crosswords For Seniors For Dummies 978-0-470-49157-7

iPad 2 For Seniors For Dummies, 3rd Edition 978-1-118-17678-8

Laptops & Tablets For Seniors For Dummies, 2nd Edition 978-1-118-09596-6

Smartphones & Tablets

BlackBerry For Dummies, 5th Edition 978-1-118-10035-6

Droid X2 For Dummies 978-1-118-14864-8

HTC ThunderBolt For Dummies 978-1-118-07601-9

MOTOROLA XOOM For Dummies 978-1-118-08835-7

Sports

Basketball For Dummies, 3rd Edition 978-1-118-07374-2

Football For Dummies, 2nd Edition 978-1-118-01261-1

Golf For Dummies, 4th Edition 978-0-470-88279-5

Test Prep

ACT For Dummies, 5th Edition 978-1-118-01259-8

ASVAB For Dummies, 3rd Edition 978-0-470-63760-9

The GRE Test For Dummies, 7th Edition 978-0-470-00919-2

Police Officer Exam For Dummies 978-0-470-88724-0

Series 7 Exam For Dummies 978-0-470-09932-2

Web Development

HTML, CSS, & XHTML For Dummies, 7th Edition 978-0-470-91659-9

Drupal For Dummies, 2nd Edition 978-1-118-08348-2

Windows 7

Windows 7 For Dummies 978-0-470-49743-2

Windows 7 For Dummies, Book + DVD Bundle 978-0-470-52398-8

Windows 7 All-in-One For Dummies 978-0-470-48763-1

Available wherever books are sold. For more information or to order direct: U.S. customers visit www.dummies.com or call 1-877-762-2974. U.K. customers visit www.wiley.ca or call 1-800-567-4797. Connect with us online at www.facebook.com/fordummies or @fordummies

DUIMMIES.COM

Wherever you are in life, Dummies makes it easier.

From fashion to Facebook®, wine to Windows®, and everything in between, Dummies makes it easier.

Visit us at Dummies.com and connect with us online at www.facebook.com/fordummies or @fordummies

DUMMIES.COM Making Everything Easier

Dummies products make life easier!

- DIY
- Consumer Electronics
- Crafts
- Software
- Cookware

- Hobbies
- Videos
- Music
- Games
- •and More!

For more information, go to **Dummies.com**® and search the store by category.

Connect with us online at www.facebook.com/fordummies or @fordummies

Making everything easier!"